Sunshot

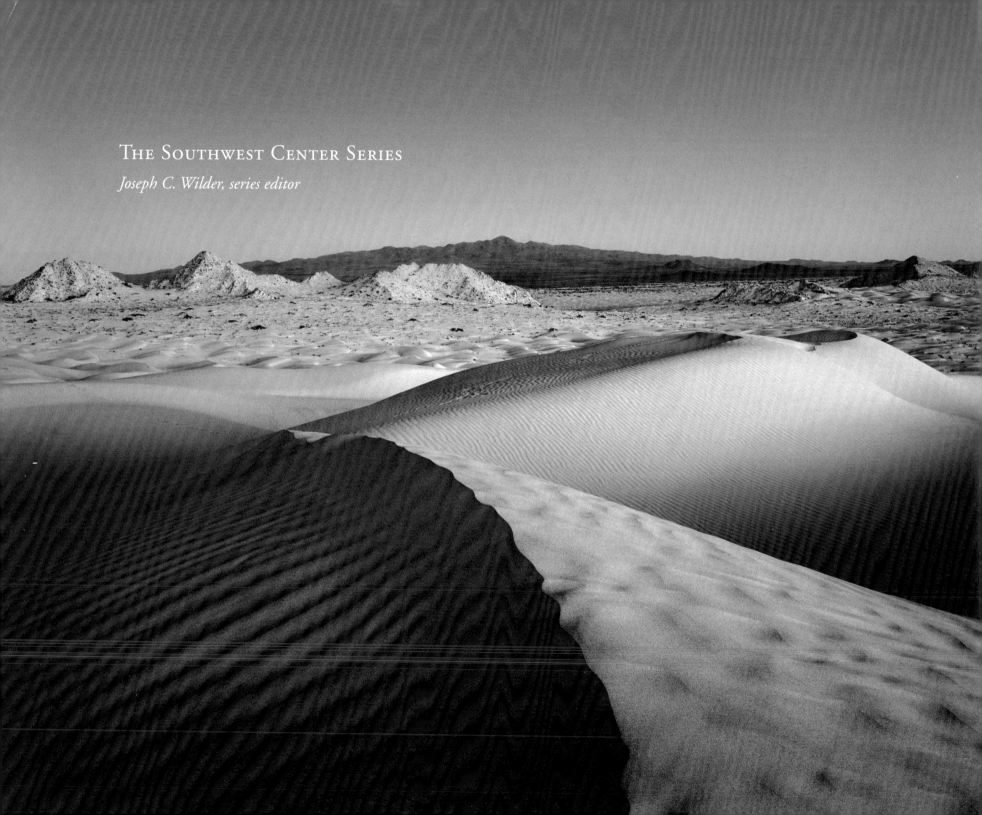

The Southwest Center Series

Joseph C. Wilder, series editor

Sunshot

peril and wonder in the Gran Desierto

Text by Bill Broyles

Photographs by Michael P. Berman

THE UNIVERSITY OF ARIZONA PRESS

TUCSON

The University of Arizona Press
Text © 2006 Bill Broyles
Photographs © 2006 Michael P. Berman

♾ This book is printed on acid-free, archival-quality paper.
Manufactured in Canada
11 10 09 08 07 06 6 5 4 3 2 1

Publication of this book is made possible in part by a grant from
the Southwest Center of the University of Arizona.

The Southwest Center Series list is on page 243.

Library of Congress Cataloging-in-Publication Data and additional
copyright information appear on the last printed page of this book.

For Jennifer Six. MB

In memory of my parents,
Frank and Wanda,
who probably worried but always encouraged BB

In honor of Joe Wilder,
who makes good things happen.

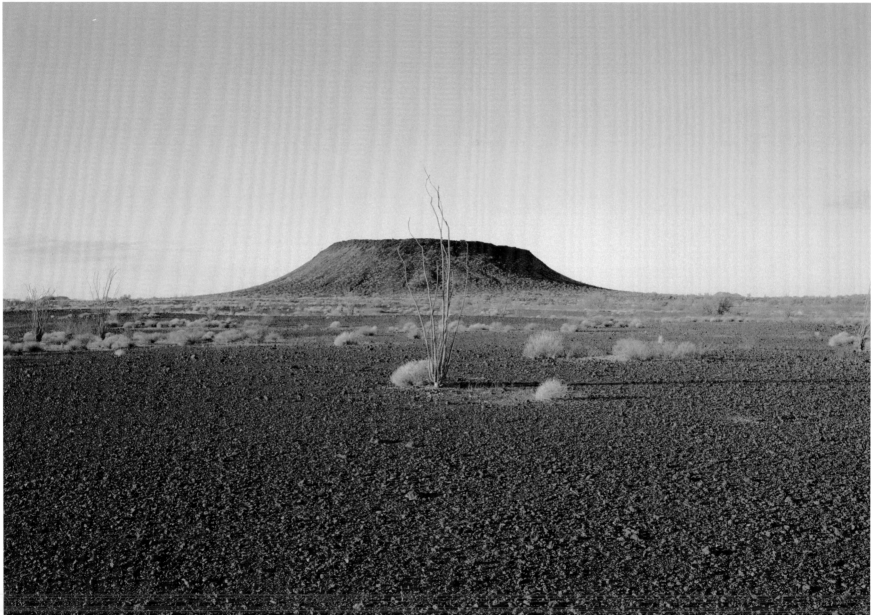

Contents

And a Grand Desert It Is IX

Devil's Driveway 3

Devil's Highway 9

Stranded 17

Waylaid by Beauty 23

Lion in Summer 29

Go Back 33

Spring 39

Passing Through 45

Faces 53

Perils 73

Wonders 83

Hawk 93

Glenton Sykes 97

Night 105

Ultimate Dude Ranch 113

Salt 119

Across the Heart 133

Knowing 149

Reasons 159

Bowden 163

Ground Zero 173

Letting Go 193

Devil's Oven 203

Epilogue 209

Photographer's Comments 213

Acknowledgements 217

Chapter Notes 219

Library 233

List of Photographs 235

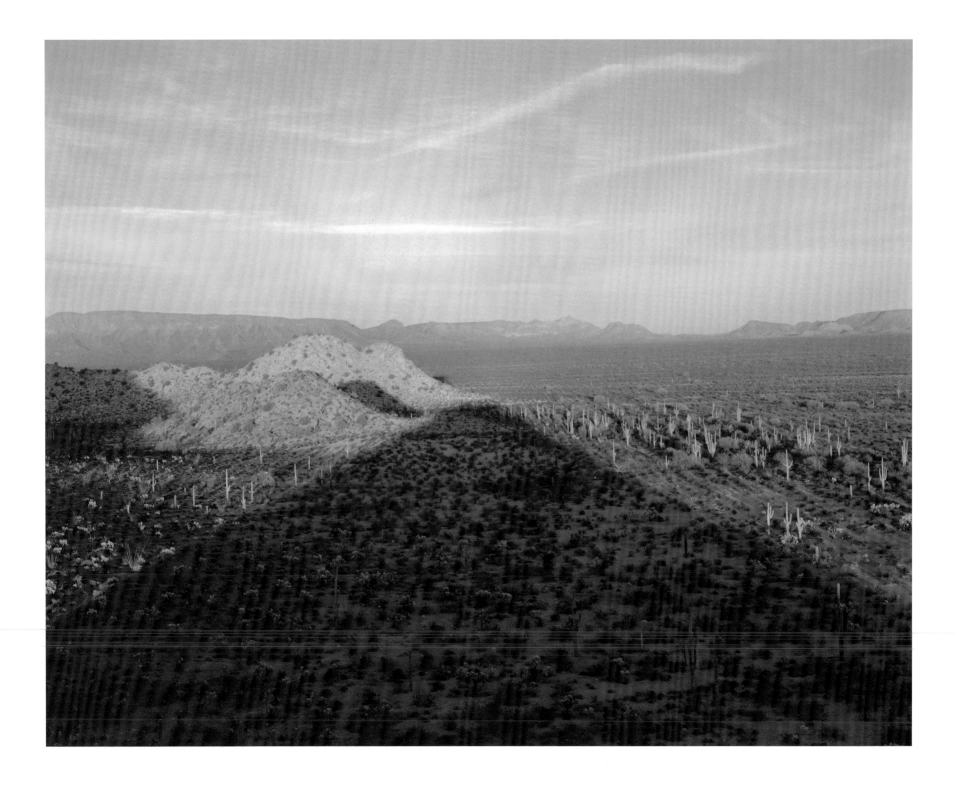

And a Grand Desert It Is

"But I will tell you this: in the desert, there is all—and yet nothing."
"Stay!—Explain that."
"Well then," he said, with a gesture of impatience, "God is there and man is not."

Honoré de Balzac, "A Passion in the Desert'"

FROM BEYOND the spinning globe of Earth, we watch as continents pass below, great masses of exotic land- and seascapes, richly interesting humans, and amazing forms of life. We know and recite many memorable places: the Nile, Australia, the Andes, polar ice caps, fjords of Scandinavia, the Congo, Empty Quarter, Pacific Ocean, Gobi, game plains of Kenya, the Amazon watershed, volcanic and coral archipelagos, Easter Island, Mount Everest, Mariana Trench, White Cliffs of Dover, Canadian Rockies, Bay of Bengal, Fujiyama.

In North America we see the Great Lakes, Grand Tetons, Grand Rapids, Great Salt Lake, Great Sand Dunes, Great Slave Lake, Grand Banks, and Great Smoky Mountains. And in the southwestern corner of the continent are the renowned Grand Canyon, Rio Grande, Great Basin, and a lesser known but equally fascinating landscape, a sun-drenched desert known locally as El Gran Desierto del Altar: the Grand Desert.

It is a subregion at the heart of the Sonoran Desert biological zone and forms a dry borderland with the United States and Mexico. Some teasingly call it the Stinking Hot Desert and the Cactus Coast; others have seen and appreciated—or feared—parts of it and left names like the Forty Mile Desert, Tule Desert, the Malpais, Lechuguilla Desert, El Pinacate, Yuma Desert, Dry Borders, El Gran Despoblado, G-- D--- Desert, and the Devil's Highway.

It's a desert where stately saguaro cactus stand near aromatic elephant trees, where suave sand dunes caress the edges of jagged granite mountains. It's a desert where we can go from watching bighorn sheep in the morning to whales in the afternoon. As our friend Charles Bowden reminds us, "It's a desert with a beach." It deserves respect and a name to match its grandeur. In the next few hours Michael and I will take you there, to the Grand Desert.

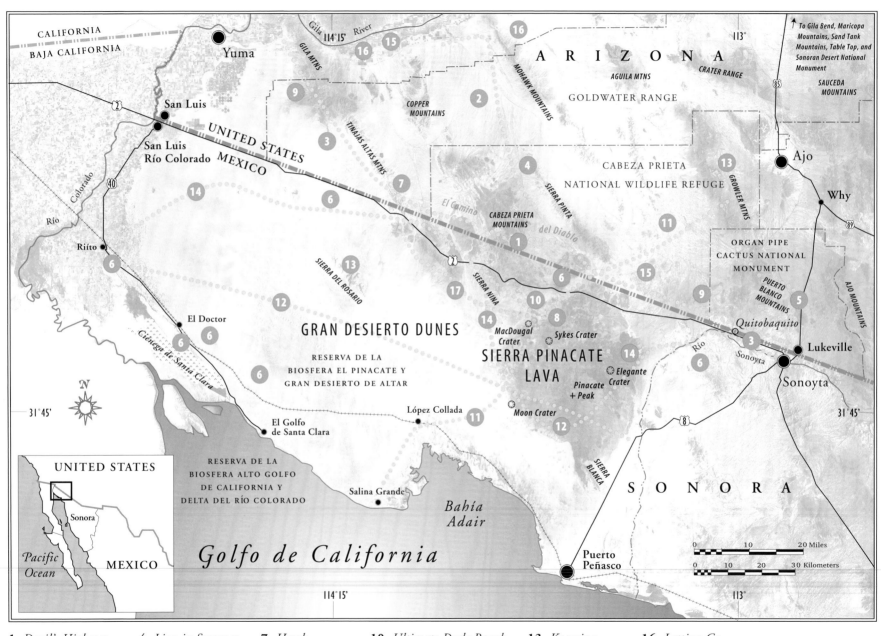

CALIFORNIA
BAJA CALIFORNIA

Gila River
114°15'

ARIZONA

113°

To Gila Bend, Maricopa
Mountains, Sand Tank
Mountains, Table Top, and
Sonoran Desert National
Monument

Yuma

16

15

16

AGUILA MTNS

CRATER RANGE

SAUCEDA
MOUNTAINS

San Luis

GILA MTNS

MOHAWK MOUNTAINS

GOLDWATER RANGE

85

9

COPPER
MOUNTAINS

2

UNITED STATES

San Luis
Río Colorado

MEXICO

TINAJAS ALTAS MTNS

3

4

CABEZA PRIETA

13

Ajo

NATIONAL WILDLIFE REFUGE

Why

Colorado

40

7

SIERRA PINTA

14

6

El Camino

CABEZA PRIETA
MOUNTAINS

del Diablo

11

89

GROWLER MTNS

Río

Riíto

1

ORGAN PIPE
CACTUS NATIONAL
MONUMENT

6

2

15

PUERTO
BLANCO
MOUNTAINS

5

SIERRA DEL ROSARIO

13

SIERRA NINA

6

9

AJO MOUNTAINS

17

10

Quitobaquito

Lukeville

12

14

MacDougal
Crater

8

Sykes Crater

14

3

Río

El Doctor

6

SIERRA PINACATE
LAVA

Sonoyta

6

Sonoyta

GRAN DESIERTO DUNES

Elegante
Crater

RESERVA DE LA
BIOSFERA EL PINACATE Y
GRAN DESIERTO DE ALTAR

Pinacate
+ Peak

6

Ciénega de Santa Clara

López Collada

11

Moon Crater

12

8

N

El Golfo
de Santa Clara

31°45'

SIERRA BLANCA

SONORA

RESERVA DE LA
BIOSFERA ALTO GOLFO
DE CALIFORNIA Y
DELTA DEL RÍO COLORADO

Salina Grande

Bahía
Adair

31°45'

113°

UNITED STATES

Sonora

Golfo de California

Puerto
Peñasco

0 10 20 Miles

Pacific
Ocean

MEXICO

0 10 20 30 Kilometers

114°15'

1	Devil's Highway	**4**	Lion in Summer	**7**	Hawk	**10**	Ultimate Dude Ranch	**13**	Knowing	**16**	Letting Go
2	Stranded	**5**	Passing Through	**8**	Glenton Sykes	**11**	Salt	**14**	Bowden	**17**	Devil's Oven
3	Waylaid by Beauty	**6**	Faces	**9**	Night	**12**	Across the Heart	**15**	Ground Zero		

Sunshot

Devil's Driveway

First prisoner: "It must be 120 degrees in the shade."
Second prisoner: "Course you don't have to stay in the shade, ya know."

Harry Belafonte, "Talkin' an' Signifyin'"

A friend and i planned to walk El Camino del Diablo in August. That translates to "the Devil's Highway" and 130 miles of searing, grand desert between Sonoyta, Sonora, and Yuma, Arizona. Undocumented immigrants, primarily from Mexico and Central America, pass through this blazing desert on their journey north—and every summer some die here. A hundred and fifty years ago, other pioneers braved the same highway. They were not always successful, either. Our hike would study the effects of heat stress out there by subjecting our own bodies to it.

But I got anxious and conducted a preliminary experiment. A warm-up test, so to speak. This seemingly crazy investigation was done at home in Tucson. In a closed automobile. It will live in lore as "la Calzada del Diablo." The Devil's Own Driveway.

This was the preview, the economy version of the full hike. Forget the backpack and long trail. The laboratory was sitting right there in front of the house: a shiny car in the bright June sun. All I needed was to gather a squad of thermometers and some basic medical gizmos to measure vital signs.

The modern car is a greenhouse of glass. Solar energy enters but can't leave. While this principle serves nicely to warm one's buns in winter, it torches them in summer. I knew that temperatures and pressures inside a closed car on a hot day could braise bare skin, crack dashboards, and even explode windows.

Even so, I readied my experiment with a few goodies, and at 10:00 A.M. sharp I popped into the car parked in my driveway and closed its doors. The doors had stood open for over an hour, and although the outdoor and shaded temperature was only 92 degrees, the car's interior was 98 degrees. No sweat. I had a giant-sized iced cola, a good book, and a radio. I was set for the rest of the day. Baseline pulse was sixty-two, blood pressure 118/78, respiration nine, and oral temperature 97.2 degrees. All systems were within normal parameters of operation.

Within the first seventeen minutes, I began to sweat, especially where the sun hit my bare legs. The inside temperature had risen to 114 degrees, while outside it was still 92 degrees. By 10:25 I had polished off a dozen pages of the book. The mercury had risen to 118 degrees, and my own stats had started to flutter. Pulse was up by sixteen, temperature by 0.4 degrees, and respiration by three. Though I was sitting still, my body acted as if it were working 25 percent to 33 percent harder.

Heat shimmered off the car's brown hood. The metal clipboard and even the paper on it were hot to the touch. A meat thermometer on the dash read 130 degrees. My shirt was soaked and I dripped onto the pages. By 10:42 sweat poured from my forehead and arms. Two minutes later I started to fidget and could no longer concentrate on reading. My hair was soaked. "This is only morning," I thought. "What'll the afternoon be like?" I drank some soda but wasn't really thirsty.

At 10:47 I began to feel my pulse throughout my head and chest. It was up to 92. Breathing was now twenty, and my temperature had warmed to 99.2 degrees. Blood pressure read 124/84. And I was sitting, not exercising. One thermometer was off its scale at maybe 126 degrees, and the dash gauge read 145 degrees. At 11:01, a headache sprouted, and I found myself subconsciously draping a towel over my exposed legs. I hadn't noticed, but my socks and cutoff jeans were soaked, too. Reading was out of the question. I couldn't keep the sweat off my glasses, so I tossed the book into the backseat.

At 11:09 my scalp started to itch, and a minute later I stared down the temptation to open the door. By then I knew that the experiment wouldn't last into the afternoon. By 11:15 my nose began to run uncontrollably. Sweat coursed from my pores in rivulets. I was at a crisis and my vital signs proved it. The pulse (it was no longer "my pulse" but "the pulse") had soared to 116, almost double. Respiration was now shallow at twenty, and my temperature had become a fever at 100.6 degrees.

My lip cream had melted out of its tube, and the twenty-four-hour deodorant tube I had jestfully set on the dash was oozing into a puddle. No ice remained in my cup, which still was almost full. The oral thermometer threatened to pop its tube, so I cooled it in the cola. The next five minutes were bad. I could feel myself starting to struggle. I squirmed and felt dizzy.

By 11:24 the interior of the car was at least 136 degrees and over 160 degrees on the sunny dash, hot enough to cook ham. Outside in the shade two mockingbirds cavorted in the "cool" 96 degrees. My vitals had raced beyond prudence. My clouded mind wrestled with the blood pressure cuff and finally noted 136/98. The pulse was actually down to 110, but it was thin and flighty. I realized that I was panting to breathe. Forty shallow breaths a minute? Yes. And I felt as if I were finishing a marathon.

The clincher was my temperature, 102.2 degrees. "That can't be right," I thought. On a second check it read the same. At that rate I'd soon be into the danger zone of delirium and brain damage at 106 degrees. Determined to extend this test until noon, I tried to flex some willpower. I drank some soda. I wiped my brow. I closed my eyes. I reread the car thermometer. One hundred and thirty-six plus. Over 160 degrees on the dash. Ninety-seven outside. Outside. Outside was far away.

The most I could wring out of the experiment was seven more minutes. At 11:31 I reached for the door handle, but it was so hot I couldn't pull it until I wrapped a towel around my hand. Then I pushed the heavy, heavy door open and staggered four steps to the house. I was dizzy and I crumpled to the floor in relief even before I

could reach the refrigerator. No matter. I still wasn't thirsty. Just very, very tired. I lay on the floor and my pulse receded from its resemblance to a jackhammer to the mere throbbing of a roofing hammer. My clothes were sopping wet.

The headache was painful. The mind fuzzy. I couldn't quite decide whose house this was. My face and ears were still noticeably reddened when I finally struggled to the kitchen. Those bloodshot eyes didn't look quite like mine, either. Funny, but still I wasn't thirsty. I had entered the realm of heat stress and hadn't even felt dehydrated.

At 11:42 I felt chilled, with a rash of goose bumps as the sweat finally got a cooling grip on the fever. That must have been a sign that the blood, which had been diverted to cool vital organs, was returning to cool the rest of my body. Eight minutes later my vital signs were back to normal, but I was exhausted. A noon check of the car showed almost 170 degrees on the dash and at least 140 degrees on one bulb thermometer that hadn't topped out.

Hours? Tough guy?

I had mustered only ninety-one minutes before I was dangerously sick. And this wasn't the full rage of a genuinely *hot* summer's day. The official high was only 98 degrees, not a record 120 degrees. The experiment was not fun. I kept thinking, "If I can't make it more than ninety-one minutes in the Devil's Driveway, how can I handle the Devil's Highway? How does anyone?" And I kept pondering: what if I had been an infant, invalid, or pet, and couldn't have opened that car door? What if I had been out there, there on the real road, on El Camino del Diablo?

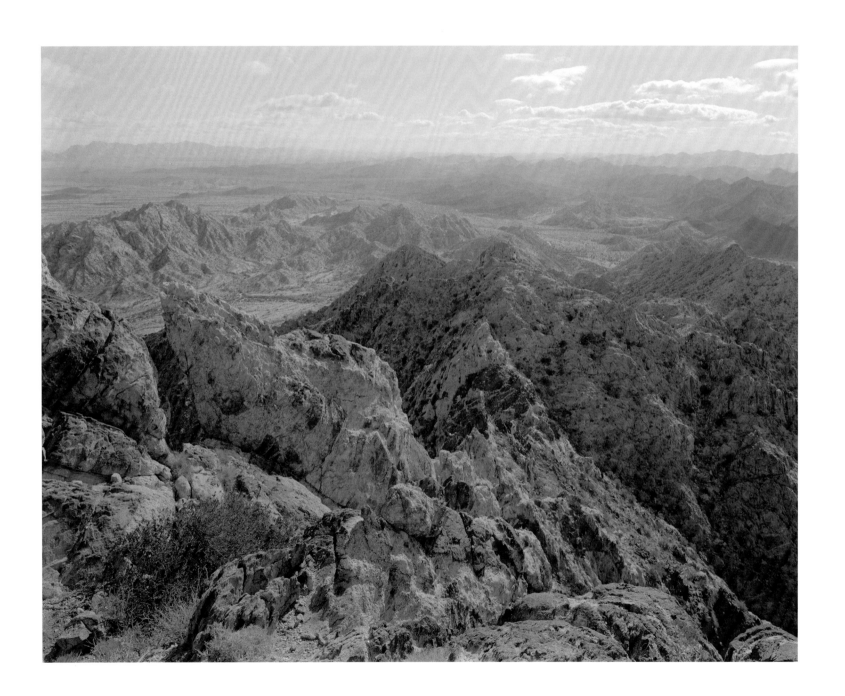

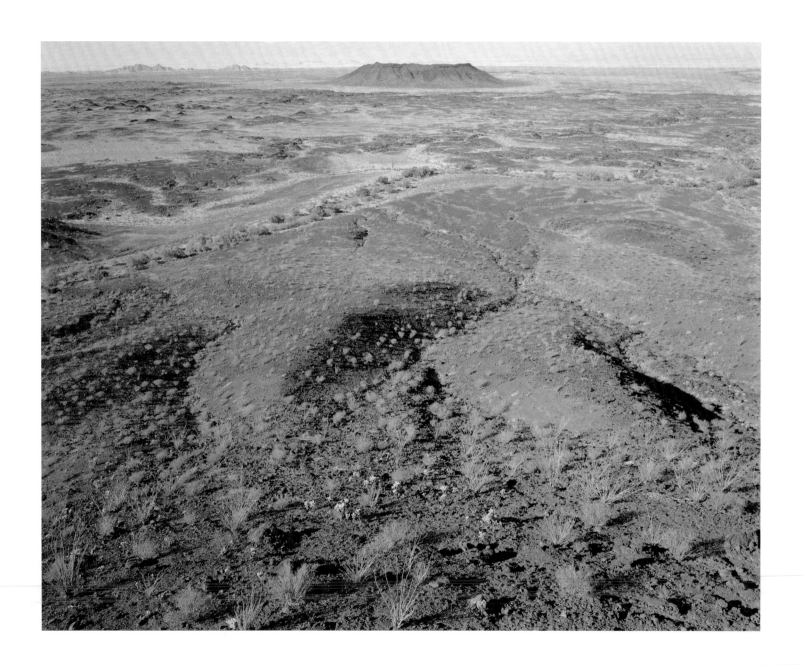

Devil's Highway

IT WAS NEVER AN EASY TRIP: not then, not now. But with a name like El Camino del Diablo—the Devil's Highway—you wouldn't expect it to be. Even the easy parts were arduous and the hard sections downright perilous. With 130 miles of desert to go—110 miles of that without permanent water, no canteen—or gas tank—could ever be too full.

Not everyone survived the journey. The ordeal of traveling by foot, horse, wagon, or car from Sonoyta, in Mexico's state of Sonora, to Yuma, on the Colorado River, claimed the unlucky and the unprepared. One relieved survivor of the Devil's Highway recalled the trip as "a shortcut through hell." Other travelers called it worse names—before they died of thirst or heat stroke. In recent years too, many travelers have been hard pressed to survive.

The first leg of the trip was straightforward enough. In Sonora the road began in the frontier towns of Caborca or Altar, and then passed through a few outposts offering water and grub. Midway one could lay over in Quitovac, an ancient spring, and then muster one's strength at Sonoyta or Santo Domingo, neighboring villages on the intermittent Sonoyta River. On the second leg one more waterhole could be counted on, the spring at Quitobaquito, but then the trip to Yuma became a leap of faith across the desolate stretch known as El Camino del Diablo.

If it had been a wet year, water might be found a few more miles downriver, pooled on the surface. Perhaps the sand-filled tub in the rock at Tule Tank will have caught a few gallons of runoff. Possibly, if not too many travelers had passed this way, the pools at Tinajas Altas (High Tanks) might hold enough for canteen, livestock, or radiator. In this land averaging just three to ten inches of yearly precipitation, a miraculous rainstorm might anoint us with a deluge and fill every arroyo with salvation. But, it might not. The route was iffy and risky.

Yet, many people have used it. Prehistoric and historical Native Americans lived and traveled in the area. El Camino was but one segment in an intricate web of trails connecting every waterhole, harvest camp, and hunting ground. The people even traded pottery and abalone shells with other cultures as far flung as the heart of Mexico and the Pacific Coast of California.

The first of the foreign travelers was a Spanish contingent led by Captain Melchior Díaz in 1540, eighty years before the Pilgrims arrived on the continent. Then Padre Eusebio Kino, founder of San Xavier Mission, traversed El Camino in 1699. Though difficult, the route was direct, following a natural geologic corridor pinched between rows of rugged mountains and impassable waves of lava and sand. Word spread and sporadically others followed, until by the early 1800s the route was known as the Sonora Trail and, later, the Yuma-Caborca Road. Sonoran settlers pressed on to San Diego, Los Angeles, and San Francisco. Some returned to Sonora for visits and business.

Most of those early families, prospectors, cowboys, and workers are now nameless, but some became prominent. Juan Forster, who moved to California in 1833, later owned the rancho that became Camp Pendleton Marine Base. Sonoran natives Nariciso Botello and Luis Arenas became players in Los Angeles politics. Antonio Franco

Coronel, who moved from Sonora to California in 1839, became mayor of Los Angeles and later state treasurer.

By the time gold was discovered in California in 1848, the road was well worn, so miners in northwestern Mexico were among the first to hear the news and rush for the goldfields. Unfortunately, word arrived at the end of spring, and some of those who left immediately were unsupplied or unprepared for the rigors of summer travel. Some were just plain unlucky. As many as four hundred died, and piled-stone crosses marked their graves along the trail.

Boundary-survey parties studied the land after the Gadsden Purchase in 1853. They mapped, described the geology, and cataloged plants and animals. After a second boundary survey in the mid-1890s, other scientists arrived to study the region and its storehouse of wonders. W. J. McGee, Daniel T. MacDougal, William T. Hornaday, Carl Lumholtz, and Forrest Shreve head the list of botanists, geographers, ethnologists, archaeologists, and zoologists seeking to unravel the mysteries of this corner of the Sonoran Desert. But, by 1890 the railroad had come to Arizona, and El Camino had become just another lightly traveled country trail.

Desert hydrologist Kirk Bryan, who toured the area in 1917 for the U.S. Geological Survey, advised all motorists to carry ample supplies plus more than ample water. He noted that even in September, after the brunt of summer's heat, he and his survey partner used "for all purposes, including drinking, cooking, washing, and filling the radiator, from 9 to 13 gallons a day."

Throughout, no one settled between Quitobaquito and Yuma, not the padres, not the immigrants, not the scientists, not the travelers. Sure, miners tented at the Fortuna and Papago mines, someone set up a shack at Tule Well in hopes of selling water, and ranchers sometimes ran line camps. But permanent civilization? Nothing developed, so

today this land remains *despoblado*—an unpopulated and untamed tract of desert. And thanks to wilderness areas and military ranges, it is likely to remain as nature keeps it.

Today we can retrace the entire El Camino trip in four-wheel drive, air-conditioned beasts with fat tires, but the region still isn't for the casual camper. It has too much sand, too many thorns, too little entertainment, too much nothing. Most visitors today are serious students of natural and human history coming to tread paths of antiquity or feel the pulse of nature. A good starting point is the oasis at Quitobaquito Spring in Organ Pipe Cactus National Monument where, sitting under an immense cottonwood, we watch ducks paddle on the pond. It's cool and peaceful, but we cannot stay at this last outpost of progress. We must head west. Like those before us, we're pulled by hope and pushed by fear.

From the spring, the old route followed the course of the Sonoyta River for a ways before striking west, but nowadays we jog north to catch a branch road on which Louis Jaeger's freight wagons carried supplies to the early mine at Ajo and returned to Yuma with ore for milling in Swansea, Wales, halfway around the world.

When we enter the Cabeza Prieta National Wildlife Refuge, we bounce westward across creosote flats and through mesquite thickets. In 1990 much of the refuge was designated a wilderness area. Being a wildlife refuge, its primary role is to protect animals and plants. If we're alert, we may spot a Sonoran pronghorn, desert bighorn sheep, or golden eagle.

And we'll have plenty of time to look. This trip imposes a different pace. The unimproved road is rough and slow, like the wagon trail it was. Ruts the size of curbs angle across it, and soft sand in rain-cut washes keeps us shifting gears. Jagged rocks loom out of nowhere. Limbs and spines snap and scratch, grab and jab. Once botanist For-

rest Shreve, a veteran of desert camping if there ever was one, wanted to drive El Camino, but his own car was in the shop, so he borrowed his wife's. She insisted that he drape canvas strips along its sides like chaps on a cowboy. Another visitor came in a rented Blazer; at check-in time the rental firm demanded a new paint job.

One friend recalls driving eighty miles and never getting higher than second gear—and repairing three tires, to boot. With heavy rain the road becomes a muddy ditch, stranding us for hours. We learn to take things easy and don't feel guilty in the least for stopping to sit a spell under a tree while a clutch of Gambel's quail chicks scratch and peck in the only lane.

Come nightfall we camp near Papago Well. Originally dug to serve Papago Mine, it later filled the troughs of Jim Havins' cattle camp. Now the windmill spins to fill its tank for wildlife. Fragrances intensify at night, and we catch the queen of the night's ineffable perfume. A coyote yelps in the distance, and a stealthy mule deer comes to the tank for a drink. Come morning we awaken to cooing doves.

At Las Playas, where we rejoin El Camino, which had looped south of the border at Quitovaquito, we're more likely to see dust devils than water. Scrubby mesquites tangle the dry lake floor. After summer rains, the playas come alive with toads, which have survived a year underground. The tracks of hunting herons and ravens stamp the dry mud. On the horizon travelers discern the distinctive refuge namesake, Cabeza Prieta Peak. Its cap of black rock marks a pivotal guidon for the next fifty miles.

Las Playas grades into the Pinta Sands, named after the two-toned range to the north. Some seasons these sands burst with lupines, primroses, ajo lilies, verbenas, and sunflowers, but in dry years the seeds and sands swirl in the wind. The dunes encircle a peninsula of the Pinacate lava flow. Here on a moonless night, the black basalt swallows

light, and campers brave enough to snuff the lantern are rewarded by a glittering array of stars. The Milky Way shines brightly; constellations leap into focus. Still, the faint glow from distant cities reminds us that even in this remote spot we cannot entirely escape civilization.

For such a historic route we might expect place-names every few miles, but here names are few and signposts fewer. Folks probably coined their own appellations for places, much as I find myself doing. One blank spot I nominate "Windy Camp." For two days the northern winter wind blew, evoking one of the ancient Tohono prayers to god I'itoi: "Please stop the wind." Even the intrepid Padre Kino was once turned back by a pestiferous norte wind, which roared night and day for over a week.

You, too, will name memorable spots. Together we might even rename El Camino del Diablo. Road of the Cabeza Prieta? Freeway of the Faithful? Path of Scratched Paint? Way without Water? Direction of Dread and Dreams? The Rut?

The camp at Tule Well is under the limbs of enduring mesquite trees, fed by water within thirty-five feet of the surface. Sometime in the late 1800s an enterprising merchant hand dug a well with a mind to sell water to travelers. He didn't last, but the well did. Today the water is still brackish and offensive, but more palatable than when Raphael Pumpelly and his family drank from it in 1915. Later he ran into a friend who had been there earlier. The friend inquired how he liked the water. Pumpelly replied, "Not much." The friend smiled and said, "Naturally, for we found and left a man in it two years ago." Some friend.

Three miles to the west, an unobtrusive side canyon conceals Tule Tank, a natural rock catchment where water might be found by digging in the sand. Tracks of desert bighorn sheep and the aromatic elephant tree, related to biblical frankincense and myrrh, greet us before we snap photos of each other posing at the historic tank.

A few miles beyond Tule Tank, we break out of the hills, and the trail steers straight for Tinajas Altas. Psychologically this must have been the hardest part of the trip. In the clear desert air, the tanks loom deceptively close, but eleven slow miles of sand, rock, and thorn lay between. Eight miles out from the tanks, a stone ring encircles an arrow pointing to Tinajas Altas, as much to encourage as to inform. Many perished in this stretch, some within yards of the upper tanks, whose slick granite ramps they were too weak to scale. One surveyor counted fifty graves on the flats, though all have been erased in the last few decades by careless campers. Always a focal point for marauders, revolutionaries, and smugglers, this canyon now suffers the pain and ignominy of off-road driving, random target practice, and littering.

In good health and with traction shoes, we clamber for the upper tanks. Nine sets of them nest in this narrow defile. It's tough going. The buzz of bees and hummingbirds in the chuparosa fills the canyon, and the cascading twi twi twi of a canyon wren welcomes us. The shade revives us. Then we, like those long before us, must decide which fork to take to Yuma.

One, the sporadically graded "good" road, rolls north to Wellton. From there we can go to Ligurta and follow the Gila River to Dome and then into Yuma. Pioneers desperate for water and livestock forage broke directly for the Gila. For us it is a faster route to convenience marts and paved roads.

The alternate, a more direct but riskier route to Yuma, snakes west through a pass in the mountains. This fork was for stronger parties, and even today it is less traveled and more difficult to follow without maps. The leg angles northwest for the Colorado and wanders

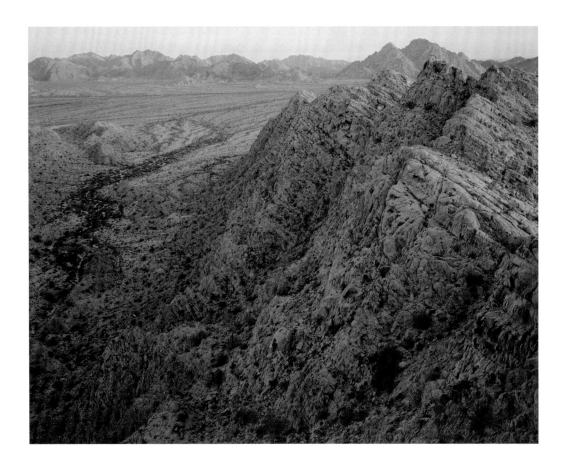

through the stripped site of Fortuna Mine. This section is the starkest of the trip, with barren rock, sparse plants, and shifting sands. After an interminable grind we abruptly intersect a paved subdivision street, aptly named El Camino del Diablo, and then roll smugly into Yuma, where early travelers crossed the Colorado River at Algodones or Pilot Knob.

Give the devil his due: if this indeed is his highway, he surely picked a special place for it. If we're lucky, we won't have more than one flat tire and a few new scratches in the paint, but we'll have rubbed the desert heartland and wheeled across our own history on one of Arizona's first "highways." We'll know we've been somewhere.

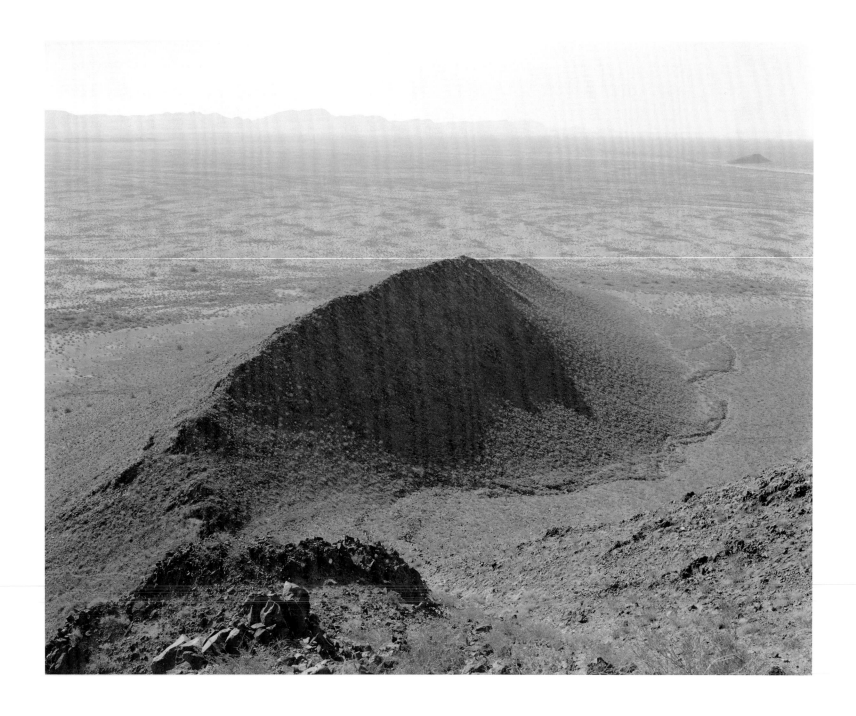

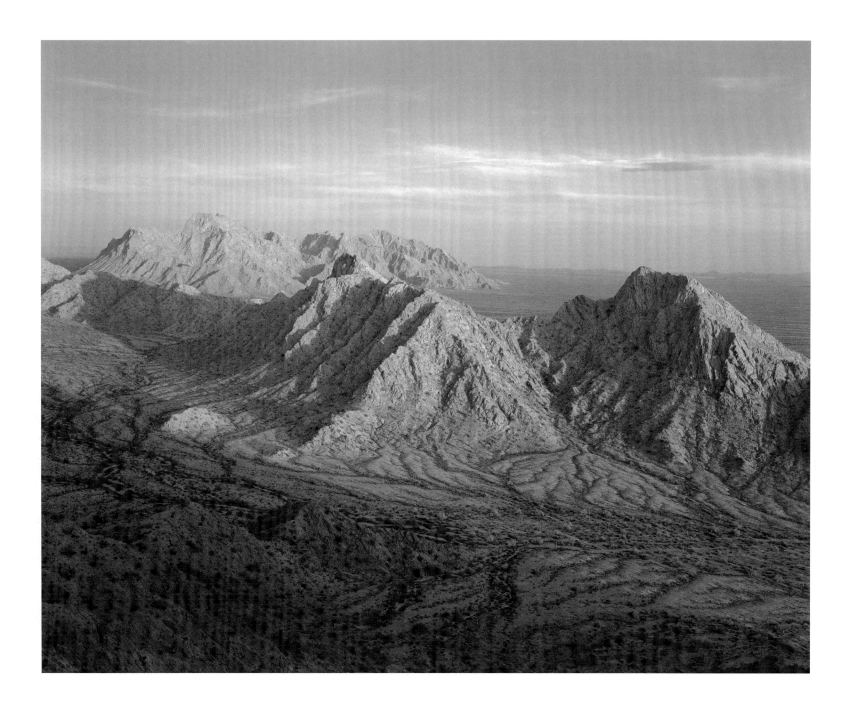

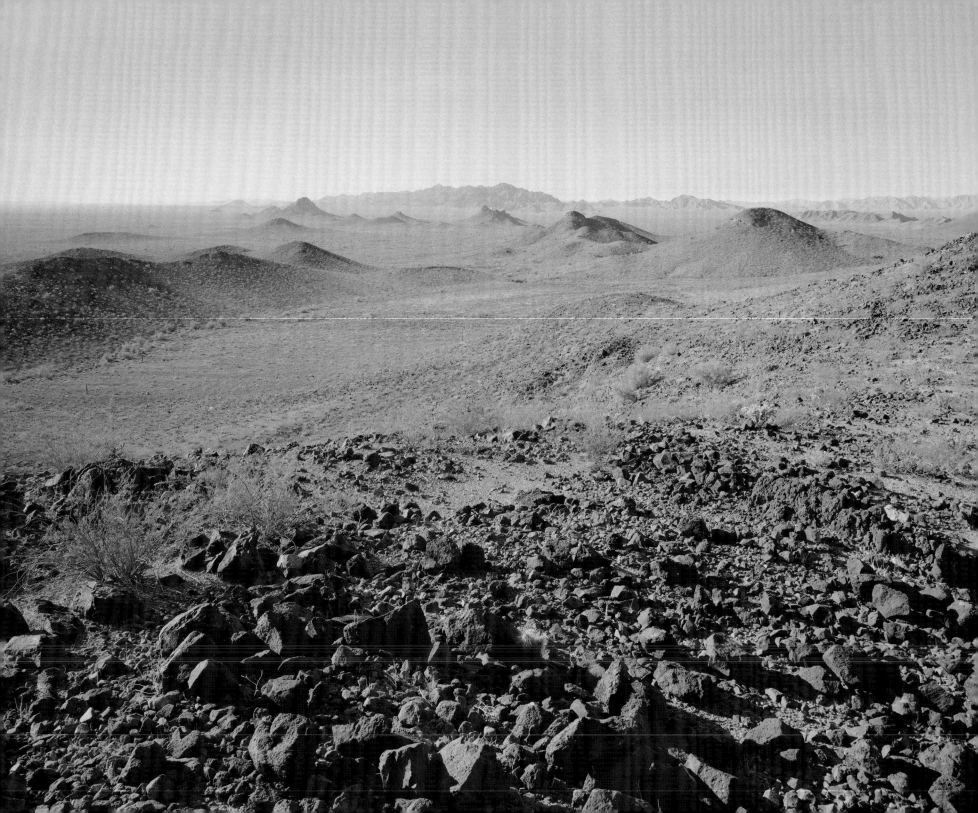

Stranded

"If you don't give up, and don't give in,
You may just be O.K."

MIKE AND THE MECHANICS, "THE LIVING YEARS"

"The mood of the desert is never
sad. It is either entrancingly smiling
or terrifyingly grand; radiant in its
ephemeral garb of flowers and in
the golden silence of its bare plains
and tinted mountains.... But it is
the smiling mood that leads the
unwarned or unwary astray, or
lures [them] to the tree-fringed
lake to find only sands and death."

RAPHAEL PUMPELLY,
MY REMINISCENCES

UNHAPPILY I FOUND MYSELF staring at fractured metal and smelling axle fluid on a jeep trail thirty miles from the nearest outpost of civilization. The truck hadn't steered quite right for the last mile, but nightmares couldn't have envisioned this. The front differential case, fatigued from a quarter-million miles of lousy roads, had split apart like a rapidly wiggled paper clip, dumping lube, axles, and gears into the sand. The differential bowed to the ground. One tire pointed up road; the other splayed pathetically to the side like a broken wing. I was heading nowhere.

In the vast backcountry, I have splinted broken mainspring leaves, traced shorted wires, spliced punctured fuel lines, stuffed inner tubes into ripped tires, and changed clattering wheel bearings, but this disaster was beyond any tool, part, or skill in my kit. My ideal weekend had taken a drastic detour, though this inconvenience was nothing compared to what would have happened if the thing had ruptured in the fast lane on the freeway.

It was pointless to cuss the truck, especially since I'm the culprit who had driven it to wrack and ruin. I just made a cup of tea, sat on the hood, and numbly reclined against the windshield. The evening was beautiful. Ragged granite mountains, bathed in starlight, rose to the east. Dew prodded fragrance from the creosote bushes. I had a week's food and water. I had it made.

But driven by a self-imposed schedule and after scant deliberation, I impetuously decided to walk out to a settlement on the highway and roust a tow truck. Although a butte near

the town looked to be only fifteen miles away, I knew it was more than double that, but no problem. I'd walk all night and be back with help right after breakfast. I slipped a note under the windshield wiper explaining my route. I didn't bother explaining the problem—that was self-evident. I tucked a couple of juice cans and a gallon of water into a frayed daypack, waved good-bye to my once-trusty truck, and tromped up the road.

The constellations shown brightly. The sliver of a moon wouldn't be up till much later. Something scurried in front of me, probably a kangaroo rat. A lone buzzing mosquito followed for a mile and then left. I was enjoying the hike, but after two hours the town didn't seem any closer. Yet, this was spring and all was beautiful.

About three A.M. I curled up in my coat and tried to sleep. The sand was soft but cold. The truck would have been cozy. Roused by the deepening chill before sunrise, I rose and plowed onward. Color came to the east. After dawn, fantasy castles loomed and vanished ahead of me in a surreal and enchanting world of mirages. While I sucked on one of four pieces of candy I had packed, my mind wandered.

I remembered finding another walker west of here on a Fourth of July, lying peacefully under a tree not forty feet from a rough road driven daily. It looked as if he had simply lain down for a nap. His shirt hung in the paloverde tree, maybe to make shade or more likely to keep it clean; his bag and sundries were organized around him; and his radio—its batteries now dead—was just where he had set it to play. But he had left no sign or marker *on* the road, so no one

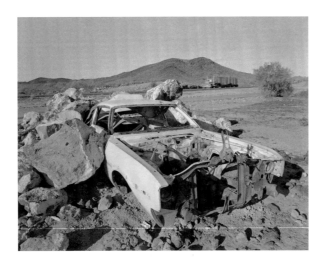

knew he was there. A cairn, a shoe, a can, or a dirt arrow would have sufficed. It was a week too late for anyone to help him. My first words when a friend and I found him were "You poor sonofabitch." The first words of the Border Patrolman we fetched from Wellton? "You dumb sonofabitch." Dumb or poor, the man was needlessly dead, and we the living were helplessly sorry for him.

The candy melted away. I pondered what would have been had I stayed at the truck: I might have gotten to finish a couple of those books I always bring but never read, or caught that nap I'm always hoping for, or written those overdue notes to friends. I could have filled my cup and plate as many times as I wished. I still could have seen the same dawn break, watched red-tailed hawks wheel in the wind, and inhaled the creosote's perfume.

If this had been summer instead of spring, I wouldn't have chosen walking out. I couldn't have carried enough water to make it safely. No, in summer I would have stayed with the vehicle, slept in its shade, and gulped water. In raw winter, the truck would have been a haven against rain and wind. The cigarette lighter could start a warming fire, and the seat would make a fine bed.

I could have used my rearview mirrors to lure would-be rescuers. Floor mats and extra clothes could be laid on the ground to make conspicuous panels, like a giant cloth sign. In the words of friend Tom Harlan, cofounder of the Southern Arizona Rescue Association, "Make yourself seen; attract attention. Get BIG!" I could have used road flares or a camera flash to signal at night and could have burned the spare

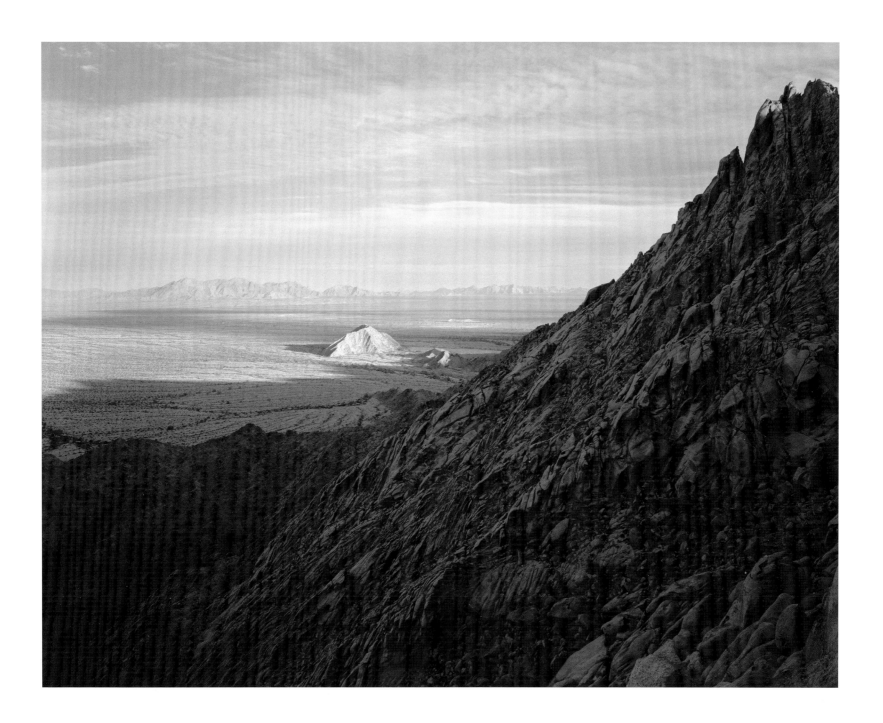

tire to make smoke by day. Even a raised hood is a pretty universal signal of distress. Sometimes a cell phone can reach rescuers.

Many victims of the desert leave the road to shortcut across open but trackless and treacherous ground. The stories are as instructive as they are common. A woman and two small children look for a camp-site, get the truck stuck, try to walk out, and perish in the heat a mile from a paved road. Teenagers near Cibola take a back road, the jeep breaks, and all die in the next few days. An elderly fisherman mires his truck in sand and dies walking out, in winter no less. Two men drive a rough road to save a few miles. Their battery dies. Passersby find their jeep within two days, but rescuers locate them four days after that, with only one alive. Unpleasant talk, but a theme runs through it: stay with the vehicle.

On another trip a faulty electrical coil stalled me in a wild place three hours' drive from any human face and four hours from a mechanic's helping hand. After I'd struggled with it a day and a half in midsummer and was ten hours overdue, my worried wife at home called the sheriff's office. She explained my route and asked that he alert anyone headed my way. The deputy said he'd check. Within an hour and a half of her call, he and a Border Patrol helicopter crew were landing to offer assistance. They had spotted the glint of my truck from three miles away. A person afoot may remain unseen at fifty feet.

The biggest obstacle to salvation is human nature—we're reluctant to even admit there's a problem, let alone any emergency. We want to look capable and cool, so we deny and delay our inevitable need to get found. My own walking out was a perfect example of thinking I could whip this problem by myself. Maybe I could. But maybe I really couldn't. Life insurance policies bet on such maybes.

The trick is to keep simple inconvenience from becoming a major rescue. Few of us want to be humbled on the evening news. The best rescues are low-key calls to locate and assist a disabled vehicle or a late hiker; these don't make headlines. They are over, done, and forgotten before disaster has fallen. We must think of ourselves as a wilting plant: shade me, water me, get me home.

Twenty miles into my walk, I sensed the rumble behind me of a vehicle on washboard road. I wondered: "Will the driver stop? Is his vehicle full? Will he deliver a message? Give me a ride? This is pretty lawless country—will he even stop? Would I stop for someone looking like me?" I didn't answer that one before a plume of dust appeared on the horizon.

I sat down on the road berm to muddle. No sense of walking one more step if there's a chance for a ride. I should have thought of that yesterday. I ran my fingers through my hair and rubbed two day's beard. Not a pretty sight. The driver slowed and rolled down his window after he stopped. He looked at me hesitantly. His wife turned down the radio. "I'm Bob Brawdy," he intoned. "Was that your truck we passed?"

"Yes, sir. I'm headed to town to see if I can get a tow truck."

"Get in if you like," he said, motioning to the cluttered bed of his pickup. I squirmed in among the trash bags, charcoal grill, duffle bags, and spare tire. No king ever rode so well or gratefully as this pilgrim.

While bouncing along in the truck, I reconsidered my decision to walk out. Twenty miles afoot for nothing. Even under these ideal conditions, I would have been better off staying with the truck. In summer I would have died. Tom Harlan is right: go prepared. Stay put. Get BIG. That's the best way to enjoy being stranded.

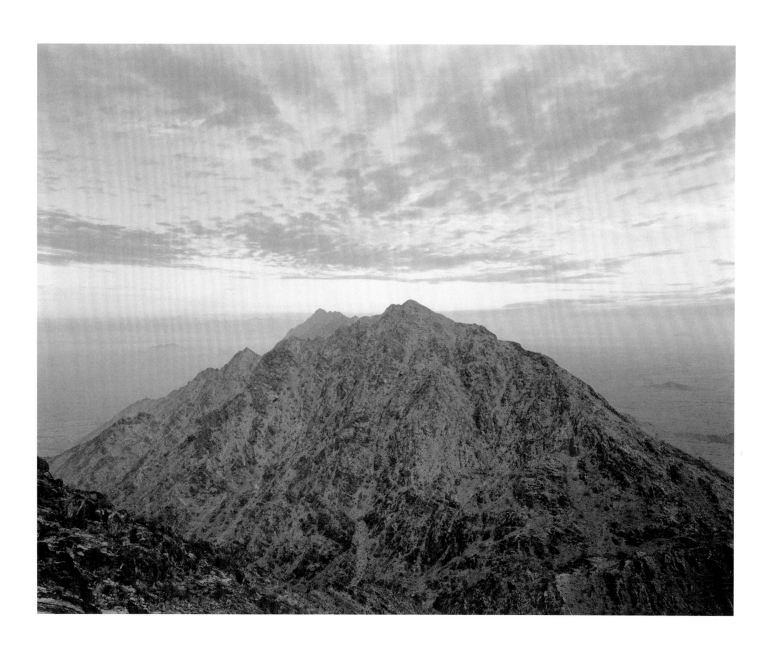

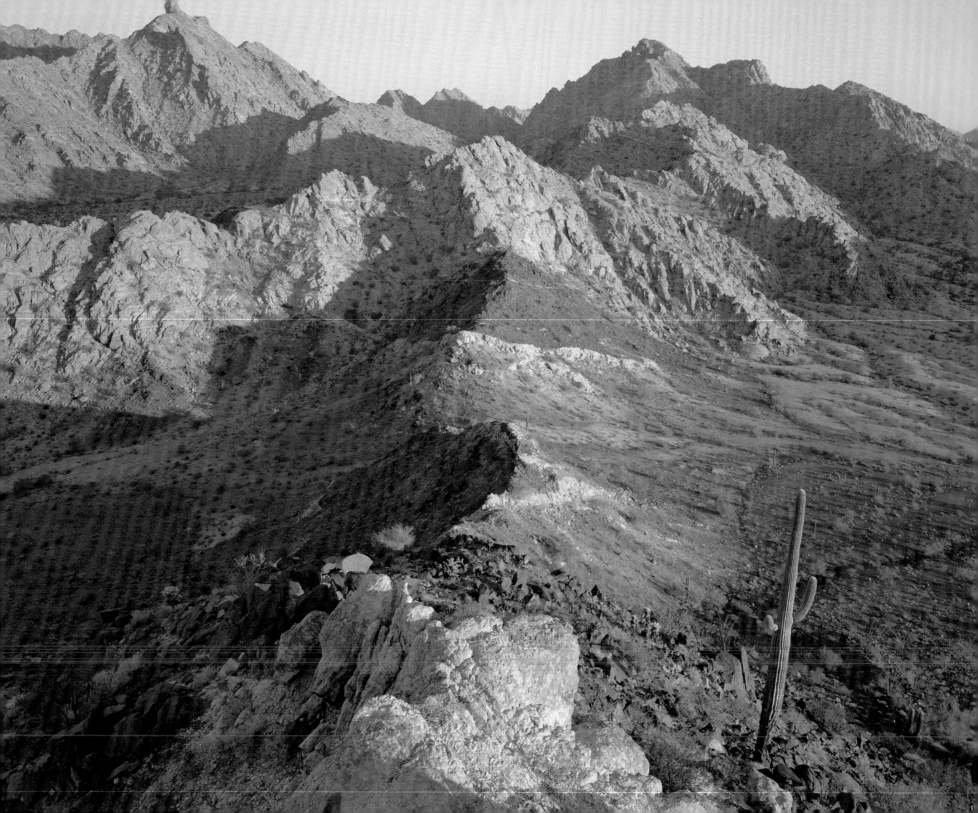

Waylaid by Beauty

You can't see anything from a car; you've got to get out of the . . . contraption and walk, better yet crawl, on hands and knees, over sandstone and through the thornbush and cactus. When traces of blood begin to mark your trail you'll see something, maybe.

EDWARD ABBEY, *DESERT SOLITAIRE*

THE GREYHOUND BUS pulled away and its taillights faded into the Arizona night. I scrambled across the freeway, climbed the right-of-way fence, and headed eastbound on the devil's road. My previous visits by jeep had dared me to return. So, now afoot, I returned to test myself against the country, to learn how fast a mediocre marathon runner could coax himself along the 130 miles. Zany? Sure. Challenging? You bet. Fame and glory? Only in my own mind. Genuine runners could make the whole trip in less than a day; I just hoped to finish. A few caches of water and candy bars had been stashed ahead, and a hip pack held spare eyeglasses and socks. So, on a raw February night I was ready and I went.

The modern route starts in a Yuma subdivision on a street named El Camino del Diablo, but within a couple of miles, I left behind the dazzling security lights and barking dogs, and I trotted like a coyote toward trail's end. At first the road proved sandy and easily followed without a flashlight, but then several rocky sections forced me to walk. I struggled to keep my mind on the trail; shapes and shadows tugged on my sense of wonder. The night gallery hung artful cliffs on the starlit sky. Silhouettes of ocotillos and scudding clouds framed the scene.

Dimly I began to realize that all my training and advanced calculations had failed to predict the trip's true conflict: the drive to succeed versus the urge to enjoy. The goal to say "I did it" versus a lure to linger, to see, to touch, to know. One voice said, "Scurry on"; the other, "Sit beside the creosote bush and marvel." I was prepared to endure, to ache, to bleed; I was not prepared to be waylaid by beauty in a desert.

At night the sinuous road was a pure line. Paloverde trees and ocotillos waved as if I were in a parade. The trilling call of a poorwill filled the silence. Motion itself felt good. The first cache was surprisingly easy to locate and filled me, but the ragged ruins of an old mining camp at Fortuna and its folds of black rock marbled with white left the lasting impression. Through a wash and a mountain pass, the sense of progress began to grow, as did confidence. A pack of coyotes howled and yipped up a side canyon, friendlier than the growl of the town dogs. I envied the coyote and tried to emulate its durable lope.

By now I realized that my progress, though invigorating, was slack. Blaming the drowsiness of working all day and traveling half the night, I quit fighting and lay down to sleep. Without cot or bag, I stopped in the next sand-bottomed wash, checked the ground for stickers and stingers, and lay down in the fabled pilgrim's bedroll. First I spread out my pride for the mattress. Then I fluffed up a cloud for the pillow and slid between the silky sheets of the evening zephyr. Finally I tugged that warm comforter of stars and tucked it around my neck. What a bed! Actually it was a revelation. For twenty-five minutes I slept soundly before the chill roused me. Rested, I popped up and resumed walking. As a friend loves to chide, if you can't sleep on the ground, you haven't walked far enough.

The quiet rang. Orion passed into the west, and the dipper swung its course. The coolness was brisk and energizing. My mind wandered, freed by repetitive motion. Deliciously, it was a time of cool air spilling over warm skin, of dew raising the intimate smell of earth, of the sound from life's own breath. The morning star preceded a coy moon, and the silhouetted trees twirled a gray kaleidoscope. Twice more before the sun rose I napped fitfully.

Onward. The road veered toward the rising sun, which gloriously lit distant ridges. Black-rock ships sailed on golden dunes. Backlit ridges loomed like castles on the immense, desolate sand plain. I admired those long-past travelers who had trudged this path and risked their all. I remembered reading about one lost soul who, fevered by thirst's dementia, imagined that pincushioned balls of cholla were crystal goblets winking with tiny rainbows of dew.

But the pace was slowing. Optimistic pretensions made at home in an easy chair eroded in the rigor of physical reality and, more so, my growing unity with the land. Sunrise found me incorrigibly behind schedule, and I struggled to care. Mysterious side canyons, secret rock niches, seductively perfumed flowers—all enticed me to stay. Reluctantly, I declined their invitations and continued. Ulysses resisted the Sirens; I began to understand that I couldn't have.

The sandy road was alive with fossil-like shapes of lizards. Where each one had nestled into its sandy bedroll for warmth last night,

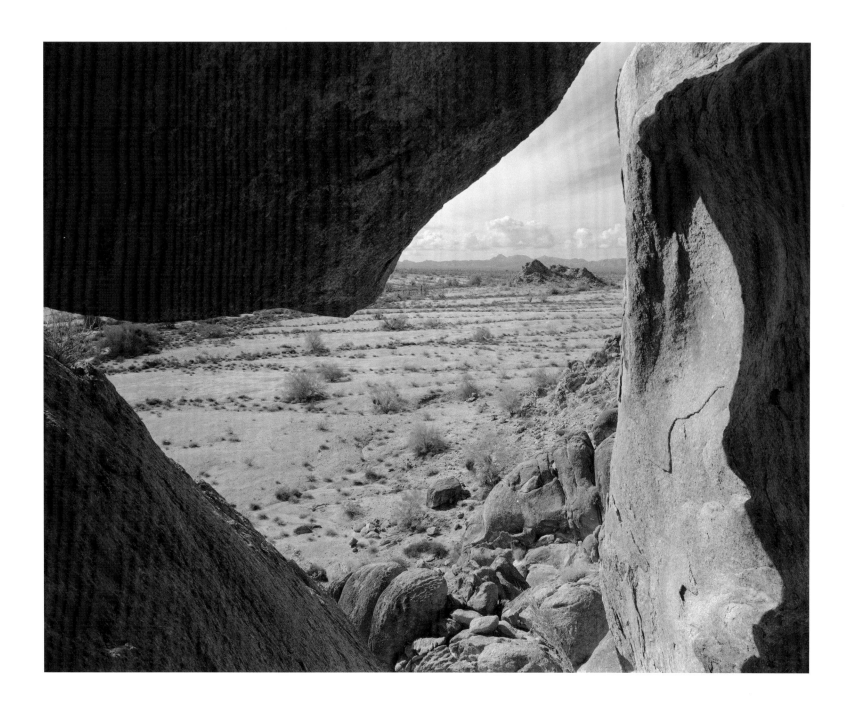

there remained the strict outline of its body and tail, replete with claw marks. In a wash I knelt down to pet a torpid spiny lizard taking his night's slumber. His mouth curved in a smile, and a slight curve in his tail suggested a reveler who had not quite made it home from the party. Later, pawed tracks showed where a hungry coyote had rousted one tardy sleeper.

Nearing a waterpocket I threw off all claim to a speedy trip and followed Indian trails instead of the motor road. Small pottery sherds and fragments of seashells lay broken where they had fallen from tired hands centuries before. Then and now seemed to merge. Forward and backward didn't matter. I wouldn't have been startled to see a prehistoric clan camped around a fire, ox-drawn carts rolling toward hope, or a column of armored conquistadors glinting in the sun. But I saw no one, save two local ravens. The lowest pool at Tinajas Altas was the color of coffee, but I knew that come summer it would fill and clear, revealing fairy shrimp and myriad toad tadpoles. Reaching this waterhole lent a sense of scale to the trip and buoyed my confidence. Ahead lay range after range. My push became the land's pull. I was a bee in a universe of sweet flowers.

The distinctive Cabeza Prieta Peak loomed across twenty miles of open desert. Patterned creosote flats brimmed with tracks of life on the move. Prints of kit foxes, Pinacate beetles, and pocket mice chronicled the comings and goings of a larger, unseen community. Seldom even trying to run now, I settled for walking fast. My mind stopped thinking; only the swirl of sensations mattered. Everything, even the rocks and sky, spun alive.

The sun ran its course and twilight softened the land. An old well marked midway on the route. The windmill squeaked and chortled. Its cozy cabin, shelter to many a traveler, didn't tempt me as much as the open sky did, so I continued. The image of sunset etched

itself on my memory like film. Phainopeplas and quail provided the soundtrack. During one rest I sat too close to a kangaroo rat's door, and it thrummed its tiny feet in disgust. An owl hooted up the wash.

Maybe Thoreau was right: we're enriched by what we can live without. A night on the move, by starlight, is a night to be cherished, not dreaded. Funny, I had expected to think of luxurious beds, large steaks, and hot showers during these times of trudging. But I didn't. I was half a day behind, meaning another night out, but I began to see it as another night of luxury and freedom.

Pace was now a mechanical gait; running had ceased to be an option. Familiar places—lava buttes, stone markers, wide washes—became gauges of progress, but the notion of progress changed. Beauty became the milepost. And starlight lit my way through the night. Another mountain, another gap between rugged ridges, another flat, another lava flow. A heavy dew accentuated the cold of early morning, but even in the exhaustion of a full day's travel, I did not question being here.

The morning star rose, then the moon and, shortly, dawn. A cache, a nap, and a walk made an easy cycle. Time smaller than the heavens became meaningless. I pocketed my watch. The orange line of sunrise found me reclining on a dune; I stroked the damp sand like fur and delighted in its patterns. I finger-painted geometric nothings, though by noon the wind would clean the quartz canvas. Tiny mites, beads of red velvet, ignored my art and shuffled their own designs on the sand.

In a dry lake bed I found more fragments from broken pottery and water jars. As if trying to touch those ancients I felt but hadn't yet seen, I frittered away an hour futilely searching for something whole, something held by the living hand that made it. In the country beyond, lava alternated with sand flats. Living in the moment,

I piloted toward a tree, a rock, a ridge. I found myself dawdling. The tide called sun washed this land in light and warmth. At high noon I dozed belly down on the black-rock pavement. No lizard was ever more serene. Easterly now. Low ridges dominated the view and inspired me to jog several miles for no purpose other than joy of motion. Wild animal tracks—an unseen squad of javelina wandered ahead of me.

Reverie replaced guilt about the sluggish pace. The country had seduced my ambition and I no longer cared. So what if my legs quivered when I rested, if my pace sagged, if the ground pummeled my feet? This was the place I wanted to be. From behind a steering wheel, I had never realized that the desert paints with so many hues of green, that a single yellow flower can be seen from such a great distance, that progress means only thumbing pages in some grand book.

Another twilight, another sunset. Quail clucked as they vied for a roost deep in a mesquite. Darkness caught me several miles west of Quitobaquito, a spring-fed desert pond that sequesters tiny pupfish. Like Brer Rabbit condemned to his briar patch, I was "doomed" to yet another night out. And I wasn't disappointed. In tune with the land, I could have happily stayed anywhere and enjoyed the scenery. I didn't want to leave. I realized I wasn't a tireless coyote after all; I was just a bunny, all eyes and ears, content to tarry. The trip had become an athletic forfeit. Pace evaporated like fleeting desert dew on silvered threads of spider webs. The journey itself, not the arrival, became the point of it all.

Several wide washes, with sandy bottoms and overhanging trees, crossed the trail. Each was like a railroad crossing, clanging, "Stop. Look. Listen." Easily I wished for spring afternoons to lie in the sand under shading boughs and listen to bees in the mesquite, or simply to watch clouds drift. In one of these washes I paused to search out a sublimely scented flower, subtle and inviting in its special mystery. Thirst didn't yet bother me and food wasn't even a dream. Instead, I wished for a camera, a microscope, a stronger nose, a more sensitive ear. And time to wallow on my belly, eyeing things close-up, with my arms around the world.

At trail's end near Sonoyta waited a ride home. My friend Al jumped from the car and pumped my hand, "You did it, Willie!" I couldn't think of anything to say. I hadn't done what he thought. The reaching was everything, the arrival nothing. Times and distances? Mere excuses for the stroll. A failure? No, a finding of land and self. Trophies? A thousand common things seen new.

Lion in Summer

Our earth with all of its living creatures, is a rarity in the Universe—rarer than the rarest of endangered species. . . . The Universe would not miss the planet. It will not miss lions. It will not miss humans.

HARLEY SHAW, *SOUL AMONG LIONS*

OVER THE YEARS I've logged many miles in wild country. I've seen black bears, bobcats, deer, elk, coyotes, bighorn sheep, moose, foxes, and even a grizzly—but no mountain lions. Now I've seen one, and I still can't believe it.

Lions were furthest from my mind when I drove to a bighorn sheep watering hole in our southwestern desert. The heat was 115 degrees and I feared that the tank was dry. Dust rolled into the truck as I drove the jeep trail, but the breeze through open windows was my only salvation. Down the hill from the tank, I slowed to park the truck when a flash of movement left the waterhole and stopped in front of the concrete wall of the tank. "Sheep!" I thought instantly, since that's what I expected to see.

I slipped the truck into neutral and peered through the dirty windshield to get a better look. I'm an amateur, not an everyday, schooled wildlife expert, so my enthusiasm must be tempered by caution to get it right before reporting what I've seen. I saw legs and some sort of body, but the head was nondescript. This confused me, since bighorn rams sport outrageous headwear, and even the horns on ewes are obvious. I squinted harder. I was seeing a patch of color on something that didn't want to be seen, but it was an off shade of brown for any sheep or even a coyote. It blended with the buckskin granite. Bobcat, maybe? No, the size of this thing would equal three or four bobcats sewn into the same skin.

29

As I reached for my telephoto lens and camera, the thing crouched next to a boulder and pondered me. I could see two eyes, but they weren't sheep eyes. No horns. Not a sheep. No antlers, not a deer, which would be unheard of for this stark spot, anyway. I continued the checklist of options, but by now I felt like the dunce of the class. Its ears were erect. Front view looked like a coyote with mumps. What was it?

For over two minutes we stared at each other, each deciphering and sizing up the other. Hopefully, it wasn't as bewildered as I was. Then it looked around, as if bored or plotting an exit. Through my lens I began to recognize cat ears, but they weren't tufted like the bobcats I'd seen. It had a white patch on its throat, but I couldn't see bobcat spots. I'd heard stories of mountain lions in this region, but they're quite rare and almost never seen. In theory, young toms rove into unlikely territory looking for worlds to conquer, but I couldn't imagine one here. I focused the camera. Shot. Wound and shot again.

I reached for the door handle, but as if reading my mind, the animal walked from beside the boulder and sauntered up a tiny rock draw. Its tail stood out like a broomstick. Then and only then did I *know* what I was seeing. Mountain lion! Adrenaline pumped and I leaped out, camera in hand, to catch a better picture as he climbed the draw. In that instant he was gone, gone not by speed but by stealth. I scanned that granite slope for minutes before following. Never again did I catch sight of that cat. He evaporated. I felt he was still close by watching me, as unseen others likely have been.

As if that weren't enough for one day's confusion, my mind refused to believe that I'd really seen a lion. It was like I'd dreamed the whole show, as if my mind had deductively constructed the cat out of chimeric logic, processed him out of a series of eliminations, fabricated him out of patches of color and texture. Not this, there-

fore maybe that. . . . I hadn't touched him or heard him, and I could find no tracks.

What if I was wrong?! Credibility hangs on correctness. Beyond endless teasing, I could just hear friends saying, "Oh, there was a report of one out there, but the fool got it wrong and we've been trying to correct the stupid mistake ever since." And, as happened to the boy who cried wolf, no one would ever again believe anything I saw or said.

My confidence was shaken. Can't even tell the dogs from the sheep from the cats? Back to the library, where they have neat little drawings of the whole animal. And captions, too, just so you don't mislabel it. I used to think that if I saw Bigfoot or Nessie, I'd call the newspaper desk and sell my story to the networks. Then I thought I'd never tell anyone, even if I had a poster-sized photo. Now, I'm unsure what I'd do.

Logic twisted my senses. I *had* seen him, but my mind played games with my confidence. I was talking myself out of it. Why a lion here? Waiting for sheep to come to a dry tank? No discernable pug marks in the area. The cat seemingly hadn't killed anything or tried to eat the two dead white-winged doves at the tank. Why wasn't he waiting at a wet tank, where there'd be lots of sheep standing in line to get a drink during this blaze of summer? Why wasn't he thirty miles away on the Gila River, chasing deer and drinking running water, instead of lying here with thirsty bees buzzing around his nose?

Argument wanted to be stronger than perception, and confidence was determined not to be wrong. Better to say nothing than to say it wrongly. It wasn't just deciding which synonym to call him—puma, panther, painter's cat, mountain lion—but it was deciding to call him anything at all! Every year some new animal shows up in the local newspapers. People report "black panther" and only a jet-black dog is

found. People report jaguarundis, a small jungle cat, when the nearest confirmed specimen is three hundred miles distant. I didn't want to be one of those people.

Maybe my imagination had taken over. The previous summer I'd filled my mind with books about Ben Lilly, an old-time lion chaser. The previous spring on a canoe trip, I'd stared at bushes along the Colorado River where Aldo Leopold reported lion and even jaguar seventy years before. They worked weeks to find lions. But this . . . I hadn't worked at all. I hadn't tracked him. I hadn't even gotten out of the truck. I didn't deserve to see a lion.

Only after a night's rest did I venture to pencil the words "mountain lion" in my daily log. And it was with trepidation that I mumbled to a wildlife official when he scanned the field report, "Yes, I saw a lion at that dry tank." I expected him to laugh and ask me what brand of cactus juice I kept in my canteen or how long I'd stood in the sun without my hat. But he didn't.

He leaned back in his chair and tossed the report on his desk. "You know, a lion was spotted there in 1978 or '79. I wonder if there's a family living in that area."

He looked puzzled at the depth of my sigh.

Go Back

"Agua Salada 75 miles. Go back and fill your canteens."

AN EARLY ROAD SIGN JUST BEYOND A LONELY DESERT WELL.

When your canteen gets down to half full, turn around and go home.

RONALD L. IVES

"I opened my eyes to a heat-reeking plain, and a sky of that eternal metallic blue so lovely to painter and poet, so death-like to us.... I tried to talk—it was in vain, to sing in vain, vainly to think; every idea was bound up in one subject, water."

RICHARD F. BURTON, *FIRST FOOTSTEPS IN EAST AFRICA*

BY NATURE the Arizona and Sonora deserts are dry, and the reliable waterholes used by historic travelers and settlers are few, far between. When viewed at highway speeds the landscape can look parched, yet scarcely a mountain or valley doesn't have secluded pockets of water. Places where a bird or mammal can drink are more numerous and varied than many desert residents imagine.

The dot on my map read "water," but from the looks of the arid terrain, only the gullible or the desperate would believe it. Right then I was among the desperate. Alone, afoot, and a little afraid, I had just hiked across two flat valleys and through a jagged range of granite to reach the mouth of this canyon. The map had better be right or else I'd have to confront several decisions, the least serious being that this fine hike would abruptly end. Basically, there would be one strategy: cache almost all my backpacked gear and break for the nearest trace of civilization, thirty-one miles away.

The mountains of southwestern Arizona rise steeply from the desert floor. This canyon started with a sandy wash and raced eighteen hundred feet to the spinal ridge in less than half a mile. A few hundred yards out from the canyon's mouth, I spotted a sherd of prehistoric pottery, and then a segment of an ancient human footpath, which I followed until it skittered through heavy brush. Coyote trails, too, converged toward the canyon as well as occasional hoofprints of bighorn sheep. The marks' freshness could be a good sign if the sheep, too, were coming for water.

From a scan of the land and map, I pegged the waterhole at the base of a smooth rock apron where during infrequent torrential storms surges of rainwater plunge down the canyon before being blotted by the sands of the valley floor. This water was a *tinaja*, which means "earthen jar" in Spanish. Geologically,

33

tinaja signifies desert-mountain rock pool, though pothole or plunge pool also convey the essence. It is literally an eroded cup in impermeable rock that catches rain runoff. Small ones may hold five gallons and last for a week after a rain; the largest may hold fifty thousand gallons and last year-round except in prolonged droughts.

Ideally, they fill twice a year with our Sonoran Desert's two rainy seasons, but this cycle offers no assurance. Spotty and meager rains make tinajas unpredictable. Some tinajas have large catchment aprons, which magnify any drizzle; a tenth of an inch may raise the water level the greater part of a foot. Others may demand an inch of rainfall to even start water flowing down the canyon bottom, so they fill only during cloudbursts. This one lay heavily shaded in a cliffed gorge. Limbs of an ironwood tree arched tightly over the cool but dim retreat. I swirled aside the surface flotsam and sank my canteen well below the surface to slurp its fill. The hike saved and canteens topped, I lounged on a flat rock, contented, like a lizard basking in the morning sun.

Since then I've discovered, as every desert visitor eventually does, that desert water comes in many precious forms: tinajas, wells, charcos, represos, playas, springs, catchments, kiss tanks, washes, and even streams.

They are children of rock, but they are reared by clouds. Some sit in granite, basalt, or sandstone, while others are perched or sunk into valley alluvium that fills chasms thousands of feet deep. Rain in this part of America comes in two sessions: the frontal storms of winter and the tropical thunderstorms of late summer. The rain is seldom much, ranging from two or three inches a year in the driest areas to over ten inches in lusher places. Most of what doesn't soak into the parched ground soon evaporates. The evaporation rate may exceed 120 inches a year, meaning that an open barrel of water ten feet high would be dry by year's end.

Where rock pockets lie in fractured, leaky channels, some pioneers would make their own tinajas by lining the pockets with cowhides in hopes of catching fifty gallons of runoff here and another hundred gallons there to slake the thirst of stock and family. A variation was to lay out a tarp before the onset of a storm and then funnel the runoff into cans and buckets. Some miners used dikes and channels to divert ground runoff into unused shafts and prospect holes so they'd have water and could save an extra trek to town. Others built cisterns fed by roof gutters.

Early desert ranchers, farmers, and miners often dug wells for their permanent needs, and soon the windlass and then the windmill came to symbolize the procession of civilization. These first wells were hand-dug affairs, some of them punching over two hundred feet into the unconsolidated dirt and demanding more than a little courage by the digger. He would be lowered and raised with a windlass. He relied on a short-handled pick and shovel, though occasionally dynamite would be necessary; needless to say, he preferred a very long fuse. The hole was generally about four feet square and probably curbed and braced near the top. Some of these are still in use, though most people have replaced the windlass and bucket with a motorized pump or windmill.

Later, of course, drilling supplanted digging. The drilling derrick and windmill lent a permanency. Many of these hit layers of aquifer water, but frequently the water was highly mineralized. "Salt well" may be the most used of all desert appellations, but in this desert, no water was too foul to drink. One way to make a mark on history was to sink a well with your name on it, which was then perpetuated on the maps and in the travel guides. Wells bearing names such as Childs, Cameron, Platt, and Charlie Bell are now etched into the geography.

In 1916, four years after Arizona's statehood, the federal government began a systematic survey of desert waterholes. Led by Clyde

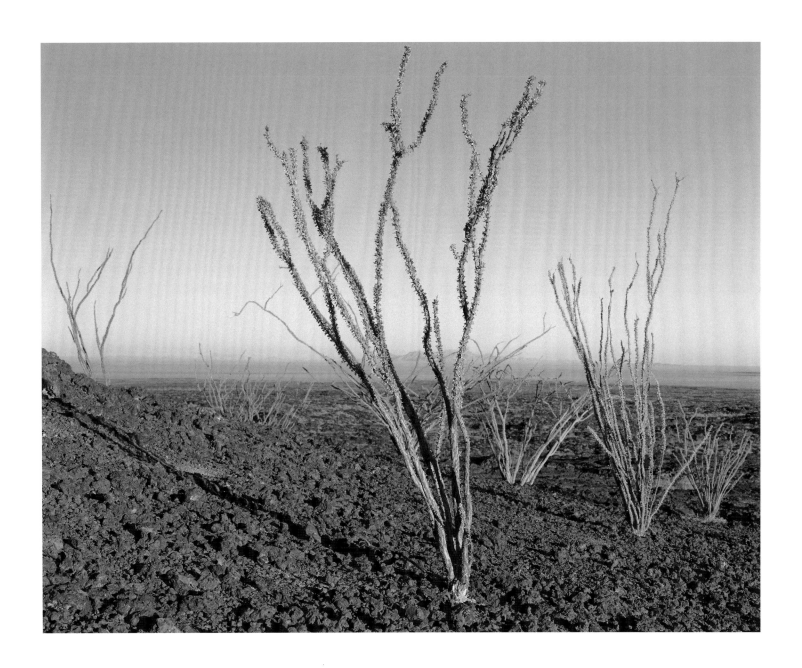

Ross and Kirk Bryan, these surveys produced road guides to desert watering places, many of which still serve travelers, game, and livestock. There were so many obscure waterholes that even in three years of intensive fieldwork, the surveyors didn't reach them all.

Desert watering places are nature's answer to convenience marts—if you know the right corner and realize that the store isn't always open. Early motor travelers were encouraged to carry a rope and bucket in case the well had none. With the standing A-frame and pulley, a horse or car could pull up the laden bucket. Cars also carried a shovel in case the water lay just a few feet below the sandy surface of the tinaja or arroyo, and a tarp did double duty as a way for travelers to harvest water from squalls or to shelter themselves. However they got the water, a cloth strainer was required to strain out the bugs, leaves, and grit. In the days before antifreeze, one group of travelers drained the water from their radiators every night to use for washing bodies and dishes, and then poured it back into the radiator for the next day's drive. The engine heat purified the water, and sediment settled out.

But it wasn't wells that watered the ancient peoples or lead the first European explorers through the desert West. The ancients employed the mountain tinajas and the seasonal sources in the valleys. Early visitors to Papago Country, land of the Tohono and Hia C'ed O'odham, found that families lived near tinajas in dry seasons but moved to the valley when rains came. There they farmed corn, beans, and squash, using brush diversion dams and charcos, or pools of water left by flood runoff in hardpan clay depressions.

They even went one step further and impounded water in charcos by raising an earthen dam at one end. This retained and spread the water, allowing a field to be sown, as well as deepening and prolonging the reservoir. This type of agriculture is called *temporal* farming.

For livestock the waterholes became the represo ("mud hole," "stock tank," or just plain "tank").

The ancients gave descriptive or legend names to their water places. For example, Tinajas Altas was known to the O'odham as *O'ovak,* or "where the arrows were shot." This name recounted the myth that two warriors shot arrows across the ridge. One's arrows cleared the mountain, but the other's didn't and where they struck the slope, pools of water formed. The European explorers tried, when possible, to follow rivers like the Gila and the Colorado, the Santa Cruz and the San Pedro. Even if the river dried for a stretch, they might find springs or isolated pools. Beyond the river valleys they followed the gridwork trail system of the native peoples who had routes to and from virtually every natural water source. In this game of hopscotch, the explorers and missionaries, the soldiers and scientists were usually guided by native peoples.

Springs sometimes do appear in unlikely places. Quitobaquito Spring and its neighbors at Organ Pipe Cactus National Monument sit on the edge of a sandy flat and a rocky hill. Here water is pushed to the surface through fissures in the earth. A couple of places are named Dripping Spring, and like a leaky faucet, it takes hours to fill a canteen one drop at a time. Charlie Bell Well reportedly was dug on the site of a seep formerly used by Apache horse raiders, and the deposits of *salitre* near Tule Well indicate that the water table may have bubbled to the surface in centuries past. People noticed things like that and kept them in their mental file cabinets.

Another unusual desert water phenomenon is the playa. These are table-flat lakes where water flows in but not out. Sometimes covering square miles, a full playa might be only ankle deep. Yet, a number of travelers have been saved by a deluge on a playa, though many more have been stranded for a day or two in the muddy mess.

The least common of desert waters is the kiss tank. These are named because of the method of drinking from them. They are so small, holding but a few pints at most, that "kissing" the rock basin where they are is the only way to drink from them. Strangely, they occur in deep canyon bottoms during clear weather when conditions are right for dew to form on sheets of impervious rock. Then the dew collects in small depressions, making puddles of desert dew. These most ephemeral of desert watering places evaporate by afternoon.

Stories, in both fact and fiction, have spun around the events at a desert waterhole. Historically, intrepid explorers and scientists, bandits on the lam, valiant homesteaders, determined miners, and ambitious cattlemen swirled around these waterholes. After all, everyone eventually came to water. And, yes, more than one desert spring or tinaja supported a moonshiner during Prohibition. The mash was made from mesquite beans, cooked over mesquite coals, and bottled in discarded glassware. Rusted vats, barrel staves, and copper piping can still be found near some waters. Southwestern fiction masters such as Zane Grey (*Desert Gold*), Louis L'Amour (*Last Stand at Papago Wells* and *Kid Rodelo*), and Jeanne Williams (*The Valiant Women*) frequently swirl their conflicts around historic watering places.

Nowadays, in these times of swift transportation and municipal water companies, waterholes lack the attraction they once held for desert travelers, but they have become marvelous places to view wildlife. Though etiquette and law preclude camping right at the waterhole, taking a secluded seat nearby is like buying a ticket to a series of nature films.

In late summer toads mate and tadpoles metamorphose in desert pools. Their cycle is swift; the spadefoot toad can go from conception through tadpole to hopping juvenile in ten days. Red-spotted toads live and feed in nearby rocks and soil, but they come to water at night to party and mate; they can frequently be seen leaving tinajas and represos before first light. Deer and foxes generally arrive in the dimmest twilight, and they're so quiet that a drowsy observer will miss them. Around sunup the doves and quail come calling. Midday may hear the croak of ravens or the scream of hawks. A coyote may steal a drink on its appointed rounds—one's loud lapping once woke me up from a noon nap, but usually they come as a family to drink at night. They are noisy guests, barking and whining and swishing their tails against rock and limb.

The action is slow but the pace is relaxing and eventually rewarding. Once I even saw a golden eagle standing drumstick deep in a summer's puddle, splashing and sipping while half a hundred thirsty but prudent doves silently perched in a nearby paloverde tree. Another time, as I sat beside a boulder, a bighorn ewe brought her fuzzy lamb in for its first taste of anything but mother's milk. On the larger desert waters—playas and represos—waterfowl may pause to rest on their migrations. Few sights are more startling than to see mallards, herons, or even a pelican rise from a desert pond screened by mesquites and saguaros.

To put things in perspective, in summer a dove will prefer to drink twice daily, a cow or steer daily, a horse every couple of days, a coyote daily to never, and a Sonoran pronghorn perhaps never. A human? Hourly. The person may consume a quart at a time, but a bighorn can take in almost four gallons in one filling! To come to know at least one watering place is to feel the very pulse of desert life. And, by the way, if you head for Agua Salada or beyond, go back and top off your canteens.

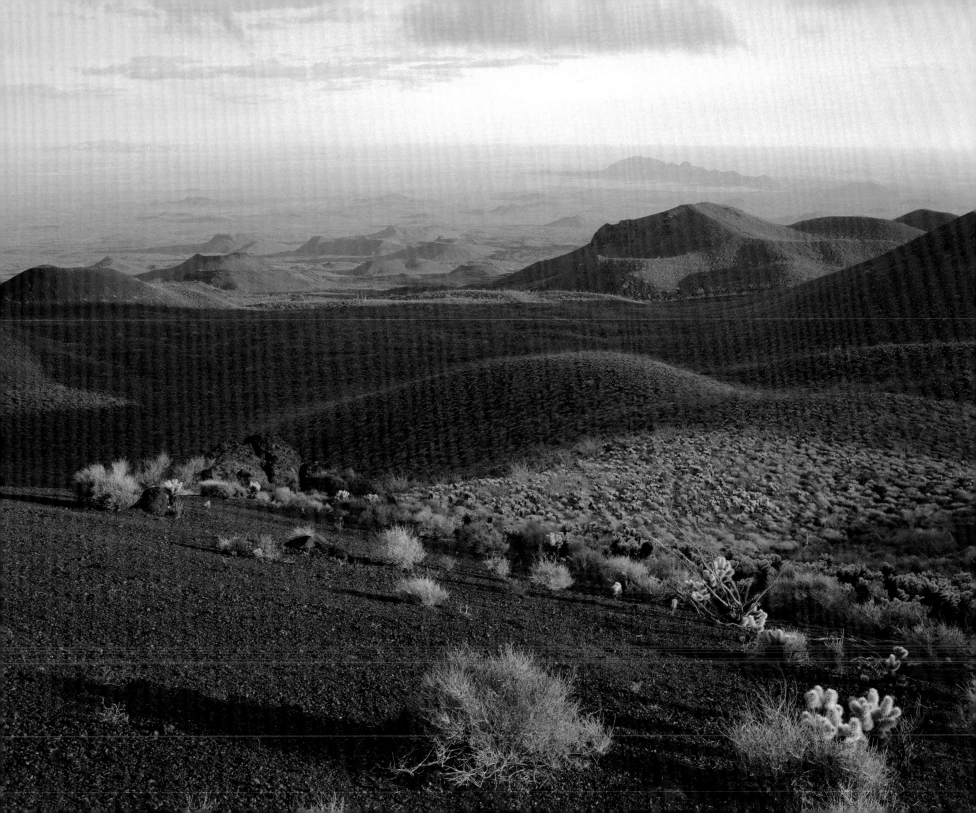

Spring

*"The mystery of language was revealed to me. I knew then that "w-a-t-e-r"
meant the wonderful cool something that was flowing over my hand. That
living word awakened my soul, gave it light, joy, set it free."*

HELEN KELLER, *THE STORY OF MY LIFE*

DON'T GET ME WRONG. I love rock and sand, snow and sky, fishing and hiking, but for sheer delight give me the wildflowers of a desert spring. If I could invent myself a full-time job, it would be official spring watcher, and I'd rely on a calendar told by birds and plants, not by the tilt of planets.

Even though frost seldom visits Arizona's low desert and snow is rare, winter can be blustery, dark, and much too chilly. So, thoughts of spring start early, in December, when the winter rains urge seeds to sprout. If we're lucky, by January the green sheen of spring will carpet the ground with tiny blades of grass and leaves of mallows, evening primroses, verbenas, and lupines.

Ajo lily bulbs probe the surface with hesitant green leaves, as if testing the weather. If they approve, they'll grow as high as your pockets and set dozens of white trumpet flowers. As a spring watcher, I know that if the ajos are plentiful and ankle high by New Year's, we'll probably have a floral show worth bragging about.

The factors are obvious: rain, temperature, sun, seeds—but the proper mix makes it a difficult equation. Rain needs to be at the right time and in the right amounts—it takes at least half an inch to trigger most seeds. El Niño years seem to do this best, but we still need to factor in the temperature during and after the rain, soil warmth, and the amount and angle of sunlight. Then we must factor in frosts and the nutrients in the soil—a good flower crop one year might use up much of the nitrogen, making two bumper crops in a row unlikely. Some

of the factors we may not even realize yet. Each year reporters at the city newspaper ask a local eminent botanist to predict the next great flower show, but it's impossible to be 100 percent correct, so even he has given up, preferring to just enjoy what comes.

This helps explain why many of us living in the city have been disappointed by our personal attempts to scatter wildflower seeds and water them to success. I've sown, raked, and watered, trying to coax seeds out of hiding, but flowers, like Goldilocks, need things "just right" to do their best. Saguaro cactus, for example, may have a good crop of young ones only three or four times a century, and some wildflower seeds may lie dormant for decades before being stirred by the exact combination.

After the year's shortest day has passed, we anticipate the days when we no longer need headlights while driving to work and when we can leave our jackets at home. There's a little more light at dawn and a lot more optimism in our hearts. Then one morning we hear the mating call of the mourning dove—that plaintive murmuring song announcing nesting time. It will rise to a crescendo in April and May, when joined by the who-cooks-for-you call of returning white-winged doves. Some days their songs fill entire valleys. A caller from New York asked me to hold the phone outside just so he could listen to the doves.

Other desert dwellers have their own ideas about the start of spring. In February side-blotched lizards creep out of their hidey-holes as the days warm, and they sun themselves on rocks, hoping that beetles will hatch soon. Rock squirrels leave hibernation to hunt for food, and if we're lucky we'll glimpse a coyote pup or a desert bighorn lamb. Cactus wrens pick up dried grass to build nests. Hummingbirds steal spider webs to twine dainty cups for two pea-sized eggs.

Among the first flowers of the new year are bladderpods and brittlebushes, forming bright yellow patches amid the brown chaff of winter. We hike into the desert and spot red wands of ocotillo. Pinhead flowers of spiny herb contrast with trumpet-sized sacred datura, perhaps the largest flower we see in the desert. Mats of purple nama carpet ground between taller plants, and we lay on our bellies to gaze into white desert stars. We know that spring is coming.

Some old-timers swear that the end of winter is best measured by the mesquite tree, which announces the passing of the last frost by sending out new leaves. This tree, prized for its shade and wood, seems uncanny in its ability to judge spring's advent, though the native bees wish that it would start blooming sooner. On average, mesquites leaf out in my Tucson yard on March 17, remarkably close to "official" spring.

Later the catclaw and white-thorn acacia trees, which shun winter even more than the mesquites do, make up for their tardiness with clouds of fragrant flowers. The blooms of bebbia, also known as chuckwalla's delight because it is that lizard's favorite food, draw hundreds of checkered skipper butterflies. Parasitic desert broomrape, hidden by its host, reveals itself to the world with gaudy purple petals. Bushes of humble trixis, goldeneye, and brittlebush, which we otherwise wouldn't even notice, rave with yellows, as only the desert can. Coyote gourds open and close their golden flowers before the morning's full sun.

Even the staid and cautious creosote bush flatters itself with a glorious flurry of yellow flowers, which will become fuzzy white seeds. In June, after the creosotes have bloomed and set seed, the bushes are white with furry pods. This presents its own challenges for driving on the narrow trails and roads, especially for those of us who don't have

air-conditioning and are compelled to drive with the windows down. Every time the side mirrors of the truck hit a creosote branch, seeds fly into the air like a blizzard of tiny snow-balls. They spray through the windows, covering seats, falling inside shirt collars, lodging in ears, and working their way into pockets. Every few miles I stop to brush away patches of them, but loners can hide for years. I don't own one camping bag without seed souvenirs lurking in the side pocket.

Everybody in Arizona has a favorite story about a meeting with spring flowers. A friend of mine regularly traveled El Camino for six years and thought he knew the plants there quite well, but in the seventh year, he was astounded to find fields of blue sandlilies, which grow from bulbs in the usually seared and vacant sands and then lie dormant for years until enough rain again falls.

My own memories include a hike through knee-high primroses, ajo lilies, and lupines. I

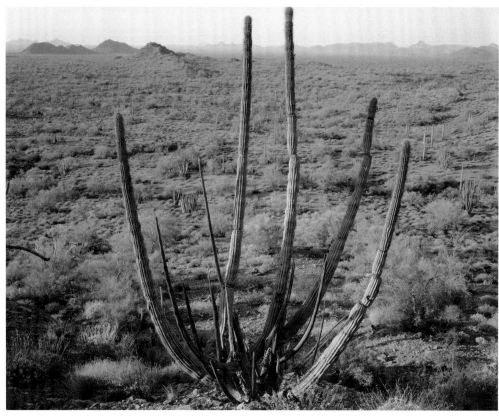

couldn't take even one step without treading on a leaf or knocking puffs of pollen from a flower. The next year, sand was blowing and only a few dried stalks lay scattered on the same ground. Part of the definition of a desert is that it's drier some years than others, so we who live here come to appreciate the times of plenty and, in times less bountiful, to respect the few flowers that do bloom. After a wet winter it's common to see globe mallow chest high, but in dry times,

an admirable mallow may reach only four or five inches and struggle to set a single flower.

Invariably after my spring hikes I reach for an identification book on the shelf even before taking a shower. Once I headed home a day early from a remote desert mountain range in order to find the name of a dainty plant I'd never seen in all my travels. It turned out to be a desert five-spot, and on the whole hike I saw only four of them, all on

one bank above an arroyo. The flowers with short lives are enchanting, but the old standbys bloom year in and year out. Yellow paloverde blossoms drift in windrows like fresh-blown snow. Ironwood trees, with small pea flowers, flourish and roar with the sounds of bees gathering pollen.

By April we begin to see baby cottontail rabbits and fledgling cactus wrens. If we're lucky we'll even see a baby Gila monster, fresh from the egg and looking all the world like an adult in miniature. Hordes of orange and black blister beetles attack lupines on a slope, but by tomorrow the beetles will have moved on. I mark the days.

I've traveled to a number of places to see wildflowers. As a kid, my first flower tour was a family outing along the Apache Trail, east of Phoenix. Even with my boyhood preoccupations with sports and girls, I remember to this day the golden slopes of poppies and yellow brittlebushes accented with deep pink Parry's penstemons and purple lupines. Another time we went to Organ Pipe Cactus National Monument along the Mexican border. It was glorious with owlclover, Mexican gold poppies, desert marigolds, and wild morning glories.

In recent years I've found some less-traveled places to hunt for spring. One of these is an unnamed canyon in the Cabeza Prieta National Wildlife Refuge. It slices through granite, and its sands make good soil for a number of plants. Bighorn sheep and desert tortoises live here too. The sun bounces off the canyon walls to warm seeds, so flowers bloom early. Stands of red chuparosas attract hummingbirds here when the birds are scarce everywhere else. Another special place is the Mohawk Dunes between Yuma and Phoenix, where the purple sand verbena spreads across the sands, and tracks of lizards and foxes scribe the sand with the stories of their travels. Golden swatches of desert sunflowers sweep to the horizon.

How does my own bird and plant calendar stack up against the one on your wall? Over the last eight years I've kept weekly records of what I see around my home in the desert near Tucson. I chart flowers blooming and leaves falling, birds nesting and coyotes whelping. White-winged doves have arrived at my door as early as March 10 and as late as April 1. The average date? You guessed it: March 21, the start of spring, just like your calendar told you.

When is spring over? Some say when the paloverdes drop their seeds; others, when the saguaros bloom in May and June. Perhaps it's when Gambel's quail chicks hatch and, as if on wheels instead of legs, race madly after their parents. Maybe it's when smoke trees burst into blazes of purple color along the low washes. But spring's last whisper may be when the queen-of-the-night cactus blooms, filling the air with such a powerful perfume that grown men have been know to swoon. A queen-of-the-night cactus by my driveway has bloomed as early as May 20 and as late as July 10, but the average date is June 19, just two days off the "official" calendar.

From now on I'll use the arrival of whitewings as *my* official beginning of spring, and I'll know it's over when the queen blooms.

The days grow hot. I sweat while sitting in the shade. Birds fledge. Wind blows buckwheat skeletons across the sand, and antelope ground squirrels stuff paloverde beans into their cheeks. The pace of life slows under the heat, as if catching its breath from the frenzy called spring. The quail and I hunker down, awaiting the distant rains of summer.

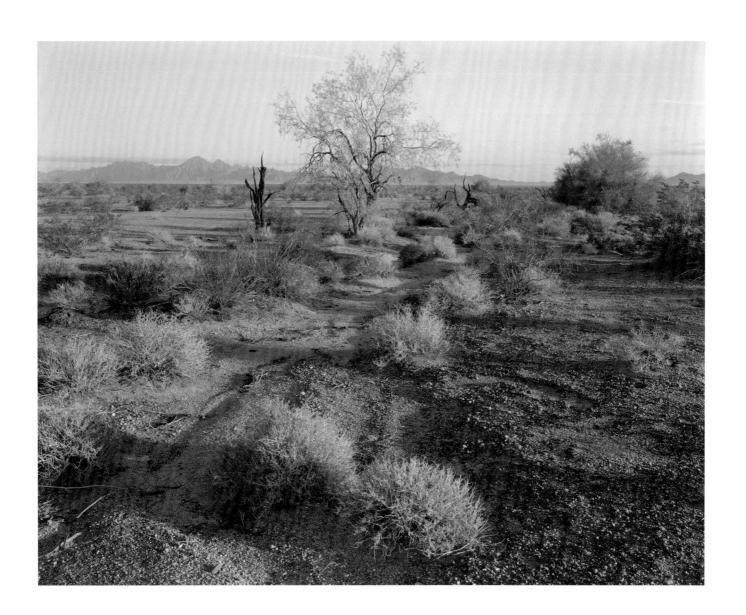

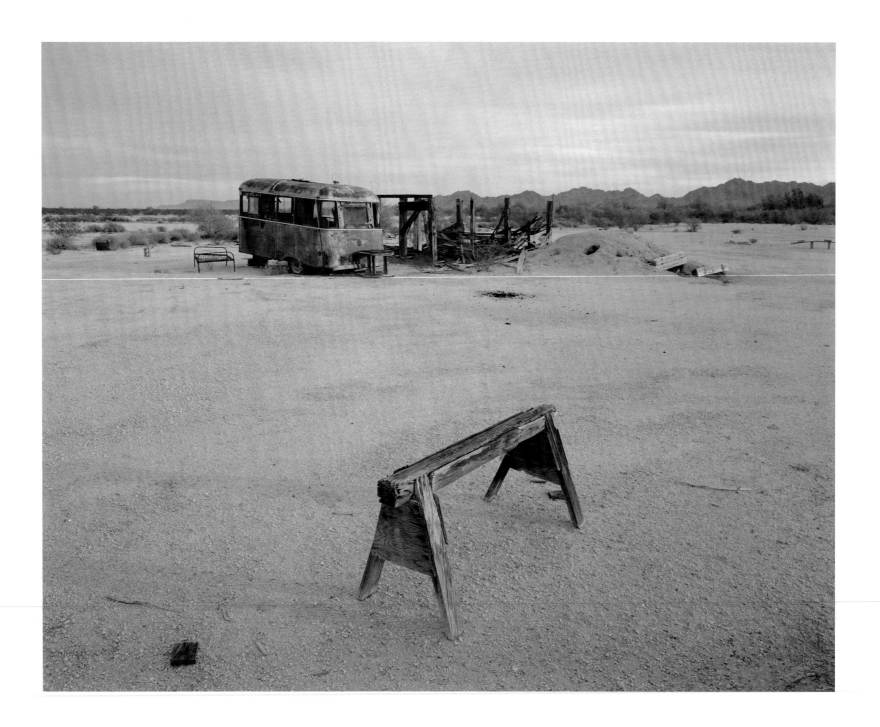

Passing Through

I got a letter from a Man yesterday wanting to know Why
it was so Dry on the Desert, so I wrote and told him it
wouldn't be a Desert if it Wasn't, which is Why it Was.

DICK WICK HALL

IT'S A MODEST WALK from the Organ Pipe Cactus National Monument campground to Victoria Mine. Tennis shoes and a hip pack will do for a day jaunt. But it's also a revealing stroll. Half a mile from the road, I was in another world, which humans—my kind—have never figured out how to call "home." This land was always too hot, too hard, too dry, too distant, too . . . something. Even today it is frontier, the edge of civilization, the drift line of society's relentless waves. If Tombstone was the town too tough to die, this was a place too tough for us to live. Heaven knows, people tried, but a few brief mining camps and cowboy shacks were all that this land could support. Deserts are like this.

I was going for several days and had loaded my shoulder pack with food and gear. A trail with easy ups and downs has been scratched across the rolling granite ridges. Along the way a young woman sat on a bench writing in a diary. Though I didn't mean to, I startled her by asking if she was writing a book. She smiled and nodded, continuing to scratch the pages with notes on the heart's business. It wasn't long before I could no longer hear the sounds of cars. Cactus wren songs carried on the breeze.

Ahead I could see dumps of unwanted rock from diggings at Victoria Mine, which hasn't been worked for nearly half a century. Bats, not miners, now use the shafts and tunnels. The coffee-colored rock around the shafts doesn't look particularly different from the weathered granite of the rest of the mountain, but keener eyes than mine obviously liked what they saw. Half a dozen pits and holes pried into the hillside looking for gold and silver. The mine must

have been a bustling place for a few years following its discovery in the 1880s. Headframe foundations and a large iron wheel for power belts hint that this was more than a pick-and-shovel operation.

Rock walls outline Mikul Levy's one-room store, called Tienda de Campo America, which thrived about 1900. The roof caved in long ago. Levy owned the mine, too, at one time and named it after his foreman's wife, Victoria Leon. Because of its nearness to the Mexico border, the mine was also known as La Americana so that no one would mistake it for foreign ground. Most of the miners must have lived in tents or in the open. A few rails from handcar tracks show where they pushed rock over the edge or into wagons, which hauled it to distant mills. But falling ore prices and rising groundwater in the shafts rendered mining impractical and killed any hope of profit.

A couple of tourists with German accents asked me about the mine. I told them that it was founded by a nameless frontier prospector and his Native American wife from a California tribe. Then Cipriano Ortega, a Mexican bandit turned land baron, bought the mine and later sold it to Levy, who was born in Texas, educated in Germany, and whose parents were from Spain. They asked if no one came from Arizona, and I said, "Out here we're all from somewhere else, but we stay by choice."

I left them to puzzle the ways of Americans and headed northwest to Senita Basin, the only stand of senita cactus in the United States. The senita is a chunkier version of the organ pipe. It has up to a hundred arms and may stand twenty-five feet tall. In late spring senitas put out pinkish funnel-shaped flowers, which contrast with the hoary head of gray spines on each arm.

The monument's namesake organ pipe cactus mingle with the senitas and a thick underbrush of bursage, cholla, and creosote. In spring the bare, sandy spots are arrayed with flowers from dozens of different species living glorious but short lives. Poppies, owlclover, primroses, phacelias, asters, and desert sunflowers begin the list, but it is long and colorful.

I could have turned around here and made a wonderful day of it, but I had my backpack and pressed on. The sun peeked from behind billowing storm clouds, and the wind held the scent of rain. I made for the next place-name on the map: Milton Mine. It was once owned by Jeff Milton, arguably Arizona's most eminent lawman ever. Others were more famous—Wyatt Earp, Harry Wheeler, John Slaughter—but Jeff was the dean of badges. His story was told by J. Evetts Haley in *Jeff Milton: A Good Man with a Gun*. I've met old-timers who knew Jeff, and to a person they affirm his authenticity as the real thing: honest, reliable, fearless, gentle, indestructible.

During the first third of the twentieth century, he rode this borderland alone looking for smugglers and outlaws. He caught many and brought them back to jail. A few wouldn't come peaceably, so he buried them. His motto was, "I never killed a man that didn't need killing; I never shot an animal except for meat." He wouldn't even kill rattlesnakes, because they meant him no harm.

Jeff had a sense of humor, too, though sometimes it cost him. Once he took an urban executive on a desert trip to look at a mining claim Jeff wanted to sell him. The man saw Jeff crumbling a chiltepin pepper on his own breakfast and inquired what it was. Jeff replied with a wry grin, "Water cooler. It makes things cool." Now, chiltepin is just about the hottest thing going. It's M&M-sized dynamite and hotter than a summer sun—only a well-tempered mouth can survive a bout with it.

The man nodded as though he'd learned something special. Later in the day, when he was hot and thirsty, he asked Jeff for a couple of those "water coolers." Jeff soberly handed him a couple. After the

man had drained most of his canteen trying to put out the blaze in his mouth, he called off the deal. Jeff figured that prank cost him twenty thousand dollars. But he gathered himself another supply of peppers next time he visited one of the canyons in Organ Pipe, where they grow wild. As you can still see today, Jeff's mine was a trench where he and friends scooped out copper and silver ore. He worked it a few years and then sold it to someone else. Its only real profits were from selling the deed, not from the ore. Jeff went back to being a lawman.

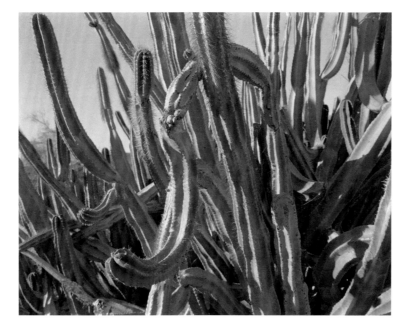

no pottery had been made close by, these pots had been carried from at least forty miles away. I picked one up and looked at both sides. It was a plain potsherd, without design or painted lines. It was theirs not mine, so gently I replaced it precisely as I found it. The experience is like shaking hands with someone a thousand years old. I wondered who they were and what made them smile.

That evening I camped a few miles north of Jeff's mine. Rain drizzled most of the night. A few flashes of lightning blazed the sky and the wind howled. I slept fitfully in a nylon cocoon hikers call a bivy bag. Somehow my wool cap got pushed down over my eyes, and I didn't see the sunrise, but when the whirl of hummingbird wings buzzed my head, I knew that the rest of the world was up and ready.

The trail beyond was primitive, though it has been used by people and animals for thousands of years. In recent centuries, paloverde trees have overgrown the trail, forcing even the coyotes to detour. Occasionally I spied a flake of obsidian, from a broken arrow point, or a sea shell, which someone had carried from the distant ocean to use for jewelry or a utensil. Sherds lay by the trail where a clay pot had been dropped accidentally by some ancient traveler. Since

To the north lay the Puerto Blanco Mountains, rising a thousand feet above the valley. I thought that a dip in the ridge might provide a pass to the other side, so I followed the dry wash bottom that way. When it grew rocky, I climbed its bank and found a trail made by wildlife and used by prehistoric people. In places it passed between cholla cactus, and in others it wound under low branches of paloverde and ironwood trees. Occasionally it went through a brambly catclaw acacia, one of the desert's most innocent-looking but aggressive citizens. Its clawlike thorns rake exposed skin, and blood flows freely. I gave them a wide berth.

The trail grew fainter. In places gravel atop smooth rock made the footing treacherous. To the side were rising cliffs of white and yellow tuff, spewed by an ancient volcano. An easier pass west of here a few miles is named Puerto Blanco—white door—for these tuff cliffs. A saguaro cactus stood tall on a rocky ledge scarcely wide enough for

an owl to perch. At the pass I stopped for lunch and the view. To the north I saw range after range of mountains. Wind zipped through the limbs of foothill paloverde trees. The scrapings of a bobcat and tracks of a mule deer marked the earth. Ravens squawked overhead, hoping that I'd be messy and leave them some crumbs.

As I descended the rocky north side of the pass, I veered left and headed for Dripping Spring. A web of foot and animal trails led to it. I fought my way through a maze of plants and limbs to the cavern where the spring is. Coursetia bushes—trees by desert standards—were in bloom, showing their yellow and purple pea flowers. Several velvet mesquites marked the entrance. Even before I saw the actual surface, I could hear the dripping of water into the pool, which lay in a dim alcove the size of a walk-in closet. The water is mineralized and smells slightly of sulphur. Tracks of deer, birds, and coyotes on the apron to the pool registered some of the visitors. A pair of eyes at the water's surface revealed a submerged toad waiting for a dragonfly to arrive.

Desert travelers are tied to water. Every cupful is precious. Even though I had brought enough water with me, I felt safer knowing this spring was here. I scooped up a handful to taste. I've sampled worse, but it is wetness that matters. The satisfaction lies in the luxury of having water at hand.

To the northwest stands Kino Peak. It is big, stark, unfinished. A castle of rock carved by rain and wind from the neck of an ancient volcano. On another trip I went to the summit by a circuitous route that looks impossible but proves easy once the small cairns marking the way are found. Bighorn sheep are known to make it to the top, but that is little comfort to us.

Someone had told me how to find the trail's start, but they also warned me that straying off the route led to numerous dead ends at the tops of tall cliffs. After climbing up a steep slope, around a cliff, up a false summit, and dropping down a chute, I hiked a series of switchback ledges to the summit. It isn't a place for faint hearts or careless steps. It all makes sense when standing on top, but the first person who surmounted the summit must have made a number of false starts in trying to string together a route. Even the bighorns jump up and down ledges that don't lead directly to the top.

From the summit of Kino, peaks stretched far to the horizon, and I think I even saw the Gulf of California. To the west and north, I looked into what may become Arizona's fourth national park. It could be as big as 3 million acres. Together with the Pinacate and Alto Golfo biosphere reserves in Mexico, it would feature twelve thousand square miles of open, wild space with enough elbow room to stretch our legs and imagination for a lifetime. We need such places.

The peak is named for Padre Eusebio Kino, a Jesuit priest who traveled throughout the region in the 1690s and several times crossed what is now the monument. He established missions and mapped unknown places in the western desert. But most of this land then, as now, was unpopulated, so he didn't stay.

I've heard that we're born with a love of a place. For some it is the sea; for others, alpine meadows, farm land, or prairies. Maybe yours is the dense timberland of tall pines or even the city. Some wanderers spend a lifetime trying to find out which is theirs. I've found mine here, but even then, I'm just passing through.

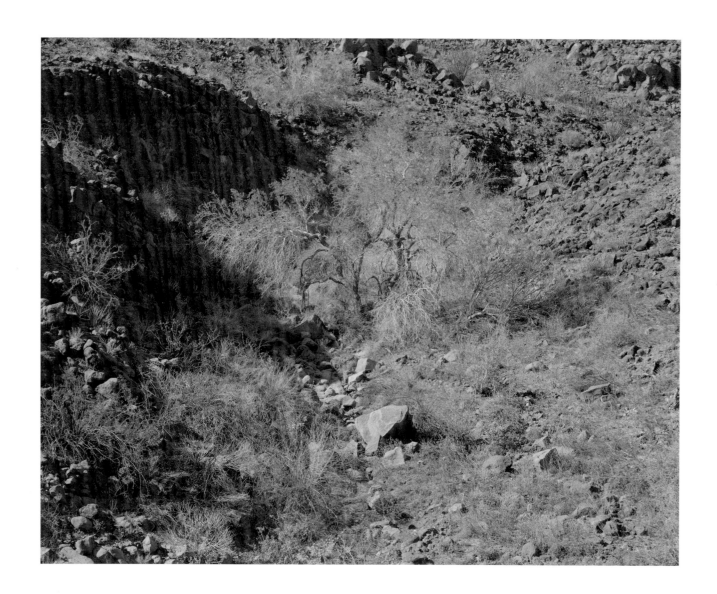

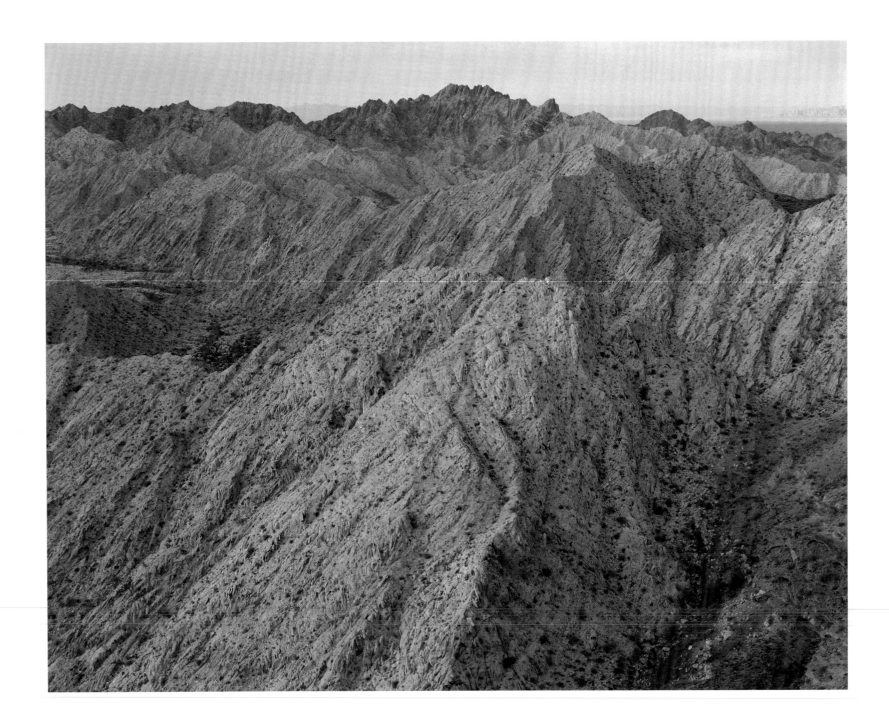

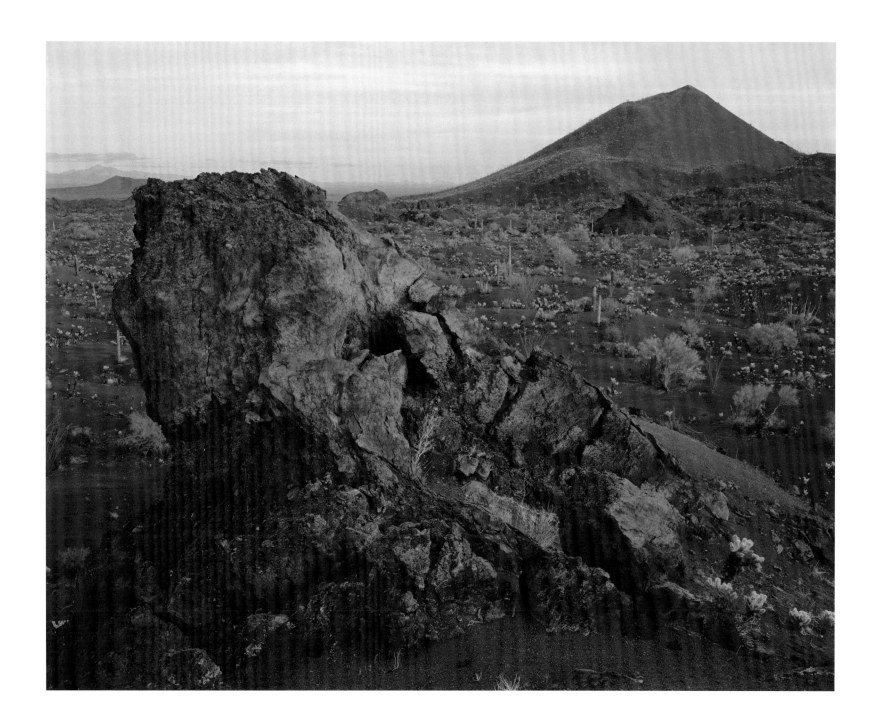

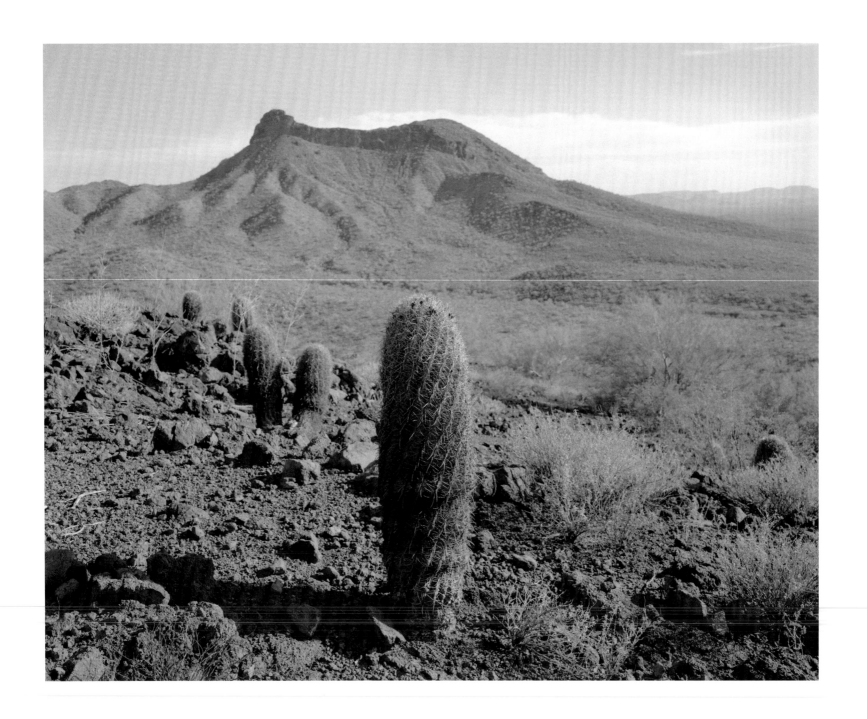

Faces

THE GRAN DESIERTO is a despoblado, an unsettled vastness. In 1925 Kirk Bryan reported only one person living between Ajo and Yuma: the watchman at Fortuna Mine in the Gila Mountains. Today not even he lives there. We can walk westward 120 miles from Ajo and not cross a paved road. We can walk 130 miles southwest from Gila Bend and cross only one paved road and a railroad track before stepping into the Gulf of California. In Mexico a few people work on the railroad or round up range cattle, but the only settlements are ejidos and truck stops along the highways and fishing villages along the lower river and delta. Campers, Border Patrol agents, park rangers, tourists, and especially hikers are few and far, far between. I've seldom run into people out there, but those chance meetings linger in memory.

Ejido Cerdán Weeds grow along Mexico's Highway 2, where staggering and broken ejidos litter the sides of the asphalt strand that connects San Luis and Sonoyta. Their signboards outlive the flesh and voices, the hopes and miseries. It's not unusual to see an official road sign pointing to a debris pile that once was a dream.

To see Ejido Cerdán is to see naked frames of stripped shacks, their tar paper removed when families fled to parts beyond. It is to see armless dolls, casualties abandoned in the battle to survive. It is to kick enameled washbasins left to catch

53

only drifting sand. It is to smell the leaves of eternal fall, where the green force wilted. From here most any other place has allure.

"Ejido" implies a cooperative farm, a place where poor but industrious people can merge their strength and wield enough force to tame untilled wasteland, land labeled on maps as *terrenos baldíos.* If they can bring it water and seeds, they can make it sprout and blossom. They can make it feed them. They can. . . . Maybe somewhere there's a hope and a will and a way that can, but it isn't here. Certainly not for these *peónes,* without capital, training, or loans. Though brave, these campesinos can't rally this land with mere shovels and hand-dug wells. They cannot stop the sun or halt the wind.

To the south lie fifty miles of sand. Children's footprints venture only a couple of hundred yards southward. Tire prints wander the faint washes and circle the few trees. Tracks of a shepherd and a few goats extend a mile at most from home. A few hundred yards to the north is the fence—*la linea,* the line—and the Yuma Marine Corps firing range, bomb cratered and starkly littered with charred and riddled targets.

On a gray afternoon one Christmas Eve I pulled into one of these ejidos. The name, Ejido de Aquiles Cerdán #1, filled the road sign. I was there to watch an event with my own eyes, though I feigned other business. Two curious *jóvenes* skipped over to investigate my raised hood, for few people stop here, even though thousands of vehicles pass daily. I asked if there was a mechanic thereabouts who could give me a short piece of electrical wire to fix my radio. The kids, Tomás and Enrique, offered to show me where the mechanic lived, though there were only three or four options. But they kept looking past me to the west, as if they were talking to someone over my shoulder.

The kids jumped into the truck, and we drove two hundred yards to Martín's house. A mechanic out here hasn't been to factory-certified

courses or trade schools. He's the one who owns a wrench and once fixed something so it ran. Mexican mechanics are ingenious. I've heard of them popping a differential out of a heavy truck and carrying it in a VW fifty miles to a welder. I've seen them pull crankshafts and walk miles to the nearest road before hitchhiking to town for a welding job, then return to install it and drive home. Once a friend and I stopped to get a tire fixed at a roadside shop in Pitiquito. He coached the high school gymnastics team and taught physical education; I was a coach for the track team. The *llantería* had no power tools. An older man looked our tire over and then flew to work. With just a few pry bars and a hammer, he dismounted our flat, patched it, and remounted the tire on the rim in less than fifteen minutes. It was one of the most impressive athletic performances either of us had ever witnessed. He wasted no motion, made every hit count, and applied leverage like a Greco-Roman wrestler. His hand-eye coordination was exceptional. A couple of years later I inserted an inner tube in a similar tire and wheel. With a Hi-Lift wagon jack, crowbar, screwdriver, and hammer, I spent an entire summer afternoon fixing the mess, and at that, I was grateful not to lose a finger.

As we arrived at Martín's I saw kids running westward. My two said rapidly, "Here's Martín's he can help with the wire adiós" and sprinted away. A single-engine airplane circled low over the compound. Gleeful kids scrambled after the plane's shadow. Dogs yelped and romped. One small lad followed, pushing his dog in a wheelbarrow. Smiling adults peered from open doors.

The plane dropped something. Small packets fluttered to the ground. Kids ran after wrapped candy and screamed. Dogs barked. One adult joined the game of pickup. Then others swarmed below the plane as it made repeated passes over Cerdán, as if the end of the rainbow were touching tiny pots of gold. Cheeks puffed like squir-

rels, and pockets bulged with sweet wealth. Laughter rang and broad smiles revealed candy-colored tongues

My wire was forgotten. But I had known the plane was coming, and I didn't really need wire. They had known it was coming, too, since the candy drop had become an annual affair. The plane was one of the U.S. Border Patrol's Piper Super Cubs, the kind they used to track people who cross that wire line north of the ejido. It circled low over the ejido and dropped more candy. Two patriarchs stood in a low patio and watched. They laughed, pointed at the frenzy, and laughed again. They were Jesús Silva and Tomás Vega Saravia.

Jesús held a wine jug aloft toward the plane. He toasted the Border Patrol. "The *migra* are our friends," he explained as purple wine streaked his chin. He yelled to the plane and invited the pilot to a goat barbecue tonight. He invited me, too. The spirit of Christmas swelled in his fist. Tomás yelled and hooted festively. A wider smile would have split his face.

I didn't know these men. They had never before seen me, but Jesús insisted that I see his garden, which consisted of a rabbit-proof fence surrounding a dozen young citrus trees and a plot of lettuce, onions, and radishes. His youngest son was sent to pick an orange for the visitor.

Watering citrus out here is difficult, explained Jesús. Water must be carried by hand or by car the 200 yards from the ejido well. They couldn't afford a pipe yet. Water was deep, at 350 feet, and the balky pump required costly gasoline. The water, he bragged, was only slightly salty. Drinking water came from San Luis in glass or plastic jugs. Chair seats were woven with clothesline. A cantina-sized table emblazoned with "Oso Negro" tilted in the patio, round watermarks staining its face as proof of good times served here. A struggling eucalyptus tree hinted at shade.

Jesús was a jovial, rounded man. His mustache fluttered in the breeze, and his plaid cotton shirt opened to the sternum. He joked about drinking much beer. He and his friends drank lots of beer in his patio. With a wink, he rationalized that they only drink it to water the trees—"the piss makes the oranges even sweeter," so he says.

His hope of financial salvation rested in cactus. *Nopales,* the young pads of prickly pear used in salads and relishes, would be his cash crop. Typically nopales are diced and pickled with water or vinegar, salt, and onions or pimentos. An important source of vitamins, they're sold as nopalitos, a sort of salad helper or relish. An acre of prickly pears neatly lined the furrows. In another two or three years they would provide an income, he insisted. Tomás nodded vigorously in agreement. His crop would grow, *"con la ayuda de Diós y nuestros manos."* He and his clan were not afraid to work. He was betting his family on that vision.

The candy, he explained, had been a fixture for the past six years. It is from their friends in the American government who care enough to notice them in their hovels. Their own government ignores them, they said. Besides, men—even policemen—who give candy to children can't be bad. They also know that when they venture across that line and seek work up north, the migra may apprehend them, but they will not abuse or rob them. And if they falter on the crossing and need help, the Border Patrol is the only outfit that will seek and rescue them.

Jesús had worked in Phoenix and California, as had Tomás. They spoke some English, and like those who have had to struggle with a foreign language in a foreign land, they spoke slowly for my benefit. They wanted to be understood. They wanted me to endorse their dream. They wanted me to share their bounty. They invited me to stay for Christmas. "We will eat very well tomorrow," they urged. I

was honored but didn't stay. Now when I pass Ejido Cerdán, I always salute. I admire folks who literally piss on adversity.

Oilman Nothing had prepared me for the sight of the oil derrick in the sands southwest of Sierra del Rosario. It stood as raw as an obscene finger breaking the smooth, pleasant lines of a friendly wave. Visible from at least six miles away by day and much farther at night, it might as well have been a lighthouse on the vast sea of sand. I had seen yellow signs guiding supply trucks and workers to it, but the bladed roads and 140-foot tower rendered the signs unnecessary. There were no trees or hills nearby to scale it.

One sign addressed this as "Pozo Tutuli Number One" and another excluded visitors. A guard dog with massive paws kept an eye on the gate, though seldom do strangers pass this way. It's six miles from the railroad and on the route to nowhere else.

Up close, the ground quivered and the tower hummed. Four immense diesel generators sparked enough electricity to power a town. The drill drive grunted and moaned. Water gushed from a four-inch

pipe into a holding pond. Bags of drilling compound were stacked to the ceiling of a storage shed. Men stood on the main platform. *Ingenieros* they're proud to be called. They have technical skills and make big pesos for Mexico. They run this show and plan the drilling strategy. They read the cores. They understand the theories.

On the flat, two men hammered on a valve assembly. A welder stood by waiting for them to give him the casing. A cook manned the coffeepot and snack shack. A group of four men wearing heavy gloves with elbow-length gauntlets rolled pipe onto a rack. To the rear of the tower, two men slung ropes and chains around these pipes so that the pipes could be raised vertically. They, the laborers, implement the theories.

Another climbed a ladder up the derrick's side and balanced on a footstool above the main pipe. He tied himself into the tower with a harness and rope. His job was to gently thread a forty-foot section onto the one below. In a world of trembling iron and galloping engines, a caress is still needed to start threads. Into these forty-foot casing sections they would drop eighty-foot drill lengths.

Enrique Gallegos asked for a *cigarro,* but really I think he wanted someone from the outside to talk with. Though he spoke broken English, he claimed to have worked twenty years in oil fields near McAllen, Texas. He liked Mexico better, though the pay is less. His family lived in San Luis and he commuted the eighty miles home each day, but many of the workers on the three daily shifts live in the closer company housing north of El Golfo. He had his own car, a black Chevy Malibu, which he parked outside the fence. "If there's an explosion or blowout, I'll run like hell for my car." He liked the idea of excitement.

The central hoist, a massive yellow block of steel wound with cables like a block and tackle, bore an American label, as did much of the other machinery. But what block do we know that reads "400 Ton Capacity" in foot-tall letters? The equipment was atypical for Mexico. In a land of dented, muffler-less trucks, the machinery here was new and unscathed. The tower was painted and apparently had routine maintenance. Things seem to be done by procedure here, not by the whim and makeshift approaches so common on the frontier.

This operation carried the stamp of PEMEX (Petroleos Mexicanos). Urged by profits and priorities, it went first class. You got the feeling that the ingenieros move whatever earth they choose. Environmental statements aren't obvious here. PEMEX sweeps the desert aside with roads and sites to make space for progress.

The firm's last well, Pozo Tebari Number One, explored to 5,152 meters. Meters, not feet. This one had run past 3,000 and was heading to 5,000. Meters. That was the ingenieros job: punch Sonora full of test holes. Probe the stratigraphy, and hope for oil or gas. This was about the tenth of Sonora's test wells. Others had been tested offshore. I think back to Enrique's car and wonder if he had kept an escape boat tied to the pilings of the offshore platform.

The Perez Boys Smoke billowed from the tule and tamarisk thicket south of the *pantano* near El Doctor. Herons croaked and ducks circled. I turned onto the dirt road to investigate the fuss. Wind swirled the flames and they crackled noisily. I had set up the tripod for a photo when down the path came four Twainsian kids. Dressed in shorts and T-shirts, they merrily romped and frolicked. This was Saturday, and the Perez boys were home from school. They asked my name. They asked where I lived. They asked where my car was. They offered to show me their ranchito. They offered me cheese. They laughed and giggled.

I hastily photographed the fire while the four funsters watched. They had set the fire. Burning the tules made more room for their

cows, they explained. Besides, it was something to do. Then I asked if they would like me to take a picture of them. Faster then you can say "Fernando Valenzuela" they lined up and smiled. Well, "smiled" is a mild word. They giggled and pinched each other and held rabbit ears behind one another's heads. They joked and laughed some more. It was like watching otters at play.

Each carefully gave me his name so I would know who was who in the photo. They were proud of going to school and offered to write their names on my paper so I wouldn't make any mistakes. And now I have the autographs of the Perez boys: Ramón, Francisco Javier, José Adolpho, and Jesús.

I asked about a recent flood, but they're far enough down the delta that the Colorado River didn't bother them much. It rose only a few feet here, they said. They fielded my curiosity about other pantanos and showed me a whole line of seeps where fresh water from the mesa trickles into the salt water of the delta. Unfettered by parents, who had gone to town, they were now in charge, and their confidence swelled like a wren's song. I was the rare audience, and like circus troopers, they loved to perform.

One tried to bean a duck with a stick to show his hunting prowess. He missed and bemoaned that he had no rifle. *"Con un rifle, yo. . . ."* Another jumped on a calf's back, and we all tumbled in laughter at the impromptu rodeo. He fell splot into the gooey mud when the tiring calf slumped to its haunches and bellered for Mom. The other two ran a race around a bush and back. Their arms pumped and their bare feet detonated puffs of dust in the road, as if firing two rows of machine-gun slugs.

They wanted to take me home, as if I were either an orphan or a passing dignitary, I couldn't quite tell which. Pressed for time I said

I'd visit when I brought a picture for them. Their eyes widened at the thought of a picture. They gave me a couple of new Spanish words and in turn asked a few English terms. By the time I left we all knew "cow" was "vaca" and "pato" meant "duck." They had obviously met few Americans and delighted in sharing their turf and knowledge. The eldest bragged about his father's cheese and thought that I should try some. Making cheese is a standard project hereabouts, and what isn't eaten can be sold to families who don't have cows.

They warned me about snakes and scorpions. A rattler had struck at one of them just last week. It had missed, but they thought it was worth talking about. The sand stung our legs, and dust from the mesa above burned our eyes. A north wind was moving in. El norte, as it's infamously known, howls. The temperature drops and the chill factor runs below freezing. Nothing moves in a norte. Were snow on the ground, we'd call it a blizzard.

We walked back to my truck amid swirls of dust. I carry candy for such encounters, as do many tourists, but I reached into my briefcase instead and pulled out a packet of pencils. Their eyes widened, and four minds clicked at the prospect of new pencils for school. They'd be the envy! And to tell that an American stranger in a big car had given them, well, it would be news. Last I saw of them, they were running full tilt back to their casita, one of many along the mesa's edge. Still, I got the better of that deal.

Taxi! A friend of mine was in the last days of the army's basic training when a gung ho sergeant arrived to recruit paratroopers. The sergeant regaled the assembly with war stories and bravado. My friend, a person of action and daring, was quite entranced. The recruiter finished his spiel and left the room amid grand applause. My friend's

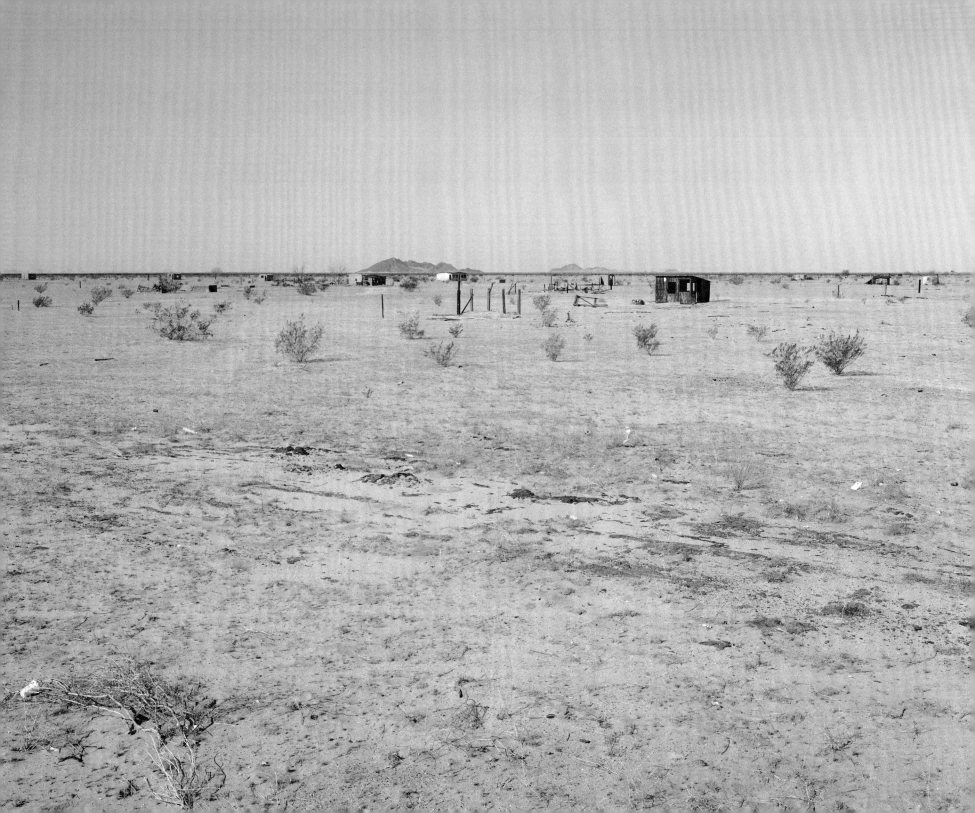

boot sergeant said quietly, "All right, men, if you want to sign up for the airborne, I'll take your names." Men eagerly raised their hands. The sarge continued slowly, "But just let me say that I never saw any reason to leave a perfectly good airplane." All hands dropped.

It's 2:00 A.M., dark, and cold. If there's a hell, it surely has alarm clocks. Why am I doing this? Why am I leaving a perfectly good bed to parade across the countryside? I call a taxi to take me to the bus depot. It arrives promptly. The driver says, "Just throw your pack in the backseat. You can ride up front." Ride? Throw? I'm still asleep.

I was surprised to find no one in the depot except a cop. There were no ticket takers, no janitors, no baggagemen, no riders. This isn't how I remembered bus depots. I picked a seat near the bus door and looked questioningly at the cop. "No one here at night but me. If it weren't for me, winos would fill all the seats." He turns the pages of the newspaper. He's a regular city cop, not some shoe salesman who bought a gun and badge.

Shortly before my bus is due, a baggageman arrives. The bus comes, but only two worn passengers get off. A guy with a small bag enters and slyly looks around the room. He sports faded denims, a peacoat, and brown hair styled by turmoil. He heads for the bank of pay phones and checks each return slot before reaching into his own pocket. He makes a collect call to San Antonio to someone obviously not happy about talking at 3:00 A.M. or to this person. The caller nervously shifts on his feet. He has many needs.

"All I need from you is an address so they'll have someplace to mail my check. Yeah, that's right, so I can tell them I have a place to live so I can get my mail. Just an address. Oh, she left me. No, my folks won't let me use their address. They won't talk to me. They won't pick up on my calls. Jesus, man, I gotta get outta here. Them? I guess they fired me, but it wasn't my fault. Didn't get along with the boss. Well, I guess I'm out with the union, too, but—" I closed my ears.

The bus driver doesn't have change for my ticket. I jokingly remark, "I thought I was riding a big-time bus line."

He replies with a look of frustration, "I thought I was working for a big-time bus line. They fooled both of us." I get my change down the line. The front door seat is taken by a balding man bundled in a brown imitation-leather coat, so I pile in behind the driver's seat. I like to watch the road. The man across the aisle tries to start a conversation.

"You look smart," he begins. I look tired.

"What's Tucson like? I'm retired, retired from the New York post office. I travel now." I nod. "I travel now. I'm out to see the world and get smart. Experience is the best teacher, don't you think? I never liked school. This bus goes to L. A. Is L. A. warm? Where is it? Oh. Do they have a northwest in California?" Before I have to figure an answer to that question, I glance toward the steps as a woman with two big handbags struggles to fit through the stairwell. He rushes to help her, and though the bus is largely vacant, insists she sit next to him. "You look smart," he says to her. "Do you know health foods? I studied up on them. . . ." I drop my head against the cold window and sleep.

I expect a Mexican border official at San Luis to question me about my bulging backpack. Technically, I have a visa, but it was issued two months ago and it isn't meant for multiple entries. I have nothing to hide, but when no one stops me and I see no visa office, I keep walking. Not wanting to carry the load any farther than necessary and not knowing where the bus depot is, I approach the first taxi.

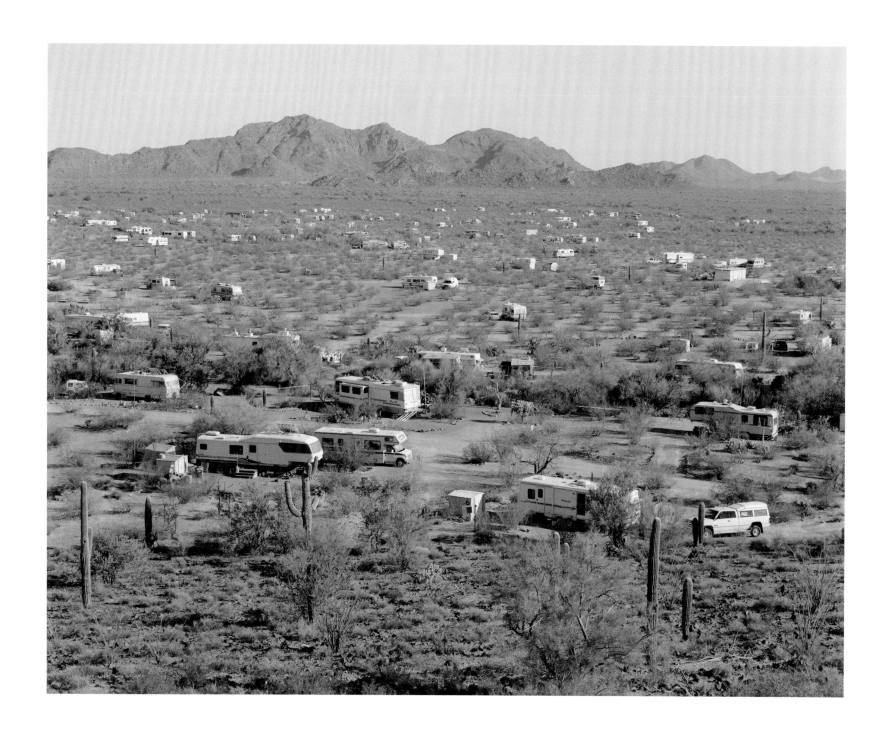

The driver, an older man named José Guerrero, proudly advises, "You remember taxi numero six. It is a lucky taxi." He's curious about my pack and not at all surprised to hear that I'm going hiking, and he tells me that the bus won't leave until much later. He offers to take me as far as I want to go. His price sounds reasonable, as does staying in the cab instead of waiting in a bus depot. I'm anxious to start walking. He recounts his own days when he marched the desert wilds with a canteen, rifle, and dog. He didn't even take a burro. He subsisted on rabbits, birds, and snakes. He motions with his outspread fingers to the lands south of Highway 2, to the lands of the lower delta, to Baja itself. "I know this old, big desert. It is beautiful but tough. Be careful."

Nowadays he sometimes guides fishermen to the sure spots off San Luis and takes hunters to Baja to shoot bighorns. He wants to get back over to a special canyon in Baja where he has mined turquoise and marble. He'd go back but his car is too weak for the tortuous trip. Next time I come he will give me a card from Oscar de León, who serves as a chief of Mexican Immigration. "You probably won't have any problems with anyone, but with his card you certainly won't," he explains.

José is sixty-one and speaks some English. His black hair has hints of gray. We pass a mansion, and I ask who lives there. "Oh, some *pinchi rico,*" he says rubbing his thumb on his fingers. "I live in a small home, but I'm happy."

A bit skeptical of his adventures afoot, I press him for evidence and ask if he has any photos. "Of course," he says. "Next time, you call me, and I'll show them to you." He makes a production of writing down his address and phone, but his smile is genuine. He drives a steady forty miles per hour on the highway. He laughs and says, "I drive slowly. I have no hurry. I've seen many years. Many things. I

like life. Maybe when I can no work more I get another dog and look for treasures again."

I have left a warm bed and jumped from a perfectly good plane, but if you're going to see the Gran Desierto, you gotta keep your hand raised.

The Bus Remember that bus you rode to elementary school? It's still running the back routes of Sonora, and it'll still pick you up.

I stood beside the road, a narrow crowned two-laner in the middle of nowhere, forty miles from any name on a regular map. The asphalt slices straight through the desert, half because the land doesn't resist, half because even the builders on day wages didn't linger. It isn't ugly, but then it isn't pretty. It's nothing. Wind, sun, knee-high bushes, and sand. Nothing.

There are no bus stop signs, no benches, no route maps. Wherever you are when the bus trundles past is where you get on. I heard the churning engine and gears wound tightly before the bus crested the hill and rose into view. It tilted to the left where the front spring sagged, like a dog with a limp forepaw. Chalky white fenders fluttered, and the rusted chrome grill smiled openly.

I raised an arm. I hoped the driver understood because I was too tired to wave or to walk any farther. He hesitated and then stopped. With no shoulder on the road, he parked square in his lane. I asked if this was the bus to San Luis, and he politely said yes, though I suspect he wondered why any sane person might think there was anywhere else to go. They apparently don't get too many American riders on this route. My state-of-the-art backpack, so sleek and maneuverable in the open, was cumbersome and awkward in the narrow aisles of a bus, so I held it overhead and walked to the rear.

Already seven passengers sat in the front seats. The driver smiled, dispensing hellos and jokes like a Good Humor Man does ice cream. Obviously, I was the only stranger.

The bus has changed since a retired man named Marvin with a rose tattoo on his forearm drove B-34 for my school district. The fire extinguisher and first aid kit are gone. The "sit down" signs have been painted over. Now two colored-ink drawings, one of the Virgin and one of the Savior, peered beatifically down from the cab.

"Cal Custom" and "Penzoil" decals adorned the dash, though you would have been hard pressed to find any custom hot-rod equipment bolted onto this clunker, and surely a bus getting 110 miles to the quart of oil wouldn't use high grade. The shifter knob was custom; its clear plastic globe featured a religious cross and glitter. The shift lever was wound like a spiral rainbow with colored tapes. A plastic saguaro cactus was glued to the dash, though no saguaro grow within sixty miles. In fact the only cactus I'd seen in the last thirty miles of walking had been prickly pears planted in people's yards and grown for salad fixins. A mandatory paper flower—the huge red kind popular at fiestas—completed the artwork.

In the front seat chattered two older ladies, one with an apparently helpless child who rocked in the seat across the aisle. The other lady was the life of the party. She laughed and acted out both sides of gossipy conversations. Her colorful shawl countered her frayed black dress. She seemed to have a strong grip on reality, had it by the throat actually, and she would laugh and enjoy herself as long as there was strength in her gnarled hands.

Three men sat farther back. Each wore cowboy boots and waist-length jackets. They smoked and talked animatedly. When another boarded the bus up the road, each stood and greeted him with *abrazos,*

manly hugs, and spurred the conversation with stories of the weekend. They evidently had small plots of ejido land where they raised crops and maybe a few goats or cows. Horses don't fare well in el Gran Desierto, and they're a luxury most folks can't afford.

Two field-workers got on in front of the most catawampus house I ever did see. It was well back from the road with no neighbors. They were dressed in brown cotton pants and long-sleeved shirts. Gloves were stuffed in their hip pockets and bandannas were looped around their necks. Their sweat-stained hats were full brimmed. Dust covered their shoes, as if they had already walked a ways this morning. Their collars were turned up and buttoned, not as a fashion statement, but in the name of function to repel chaff, bugs, and dust. Hand shears, a file, and a foil-wrapped lunch bulged in each woven satchel. They got off at a field of lettuce nearer San Luis. Even from the bus I could see the gnats clouding around each worker, and I remembered why they needed high collars and covered their faces with bandannas.

The schoolkids who boarded the bus were shined and polished. They carried their notebooks and workbooks. One had wrapped his in a belt, as if carrying his books on a leash. One studied English, and from *My First Book* he mouthed the words quietly. I was puzzled when one of two brothers took off a shoe and put it in his lap. The answer was immediately revealed when they reviewed their math by testing each other with problems scribbled on the bottom of that shoe.

School is in Riito, thirty miles up the road. We had nine students all told by the time we reached there, including two elementary girls who carried half a dozen books apiece. They wore matching pink dresses with frilly collars. A black dog had wagged its tail at their stop even after they found seats and from the window yelled to it to go home.

Just after we let the students off at the Riito school, four other boys got on. They had field shears, not books. They giggled and picked their way to the back. Two were older, maybe midteens, and the other two hadn't yet seen twelve. One of the younger ones kept tweaking the other on his ear when he wasn't looking. Pretty soon they were punching each other. They laughed while they flailed.

Several adults turned and frowned, so an older boy jabbed the youngest one with his shears. They turned to pester him. They begged for cigarettes and eventually got one to share. They leaned back in the seats, their heads barely reaching the seat top, and puffed the bejesus out of that cigarette. Never has so much smoke come from one light. They exited at an onion field. The last I thing saw was the tweaker pinching the jabber, who was soundly cuffed across his neck.

When I had stashed my pack in the alcove at the back of the bus, I had noticed a cardboard box with clothes, an antenna, and a TV set. North of Riito we turned off the highway to a settlement, and a lady who had stared out the window the whole way stepped off the bus. She and the driver came around to the back door to unload those things. They were hers. A man old enough to be her grandfather appeared and carried the TV. She looked relieved but not happy to be back home.

From there we detoured to Luis B. Sanchez. Most of the settlements around here bear people's names. Heroes, founders, and celebrities are all honored. Sanchez is a farm town built on land where the Colorado River once flowed. The recent floods had done some damage, with watermarks low on the sides of some buildings. Giant potholes, washboard ridges, and deep ruts caused drivers to swerve helter-skelter and pedestrians to weave as if the street were a freshly planted minefield.

A peeling sign touted the Karate Koreano studio, which shared a building with Liquores Fiesta. Billares Olympicos, a faded blue and brown building across the street, testified to bored Saturday nights. Red bar stools were visible within its dimness. A horse and rider led a haltered colt along a side street. Two dogs sniffed each other at the intersection. A red-eyed man hugged a street post, but no one paid him any attention. A frayed kite and its tail drooped across two low power lines. Each of the buildings bore a mask of dust. It was an unfinished town, interrupted and splattered by its own industriousness.

Our driver nonchalantly shaved the space between us and parked cars. If six inches is enough, two should be ever better. He didn't even glance into the rearview mirror. He talked to passengers and waved to people on the streets. Not all the faces on the streets were happy. Many were stern and grim, as the people scurried on their way. Except for the children, the faces here were plowed with lines of toil harvested in the seasons of sun and wind. It's a long road from grade school to nowhere, but I was grateful for the ride.

Piñata Man His shack is the color of the lava desert: the blacks of tar paper, the browns of cardboard boxes, the chocolates of discarded particleboard, the greens of freshly hewn paloverde poles. A ramada, framed with ocotillo and saguaro remnants, shades his view to the south. Volcanic rock, boiled deep in the earth, is heaped to make the fire grill that warms his coffeepot. Here on the edge of El Camino del Diablo at Los Vidrios, where the earth is scorched by sun much of the year, life teeters on survival's whetted edge.

He shakes hands softly, a concession to arthritis. The gnarled hands that have swung sledges and mucked ore and coddled dynamite no longer grip like vises. They have turned to more delicate work. But

his mind grasps the realities of life. And its pleasures. Watermelon and peach seeds on a paper plate lie drying in the sun. He will plant them when the time is right. "The melons are small but sweet," he says smiling. He grows a little corn and a few beans to supplement his larder, a cardboard box on the table. He shares his garden's bounty with the staff at a nearby truck stop that huddles meekly in nowhere, an outpost for thirsty legions. Faces with names deserve watermelon.

Most faces here are nameless blurs, seen through windshields fleeing at a mile a minute along the solitary stretch of highway. He spreads his hands and talks of bags of harvested gold. Small fortunes have passed through these palms. He talks of looking again. Like *gambusinos* (prospectors) everywhere, he has a notion where gold can be found waiting for the sincere and willing man with the right tools to pry it loose from the clutched fingers of quartz.

"But for now I have frijoles, arroz, pan, y poco carne for supper," he says sincerely. "For washing I collect water off the roof when it rains. A friend brings me drinking water when he goes to town. I have no car now. My son has my bicycle. He lives in the city, as do my other sons and daughters. And my wife."

He continues, "Some of them live in the U.S. I can visit them any time. I have a travel card. But I like it here. . . ." His voice trails like a comet's tail of things unsaid.

He turns over in his hands the small gift I have brought him for a previous kindness. He smiles broadly. "And I have a gift for you, too," he says in Spanish slowly, so that I can understand.

It was night in the desert. A friend and I had just hiked until the road used us up. It was too hot. Mere feet were inadequate in the season of inferno. We had swigged heavily to recover. Now we looked for a spot to drop. We picked the side of the highway and sidled in to ask if we could throw down our *mochilas*—packs and bedrolls—near his shack.

"Of course." He nodded, as if we were doing him the favor. And then he talked. He pointed and gestured. Like a man with a secret too good to keep, he asked if we'd like to see inside his shack. We shrugged and assented to humor a lonely *viejo* (old man). He pushed the door open and shined his flashlight inside. It was as if he had lit all the fireworks with one match. We stood among a rainbow of wildly colorful piñatas—an orange bear, a white swan, a dappled burro, a red rose, a pink Pinocchio, a yellow elephant, a green-and-pink layer cake!

The resplendence of a crystal palace was inside a desert hut. With such radiance to guide them, the Wise Men could easily have found this humble inn. Xanadu was never this vivid.

He was a maker of piñatas, those hollow figures stuffed with candy, toys, and confetti, that children bat open at fiestas. In the land of dust and rock, he fashioned the stuff of children's dreams and echoed the memories of ripened fantasies filled.

We slept under the stars with sugared visions dancing in our heads.

He offers me the pick of his piñatas. "Any one you like," he says with the sweep of a hand. I'm too stunned at his generosity to decide immediately. We talk and I stare. I finger the curled paper and turn figures from side to side to admire their details.

Carefully he unfolds his cardboard catalog to show me. It's like a Who's Who of Fantasyland. Dozens of cartoon and mythical characters have been cut out of magazines and newspapers. Mickey and Bugs and R2D2 and the Wizard are there. Horses and spaceships and

elephants and hearts, too. Each sample stands an inch or so tall. Each has been carefully pasted on the display and individually numbered. It is his idea book as well as a shopping list for prospective customers.

He starts with a full balloon and lots of patience. The balloon is covered with papier mâché, mixed from flour and water. Large balloons make bodies; smaller ones make heads. A few loops of wire frame and it is hung up to dry. Cardboard boxes form the skeletons of some figures, such as cakes, horses, and stars. The hollows will be filled with treats and confetti.

Then he cuts paper from his prism of crepe and China paper. Hundreds of folds and thousands of cuts. His scissors are thin from incessant sharpenings. Sometimes he gazes into the desert beyond the splinted-leg work table. The hours pass without frantic clock arms. Sometimes he hums to himself as he works.

When the materials are ready and the concept framed, he works rapidly. On a good day he creates five, even six piñatas. On days when the door of the hut shudders in the wind or when he is overstocked and can't find a ride to town to sell his wares, he makes none, choosing to spend the day cutting and curling paper, or walking among the rocks and cactus. Life is like that in the desert. Feast. Famine. Dreams.

His goods are inexpensive. Though paper is dear—every snippet is hoarded for confetti—labor is merely time. And he has nothing if not time. The merchants in town add 50 percent to 100 percent to his modest charge. Sometimes they consign them to street vendors who hawk the menagerie at the San Luis *garita* (border gate) to gawking tourists who never learn the artist's name: Francisco. Don Francisco to those who know him.

Long ago a lady in Mexicali taught him the basics of the craft, and now he adds the flourishes. She also taught him photography,

which may explain his eye for form. Outside, a small white dog barks vociferously at strangers. Though the size of a Chihuahua, she rebuffs strangers like a she-wolf guarding a newborn, but for friends she rolls belly-up to be rubbed. Her name is Rigoletto. Or Regalito. My ear for languages is like an andiron, not a tuning fork.

His single room is a gallery of dreams and celebration. He can scarcely walk inside. There is no radio. No TV. He seldom goes to town, where he could see a movie if he wanted to. His bed has a real mattress on a cot frame. A couple of good chairs he offers to company; he reserves a precarious chair frame bridged with plywood and a pillow for himself. His clothes fit into a suitcase. His supplies, into a cardboard box. And seventeen piñatas hang from the ceiling.

He knows the exhausting ride to town on a clunker bicycle from when he had one. He knows the sting of sweat in blisters from when he pounded iron drills into solid granite. And he knows the flare of greed in a partner's eyes from when they did find a touch of yellow. He knows the pang of family far away.

And he tells stories. He jokes. He has seen and felt much worth telling. His words are light and peaceful. His hands stroke the air with broad insights. He smiles frequently and hungers for the day when he can return to prospecting. But for now he cuts the world of fiestas from colored paper. He reads two Bibles and builds art to be destroyed by giggling kids swinging the bat of celebration.

His is a desert land, but he prowls the backyard barefooted. To walk the road to the truck stop, he slips on his black boots, bought in Los Angeles. We walk over for a meal. He and I sit talking across the lunch table. His dog's name twirls through my meager Spanish. Is it Regalito, Little Gift? Or is it Rigoletto, Verdi's lonely clown?

"Isn't Rigoletto the name of a famous opera?" I ask.

He stops his fork in midstroke and says softly, "Sí, an opera of Enrique Caruso, El Voz. . . ."

How many years does he have left? I don't know how many years he's had. Fifty-five? Sixty? Seventy? I don't ask. But he's old enough to remember El Voz. Whatever his years, they take him back to the time when hand-cranked Victrolas spun the voices and colored bare dreams. Back to those languid Sunday mornings when opera swirled from open doors into narrow streets. He curls China paper and dreams of dynamite in the hole, children's smiles, and the voice of yesterday.

A Man and His Railroad Though it was only February, the sun blazed into the high eighties. The rails bucked and snorted as they expanded. The smell of creosoted ties fouled the air. Bed gravel crunched underfoot. Unshaded, I lounged against the kilometer post and puzzled my next step.

Through the shimmering heat waves down the line to the south, a figure walked dead center up the line toward me. It stopped occasionally and bent to one side and then the other like a dipping stork. I munched a grain bar and swatted gnats.

Time by time I could discern the figure of a man. As heat shimmered off the railbed, the mirage effect made him look like a caricature in a fun house mirror. I wiped the sweat from my brow and laughed at the comedy of it all. Eventually he pulled even with my post. I waved and he, a bit puzzled to see someone here, tilted his head and looked around before waving back. I stood up and walked to the tracks. He was cordial but reserved. His name was José Huerta Vega, and El Doctor, a gandy dancer outpost three miles beyond, was his home.

He carried a yard-long wrench over his shoulder, as a woodsman would an ax. At each rail joint he would stop and tighten the bolts. On his belt he wore a tape measure. Should any rails stray from parallel,

either bowing too close or spreading too far apart, he would measure and report them. He wore a yellow plastic hard hat and sunglasses. His trimmed, pointed beard had long been gray and he was a trifle stooped in the shoulders, but his brown work pants and his long-sleeved plaid shirt were well fitted. For all the world knew, the railroad was his. He was charged with the safety and maintenance of this stretch, and by god the job would be done.

He toted a thread-worn canteen, one of those metal models wrapped in gray cloth. Not seeing my pack, he offered me a drink. He also shouldered a bag. It held a little wad of food in foil, a kerchief, and his signals. He had a red flag for daytime and a fusee flare for nighttime.

He also had a percussion cap, like a big firecracker, which he laid on the rails ahead of soft spots. "This wakes up the lazy engineers and warns them to slow down." From his chuckle I think he enjoyed that signal most. On his belt was a watch in a leather case. When I asked what time the bus passed El Doctor, it wouldn't do just to tell me. He ritually slid the watch from its case, gently buffed its face on the belly of his shirt, and studied it. "The bus comes by at 7:30 or 8:00, but it's usually late," he said scornfully. "It passes again about 2:30." Bus drivers, he implied, don't need such fine watches.

His words were uncommonly trilled and burred. He declined to have a photo taken, which is unusual in these parts, and he launched into an account of some worker who had arrived at work with beer in his canteen. Some sort of commotion or grief had followed, and the ultimate moral of the story was "Don't yield to film."

From his pocket he pulled an especially pretty agate to show me. He had found it this morning. He was pleased when I bragged on it. Also in the pocket were a car key and a house key, a few coins, and a half-dozen pencil stubs. None of the stubs were over three

inches, several were half eraser collar and half lead. My pencil had been sharpened but once and I felt like a rich man. I gave it to him. "A gift?" he asked.

"A gift."

His eyes twinkled and he rolled it between his fingers. "With your permission," he smiled, "I'll give it to the school."

We shook hands and he strode on to the next rail joint on *his* railroad.

José's home in El Doctor is one of those company houses built back in the mid-1940s. But his is the one closest to the water tank. His has the biggest and shadiest eucalyptus trees. His even has a car out front. It's a jalopy, but it runs and shows he has worked hard and long on it.

His wife is a pleasant, gregarious lady. She invited me in, but I declined because my shoes were muddy and she had just swept. She mildly protested that I could enter anyway, but she smiled when I further declined. Two teenage girls appeared from inside to investigate the stranger on their doorstep. The younger daughter goes to school in El Doctor, but the older, a budding fifteen-year-old with flashing eyes, has had enough of education.

Over the door perched the skin of a hawk. It was poised in attack position and looked alive at first glance. A coyote tail hung on the porch post and a pelt—"for a jacket"—dried on the wall. His wife gave me directions to the ancient swamp near El Doctor. It is the one Carl Lumholtz visited in 1910. She added, "And it's full of fish!" What kind? She didn't know, but here on the edge of nowhere were fish in a pool, and she was fascinated.

On the way I stopped at El Doctor Conasupo, nominally a grocery store, but like many in Mexico, it was just a few shelves in some-one's front room. They had no sweet rolls, so I settled for a couple of cellophane-wrapped packs of cookies, the kind that at home would come out of a vending machine.

The clerk, a man of twenty-five, asked "Where you go?" and smiled proudly that he knew a few English words, though I doubt he learned them from passing tourists.

Just as proudly I attempted, *"Voy al pantano."* ("I'm going to the swamp.")

The conversation continued on that "See Spot run" level while he explained that despite being right on the highway to the beach, few tourists ever stop. The store served mainly the workers and their families. It did better when the ejido across the road was founded, but as could be seen from even the fastest moving car, the settlement had foundered. Frames that once supported cardboard skins had been stripped. Tire ruts led to bare spots. At two of the homes, clothes hung on lines, but at the others, even the weeds had wilted.

El Doctor, at kilometer seventy-five on the highway, supported about thirty people total, twelve at the *cuadrilla* (the railroad section-repair camp) and the rest at the store and two ejido casitas. A crew of temporary men had come briefly to re-lay new rails across concrete ties, but they headed to the neon lights at San Luis every weekend, and it is doubtful that they sent home picture postcards from El Doctor. They would soon move along, and their memory of El Doctor would be like a salt stain in a brown work shirt.

El Camino del Juan Enthralled by Daniel T. MacDougal and William Hornaday's 1907 expedition to the Pinacate, I retraced afoot the middle section of their trip, the 240 miles from Sonoyta to the Gulf and back. I wanted to follow those large footprints. West from

Sonoyta along the river, past ranchitos and farms, I merrily wound my way. Sometimes I walked along backcountry roads, sometimes through untilled desert. The sun was pleasantly warm, and quail called from the arroyos.

At the end of the second day, I thought I knew where I was, at least within a few miles, but the scenery had changed from the old pictures. And, the tamarisk trees lining the stream screened the landmarks from view. It was like trying to navigate from the bottom of a ditch.

By the third day, I was into the rhythm of hiking—at least as much of a rhythm as a sixty-pound pack allows. But the details of the old map and their descriptions still didn't quite jibe with the modern view. I wandered through tamarisk thickets, through defunct cotton fields, and down dusty lanes. Finally, at the junction of a cow path, a jeep road, and a set of dim ruts heading westward, I decided to settle the issue. It was time for some shirt-tail navigation. It was time to find out exactly where I was, so I'd know where I'd just been and where I was heading.

MacDougal's group had had two good guides, an American border inspector and a Mexican hunter. I had only me. I let my pack down and set to work. I laid out the modern map, opened the old map next to it, and unholstered my compass. Let's see. If that hill matches this bump on the map then this line may be the. . . .

As I frittered and pondered, a horse and rider approached from a nearby ranch house. He was literally a cow*boy.* The horse was not saddled and its master was a boy of about ten. He greeted me and then intently watched my game. I was looking for the turn where the Old Yuma Trail bends westward from the river, the last reliable water for sixty miles. Once it had been a western freeway. Once it had been a lifeline to the gold rush. Once it had been El Camino del Diablo—the Devil's Highway. Now I wanted to find the exact path worn by those hardy pioneers, some of whom had died days after passing this juncture. This was a matter of serious scholarship, one involving heavy reading and historic tomes kept under lock and key at major universities.

The boy was curious. They evidently don't get too many hikers through here, probably with good reason. He asked my name and town. He sat astride his horse and then, as confident and comfortable as a kid talking on the telephone, sprawled across its back. He identified himself as Juan Alvaro. He had lived out here all of his life. He wasn't in school and seldom got to town. His home had no electricity. Water was carried up from the river in buckets. He'd never seen a compass and didn't grasp the rudiments of map reading.

But he was smart and cordial. And curious. I puzzled and looked. We talked and looked. I eyed the dim westward ruts and in a stroke of desperation chanced to ask, "Juan, what road is this?"

He looked at me with a disdain and incredulity that said, "Are you stupid? Everybody knows that!" After a pause he pointed to the ground and answered, "This is El Camino del Diablo." What else could it be? After meeting Juan, *el vaquero,* the big footprints of the MacDougal expedition were a lot easier to follow. But I'll always think of the devil's trail as El Camino de Juan.

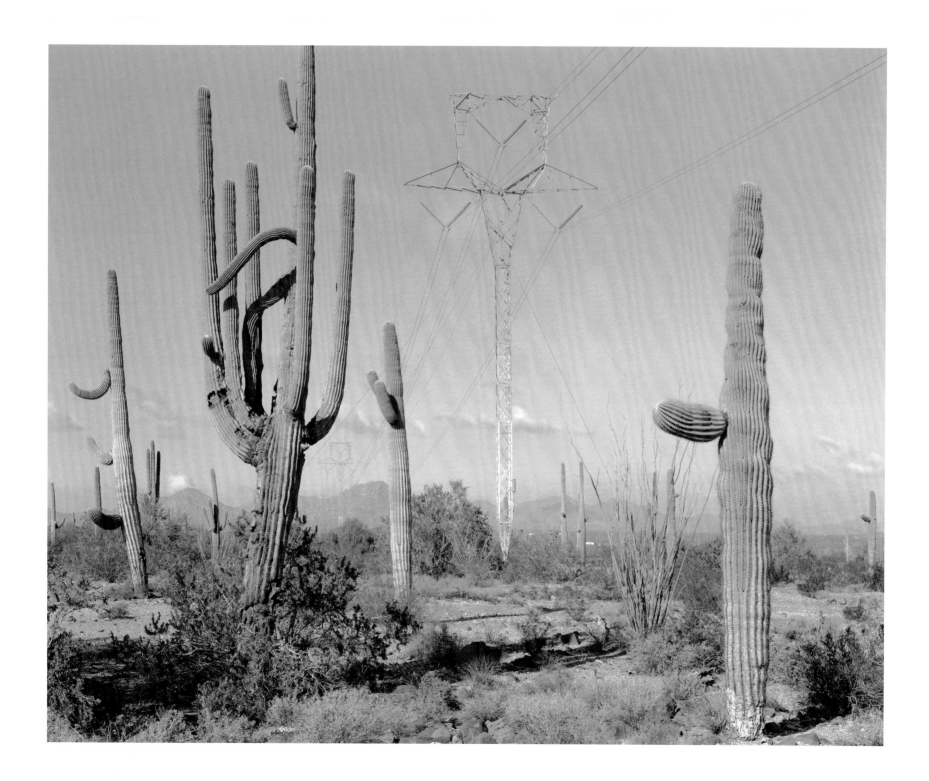

Perils

"Oh do you imagine," said fearer to farer,
"That dusk will delay your path to the pass . . . ?"

W. H. AUDEN, "OH WHERE ARE YOU GOING"

"Men trip not on mountains; they stumble on stones."

HINDUSTANI PROVERB

TO HEAR SOME PEOPLE TELL IT, the desert is a fearsome place, with mishap lurking at every step. Pain, suffering, doom, death—those fates await. How could it kill thee? Let me count the ways. Snakes, spines, falls from cliffs, scorpions, thirst, bandits, lightning, rock slides, exposure, drowning, allergic reaction The list almost rivals our own homes: fire, electrocution, fall in the tub, choking, gas explosion, power tool, murder, lightning, falling tree, asphyxiation, scorpion, rabid dog, drowning, anaphylactic shock. . . .

As a student in graduate school, I usually stayed at the dorm on weekends while my roommates went home to see their families. Once after a late supper I choked on a piece of steak, a common food, rather innocuous. But in those frantic seconds that I couldn't inhale, I might as well have been on the Moon. I was utterly alone and on my own. With what seemed like my last pint of air, I coughed out the meat and took several sweaty minutes to catch my breath. I pulled open the drapes and stared at the shadows of trees lit by the streetlights below. I would have been dead two days before anyone found me—in urban Los Angeles.

The Gran Desierto is filled with many hazards, some objective, some subjective. Some, if we're alert and savvy, we can avoid or control. Some we can't. Some we ourselves create. I wish I could say that I'm brave to hike and camp in the desert. I'm not. I wish I could say that I'm intrepid and invincible, but I'm not. And I know I'm not. Luckily, I don't need to be.

Old mine tunnels fascinate me. They allow glimpses into an area's human and geologic heritage. So when I clambered up the slope to a tunnel in the Lechuguilla Desert along El Camino del Diablo, I expected to kick a few old cans and heft pretty rocks. I caught my breath and surveyed the apron where blues and reds dominated the scattering of ore. Some quartz chunks caught the afternoon sun. The tunnel had spewed considerable rubble, pushed in a handcar along a set of tracks.

A mouth bit straight into the three-foot-wide, vertical quartz vein, but the tunnel wasn't timbered. Pausing a few moments to readjust my eyes to the darkening, I remembered one of my all-time silly capers: while hiking in Sonora, I had come across a similar abandoned claim and had tiptoed inside without a flashlight and without removing my sunglasses. The buzzing of a rattler jolted my folly, and I hastily sounded retreat. This time I doffed sunglasses and flicked on a flashlight before starting in.

Still, the tunnel was dim. My steps were cautious, yet I couldn't help but admire the ceiling. Such colors and sparkles befitted sunlit, stately domes, not the unlit underworld. I can only imagine the delight in the miners' eyes as they poked deeper into the mountain, and the hope in their hearts as they shipped carload after carload off to market.

My next step paused. In reflex to something unknown, I involuntarily gasped and stood alert. That step had put me close enough to dimly make out two, no three, goldish brown lumps on the floor ahead. Wide-eyed, I turned my head for a better, more circumspect look. Yes, they were snakes, and only rattlers in this country had heads and skins like these.

Whether I sixth-sensed them, smelled them, or subliminally saw them, I don't know, but they obviously knew I was there. Although I could only vaguely see the third, the front two lay like coiled garden hoses with their heads lazily pillowed and their eyes looking at me. They didn't stir or rattle. We watched each other for several minutes, several long, studied minutes, before I dared back out of the darkness.

On the apron, I reorganized my emotions; controlled fear counterbalanced curiosity. Being bitten here, alone, three hours' drive from a doctor, would be precarious, but curiosity rebelled and won. This opportunity to photograph couldn't go unused, so I rationalized. Rushing back down the slope and trail to fetch my camera and flash, I hurried and fumbled, half afraid that in my absence they'd slink off to some inaccessible den, half afraid they wouldn't take kindly to becoming film stars.

I remembered other encounters with rattlers. Most of them were peaceable, but once a Mojave in the three-and-a-half- to four-foot range had tried to drive two vehicles and seven sleeping people away from its tree. It aggressively rattled at a distance and then belligerently rattled all the way into and through our camp.

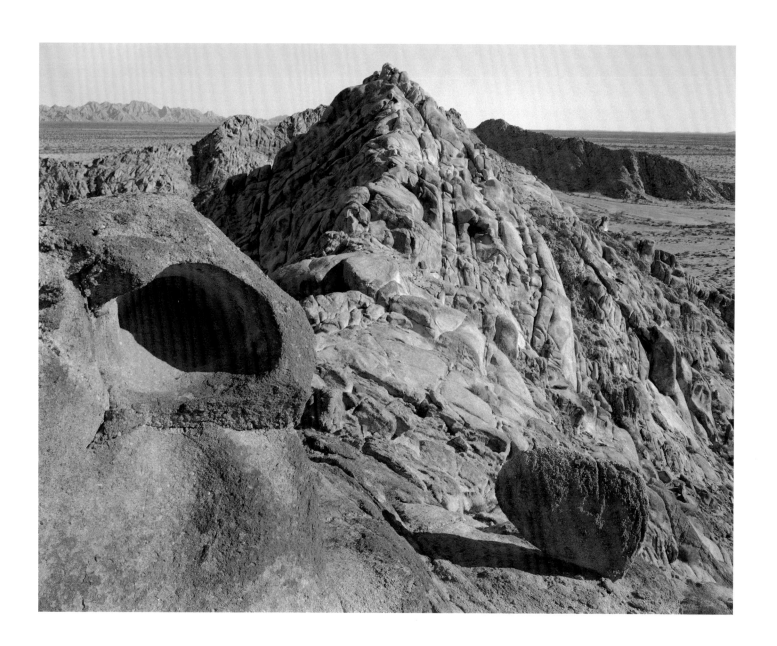

These three hadn't moved in my absence. Cautiously, I set the tripod, focused the camera, and connected the flash. This was the uneasy part: looking through the viewfinder at a rattler. Especially one lit only by a flashlight held between my knees. A couple of flash shots and they didn't move, so I risked sliding closer. First the tripod was eased two feet closer, then a hesitant human shuffled into position behind it. They looked at me and didn't move. The third hadn't moved either. I refocused, adjusted the flash, and shot another frame and then several more before I moved up again. All the while I warily held the flashlight on them and hoped that a fourth didn't lurk unseen nearby.

A knotted towel was my only defense. Should they feel cornered and flee in my direction or attack me, I planned to throw it to distract them while I escaped. Dressed only in running shorts and shoes, I had a second silly thought: I'd somehow be safer if I were wearing socks.

By now the focus ring on the camera said I was shooting from six feet. Warily, I focused and then moved back to click the shutter from arm's length, with the flashlight held unsteadily at the other arm's length. The flash popped. They flinched. I really flinched and stepped backward. But the two coils didn't unwind. With every flash their heads would pop two inches upward and then relax. The film ran out about the time my spurt of adrenaline wore off—and how many exposures and angles can you get, anyway, of two lolling rattlers that won't even budge? So I left. Left to compose and renerve myself. Left them to their peace.

Twice more in the afternoon I returned to check on them. They remained. The area was beautiful, the tunnel fascinating, and the weather pleasant, so I lingered all afternoon. I resolved to revisit my three neighbors to see what they did after sundown.

I'm not really fond of snakes, but opportunities to observe them come seldom; on a recent night hike through the same area, I had seen only one shy rattler in forty-five miles of travel. So at about 8:30 P.M. I returned to the tunnel. Cautious is an understatement for my approach. Measured. Deliberate. Chicken. Yet curiosity wouldn't fade. Slow steps. Sweeps of the flashlight. In front. Then behind. Up the slope. Scan the apron. Plan a retreat route.

Perceptibly alive and keyed, I crept up to the entrance like a tenderfoot through the sticker patch. At first I saw nothing. Then I made out a shape four feet ahead, masked by a sparse windblown bush. One rattler was on its way out, and now for the first time I could discern its namesake black tail.

The snake didn't move. For the longest time neither of us moved. Then it tired of me or the light and silently retreated to a sleepy coil deeper in the tunnel. I saw the third rattler coming toward me. Straight as a broomstick. It stopped every few inches, flicked its tongue, and then continued. The second? I shined my light carefully on every feature and saw nothing. Remember the old joke about "What's worse than biting into an apple and finding a worm?" The answer is "Finding half a worm," but I could now answer, "Expecting three snakes and finding only two."

The third continued. For an animal that can move swiftly and can strike in hundredths of a second, its pace was snail-like. That blacktail took more than ninety minutes to crawl twenty feet to the entrance. Occasionally it would check on a ledge, a rock, or crevice in a model of thoroughness, searching for any warm-blooded animal that had wandered into the mine. And during that span, I must have looked over my shoulder what seemed like a thousand times to check for snake number two.

As it neared the entrance, I chose a rocky seat on a ledge. A scorpion skittered across the rock. The snake seemed reluctant to exit with me there. By now I was hungry and figured it was, too. Perhaps the first snake would also leave if I did, so I returned to camp—cautiously aware of at least one other blacktail already out of the tunnel.

The moon rose, and I ate dinner. I was reluctant to turn in while still wide awake, so I returned to check on my charges. By now I was feeling like a babysitter. My pace near the tunnel was ridiculously slow, remindful of the slowness of the hunting snake itself. But even this pace was too fast. Despite all my caution and all my probing with the light, I came within two steps of stepping on snake number three.

"Whoa," I yelled to it or myself or the gods above. Not a brilliant thing to say when shocked by an earless predator's closeness, but that's what came out. Snakes are deaf but keenly aware of ground vibrations.

It didn't rattle. It didn't poise for a strike. It didn't even slither or coil. It just continued its route, occasionally scenting me with one flick of its black tongue. For another hour it tolerated my following as it hunted. Several times I was close enough to hold the flashlight directly above its head. Once it "yawned" and showed its folded fangs and white mouth.

Under bushes and over rocks it slowly, relentlessly, searched for food—a rabbit, a kangaroo rat, even a bird. Finally it flicked its tongue repeatedly, raised its head above the ground, and looked from side to side. Apparently it had caught the scent of some appetizer. It slithered forward to the edge of a

shallow rocky drainage, about the size of a street curb, and rested its head on an elevated rock. Its straightened body inched forward into an S-loop with the remainder of its body extended straight behind. The trap was set. The hunting posture would allow the snake to strike an unwary rodent wandering down the channel.

We waited. And waited. Nothing. I assumed it would remain poised until daylight or until mealtime. Eventually, I figured my presence wasn't helping its chances, so at 2:30 A.M. I adjourned for some sleep. Long after sunup, I revisited the tunnel to tuck in the "kids." Though I could detect no food bulges, all three lay coiled sleepily as

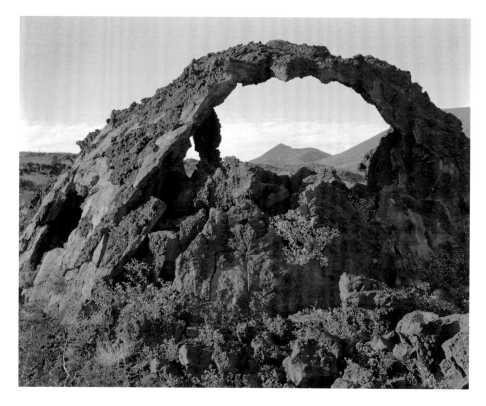

they had yesterday. Despite their sinister reputations and potency, they had treated me and my curiosity more than fairly. I wished them well.

I can remember just about every snake I've seen, not because I have a phenomenal memory, but because there simply aren't many and they are secretive animals. Seeing one is a worthy event. Night is better for snaking, but still few are seen. When I camp I usually take an hour before bedtime to prowl the countryside like a Peeping Tom. Seldom can I find more than ghostly flowers and hopping mice.

Near the southwestern tip of the Sierra Nina, I was hiking by compass through the creosote flats. It was night with no moon, but the stars were bright and my flashlight stayed in my pack. Farther down the bajada toward the dunes, the ocotillos thin and the barrel cactus vanish. I was ambling along, feeling good, and walked close past an ocotillo staff lying on the ground. It was rigid and straight. "That's a funny spot for a dead ocotillo," I thought, so I turned, retraced the four strides to it, and peered through my glasses dimly at this stick.

"You dumb rabbit. That's not ocotillo. That's a dead snake." I set my pack down and unholstered my flashlight, whose dim batteries matched my wits. The snake sure was dead. It moved nary a ripple. "Golly, I wonder how this bull snake died. Maybe a hawk dropped it," I thought, ever the curious pathologist. "I'll take a picture and show the people back home what sort of wildlife I have to wade through on these safari hikes." So I rummaged through my pack for the flashgun, then munched on a candy bar and swigged some lemonade. I had only the regular lens, so I got fairly close: nothing worse than an unfilled frame. I held the flashlight between my knees and fixed on the snake so I could focus. Four times I let rip with that flash at close range. Four

times I stood beside that dead snake while the photoflash recharged itself. Then I moved in for a better shot of the deceased's head.

At closer range I now recognized that my bullsnake wasn't a bullsnake. That triangular head and pit reminded me of a rattler. Even through the faint viewfinder, I could recognize the flick of a tongue. This was a) dead, b) a bullsnake, or c) none of the above. You can lose your leg on this quiz. I squeezed the camera's trigger once more. That's when Lazarus the snake came to life. His tail came up and he motored for all that he was worth toward the nearest creosote bush. He never did rattle. For what must have been five minutes Mister Mojave had tolerated this rube with the flash. That was the only snake I saw in a week of summer hiking in the Gran Desierto.

The next week while driving through the Cabeza Refuge, I chanced to bump into Charles Lowe, herpetologist. I mentioned my "dead" snake. He laughed and said that more often than not they freeze like that when discovered in the open. And more often than not they, as mine did, lived to slither another day. That same night I saw a big snake in the road. It sure looked like a bullsnake, but after my last bumble I took no chances and pulled the truck alongside where I could peer down by leaning out the window. Here was a six thousand-pound truck with sunlike driving lights and a hot engine parked next to a motionless snake. It too was "dead." I shot one photo, but when I pushed open the door, this authentic bullsnake broke for a rodent hole and vanished before my feet hit the ground.

Several summers later I met a Mojave at midday. It strolled along gracefully even after it spied me. It was fat, and when I approached, it flattened itself into the brown fluff grass. The black tongue flicked, though it didn't turn its head toward me. Having a short memory for Mojave ways, I unfolded the camera tripod and circled closer. It lay

still for several shots, but when I got too close it reared and buzzed. Then it slowly looped to a bush and coiled at its base. It watched me and I watched it, until the lack of action bored us both. Real heart-pounding adventure, huh? Most snake encounters are just about that dull. No wonder people are forced to invent all manner of wild hyperbole about snakes. I realized that photos showing menacing snakes reveal only one minute in a snake's otherwise slow-paced day and indict the photographer, who had riled the humble snake into fearing for its life.

Sidewinders skid along sideways until they find a rodent trail and then nestle down into the sand and lie there, half covered with sand, waiting for a midnight snack. The ones in the Gran Desierto are small. Stretched, they may go eighteen or twenty inches; coiled in the sand, they would hold your coffee cup as if they were a saucer. Though I've seen thousands of tracks bearing their distinctive J-marks on roads and dunes, only thrice have I been lucky enough to catch them on open sand where I could gawk at their speed and grace. One zipped across forty yards of loose sand in zero flat and vanished down a rodent hole. The other traipsed blithely along the rise of a dune and slithered into an ephedra bush. We all should be so good at something.

I saw the third when two friends and I strolled up a basalt cone known as The Pyramid. Skirted by drifting sand, it resembles an Egyptian tomb. Near the top, where we planned to lunch and scan the view, we heard a distinctive buzzing. Sure enough, a sidewinder of memorable proportion scowled at us intruders. It coiled and came toward us. It struck repeatedly even though we were ten feet distant. It chased us to the other side of the summit. It climbed over a rock and followed us. I took a few pictures before it declared victory and slid into the shade of a rock. In the photos it looks immense, terrifying,

king cobra sized, the serpent of serpents—except in one pose. I had laid down my sunglasses when the attack began, and the snake had crawled over them. He was maybe half again as long as the frames. The marauder of Pyramid Peak might have stretched to ten inches.

Some of the prettiest snakes I've seen were speckled rattlesnakes. At an abandoned mine tunnel, an August thunderstorm hit and I headed inside to keep dry. Someone had beaten me to the spot. By the adit lay a coiled speckled. I didn't want to stay dry badly enough to argue with it, so I stood in the rain and watched. This was a self-conscious snake who didn't like being watched. Slowly it uncoiled and tried to find a side door. There being none, it looked disgustedly at me as if to say, "Why me?" I played with my camera, torn between keeping it dry and getting a shot. The snake moved slowly and confidently. I thought that I had him cornered where I could watch awhile, for he couldn't scale the walls and I stood at the shoulders to the entrance. Little did I know.

That speckled gave me a lesson in rock climbing. It stretched most of its length up the four foot shoulder of perpendicular rock and balanced on a finger-width ledge. Slowly it inched its body onto the ledge while searching for another. It found a vertical crack with some cross nubs and inched up those. I was transfixed. It found another slim ledge, and then another. Snakes are supposed to lie horizontal. They are *not* supposed to stand vertically against a rock wall like this one was defiantly doing. Within minutes it coiled in a bush above the shoulder looking down, and I imagined it sneering at me. So much for cornering a speckled.

People who use this desert have their own habits. Once I met a group of Mexicans who had come up to Tacna from Highway 2. One of them had a skinned snake body dangling from his bindle. "Why?" I

couldn't resist asking. He looked at me as if I had flunked first grade. "It will make a good poultice for my arthritis."

So far, and I cross my fingers when I say this, I've never been bitten. My day may come. But when I hear that about half of all strikes inject no venom, I worry less. And when I hear that most victims are toying with the snake, I worry still less. Yes, I am careful—I look before stepping over bushes and I don't slide my hand into dark places. Yes, I know that a strike could disable me to the point that I couldn't walk out from some remote spot. Yes, I know that a well-placed bite could throttle me within the hour. But I also know what a treat it is to see one.

Glen Payne worked the Tacna-Wellton sector for the Border Patrol more than two decades. He got all the news. Undocumented immigrants hike by night without lights through this desert. They tumble into bushes every time they hear the patrol plane. They sleep in trees and under shrubs. They oftentimes wear only huaraches or shower shoes. Glen reports finding only one snakebite victim, an old man bitten on his big toe. The toe swelled up the size of a tennis ball, but he kept on walking.

You've got to read the accident reports very closely. It wasn't those bears who troubled Goldilocks. It was broken chairs and intemperate porridge. Wind, not the wolf, brought the two lazy pigs disaster. The wicked witch and her oven could do their dastardly work only after the two city bumpkins, Hansel and Gretel, lost themselves in the wilds. So it is in the desert.

More people succumb to allergic reactions to bee stings than do to the fangs of blood-crazed rattlers. Lightning killed more people in this county last year than any and all of the denizens of doom lurking under every rock ready to pounce on unwary desert travelers. Sunburn levels more tourists than scorpions do. When the casualties of skin cancer are tallied, the sun is the silent killer that never buzzes.

The desert isn't what some rumors and stories make it to be. Compare two cases. A friend, a bright, well-schooled lady from Minnesota, came to visit. We went to the mountains west of Tucson for a picnic. I stopped the car near a picnic table and she looked untrustingly at me and asked, "Is it safe to get out?" Another friend had been a scuba diver since God filled the ocean. She helped found the local diving club and frequently snorkeled alone, despite wearing a pacemaker to keep her heart pumping. Toothy sharks? Vicious eels? Giant stingrays? "I really get excited when I see any of the large predators," she soothes. "They're magnificent! I see them so seldom that they are a real pleasure. Problems? Gosh, no. I've had more problems from the stingers off little plant-like animals named hydroids than I'll ever have from the so-called villains."

Scorpions? Sure, they can and do deliver a memorable sting. Twice I've been slapped at home in my own bed, but not yet in the wild. Gila monsters? A friend was bitten while handling one in front of a group of zoo docents. Bees? A swarm chased me down a hillside when I stumbled past their underground hive, and every year swarms of Africanized bees kill people and pets in the Southwest. Velvet wasps can deliver a very painful sting. Kissing bugs, also called Hualapai tigers or cone-nosed bugs, suck blood from sleeping victims and produce a ferocious swelling and itch. Mosquitoes, centipedes, gnats, tarantula wasps, horseflies, blister beetles—the list is long. One might think the desert is under siege. One might wonder how anyone returns alive from the Gran Desierto. Let 'em keep thinking that way so there'll be more solitude for you, me, and our slender friends.

Oddly, among the most obnoxious, noisome, irritating things in the desert is grass. Grass? Grass. G as in grab your socks. R as in ripe, dried seed. ASS as in burrs in your shorts needling your backside. Giant sandbur, a loathsome vermin with the scientific name of *Cenchrus palmeri,* is the worst of the lot. It forms pea-sized burrs—by the billions. They cover square miles with a minefield of irritating, obnoxious burrs. Since the grass relies on animals to disperse its seed, hikers are fair game, too, and the burrs seek out socks, tennis shoes, and pant cuffs, working themselves into the fabric. If you can imagine a porcupine nuzzling your ankles, you'll have an inkling of how these seeds affect the passing pilgrim. They pierce ground cloths and sleeping bags. Leave your air mattress at home. When the grass is in season you can't find a place to sit down without clearing the ground. They can't be avoided or killed or stared down. They have to be combed out like cholla joints. Even the memory of sandburs pains me.

Cenchrus is not alone. Other grasses hurt, too. Small dried seeds with points and wings like arrowheads detach and catch in socks, shirts, and shorts. The biblical Job wasn't really tested. His list of tribulations didn't include culling a thousand pointy seeds from his robe. The aggravating sharp-stabby-itchy things technically are glumes, lemmas, spikelets, and spinescent burs, and the wholesome seed kernels themselves are caryopses or grains, but when a dog bites I don't stop to ask the details of its mouth and dental structure. If I add up all the hours of turmoil dodging dangers and aggravations, grass tops the list.

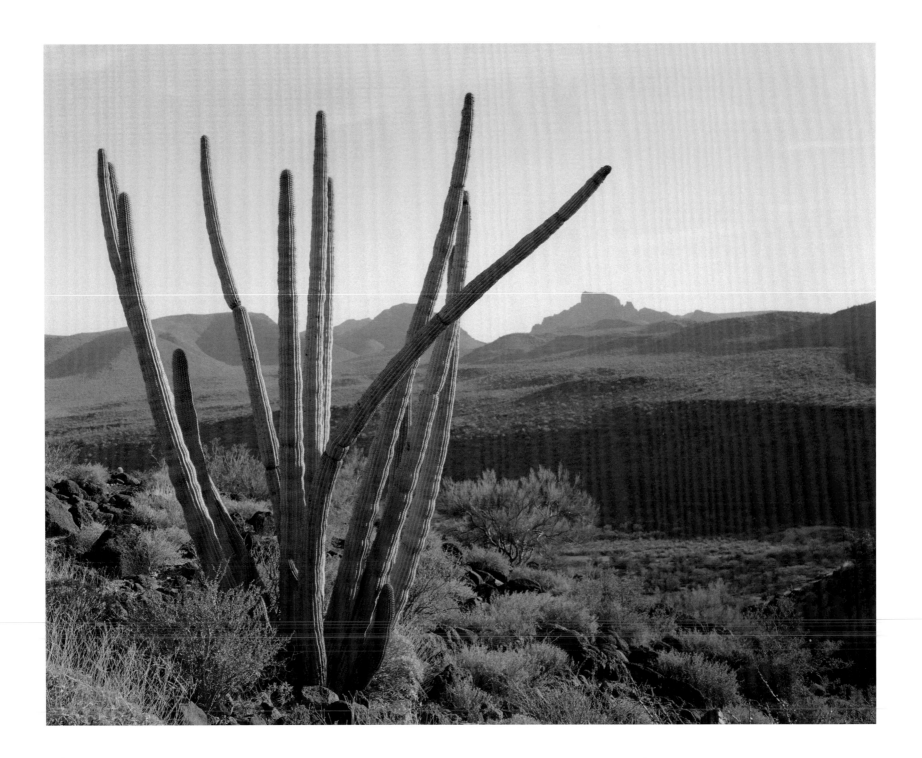

Wonders

Is there not one thing in your life that was worth losing everything for?

el-Raisuli the Magnificent, in *The Wind and the Lion*

What is this life, if full of care,
We have no time to stand and stare?

W. H. Davis, "Leisure"

When I sit on the back porch, or drive the highway, or even sometimes just look out the window, moments flash to mind, a smoldering fire suddenly stirred by a puff of memory. The desert reveals surprises and bestows unexpected pleasures.

One March, hiking from Grijalva Ranch to Pinacate Peak, I had plunged through acre upon acre of orange-flowered mallows, yellow bladderpods, and other flowers. Just ahead, on the northern slope of Sykes Crater, I saw another patch of orange, but it seemed to shimmer, as if moving. As I neared, I began to see that the orange was not flowers but rather was thousands upon thousands of orange and black insects—a swarm of blister beetles eating and mating their way across the hillside. The ground and every bush was covered. They paid me no mind, but I didn't touch any, knowing they exude a very irritating chemical—cantharidin—that raises annoying blisters. After leaving the swarm, I didn't see one more blister beetle the rest of the trip. I've seen similar throngs at Dripping Springs in the Gila Mountains and near Bassarisc Tank in the Cabeza Prieta, but each time I was astounded that so many beautifully colored beetles—orange, yellow, red, black—could explode in one place.

One night in August after a thunderstorm, I pulled the truck to the side of a two-track trail on the eastern edge of Lechuguilla Desert and stepped out to stretch my legs. To make sure I wouldn't step on a sidewinder, I shined my flashlight down and caught a stir of movement. Everywhere! The ground seethed with pencil-length millipedes, fortunately not with snakes. They seemed to be grazing on the minute algae that the rain had revived. The algae is part of the squad of tiny plants, animals, cyanobacteria, and other stuff

that makes up the biological soil crust, sometimes called cryptogamic or cryptobiotic soil. It seemed like millions of them, and I scratched a square yard on the ground. Inside the boundaries I counted, as I best I could since not one of them would hold still, over fifty millipedes and others extended as far as my flashlight beam in any direction except up. Several times during the night I checked on them, as if corroborating a dream. Come morning only a few stragglers remained, searching for narrow holes to reenter the damp ground. A few seemed intent on digging new holes and, like Cinderella trying to get home before the clock strikes midnight, busily flayed away with their "hundred" feet. I've been past this spot perhaps seventy other times and never seen another millipede "bloom," but I have seen blooms several other places, including at an unnamed tinaja in the Buck Mountains. There, several of the millipedes actually walked across the bottom of the pool to reach the other side. Now, when I see an occasional dried exoskeleton of a millipede, I wonder if it was a straggler who didn't quite make it home from an all-night revelry.

Even for May it was hot. I parked the truck off the road and pulled a folding chair out of the back. An immense ironwood beckoned and I sat in its shade. Anything is better than flailing at the glare and heat, so I relaxed with a weighty book and a wet drink. The plot thickened with intensity. I leaned forward in the chair, as if I were at a movie. Eyes pinned to the page, I reached down for my drink and felt only frustration as I clumsily knocked it over. Nothing to do but make another.

"That's strange," I thought when I returned shortly with a full glass. "I didn't notice that green splotch before. What the devil?" Here I am playing jackrabbit by relaxing in the midday shade and a mystery blob is growing beside my very own chair! Vivid green spots appearing before my eyes? I've been out here too long. I've been tipping a bad bottle.

Around the chair stood a few brittlebushes and dried stems of buckwheats. The sand was covered by a gray carpet. My drink was brown. And now the carpet had a green stain. I'm in big trouble with the owner of this house. Gray to green? The book paled in interest. I fell onto my knees and closely examined the spot. "This gray stuff is alive," I said aloud, even though no one was there. And it was. The carpet had come alive!

You won't find the carpet in the flower books with the angiosperms and gymnosperms. Few botanists can even name the carpet strands, let alone identify which is which. You won't find it exhibited at the botanical garden or desert museum. It's much too mundane. You won't find it on file in the herbarium. And yet once you start looking, you'll realize that the carpet covers more ground than anything. It has a wider range than even creosote bush or bursage, but few people notice it.

The green spot is a miracle. Although it's too simple to interest most observers, it's actually a complicated group of apparent simpletons. It is algae, fungus, and lichen, the "microflora," as some people call them. They are the beatitudes of meek plants, and it seems they have already inherited the earth.

They grow on the soil or sand surface. They grow on rocks. They even may grow on the surface of other plants, though they aren't parasitic. They grow where other plants can't. They are the first plants to grab a foothold, whether in the cleft of a freshly broken rock, or on the edge of a salt flat. When the seasons turn hot and dry, they shift to low gear. Their photosynthesis stops. They turn gray or brown. They dry out. They may lie dormant for years. But let there be rain—or spilled drinks—and boom! They're back in business pronto. In one

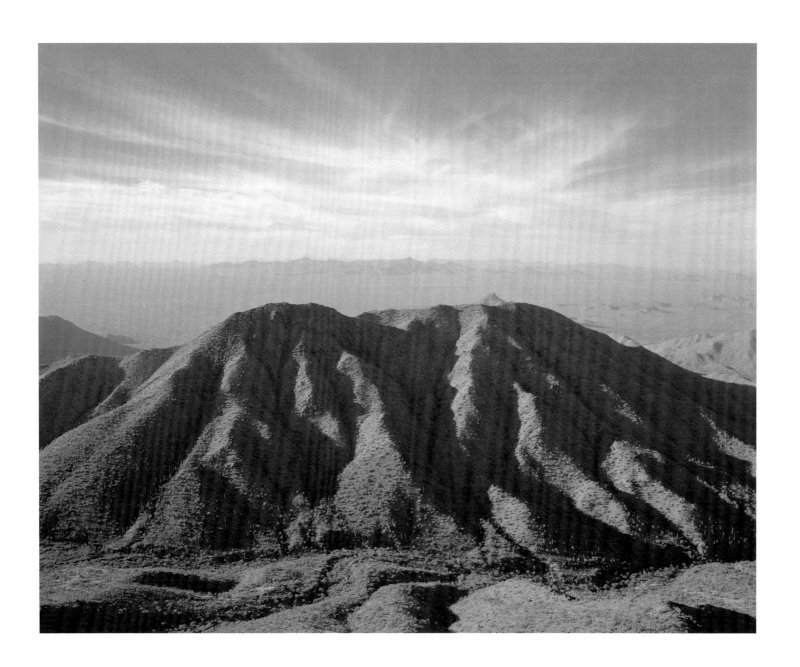

study a clump of lichen absorbed over 50 percent of its weight in water in ten minutes. Its photosynthesis went from dead stop to almost full speed in ten minutes! That's like a grizzly bear racing out of hibernation at twenty-five miles an hour. After rains or even winter dews the desert is carpeted with green. Even in summer active microflora can sometimes be found on the shaded banks of smaller arroyos and under hunks of quartz. The rock seals in enough soil moisture to permit photosynthesis, shelters the lichen from the most intense heat, and yet, because quartz is translucent, it lets pass enough light to keep the party going.

From what I can pick up with questions here and there, the lichen crust is of crucial importance. It holds the soil so other plants can get a start. It curtails erosion, both from the impact of raindrops and from sheet flooding. It holds the soil from wind erosion. Because it is a roughened surface, it slows runoff, encouraging the rainwater to percolate into the soil. Then it shields that moisture from the sun, moisture needed by other plants. By its physical growth and chemical processes, it is the first contractor in soil construction. It breaks down rocks and minerals as if bringing food from the grocery store.

The crust frequently grows in mats. And like the human skin, it's thin, maybe a single centimeter thick. And like skin, it's an essential organ. It may not be showy, but the desert would look mighty peculiar without its crust. Just as we'd need more than cosmetics and clothes to make up for being flayed alive, it's safe to say that without these lichens, the desert really would be the barren place many people imagine it to be.

Though durable on the anvil of climate, these plants are fragile under the hammer of rubber tires. One pass by a speeding motorcycle or dune buggy can pulverize and flay in an instant what sun and drought haven't intimidated in millennia. That pass slashes like razor cuts. The soil bleeds, erodes, and may literally require centuries to heal. We don't have any plastic surgeons who can do quickie face-lifts on the desert's slow-healing wounds. Repeated rips by Georgie Patton's tanks show scant improvement since 1943. Field biologists estimate that two hundred to three hundred years will be needed for the scars to disappear and the plants to be fully functional again. Both dust and rain erosion continue to increase where careless drivers have played.

Dudes in Tokyo and Berlin recognize saguaros, but the soil carpet doesn't catch anyone's eye on the travel poster. You've got be here. Sometimes you've got to spill your drink and get down on your hands and knees.

As much as I like walking, I like resting more—lying on my back, head on my pack, and looking at the kaleidoscope of clouds and sky. One afternoon on a stroll near Eagle Tank, I lay on a cool slab of granite and watched an easterly wind herd the clouds westward. In the distance, U.S. Air Force fighter planes were strafing and bombing practice targets on Range One. I paid little attention until one explosion sounded far louder than the rest. I flinched and looked in that direction. A ripple, presumably the explosion's shockwave, moved through the clouds, as if the wake of some unseen boat sailed the waters. Another time a jet, probably an F-14, roared close overhead on a very humid, cloudy morning. As the plane plunged through the mist, vapor swirled off its wingtips and broke the morning sun into a million tiny rainbows.

In Native American fables the badger and the coyote hunt together. The coyote can chase prey into thickets or holes, but the badger can

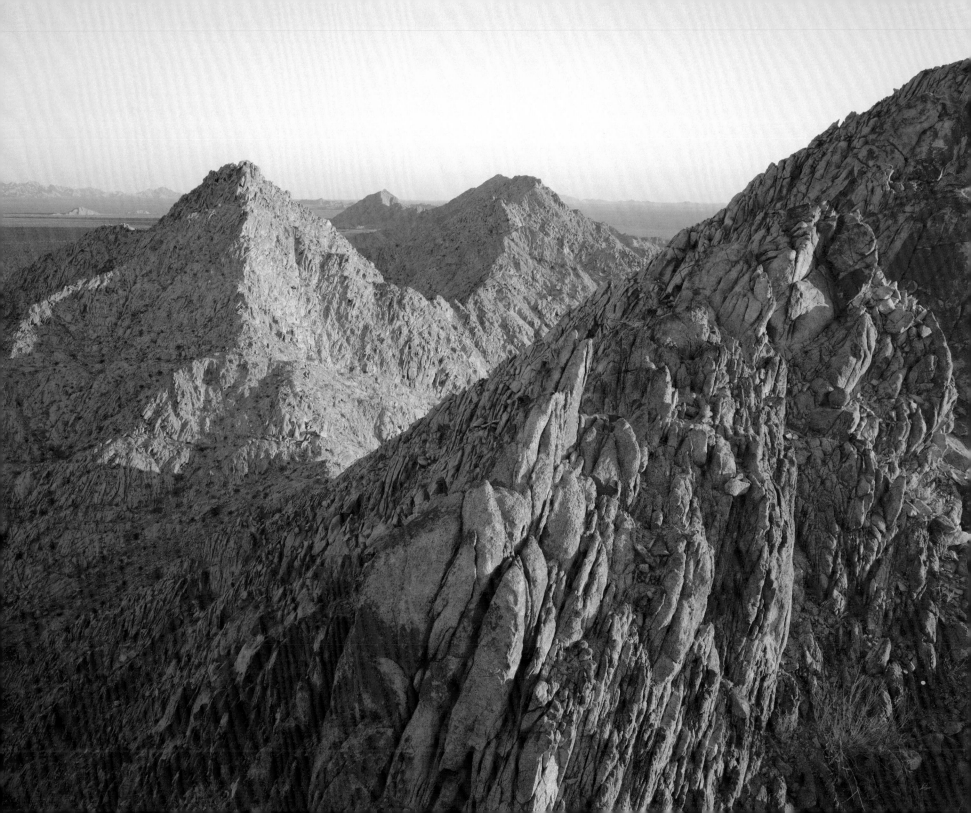

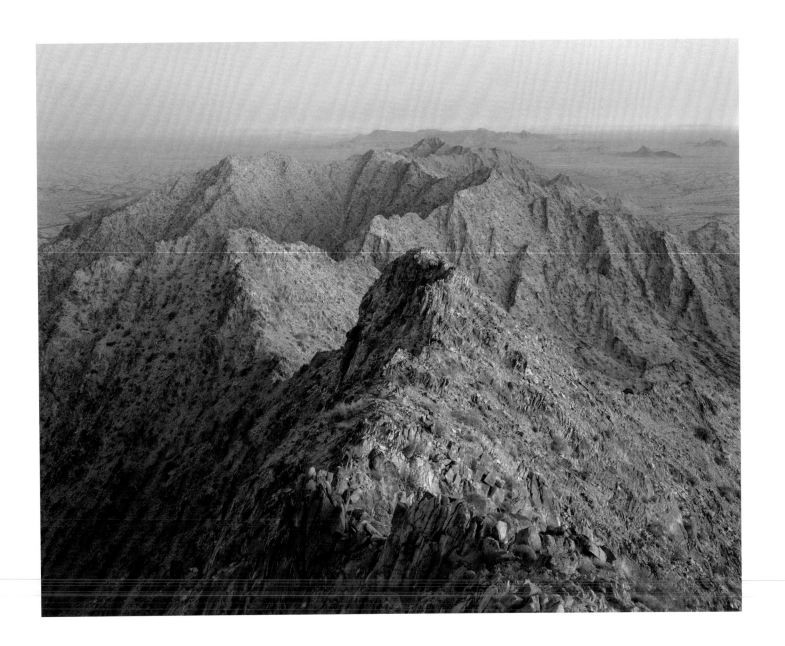

unearth the hole or penetrate the dense shrubbery. Between them, they can "worry" or move rodents, birds, snakes, and lizards into the open, where the prey can be caught. "Bunk" was my reaction when first I heard the tale. Then Julian Hayden wrote about seeing the coyote and badger hunting together. Still, I disbelieved. One morning as I was checking rain gauges in the Cabeza Prieta Mountains, I saw a covey of quail flush from a paloverde tree along a wash. Fur flashed and an animated coyote pranced at the base of the tree, much as if it had treed a cat. On the other side of the tree, a high-strung badger paced back and forth, maybe twenty feet from the coyote. At first I thought one was attacking the other, but neither was barking or whatever badgers do. As I watched them, they watched something in the tree, though I couldn't see what it was. They operated as one would expect a pack of dogs to surround some hapless animal. This went on for several minutes. The badger and the coyote each circled the tree several times while staying opposite the other, apparently to block the escape of their quarry. Eventually they either lost the opportunity or grew aware of me, for as if on signal, each turned and went its own way. Julian and the fables were right.

Bighorn sheep are majestic animals of the rough mountains. They clamor over rocky slopes where I would ask for a rope and belay. They stand aloof and peer down on lowly humans below. My own hunts to find them in the rugged canyons and ridges are usually futile. Locating one or two animals in a square mile can be vexing. But they can find me. A number of times I have walked a canyon bottom only to look up and see a bighorn on the ridgetop looking down on me. From that vantage they can spot any movement below and hear our clumsy footsteps.

One August I had been monitoring Tule Tank in the Cabeza Prieta Mountains. It held some summer rain, and though I had seen bighorn tracks, I had not seen any actual animals in the previous month. U.S. Fish and Wildlife Service, the agency that manages the land, hosted a get-together at Tule Well with neighboring officials, including some military officers. I served as a gofer and before dinner was asked to take a few of the people who hadn't wilted in the heat over to Tule Tank. I led the squad up the canyon and talked about the human history of the tank and pointed out interesting plants. As we neared the tinaja, I mentioned to the senior officer that bighorns used this tank and if we kept our eyes open we might see one. Without a pause in the conversation, he said, "Like those over there?" Sure enough, two ewes stood on the hillside looking at us.

And when I took Ed Severson to Mohawk Tank, we climbed up the narrow canyon, and just before we stepped out in the open valley above the defile, I whispered, "Ed, go first. There's a chance you'll see a sheep." Seconds after he turned the corner, I heard the clatter of bighorn hooves on the rocks above. He had seen the sheep, as if they had been waiting there on display.

But I didn't see two of my favorite bighorns, as least not well, because my glasses were off. While doing a summer sheep count at North Pinta Tank, I camped at a secluded spot out of sight of the waterhole. After I had been in the blind from before sunrise to well after sunset, the cot felt good and I quickly fell asleep. The moon was full and the air still, warm enough to sleep without a blanket. After midnight I heard footsteps. The nearest other person counting sheep was ten miles away, so I listened more intently. This walker snorted, then coughed, and kept coming. I froze and tried to see who was coming. I didn't dare reach for my glasses for fear of startling someone.

I couldn't see a flashlight and didn't hear voices. A form suddenly appeared from behind a cluster of rocks and walked straight toward me. A short fellow, I thought. A few paces from my cot, he stopped and tilted his head, which had a heavy rack of horns. The bighorn ram was puzzled at this oaf reclining in his path. He stepped forward and bumped the foot of the cot with his chest. He tilted his head from side to side, coughed, and sneezed on my bare legs. He bumped again. I lay still, wishing all the while that I could see him clearly. He continued on to the tank, and I could hear him there the rest of the night. In the morning I crept to the blind and glimpsed him on the ridge above it. Later in the day, he moved over the ridge. Six weeks later I found a dead ram in a wind cave half a mile north of the tank, and I've always wondered if it was my curious friend.

At Tinajas Altas, I camped out of sight of the tanks and set up my cot. The granite cliffs radiated intense heat, so I couldn't fall asleep until well after midnight. In my dream I felt a bump, and then another. As I struggled to wake up, I was aware of breathing, like someone standing at the foot of your bed but saying nothing. My mind raced. Bandits would have yelled or shot me by now, but I didn't have any sense of who was breathing. I opened one eye and then the other. A kindly face with two short horns peered at me quizzically, much like a mother looking at a kid who fell back to sleep on a school day. She snorted and walked off a short distance. I slowly fumbled for my glasses and camera. She stood fifty feet away and looked at me, and then returned my way. I got one picture before startling her. She walked past my cot, keeping her distance, and put her head down as she trudged up the mountain slope. Only then did I notice the herd of eight other sheep watching the whole show. They watched me for a while and then grew bored and left. Their tracks as well as hers walked close by my cot. She must have been the last in line and stopped to rebuke this late sleeper. My revised theory of scouting for bighorns is "let them find me."

I had walked from Ajo across the Cabeza Prieta Refuge. It was cold and windy. On the map the last couple of miles before Buck Mountain Tank had looked easy, but they turned out to be very rough terrain, especially on tired legs in the dark. It was well after midnight before I reached the tank where I could replenish my water. The tank, back in a tunnel, would have been hard to find if I hadn't been there before. The water was cool, but a number of mosquito and fly larvae wiggled in the water. I dipped out four quarts anyway. From my pack I pulled my little stove, a cup, and my last bag of Earl Gray tea. In the bottom of the wash I huddled behind a rock and boiled water. The ritual of dunking the tea bag and stirring the sugar cubes buoyed my spirits. I smiled at how good one cup of tea could taste, breaking the chill and filling the world with flavor. With water in my pack and warm tea in my belly, I walked westward another five hours into the night.

A little water goes a long way toward reviving a weary body in summer too. Especially on the hottest days, a quart of water can make the difference between sleeping well or tossing restlessly all night. After the sun drops and the sleeping bag is rolled out on the ground or cot, many experienced desert rats engage in a bit of ritual that provides one of any traveler's most pleasant memories. As for me, I slop a handful of water on my head, rub in a few drops of shampoo, and wash as far down as the lather goes. A couple more handfuls rinse the soap, and then the wet washcloth is used not to towel down but to wipe away the grime and perspiration salt. If a bit remains in the jug, the

crowning glory is to drain it over my head in one final rage of exuber-
ance. After being battered by a day of heat, the body feels suddenly
revived, as if the air temperature has plummeted thirty degrees. With
the slightest breeze at all, the rest of the night feels idyllic. If water
is scarce, a wipe-down with a half pint of water on a bit of cloth can
accomplish nearly the same feeling.

Funny, but seldom do memories of hard times cross my mind.
The blisters, the sweat, the aching shoulders, the chafes and scrapes,
the boredom, the daunting distance between the
start and the peak, the mosquito bites, and utter
weariness: all remind me of my own frailty. How-
ever bad it is today, there's been worse. The yard-
stick of memory says, "This isn't so bad. Cheer up.
Remember when the canoe flipped at Morelos Dam
and you thought you and Chuck might drown?
When you had only two quarts of water with forty-
five miles to walk to Riito? When your blisters had
blisters and you took four aspirins an hour to kill
the pain so you could walk?" No matter.

We enjoy being here. We don't come to the
desert to die—that's senseless suicide. We don't
come to suffer—that's misplaced masochism.
We love being here *despite* the heat and the fangs
and the blisters. Out here, even the perils become
wonders.

Hawk

None of it is important or all of it is.

JOHN STEINBECK, *THE LOG FROM THE SEA OF CORTEZ*

THOSE BROWN EYES still burn through me. Those eyes couldn't comprehend this predicament, couldn't tolerate the furies that buzzed but didn't sting, couldn't fathom a solution. On a cartoon this might have been funny: the noble red-tailed hawk grounded in a hole, being teased by lowborn bees. But, this bird was not amused.

Sometimes water is not salvation. Sheer sides of a tinaja occasionally combine with low water level to entrap wildlife. In 1925 Kirk Bryan reported bighorn sheep perishing in this same waterhole. The hawk was in a fix, unable to swim like a duck, climb like a woodpecker, or fly vertically like a hummingbird.

In July I had been climbing the granite apron at Tinajas Altas when the shriek of a hawk not ten feet above my head had startled me. I was surprised that it didn't fly when I approached. A hawk poised on the granite cliffs wasn't new, but that it was close and didn't flee was. I was checking water levels in each of four lower pools and had just finished measuring the third tinaja when I heard splashing noises coming from the pool above. I couldn't see the fourth yet, since it required a climb up a steep, sometimes slippery, ramp and then a tiptoe around an enormous chockstone boulder. Then I heard more rustling. I couldn't figure it out. A hummingbird flew past and a pair of ravens squawked overhead.

Nearing the pool I heard the rustle of feathers. I peeked over the lip and saw a drenched hawk standing on an end table–sized sandbar surrounded on three sides by murky water. The sheer sides of the pothole plunged five or six feet to the water. The pit was eight or so feet in diameter. The hawk glowered and swiveled its head. I doubted that it was happy to see me. Thousands of bees drank at the water's edge and buzzed like furies. The hawk shuffled its feet to discourage the bees from crawling up its legs. Redtails usually perch atop stately saguaros or tall ironwood trees, and soar over ridges, riding thermals and scanning the ground far below. Imagine this hawk's ignominy of sharing a roost with mere bees, the

bird of flight, power, and pride grounded in a hole tormented by mere bees that by one aeronautical calculation are not supposed to fly.

This was all places a hawk never wants to be. Its lateral vision was reduced to a few feet, and it wasn't just grounded: it was in a flooded hole, with no angle for takeoff, and surrounded by an endless stream of noisy, pestiferous bees. Repeatedly the hawk tried to fly but crashed into the wall below the lip, used its powerful wings to swim back to the bar, and then dried them for another try. I don't know how many attempts it had made, but it was tiring. The other hawk still perched on a ledge above the tank, occasionally shrieking.

At first I thought it could make its own way out—after all, when was the last time I'd heard of a hawk drowning? Never. It was a preposterous notion, though I had heard of a hawk being hit by a Marine Corps Harrier jet fighter plane in this area, killing both the hawk and the plane. Redtail feathers reportedly were pulled from the helmet of the pilot, who safely ejected near Las Playas.

The hawk paid little attention to me. Maybe it wanted to concentrate on one problem at a time, realizing that by flying it would escape me too. It made no vocal sounds. I left him to his own skill. Dressed in a T-shirt and shorts, with no gloves, I was not ready to slide into the pool and face its flailing talons and ripping beak.

But I decided to try. Back in the truck I had an extendible pole for a saw used to trim trees. I hiked back down to get it, as well as gloves and, as last resort, a towel to wrap the bird in and lift it out of the hole. When I returned, the hawk was still on the bar drying out after another futile try at flying. It gave me a suspicious look but still made no cry. I eased to the lip of the pool. None of this was easy for me either—it would be a shattering fall onto the rocks below. My grandmother talked to her chickens and said it never hurts to talk to animals, so I spoke to the hawk and it stayed settled. I asked it about

its family and told it what I planned to do. An observer would have thought I was an idiot, but the hawk didn't seem to mind.

Carefully I lifted the pole, swung it to the lip, and slowly eased its tip across the pool. The hawk eyed it. I expected the bird to peck at the pole when the tip eased into sand at its feet. The hawk didn't. Nor did it hop away nor, worse yet, frantically try to fly. Very slowly I slid the pole into the sand under the bird's feet, hoping it would get the idea. The hawk tilted its head from side to side. It hesitated. The pole was about six feet long, so if I had extended my arm and the hawk had extended a wing, we would have touched feather to finger. Finally, the hawk clutched the pole with one claw and then the other, as I ever so slowly raised both pole and bird. The hawk probably weighed a couple of pounds, but I had little leverage, so it felt much heavier.

The bird moved its wings to balance on this new perch. I feared it would jump back into pool rather than face a human nose to beak, but it didn't. In what seemed like hours but must have been only a fraction of a minute, I lifted the pole as slowly as I could and set the tip atop the pool's rock lip.

There we sat: an exhausted, wet bird and a sweating human too cautious to move. We sat for a good quarter hour as the merciless July sun beat down on us. Never did its eyes leave me. Eventually it fluffed its feathers, drying each wing at such tilted angles that I first thought one was broken. Then it preened a bit. It showed no signs of fear. The other hawk had ceased shrieking but still stood vigilant, looking down on us.

Finally, the hawk stretched its wings, looked behind at the pool, and with few flaps disappeared down the canyon. It never uttered a sound. I was deeply relieved.

When I returned to the tinaja two weeks later, three redtail carcasses floated on its scummy surface.

Glenton Sykes

HE TREATS IT like the family heirloom it is. After all, how many sons have a wondrous extinct volcano named after their father? It may be the finest of the ten major craters in the Pinacate Biosphere Reserve of northwestern Sonora. His father, Godfrey, explored it in 1907 while on a Carnegie Desert Laboratory expedition to the region. He carried a barometer down its steep slopes to plumb its depth. He paced its rim to measure its diameter. Daniel T. MacDougal named it Sykes Crater in Godfrey's honor on a popular map published in William T. Hornaday's *Camp-Fires on Desert and Lava.* Glenton was eleven years old then.

And Glenton, at eighty-eight, returns to see how his family's crater is doing. His father visited the area only once. Yet the map he drew for that trip is as good as any. Glenton has visited fifteen or twenty times by his recollection, though he's lost actual count. He uses a walking stick now, partly to balance himself but mostly as a pointer and a probe. He waves it to the south and says, "See Papago Tanks over there. That's where I've camped many times. I wonder how it will look a million years from now. Probably better than we will. One thing I admire about this area is its extreme youthfulness. All the tests on this lava indicate recent times, just yesterday afternoon, geologically speaking."

He also wields a pair of slip-joint pliers. The camper has pulled loose from its shackles on the wracking Pinacate roads. The truck, a staunch Ford F-250 four-by-four, seems to

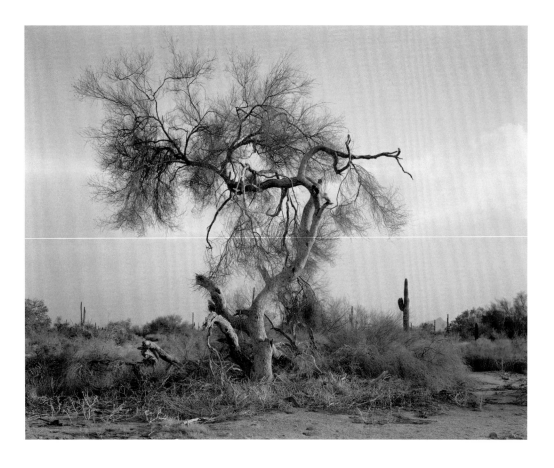

zig when the camper wants to zag. The turnbuckles work loose and Glenton, former city engineer for Tucson, lends a hand—and pliers—to retighten the turnbuckles and wires. On the steep slopes of the crater, he uses the pliers to extract the cursed cholla, which antagonizes even the most peaceable of desert hikers. When the morning cold stiffens his legs and he rolls out of his bedroll, he uses the pliers to reach down and pull on his shoes.

He wears a yellow ball cap and rides shotgun in the front seat. He looks ahead and asks rhetorically, "Is that Phillips Butte? I think it is. Yes. Down by Moon Crater I named Hawk Butte on a trip with Tad Nichols and Dr. Peirce, the geologist. It had a big red-tail hawk nest near the top. And the name Moon Crater stuck, too. When? Oh gosh, I don't know. I've committed all kinds of indiscretions, but I can't remember when that was. I called it 'moon' because of that central hill.

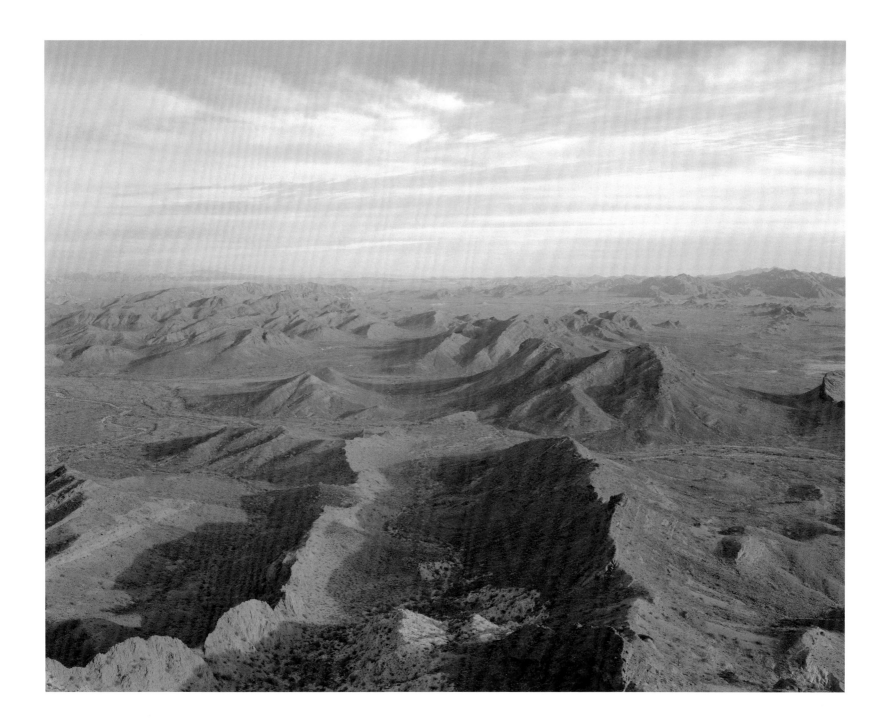

It's got a central hill in it, which is a lunar feature. Dr. Peirce was with me and he says 'that's a good idea.' Do you know that many-headed barrel cactus at the crater?"

He continues, "No, my father never brought me down here. I don't think they ever came back after the Pinacate trip. My father didn't. My first trip, I forget, was before 1958. Of course, my brother, Gilbert, and George Chambers were in here in about 1924 or '25 in a Model-T car with four or five young people. Gilbert said when the car wouldn't pull they'd just push it. I met Phillips in the early 1920s. I didn't know Hornaday. I knew MacDougal, of course, but he was not too easy a man to work for. He'd had a lot of misfortune. Phillips Butte is an awful walk up there. Phillips was a rich man: steel, banks. He partly financed the expedition. He and Hornaday had been together before on a trip to the Canadian Rockies. Elegante Crater is the better sight, but some people like this one [Sykes] best."

His father posed for a photo standing on his head atop Pinacate Peak. "I've always regretted my father being in such an undignified position, but he did it in deference to the Pinacate beetle. My father said, 'It stands on his head when disturbed, and it's my opinion that we had disturbed this peak and him. So this is my salute to the Pinacate beetle.' I never stood on my head up there. I couldn't. But the old man could. How he did it after climbing up that doggoned peak I don't know. He must have been a younger man than I am.

"My father liked to walk, but he knew how to use a horse. When he packed that bighorn down Phillips Butte through the cholla forest, he packed it on a horse. 'Best view of the country is between a horse's ears,' he said. He did very well with motor cars, too.

"I meant to bring my aneroid barometer so somebody could take it to the bottom of the crater. No, let's not go home and get it; we'll do it on the next trip. I've had it in there. It's the one my father took on the expedition and carried to the top of the peak south of Sonoyta and across to the dunes to the shore. It's about right, within twenty-five feet maybe.

"Yes, I've had some good trips down here. There aren't any field notes. They're all in my head. I'm too lazy to keep a diary, and I'm not neat enough or orderly, but I did a little write-up in my papers. Anthony, DuBois, Shoemaker, Damon, Lance: they do the writing. They're the Ph.D.s."

During one trip to the Pinacate with his family and grandchildren, Glenton and the group drove to the rim of Elegante Crater, but he doubted he could make the steep descent to the crater's bottom, so they left him on top with a lawn chair and a beer. When they returned, Glenton was chatting with a group of college students on a field trip. He told them, "Some people say there are no fossils in the Pinacates, but I am living proof that some old fossils are indeed here."

On the jeep road to the crater, we meet three people riding mountain bicycles. "I admire their spirit," Glenton says offhandedly, "but I don't think I'd like to try that now. That looks like fun, but I hope they don't hurt themselves. They could lose some skin I would suspect."

He no longer drives, and his last pickup truck was only two-wheel drive. His wife, Anna, had told him, "If you need a four-wheel-drive truck, it's a pretty good indication that you shouldn't be there anyhow." He went some pretty difficult places in that pickup. "I did pretty well in my truck. It had positraction and compound low. Worst thing that ever happened to me, they sheared me of my driver's license—it was worse than that damn stroke."

We stumble onto a delivery truck hastily hidden in the trees at Papago Tanks, twelve miles from paved road. Tracks of at least four other vehicles swirl the arroyo sand. Two men who call themselves "policía" watch us from the shadows, their eyes hidden by slouched

hats, their lips pursed with seriousness. One dangles an automatic rifle behind his right leg; the other has a pistol-shaped bulge at his waistline. They order us away. We cannot camp at a spot that for millennia has served as a traveler's oasis. Glenton speaks for all of us who suspect they carry a load of smuggled drugs when he remarks, "They said something about looking for rustlers, but I certainly hope they don't try to carry cattle in that airtight truck."

Glenton's father and mother were from England, but she had died when the boys were young, so Godfrey was raising them on his own in a tent where he was building a house on the side of Tumamoc Hill, near St. Mary's Hospital in Tucson. While his father explored the Pinacate, Glenton and his brother Gilbert ostensibly were being cared for by the sisters at the hospital, but they were independent lads who rode their one horse to town, played in the irrigation ditches, and fed themselves. Glenton grew self-reliant and observant. In his travels he measured the heights of boojum trees and the temperature of the warm springs near Puerto Libertad. On one trip he and the guys stood around watching a rancher windlass a water bucket out of his well. Later someone wondered how deep the well was. Glenton said, "Eighty-five feet." They thought he was pulling a number out of thin air. "Well, it's eighty-five," he contended, not really caring whether they believed him or not. "I counted the number of turns and multiplied by the circumference of the windlass."

The subjects riffle like wind-blown pages. Flow cycles of the Colorado River. The strange rock-work at Cipriano's dam. Prehistoric human sleeping circles that Sykes calls "Hayden's bedrooms," in deference to his long-time friend Julian Hayden, dean of Pinacate archaeologists. When someone mentions boojum trees, he reminds us that he was with his father when Godfrey coined the name. He recites "The Hunting of the Snark," the Lewis Carroll poem that lent the name boojum. "How do I remember all this junk, do you know? Like I said to my doctor last week, do you think age has anything to do with this? He looked at me and said, 'I just hope you remember to come see me in two weeks.'"

When was he happiest? "Darned if I know. I know it wasn't in the army. Oh, I guess taking the family to the coast. And Roswell, New Mexico, taking the girls out on the bottomless lakes and all that. I enjoyed the university. I really enjoyed the city engineer's job."

Glenton is being looked after by an adoring group of much younger women. He thrives on their attention. "Never lose your wife. Die first. It's a much better arrangement. Now I've got my 'daughters' here to look after. Can I help you ladies carry anything back?"

In the 1920s his father had established a string of rain gauges on the dirt road to Puerto Libertad and along El Camino del Diablo. Godfrey usually drove alone to read the gauges, and on one summer trip he got badly stuck in sand. In trying to dig himself free, he lapsed into heat exhaustion and collapsed in the shade of his vehicle until he recovered. We stop our caravan along the road for lunch. When we start to reload people and gear, someone says, "Where's Glenton?" We look and don't see him. We fear he's wandered off somewhere and gotten lost. We'd forever be known as the group that lost a legend. Before we could mount a full-out search, someone hears snoring from under one of the trucks. It's Glenton who, having tired, crawled under the vehicle, as his father had, for shade and rest.

At evening dinner around a campfire, someone offers him cognac. "I won't say 'no.' My father drank only water. I see why the British sailed around the Horn so much—they got a ration of rum. I bet the Hornaday Expedition loaded up on booze in Sonoyta or Santo Domingo on their way to the Pinacate."

When the skies blacken and the stars come out, Glenton reports, "I thought I saw the Pleiades a few minutes ago. I still have father's telescope. One occasion I was looking out from Tumamoc Hill, there in Tucson, and looked toward my homestead, where I was building a house. I saw some fellow stealing my lumber. That was a good article in *Sky and Telescope*. I should write them a letter on the abbreviation PL being doubly appropriate for Pluto since they're also the initials for Percival Lowell, who discovered it."

He looks into the coals of the campfire. "As a child I rather liked books of some of those early voyages, like *Two Years before the Mast*. Later my wife picked out what I was supposed to read. She was a great reader. She taught English with Alice Vail. I guess I wasted a lot of time reading that scientific stuff, *Scientific American, Sky and Telescope*. That's why I went into civil engineering. And, I'm too lazy to write a book. I can't type, and now I can't write. Years ago I wrote up a bunch of these off-breed yarns." The yarns covered his trip down the Santa Cruz River in a rowboat during one flood, his walk across the Colorado River mudflats to Port Isabel, and his part in the 1923 eclipse expedition to Libertad with his father and astronomer A. E. Douglass.

One of his early jobs, in 1923, was monitoring the flow of the Colorado River for the U.S. Geological Survey at Phantom Ranch in the Grand Canyon. "I was building a little boat for myself down there. I got so enthusiastic that I could hardly wait for daylight. I worked on the beach just below the swinging bridge. One afternoon I was just about to finish when to my utter surprise I heard a woman's voice. I had thought I was quite alone. I turned around and there sat a smallish woman on a gray boulder, and she slid to the ground. 'You must pardon me, but I've just had the pleasure of observing a young man beautifully lost in his task (and she said *taahsk*). I am Edna St.

Vincent Millay. Will you join me for dinner at the ranch (and she did say *raahnch*).' I regained my equilibrium by then, and I said, 'Madame, I'd be delighted.' She said, 'I'll see you at six.' And I was prompt." He looks at the fire and without prompting recites one of her poems, his favorite.

> "My candle burns at both ends;
> It will not last the night;
> But ah, my foes, and oh, my friends—
> It gives a lovely light!"

Some in the group unfold their cots and spread their sleeping bags. Glenton muses, "They were doing some surveying by helicopter up by Bates Well and found a cairn with a note in it with the initials BW. Well, I checked on it later and the BW was Burt Wilson. He and I had worked years before on the Colorado River delta survey near Imperial Valley. That would have been 1924 or so. He was super tough. So tough that he wouldn't roll up his bedroll by day. He just left it unrolled. And we came back into camp one day, and there'd been a grass fire. It burnt right through Burt's bed. He grabbed up a charred chunk of the roll and said, 'Well that's that' and slept on the ground until we got him another."

"Well, it's a very good party, but I think I'd better get up while I can and go to bed." Two "daughters" help him find his bed. He walks between them and quips, "See what trouble getting old will get you into?"

The next morning at breakfast someone asks him how he's doing. "Well, I think all right. I think I'm still here and all that. Young men look young even at seven o'clock in the morning. Someday I'll be too old to do this."

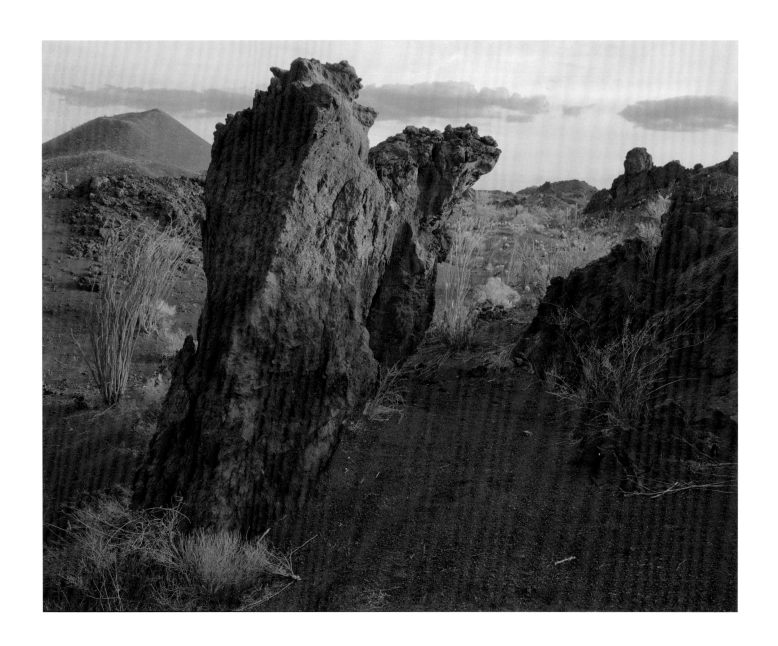

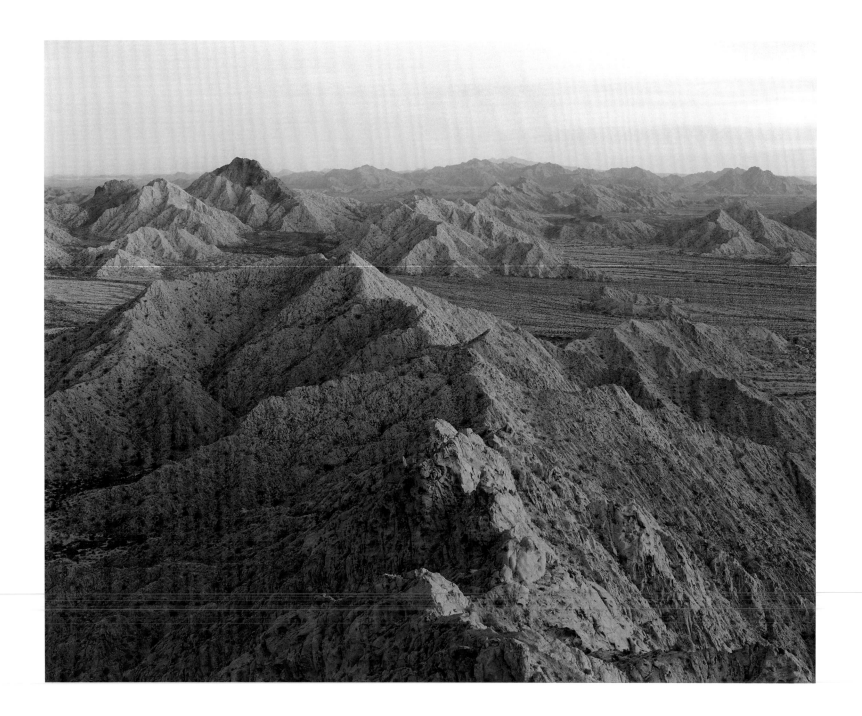

Night

"Fond as I am of civilized life and all it implies . . . I could not help longing for the fresh, cool, beautiful, and silent nights of my wild desert."

Carl Lumholtz, *New Trails in Mexico*

THE CLUES should have told me something, but I wasn't smart enough to comprehend them. As kids we "camped" in the backyard for the night and had sterling adventures. In the very yard we knew so well by day, we had new stars, prowling cats, spooky sounds, lurking shadows, morning dew, and freedom from our rooms and the usual "lights out" command. We'd talk until three and then, wearied, fall off into blissful unconsciousness to awake washed by sun.

In high school, a group of us visited a Southern California beach. By day we mixed with hordes of locals and droves from Oshkosh and Kansas City. One evening after dinner we went back to look for someone's lost watch. At first we weren't sure it was the right beach: few cars; no crowds. Ocean sounds and smells instead of radios and exhaust dominated the air. Lone and paired figures walked or stood by the surf's edge; scattered lanterns and campfires flickered.

Emboldened by a seventeen-year-old's curiosity, I approached one old-timer who was fishing. Naively I asked him, how could one fish at night? "Son," he replied after tamping his pipe, "some things, like lovin' and fishin', were meant to be done at night."

Years later I would occasionally run the hilly 8.3-mile road through Saguaro National Park at sunset. Leaving the car outside the gate, I'd jog along the loop, which was now mine and mine alone. The miles flowed because the darkness strangely suspended tired-

ness and blocked thoughts of the remaining miles. The moment filled me; nothing else mattered, and I felt extraordinarily relaxed. I saw more rabbits, coyotes, snakes, and toads than I ever did by day despite relying solely on stars or moon.

In California's Sierra Nevada I had summited Mounts Williamson and Tyndall, both rising to more than fourteen thousand feet, and by late afternoon had inexplicably yearned for ice cream, so I decided to return to town. Right then. Descending to timberline about sundown, I readied my flashlight, but mile after mile passed and starlight ushered the way. The trail proved easy. Stumbles were rare. New sounds and intensified smells filled the air. I glimpsed a meteor. The cool air invigorated and energized what had been a tough, hot upward grind the previous day. Not until the dense thicket near the trail's end on Symmes Creek did I need a flashlight. I was so refreshed and relaxed that the ice cream waited until morning.

Finally, while on a desert night hike in August, the solemn gospel truth hit me: night is a *proper* time to hike. Night hiking sharpened my other senses: whiffs of wild animals, cool air bathing bare skin, chirps and scurries in the still air. The trail was still warm underfoot, and the cooler margins kept me on track. By day I relied on sight, and my other senses got lazy, but by night they all had to work together. It's the difference between a burger joint and fine restaurant. Both can fill us up, but the best restaurant presents a full dining experience. It not only makes food taste delicious, but the food smells good and looks appealing on the plate. The utensils feel good in hand, and the food favors the lips and tongue. Compatible music fills our ears. The more senses we stimulate, the more pleasurable and intense the experience. So too with hiking.

At night we see old friends in a new light. That local canyon we've visited a dozen times reveals itself anew as we smell, hear, and touch it. We discover new moods and feelings for a place. We no longer stare at panoramas—we focus on the land in front of our faces. We appreciate the movie in black and white.

Keeping a direction and finding landmarks are more subtle by night, and traipsing through an area known for fences, gopher holes, old mine shafts, steep cliffs, and stands of prickly cactus may be riskier, but creosote flats, dunes, and arroyos are open and friendly. Getting lost at night may be easier, but it certainly isn't necessary. We can find our way with a flashlight and compass (or GPS unit). A simple AA-battery flashlight or small headlamp can handle most situations. After all, we only need to see the next twenty feet of trail to discern if the brittlebush ahead has a cholla growing next to it or if there's a drop-off down the banks of an arroyo. With the light on, our world is twenty feet in diameter, but with it off, our universe expands to far galaxies. Seldom is a night too dark or foggy for us to hike with our

lights holstered. Stars and the moon have been showing people the way for millennia; it's just that some of us have forgotten how to see.

Night hiking can be more efficient, especially for warmer climes. Sleeping by day and hiking by night means we need less bedroll—the day may be thirty to forty degrees warmer than the night, so lighter gear suffices. Maybe we don't need a sleeping bag at all, just a ground cloth or sheet so we can find a spot in the sun and loll like some sassy, sun-soaked lizard. We can hike in the cooler hours when our exertion

keeps us warm, and we'll consume less water. At midday, from ten to four, we'll pamper ourselves with a series of serious siestas under a shady tree, not fighting the heat. Ironically, in summer on the icy slopes of Alaska's Mount McKinley, we may find it necessary to hike and haul gear under the midnight sun, when the ice is firmer and the sun far less intense. Midday reflection off snow and ice can sunburn the inner surfaces of our noses and ears. Sand, too, is painfully reflective.

Night hiking can unlock us from the dawn-to-dusk routine. We can sleep when we want; we can be up when we want. We can work all day Friday and still include a four-hour after-dark hike. Many of us are night owls anyway. Single-night hikes (formerly known as "day hikes") can start and stop at whim, though it may be easier to slide into the night rhythm if we start before sundown. And we don't need to hike all night to enjoy this planet by starlight. We can trek until midnight and then sleep, or we can jump out of the car at midnight and hike until sunrise. We're free to choose. This night-owl soiree allows us to expand our outdoor skills. Star charts, meaningless by day, open new vistas. Animals who hide by day—mice, coyotes, rabbits, shrews, toads, snakes, owls, nighthawks, moths, beetles—parade at night. We recognize plants by silhouette and fragrance. We bless the cricket instead of sleeplessly cursing its incessant song.

At first, night hiking would seem to limit photographic opportunities. It needn't. We can find and capture nocturnal animals and flowers with a flash. Night dissolves distractive backgrounds and calms disheveling winds. Some plants, the exquisite and rare queen of the night for example, bloom only at night. Our day around camp can be devoted to some good, well-composed pictures instead of numerous trail snapshots. We'll be shooting at the magic hours of first and last light instead of setting up or breaking down camp by rote.

By night, routes across talus slopes, boulders, cholla forests, and dense brush all demand a bit more care. We may even relent and occasionally use our flashlight, but we can keep moving. Mountaineers accomplish twenty-four-hour super climbs, and glacier ascents always seem to begin at 2:00 A.M. from the mountain chalet in order to avoid rockfall and slush. In truth, cavers are always climbing at night.

One November, in a fit of apparent craziness, Al McGinnis, his son Pat, and I did the first—and our last—annual "Four Views of Tucson Hike." Within a twenty-four-hour period we stood atop the four major summits that ring Tucson: Mica Mountain in the Rincon Mountains, Mount Lemmon in the Catalinas, Wasson Peak in the Tucson Mountains, and Mount Wrightson in the Santa Ritas. The two toughest hikes—Mica and Wrightson—were done in the dark. It was a grand adventure that we'll never forget. We were so proud of ourselves that we had commemorative T-shirts made.

Another time, Jim Herrick, now a U.S. Border Patrolman, and I schemed up a "Two Views of the Universe" hike. The goal was to stand atop two sacred peaks on the same day. The peaks, one in southern Arizona and the other in northern Sonora, are mythological edges of the O'odham cosmos. I'itoi is a Tohono O'odham deity, and according to sacred stories, he had homes on both mountains, which also are the highest points in their areas. One peak can be seen 110 miles from the other on a clear day. So, we climbed Baboquivari one afternoon, and to fulfill our brag that we had stood on both summits in the same twenty-four-hour day, we waited until midnight before climbing off under a full moon. We used our flashlights only to double-check our harnesses and rope before rappelling down the toughest two pitches by moonlight. The trail out, usually a bit dull, was exotic, but we didn't stumble. We drove to the border station at Lukeville and slept a couple of hours until it opened at 8:00 A.M., drove to Red Cone Camp, and walked up Pinacate Peak. By late afternoon we were back home. We not only survived, but we enjoyed it and admired I'itoi for choosing such fine places to live.

I used to love campfires, intimate and warm, with their rituals of gathering wood, scraping a circle and finding rocks for the kettle and skillet, laying a kindling bed, blowing on embers, and spending easy hours feeding the flames. Some of my life's loveliest moments have been spent sitting around the campfire: warm hands, camp songs, the smell of steaks sizzling over glowing mesquite or ironwood coals. The flickering flames are enchanting, and the blaze gives a primordial sense of security. How sweet can life be!

Well, it can be even better. Kill the fire. I tired of finding wood and rubbing soot from my eyes. Hikers seldom carry steaks, and I can get warmer faster and easier in my sleeping bag than by turning one cheek and then the other toward a flame. Given the choice of watching wood burn or catching sight of a meteor, I'll pick the galaxy over charcoal any night.

Nowadays I don't use a tent or build a fire. When I get tired walking at night, I find a bare spot, kick away any stones or stickers, throw my bivouac sack and sleeping bag on the ground, and climb in. It takes all of two minutes. Opening a bag of trail food or heating a cup of tea water takes another couple of minutes. I have an extra hour or two to myself, and I sleep safer knowing that no one knows where I am. Campfires may scare away lions and bears, but in this desert, they can attract two-legged interlopers from ten miles out.

One April Diane Boyer and I planned to attend the Arizona Historical Convention in Yuma, and we wanted to add some authenticity to our trip. Because her great-grandfather, Godfrey Sykes, had traveled El Camino del Diablo frequently and the trail seemed like part of her family heritage, we decided to walk the Camino from Quitobaquito Spring to Yuma. We left the springs at sunset and walked until early morning under brilliant stars and a nearly full moon. We carried only basic packs, having decided that we wanted to travel as light as possible. Our knees and feet thanked us.

We had no trouble following an abandoned route along the border fence, even where it had been washed out or overgrown. Our

flashlights were at the ready, but we rarely turned one on, and when we did, we regretted having to readjust our eyes to the darkness. When we got sleepy a couple hours after midnight, we stopped at a flat spot, lay down, and rolled up in our bed sheets like two cocoons. The night air was calm, and I immediately fell asleep, though I awoke several times to admire the evening and listen for owls.

Come sunup, we folded the camp and began walking again, nibbling on trail food as we went, and I carried a quart jug in one hand, so I could drink at will. By late morning the sun proved too warm, so we sprawled under a paloverde tree and waited for the heat to abate. Cactus wrens and thrashers came to investigate us, as did several lizards. The tree still had some blossoms, though most had seeded and the petals dropped. We talked, napped, and enjoyed being there with nothing to do. By midafternoon, the heat broke and we again spent a minute breaking camp and headed west. We refilled our canteens at Papago Well.

By sundown we were into the Pinta Sands, and during the transition to night, our eyes gained new ability to see. The black lava of the Pinacate flow can be disorienting at night, like plunging headfirst into a bottomless hole. But this night, with the gradual adjustment and my white running shoes adding some depth perception against the black ground, walking seemed easy. In some places we walked the trail and in others we blissfully strayed and wound around creosotes, diamond chollas, and bursages. We marched until exhausted, and then lay down on the western Pinta Sands, where I had cached a gallon of water.

The next day we drifted cross country and made for a distant pass south of the trail. The ironwood trees were alive with blossoms and, seemingly, a bee in every flower. We counted five or six sizes of bees as we lounged in the shade of one particularly grand tree. We had no

trouble dozing fitfully in the full light of day. Those afternoon naps on the couch, with the televised baseball game blaring, seem to have taught me the valuable skill of sleeping with the lights on. Near some nameless hills we started seeing hoofprints of bighorn sheep that had ventured several miles out from the main mass of the Sierra Tuseral to eat tender new growth on the ironwoods. Toward evening we reached Tule Well and again topped off our canteens. We walked into the night and stopped near the Grave of Eight, where the contrasting lava and granite of Tordillo Mountain loomed north of us. We slept in a small wash, a place that we'd never choose if camping by car, but one that by night suited us fine.

With morning we walked to Tinajas Altas and rested under the biggest of the famous old ironwood trees, trees that shaded the first European explorers, the padres, the forty-niners, and likely Godfrey Sykes himself. The trip was like strolling through a park. During the warmest midday, we rested in the shade. We never suffered. It was too easy.

Toward evening, we left Tinajas Altas and made for Yuma. A strong, cold wind arose and lashed our faces, so by midnight we were chilled and tired of fighting. As before, we simply found a flat spot and lay down. "Making camp" took about a minute and reminded me of coming home from work, taking off my jacket and shoes, and plopping down in an easy chair. A few gulps of water chased some M&Ms and gorp. Late the next evening we reached my car on the outskirts of Yuma. The comings and goings of the sun made no difference to our journey. We walked when we wished and slept when we tired. How simple can it all be?

When you think about it, this is how our ancestors traveled. I didn't invent night hiking—I just rediscovered it for myself.

The Ultimate Dude Ranch

A Moment's Halt—a momentary taste
Of Being from the Well amid the Waste

Edward FitzGerald,
"The Rubáiyát of Omar Khayyám"

IT DOESN'T ADVERTISE. It doesn't need to. It's the ultimate dude ranch. We don't need reservations. No tipping is allowed. The atmosphere is accredited authentic western. And once we arrive, we're way "away from it all."

So away that it has no phone, no morning delivery of the *Times,* no limo service, and no electricity. Except for the stock truck parked next to the chicken coop and an occasional tune on the battery-powered radio, it predates the last century. The pool is never crowded, nor are the tennis courts, and the sauna is never closed for cleaning—there aren't any. Plush and opulent? Rated with five stars? Recommended by royalty? Hardly. Still, it ranks with all fine guest ranches.

This is our genuine Mexican ranchito, located mere hours from the city by dusty roads. Rancho Guadalupe Victoria is its christened name, but to find it locally, just ask for the Grijalva Ranch, since Jesús Grijalva is the one who founded it. But small matter: it's just like a thousand other ranchitos spread like cactus wren nests in the cholla across Sonora. These are working ranches, not hotels with pampered strings of riding stock.

"Working ranch" is a euphemism for two stark facts of life. One: raise cattle or starve. Two: make ends meet or do without. Cattle aren't easy to fatten, especially when your pasture is a sandy creosote flat rimmed with lava in a hellhole euphonically labeled on maps as El Gran Desierto. That's Spanish for "Big, Bad Desert."

When rains do fall, the annual plants are lush and filling. When the rains forget, the ground chokes on its own dust. A 580-foot well sucks salty, warm water from below the sands. That's twenty-nine sections of twenty-foot pipe to pull every time it puckers dry. The pump, from Coffeyville, Kansas, must run ten hours a day just to keep the stock tank full enough to slake thirsty cows. When the range is bountiful, cattle may roam twenty

miles across nature's pasture. When the range is seared by heat and drought, they linger at the ranch and must be fed. Then their diet is supplemented with alfalfa hay, cottonseeds, grape pulp, and molasses, all expensive to buy and transport. What with feeding and watering, plus doctoring infections and protecting from two- and four-legged varmints, raising cattle just isn't on the list of easy jobs.

To make those ends meet requires stretching available resources with ingenious utilitarianism. Junk is trove that a cowboy hasn't figured out how to use yet. A dished hubcap makes a jim-dandy water dipper and washbasin. Price was right too. Free. Discarded tires are slit vertically to make half-doughnut water troughs for the chickens. And where there wasn't enough wood to finish the mesquite-log corral, tires are hung on the barbed wire to buffer rambunctious livestock in a "rubber room." Tire strips make classy hinges, too.

An abandoned bus was dragged in and parked next to the corral. It makes a nifty private room for the head vaquero. In winter, it shelters him from the norte winds and keeps mice out of his belongings; in summer, he sleeps outside on a cot under the stars that shelter us all. The south-facing ramada is roofed with what a seamstress would politely call "remnants": palm leaves, saguaro ribs, driftwood, and an occasional piece of cut lumber found along the highway. The scene could be an adobe ranch in Arizona, a rough frame cabin in Oklahoma, or a chinked homestead in Montana.

The staff doesn't dress like Roy Rogers, with fancy boots, monogrammed belts, and silver spurs. Drab, worn work clothes, straw hats for ventilation, and plain shoes make their outfits. But who do you want running your dude ranch? Somebody who is always over in the next county rescuing damsels and posing for pictures with his guitar? Or Ricardo, Daniel, Oscar, and Pancho, who will lovingly tend the stock by peeling the skin off a grape so a fuzzy chick can eat it? They'll discipline the fractious cats and dogs with a sling of water, not a swat or kick. They'll wash down a grungy cow. They'll work a corralful of fidgety cows just to fetch a shaky-kneed, motherless calf an extra bucket of milk. They'll defy an ornery bull to patch its festered cuts. If the motor breaks, they'll find a way to fix it. They'll make cheese and jerk meat. They'll pour coffee for anyone not too uppity to shake a grimy hand.

When you meet a man whose biggest laugh of the day came at seeing a three-week-old pup, weighing maybe five pounds, confront a straying cow muzzle to nose, you know you've returned to the womb of good-natured humor. Self-reliant. Creative. Curious. Durable. Honest. In short, good men to ride a trail with. They're real cowboys.

I had the pleasure to stay here in August several years back. Unannounced I walked in off the desert very dry and rumpled. The crew didn't know me from any yahoo, but they jumped forth with drink and food, with chair and bed. I was a few hours from death.

For dinner they had one small tin of tuna, a dozen tortillas, a couple of potatoes to fry with an onion, a kettle of frijoles, and lots of coffee. Instead of dividing this repast two ways, they unhesitatingly cut it by thirds. I thought I was king of the world. They lent me a blanket and a set of bare bedsprings. The cot had a rolled jacket for the pillow and no mattress over the springs—to better allow air circulation on hot days. Besides, that way bed critters aren't a problem and the chickens won't foul it. The easily laundered blanket served as both mattress and cover. For three nights I slept most fitfully.

They patiently explained to this ultimate dude how to fire up the cantankerous pump. They let me yank on the gate rope when the lead

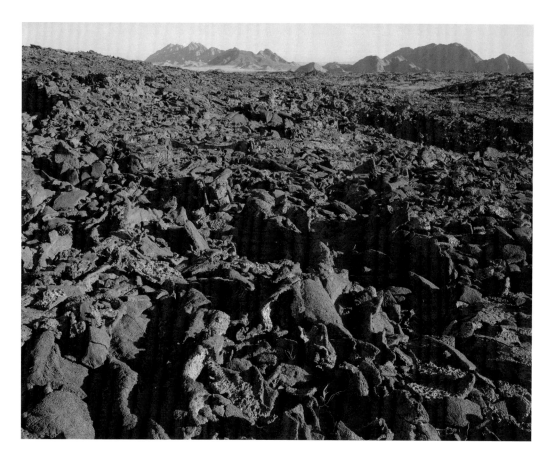

cow got through. They let me help unload hay, even put me on top where the dust wasn't so thick. They insisted I take first shot at the shower, and never has water dipped from a bucket felt so cleansing.

They even tolerated my busted Spanish, which consisted mainly of words like "bronco," "la riata," "corral", and "rodeo," which vaqueros of old slid into our English vernacular. One night lightning slashed the eastern sky and renewed our prayers for rain. Twice raindrops splattered on us as we slept, but no one thought of moving inside. It was too precious, as were new friends and serene dreams. Those were perhaps the most idyllic days of my life.

So what, you ask, does a dilapidated ranchito on the edge of oblivion have in common with all great guest ranches? Hospitality, amigo. Purest and simplest hospitality. *That* makes the ultimate dude ranch.

Salt

Then Coyote took me, whence we came
And reached the wide-spreading ocean.
Under smokelike spray he carried me
Even to that place I had run along the beach,
And there he left me.
Then down I fell but rose, and toward the east
* came running.*
There sat our leader, head upon his breast.
He had not slept.
Straight to him walking, into his hands I put
The power I had won, tight pressing it.
Then I saw emerge
The sun, the gift of God.
Then up I looked, I followed the road.
I camped four times and reached my land.

FROM A TOHONO O'ODHAM SONG

IN THE OLD DAYS desert people knew the desert, their desert, their home. And they made pilgrimages to the ocean, to pray and purify themselves, to learn and show courage, to gather and bring home shell, salt, and ocean power: rain. Two seasons, autumn and spring, were proper for gathering salt. The ancient people of that vast desertland astride El Camino del Diablo would journey from their many scattered villages to coastal flats, where generations of tides deposited the precious mineral. The stated goal of this trip to the remote reaches of their universe was salt. Simple, simple salt.

But to people without, salt not only brought flavor, preservative, and barter, it also symbolized prosperity. It carried with it omens of rain, rain then as now delivered by fickle winds laden with gulf moisture. The trip also allowed them to bestow gifts and prayers directly on the ocean itself; thanks, praise, and sharing are never presumed by people living on the fringe of oblivion. Therefore, the pilgrimage was an important religious venture, with grave import for everyday life itself. The trip's importance and rigors also sufficed to initiate young men into adulthood and, as such, offered an alternative to scalp taking or eagle killing as a way of obtaining "dream power," that supernatural plateau of understanding reached by bravery, endurance, and divine favor.

A typical salt trip covered six to ten ritualized days and 200 to 350 rugged miles through some of North America's most hellacious desert. Their route traversed sandy creosote plains, rocky trails through cactus forests, jagged lava flows, and trackless waves

of dune sand. Their lives depended on a few distantly scattered water-holes. Starting from a village somewhere in the vast Papaguería, the band of men headed to the vicinity of Sonoyta, a proper jumping-off point for the trip. The band might be small, maybe half a dozen, or larger, up to forty men.

Only men made the trip. It was a tradition designed to confirm initiates and to renew elders. The initiation trip would be difficult—twenty-five to forty miles a day of concentrated walking, pangs of thirst and hunger, unknown country, and fear of error or failure. As in most of these ventures designed to prove merit by testing, overcoming fear of the unknown is a major battle. Undoubtedly the trip was harsh, and like any harshness—hefting a heavy rock, diving deeply, running far—the first time *is* tough. As one modern marathoner said of his first attempt at

pressing his personal limits to twenty-six miles, "At eighteen miles I thought I'd die; at twenty-three, I wished I'd die." But amazingly, if the preparation has been true, fear of failure generally gives way to accomplishment. Or, as a hard-pressed character in *Treasure of the Sierra Madre* reviewed his fear, "The worst really isn't so bad when it gets here." But among the Tohono O'odham, south was also known as "the direction of suffering."

After making his initiation trip, the visionary was required to return the next three years. In some psychological ways, these trips would be the tougher. After all, the physical trip had been done; these limits had been pressed back. But the mental, the memory, works on a person. Take running up a steep hill: we know we can do it, but we also know how much our lungs will ache, and our arms will tire, and our legs will tremble, and then we're unsure we want to try, unsure we want to pay that price one more time. The second marathon, the second parachute jump, the second high dive are the toughest. The first time, we were carried along by fear, adrenaline, novelty. The second is an emotional letdown, for it has already been done, but the second is the more important because it determines habit and confidence and proficiency. The first one is a dare; the second is a drudge. The third? That's where the fun begins. So, though the emphasis seems to be on the first-timers, I believe the salt walks were as important for the elders as for the novices.

Certain preparations and rituals were observed to ensure the trip's success. For example, the traveler made new equipment: two pairs of sandals, a salt-carrying net, and gourd water bottles. Undoubtedly, much care and a few blessings went into this project, because his very

life depended upon their reliability. The trip would have begun with ceremony and ritual songs, and en route the leaders led the customary songs and campfire talk. The conversation never directly spoke of the devil, refusing to use "sun," "salt," "heat," "water." Much as the Old Norse used kennings, compound metaphors like "whale-road" for ocean, these O'odham used "shining traveler" for sun.

Another ritual was drinking only when the elder permitted. Yet another was sleeping head toward the sea, so that "its power can draw them on." The leaders also carried prayer sticks and eagle feathers for consecration at a waterhole, sacred cave, or the ocean's shore. To scratch himself, a novitiate was required to use a stick broken from a creosote bush, and he couldn't talk or turn around without permission. Travel was single file only.

With a little thought, it isn't too difficult to see a modern purpose in each of these rituals. Take single-file travel. The trail, being only one person wide, is an easier path, so they do not step off lest they injure the house of some animal and incur its anger. The soil is undermined with subterranean burrows—homes for ground squirrels, snakes, badgers, rabbits and even burrowing owls; to break through the roof of someone's home is not only rude to the occupants, but poses

risk of ankle sprain or, in our imagination, snakebite. Later, in crossing the tidal flats, the only easy way follows the narrow, packed coyote trails across the expanses of goo and mire a few inches to each side. Ancient single-file trails used by countless Indian parties still constitute the best routes in this territory.

Fortunately water was always available at the Sonoyta River and at Quitobaquito Spring. From there on their lives relied on three water sources: what they carried, mountain tinajas, and coastal *pozos* (fresh-water artesian springs). Knowledge of the country, of the weather, of the fauna and flora, of themselves, and a little luck (or spiritual grace) was all that kept them alive. This desert is seldom kind to the inept and unconditioned. Their gourd canteens might have held, at most, a quart apiece, barely sufficient to sustain them from one waterhole to the next river, spring, tinaja, or pozo.

A few tinajas were key stopovers along the route. These rock tanks, some as large as backyard swimming pools, some as small as bathroom sinks, are rare. The reliable ones may hold water for many months. Though the ancient elders knew every tinaja and its habits, they seemed to favor Tinaja Cuervo for their salt encampments. Along the coast, pozos unexpectedly well up in tidal flats. Subterranean water

"flowing" from the sand dunes is forced upward at unlikely places by impervious clay pans, forming a shallow basin surrounded by a green lip. Pozos seem relatively permanent in the span of human lives and the salt gatherers undoubtedly cataloged them too.

The salt party left its home village with a day's water in their canteens and pinned their hopes on a waterhole twenty-five to forty miles distant. To facilitate a quick pace, members traveled very lightly burdened by equipment or food and, depending on their village's location, could reach the Sonoyta area in one to four days. Some villagers living east of Sonoyta went to Salina San Jorge.

The next night's stop probably found them at Tinaja Cuervo on Pinacate Peak's southeastern side. There, after appropriate rituals, they would rest again and rehydrate, for the next day meant confronting the dunes, the large sea of sand so difficult to cross. At Cuervo they would have found firewood and shelter from the wind.

From Cuervo they likely drew their bearing to Picacho del Diablo, summit of Sierra San Pedro Mártir across the Gulf of California in Baja, knowing that it would guide them to Salina Pinacate. To reach the next water at La Soda or another of several nearby pozos, the band faced twenty-five difficult miles across Sahara-like soft sand.

At midday in the spring or fall, La Soda can be a pleasant stop, but it has no trees, shade, or good firewood, and nights are wracked by wind and damp chill. Their excitement or shivering would have aroused them before dawn, for soon the group would reach Salina Pinacate, the salt depot. The ocean leaves salt here under two conditions. At extremely tall tides, the sea sweeps into these tidal flats and covers them with a few inches of water, and as the water recedes, the remnant dries, depositing precious salt crystals. The accumulation of centuries may add up to several inches of salt, like giant brine vats. These layers may be collected as one would pick up dinner plates.

Secondly, the water of high tides pushes salt to the surface of the silty flats by capillary action. This produces a popcornlike salt and keeps the salt concentrated on the surface.

At Salina Pinacate the rituals included body rubs with salt, songs of offering, and runs around the salt flat. Then the leader would offer sacred sticks and blessed corn to the ocean. Each person would wade into the ocean as far as he dared—these were nonswimming desert people who seldom encountered water more than a few feet deep. Finally, the salt was respectfully, carefully loaded into net bags. And with singing and praying, the men would return home via the same route until again next year they had to gather the salt and honor the sea. Thereby, they prayed for health, long life, and rain.

And so from time on time these warriors delivered the precious cargo to their grateful village. They returned tired but proven and worthy, and though tradition wisely dictates a rest period, they returned with power: surges of dream power in the novices, renewal of power in the elders. They had confirmed their duty to their village and the tribe, ensuring rain and prosperity.

My own salt trip began under an outrageously bright moon at Charlie Bell Well west of Ajo, Arizona. Mid-December is too cold for a comfortable salt walk—the ancients avoided winter—but I went anyway.

Two friends had driven me from Tucson to the Growler Mountain pass above the well. The area shows signs of ancient habitations and crossroads, so this seemed a suitable place to begin a salt walk. My own rituals, which to any Tohono O'odham ghost must look far stranger than his to me, sufficed. Rituals I suspect are a strange conjunction of whim, empiricism, gamesmanship, and practicality. My own include nibbling two or three squares of chocolate candy—never more than three; holding each shoe sole up and bouncing it twice on

the heel to expel sand and scorpions; slinging the magnetic-compass totem around my neck; and never leaving a sleeping or dining spot until I've recircled it twice to ensure leaving nothing behind. These procedures might well go into the anthropologist's notebook as ritual behavior. At 3:23 A.M., my rituals complete and my mind ready, I left to pay respect to the sea and to gather the salt.

The land was quiet—no wind and no birds yet, not even owls or nighthawks, just rough, rocky, lava-strewn terrain, bushes and trees. At 5:40 A.M. I lay down on bare ground to nap and, despite the thirty-eight degrees, slept until almost seven. Someday I'll launch a trip in rested condition, not beat down by the rush at work and readying for the trip. And I'll begin healthy—a recently pulled hamstring was wrapped but still worrisome—and I'll start conditioned, in marathon-ready shape. Someday. Continuing across country, I saw two coyotes before dawn, and then in the first morning rays, the reflective target drones, dropped to earth by air force tow planes like silver arrowheads, mirrored sunrise.

This first morning I hiked cross-country south down the broad valley separating the Granite range from the Growler escarpment. The valley is primarily creosote bushes and bursages, with some mesquites and a few saguaros. Several birds and I witnessed a spectacular sunrise. Occasionally, pottery shards or an ancient trail caught my curiosity, but basically this day was a pleasant stroll down to Papago Well. The well had a windmill, water trough for wildlife, and a reservoir tank, where I drank my fill from the spigot, ate lunch, and rinsed most of the dust out of my socks.

From there I turned west and took one of the prettiest of washes, with many birds, trees, and shiny sand; I passed prospector Dave O'Neill's grave, a reminder that even the old desert rats aren't immune

to fatal failure in this country. After sunset my route cut across El Camino del Diablo and the dry lakebeds of Las Playas. Sometimes they are a muddy mess, but this time the playas were dry. Even so, if you want to test your knees and hips, walk across Las Playas in the dark: no two steps are on the same level. My ankles bent every which way, and at first each step was as tentative as a blind man expecting a curb or pothole, but eventually I began to feel a rhythm to it all, adjusted my step, and plunged forward like an animated mogul skier. At the far edge of Las Playas is the border fence, the barbed wire reminder of "their" country and "ours." The ancients observed territories but didn't have to contend with barbed wire subdivisions. Having a documented visa, I didn't feel too criminal when I stepped over the line.

The moon appeared and the compass confirmed local landmarks. By midevening I stopped to sleep fitfully, but by early morning I scrounged deadwood and started a low fire to cut the cold. Partly by comfort, partly by tiredness from yesterday's thirty-six miles, I slept until the sun awakened me, which is not a bad way to start a day.

This crispy cold morn was especially pretty. After a few miles working the kinks out of my muscles, I passed a hand-dug dry well, perhaps twenty-five feet deep, and gazed at the stratigraphic record of lavas and sands. Crossing the highway, Mexico 2, I skirted a lava butte before angling across the creosote flat, bypassing my friends at the Grijalva Ranch. Theirs would have been a hearty welcome, but I was already slow and knew that salt walkers had scant time for social detours; still, it was hard to pass them by.

My walk was taking me on the west side of the Pinacate range, though the salt trekkers would have approached it from the east. At Tinajas de los Papagos I had a cache of water and food, real food,

like a can of vienna sausage, a can of pears, and a soda, not just the chocolate bars and grain bars on which I had relied so far. In two days I had drunk four and a half quarts of water to cover over fifty miles, so I refilled my canteens, which were really just emptied plastic soda and bleach bottles, light, free, and tough.

So far the trip was straightforward and fairly easy. But I knew that ahead the country roughened and that I was getting no fresher. So, I took an extra drink of resolution at Papago. It is well that I did. The next section, down Papago Wash to the Sierra Extraña, proved most interesting, but the trails cut across the lava flows that form the wash's banks, leaving me to negotiate the rocky wash bottom, shrubby thickets, and jagged lava shelves. In places I followed coyote trails, but even the moon couldn't penetrate some thickets and I had to use my flashlight occasionally. But after a tumultuous sunset and serene moonrise, the wonderland of shapes and forms and textures and shades and remoteness gave the wash a special merit. Eventually, though, I wearied of it and cut a beeline for the distant coast.

The quiet, the absolute quiet of sound and breeze, sent shivers up my neck, a bit eerie, a bit mystical, and captivatingly beautiful. Words never give me much success, and here they fail me even further: if you've been "there," you know; if you have never hiked wilderness at night, you must go now, tonight, this instant, at least in your imagination.

The highlight of the evening occurred when I stopped beyond the sierra to sleep at the edge of the dunes. I selected a site between a hummock of ephedra and a scrubby paloverde tree, but before I could even drop my pack, a kit fox pranced from behind the ephedra and twice circled me at close range. Motionlessly I waited to see if he'd return. Sure enough, in a minute, he sneaked up behind and sniffed

my leg. Even two day's worth of trail dust didn't seem to phase him. He padded away and then made three more playful, puppylike loops around me: stopping, looking, feinting, running, walking, before slipping into the night as quietly as he'd come. Fox pads on dune sand are about as quiet as can be.

The edge of the dunes seemed much livelier than any part of the trip: owls, roosting quail, coyotes, bustling little furry critters. I awoke only a few times to stoke a small warming fire and was much refreshed when I began day three a full hour before sunrise. The sand dunes are aptly named "sea of sand" because indeed they resemble sculptured, rolling ocean waves. Both are wind formed, transient, sensuous in their smoothness—and both are frustrating to travel, a frustration addressed by how a person copes with sand-filled shoes. Like lying on a bed of nails, one grain is more irritating than a shoe full. One extreme would be to hike in hip waders, like a fisherman in a stream—then I'd probably never have sand inside. A midline solution would be sandals, like scuppers on a self-bailing boat, but my toes would get sunburned. The other extreme would be to travel barefooted and never have an inside-outside problem. My feet aren't tough enough to go unshod, and waders would be a comical but sweaty inconvenience, so I adopt a diplomat's theory of sand: a shoe can get only so full before no more sand enters, so I ignore the load and shuffle onward, ferrying grains from one dock of the desert to another.

A weather front appeared to be moving in from the northwest. The cloud line announced that I should expect wind by late afternoon. So far, the morning temperatures had been in the high thirties with warm (sixty-five to seventy) afternoons and no wind. Should the weather take a worse turn, with an all-day wind- or rainstorm, I'd pay the price for traveling light, though not as light as the original

salt seekers. My main outfit consisted of running shorts and T-shirt, supplemented by a long-john top, a thin pair of trousers, a wool balaclava and wool shirt, and a windbreaker. A day of wind would eat my lunch. But when the nearest waterhole is ten miles back and the nearest building is seventeen miles distant, holing up is not an option.

The dunes are tough to travel partly because they lack landmarks and require navigation by stars or compass, and holding a straight course is difficult, like trying to walk a straight line down a bustling corridor. Cresting one difficult ridge, I found an immense, flat bowl on the other side, surrounded by more shifting dunes. I looked for firmer sand to alleviate the trudge, as did the ancients. From the dune tops I could see the ocean at Adair Bay, but seeing isn't arriving.

The toughest part of the trip was the hummock dunes that lay between me and the shore. These choppy dunes are pointless. Interminable. Tedious. A trip through them is a trudge. My mind daydreamed this stretch away, and I had no idea what planet I was on until I first heard an osprey. And then a second. These magnificent fish hawks venture none too far inland, so even my plodding, dulled mind could deduce the nearness of the shore and my cache of water and food near the railroad tracks.

The handful of food and a quart of water were gloriously invigorating, and with less than an hour's rest I was gone again. The plan—to intersect the head of Adair Bay, skirting the mudflats, and then head south to Salina Grande—seemed reasonable, so I took my line and walked into the last rays of sunlight.

The coastal dunes here are brushy, thorny affairs, not nearly as tractable as the ones farther from the ocean. The ocean proper still lay two to three miles south, but many tidal flat fingers reached northward, some even reaching the railroad. I crossed one finger, a shim-

mering white flat that crunched underfoot. The crunch was from the dried algae crust and the salt, though this salt was too churned with silt and algae to be worth collecting. Walking these flats is very easy. Under dry conditions, they are a fast surface, but when moistened by rain or high tide, they degenerate into a slog.

My compass route went across more dunes and a small flat. Then came a big tidal flat. And my plan fell flat. Supposedly about two miles across, this flat would take only an hour and would save three or four miles of walking around its perimeter. I did know that the full moon would bring large tides, but I had also consulted the tide chart, and the magnitude was not supposed to be very high. Yet we must remember that I'm the same fool who, on a dune walk some years past, carried a mask and snorkel from Moon Crater across the dunes to the ocean only to find the tide was out with at least a mile of goopy mud between me and the salt water that I couldn't reach, let alone swim in. With the moon at my back, the ground directly ahead was shadowed and I couldn't see the glisten as tidewater moved into the sloughs and silently rose, but soon the crunch of my steps ceased and each footfall began making kissing noises. "A temporary problem," I thought. "Onward." My feet became heavier, my shoes changed color, and mud now splattered my calves on each step, so being a cautious sort, I decided to detour a bit and then resume my course. I must have detoured twenty times and each time found slipperier footing, deeper sloughs, and more aggravating mud. I wondered if the ancient ceremonies included pratfalls or donating shoes to the big slurp. The new ceremony does. Sometime when you're bored, try balancing on one leg, reaching down into knee deep mud, yanking up a seized shoe, and then putting that shoe back on your foot. The first time was funny; the tenth was panicked. No place to sit down;

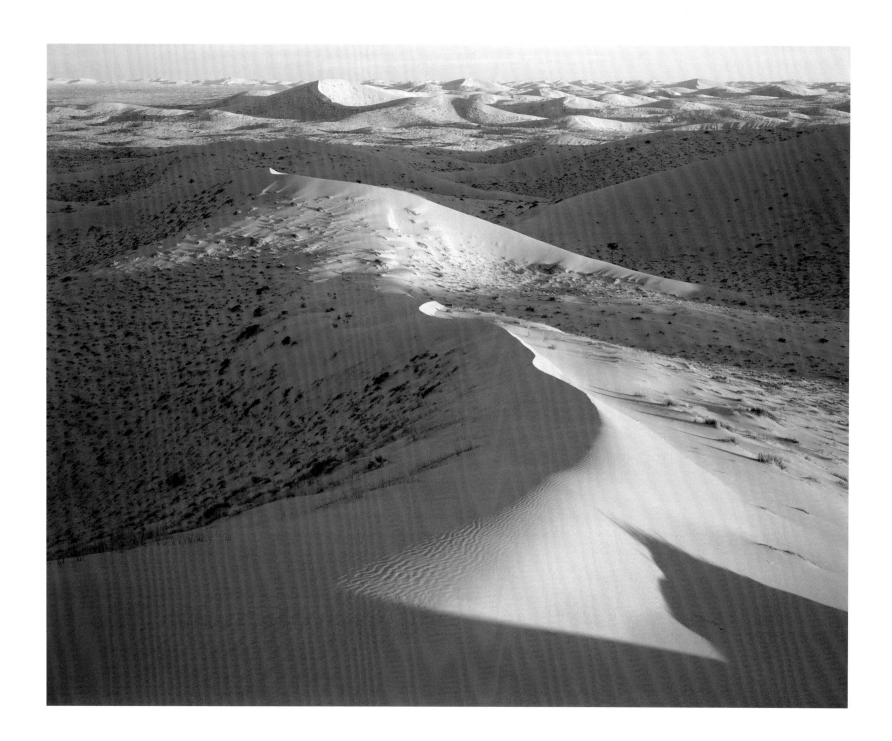

no place to sleep; and no place to even stand and rest, for slowly the mud sunk underfoot, and I had visions of sinking out of sight or being swept away by a tidal rush.

So I kept moving and eventually worked out of the man-eating salt flat to a point southeast of the railroad maintenance town of Lopez Collada. I could hear dogs and catch a solitary light. Those three or four miles I'd hoped to save were squandered. Presumably the Indians had not been so foolish. When I encountered a sand dune about midnight on the flat's western edge, I gratefully sat down to rest and celebrate with a slug of water and chocolate. Scanning the area for firewood, I found none. Funny, a century ago Carl Lumholtz found none, either. Funny, the humidity, the tiredness, the lack of a real sleeping bag, and the lack of any flame made for a cold, miserable night. Cold wind kept sneaking down my back, and every half hour I'd wake up, munch a piece of chocolate, and rub my legs before relapsing into sleep.

Before sunrise the cold forced me to repack and start walking just to warm up. I staggered, shuffled, hopped, and limped. Cold, sore, cramped muscles are as efficient as two flat tires. A dirt road for salt trucks runs south to Salina Grande, a follow-up on Lumholtz's suggestion to mine the deposit. It's a long road, made longer by my shortcuts. I was tired.

Not until late afternoon did I reach the Salina, a marvelous arm of the sea reaching perhaps five miles inland and providing many acres of salt. Whereas O'odham would have hand scooped their salt into handwoven bags, nowadays mechanical loaders fill dilapidated trucks. Salt mines are the end of the road for old trucks, as attested to by the corroded fenders and hulks of abandoned equipment. I scooped up handfuls of salt, filled a nylon bag, and thought of friends to whom

I'd "pass the salt." I thought of the ancient kinsmen who sought the wind and rain, the salt and prosperity.

With that filling, I sat down on a patch of sand, supremely satisfied with myself. I had sought the salt and had met with success. Was it worth four days' walk just to fetch a pound or two of symbolic salt? If you believe in symbols, principles, and ancient forces, it is. If it brings rain and prosperity, it's priceless.

And so began the second half of this trip: the bringing of the salt home to friends. I filled my water jugs from one of the marvelous pozos near the salt mine headquarters. Today the well is boxed with boards so dogs and birds don't foul it. I brought home half a jug that sat for a long time atop my refrigerator. For a while it looked pure before turning opaque green and then brown. Another sample I brought home flunked its lab analysis. The friend who tested it admonished me, "I sure hope you didn't drink any of that." I had, of course. Later it grew algae and hatched two water beetles, a mosquito, and only heaven knows how many microbes.

A hound from the salt company headquarters joined me for supper—he was probably supposed to guard the bulldozer from seagulls or something. He didn't like chocolate and wouldn't even sniff granola, but like true *compañeros* everywhere, he loved a few strokes behind the ears.

My dilemma as I watched the sunset was whether to continue the coastal route to El Golfo (some forty miles of sand by a route I'd never been) or to return to the railroad and catch some sort of a ride somewhere. I had my salt, plus two sore feet and a very tired body. I had enjoyed four of life's prettiest days, had pleasantly exhausted myself, and had learned a bagful about my favorite country. Why press

my luck? Idealistically, I should have hiked back to Charlie Bell, but Christmas was coming and in Tucson I had somebody to call.

So, I left my tail-wagging friend and started north. About midnight, roughly halfway to the tracks, I unwound my sleeping blanket and called it a day. Tomorrow I'd hope for a truck going north. This night's bivouac was also cold and I repeated the cycle of sleep between rubs and nibbles. Before sunrise I awoke and realized, "Hey, today is Christmas Eve." Soon I was on the road and had made another five miles when I heard a truck, a decrepit green Ford.

Now this was no ordinary truck. It had been beaten, but its current driver not only thought that baby could run, he thought he was leading the race. After seeing an apparition with a blue backpack hold out his thumb, he stopped as soon as he could—about fifty yards up road in a cloud of dust. I gladly climbed into the pickup's bed with what seemed like four hundred pounds of tools and junk that bounced off the floor at every bump, as did I. Away we went: the hard-of-hearing foreman, Santiago Monterrey, at the wheel, with two workers in front, and me, the tourist, in the back. We power drifted the curves, flew the larger bumps, and left a rooster tail of dust, but it beat walking.

I lent a hand when we stopped to take the batteries off a huge dump truck, which had wandered off the road into a tidal flat. The truck had wallowed in frame deep on both ends, and not one of its ten tires could help. Few words were spoken, but plainly no one was happy about spending the rest of the day gathering that monster out of the mire, so we went on.

We arrived intact at Lopez Collada, where the salt is dumped by truck at a siding and then scooped by a front loader into gondola cars. I asked one of the men about the train schedule to Rocky Point, the nearest town, and he said to check with the stationmaster. He also invited me back to lunch. A gentleman living in a hut who shovels salt for a living invites a grungy hiker home to meet the family and eat lunch. If a man and a woman-in-waiting had knocked on his door this Christmas Eve night, he undoubtedly would have given them his own regal cot. His next-door neighbor, the other worker, also invited me for a meal. I guess they figured I was harmless or salvageable.

Up the tracks the stationmaster and an assistant, José, were trying to fix "el motor," a Fairmount thirteen-horsepower line car small enough to be levered off the tracks by two men. The stationmaster was straight out of a western movie: boots, hat, vest over western snap shirt, and a face for all the world like the typical desperado—black hat pulled low on the eyes, mustache, and goatee. His smile canceled all pretense to meanness, but with a Screen Actors Guild card he could make a fortune. His pocket watch hung in a special case from his belt, as did a holstered paper punch. Together the stationmaster and José ingeniously reformed a round metal rod to make a new accelerator linkage and assured me that I was quite welcomed to accompany them *horita,* pretty soon.

There were perhaps twenty-five people, including ten children, living here and three automobiles: the green truck I had already ridden in, an old Chevy two-door, which appeared capable of driving only the fifty yards between the well and the tracks, and a homemade buggy affair, which looked shy about starting. None of course would be going to town, and for good reasons, few outside people visit here.

The railyard had tons of replacement ties, rails, spikes, and pads. A gasoline-powered hacksaw cut rails, and an assortment of wedges, levels, and pry bars positioned the rails. Automation hadn't yet reached this stretch of track. But it was all strangely efficient. The line car could

be taken off or put on the tracks in less than sixty seconds using a miniature roundhouse that pivoted the car to the side of the railbed.

A freight train—*la cargodera*—arrived westbound for Mexicali, and though that wasn't the direction I wanted to go, the stationmaster offered me a seat in the caboose. He made it clear that I was still welcomed to go east with him later. Most hoboes would not be allowed in the caboose, so apparently I was now a guest. Still, I held out for a trip to Rocky Point.

The station house was a one-person telephone booth hooked up to the overhead telephone wires—the top four for the government and the bottom two for the railroad—with a battery-powered signal arm overhead. Collada had no electricity.

The telegrapher's eight- or nine-year-old niece swept the office and the ground around it, twice, before lunch. These folks are very fastidious, almost as fastidious as they are solicitous about kids or dogs near the tracks, especially if a train is due or in. His very small son played "cars and trucks" nearby, and the niece kept a motherly eye on him. Their company home is directly behind the station, sharing shade from the same tamarisk trees. The telegrapher's wife worked around the house and he shuttled back and forth. He seemed to enjoy having his family and work together and admitted he was very fortunate. His wife offered me a cup of coffee, which I gratefully accepted. She was one of those ladies who carried herself and her life with dignity, poise, and charm. Queens have it; some stars have it; she had it.

The stationmaster headed out west to fix something, so I sat with José and over a Pepsi talked about the area in my rudimentary Spanish. Lopez Collada was founded in 1947 or '49 as a rail-maintenance section town (*cuadrilla de tramo*). The trees, the buildings, and the tamarisk trees dotted along the line all dated from then. José had lived here for twenty-five years, and his ten children scattered as far as Salinas, California. He lived alone, except for his dog, Oso, and his cat, Piti, which protected the area from sidewinders and scorpions. The conversation included U.S. foreign policy (a big question in Mexico), Mexico's oil reserves (ten test wells were reportedly under way in the Adair area), gold and lost missions (he's still looking), and wild animals (foxes outnumber coyotes around here). I missed a lot, but I caught enough to stay in the game.

My discourse was interrupted when Piti came bounding back to me. I thought he came for more petting and purring, but his motive became obvious when I turned around to face a large platter of tostadas being handed over by the stationmaster's wife. Live on chocolate and granola for four and a half days and then we'll watch you stammer your stunned thank you. Frijoles, cheese, fish ceviche, and tostadas with cooled, crisp lettuce. Ah, ceviche. It was complemented by a cup of Mexican coffee, which she had correctly sugared after once watching me do so in the morning. Never was a meal more thoughtfully given nor more appreciably received. Maybe a wise woman bearing tostadas was among the Christmas Magi. Christmas was alive and well in Collada. Seldom has anyone eaten better, and I shared a bite of ceviche with the cat.

In late afternoon the master returned along with another track motorcar. It was enclosed and pulled a flatbed car filled with pipe and iron. This was our ride to town, and immediately things happened. José piled his returnable Pepsi bottles into the bed; two suitcases were tied in, and I tied my pitiful pack to a large pipe for the helter-skelter ride to town. Someone motioned for me to get in. Six adults and two children squeezed into the motor. They included José, the stationmaster, and his wife with her son and niece. I was honored by a front seat,

which in a motor means in front of the axle, much like the front bench of a roller coaster. We bounced and sputtered and darted on the best tour of the desert a person could ask for in the best of company. The O'odham, too, would have loved this return with their salt.

The train arrived after sunset amid Christmas Eve festivities. Not five minutes passed without firecrackers or fireworks, and people wandered noisily from party to party. Traffic was thick and dogs yelped at passersby. When I had to find a restroom instead of a bush in the open, the magic spell of the salt walk was broken. I had left the desert and fallen back into civilization. No bus was scheduled until the next morning, no train until after midnight, and no trucks were moving north, so I settled in for the longest, coldest night of the trip. This included waiting three hours, split between a taco stand (an ill error I came to regret) and a hard bench, reviewing the skid-row hard cases animated by holiday hooch. Then I sat another four hours on a baggage box in a drafty, unheated passenger car before we even left the railyard. The cold ride to Benjamin Hill was sleepless, and the bus for the next leg of my trip was late due to a breakdown. I did sleep thirty minutes around noon. The day was so long that it scarcely seemed like Christmas. All I wanted for Christmas was a cup of hot tea and a place to lie down. But I was contented. I had gathered the salt. I had survived. I had learned. I had returned to the basic needs of life and was happy with life itself, not just with things. I looked awful and felt worse, but I had located Christmas in an unexpected place and brought it home.

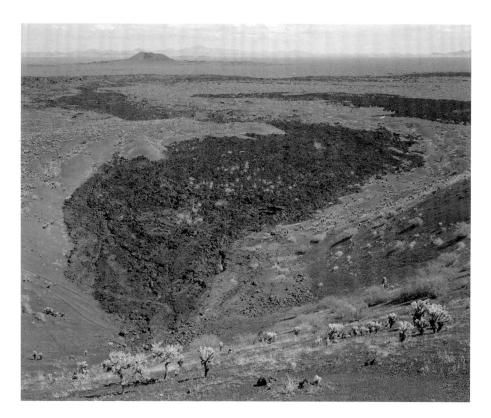

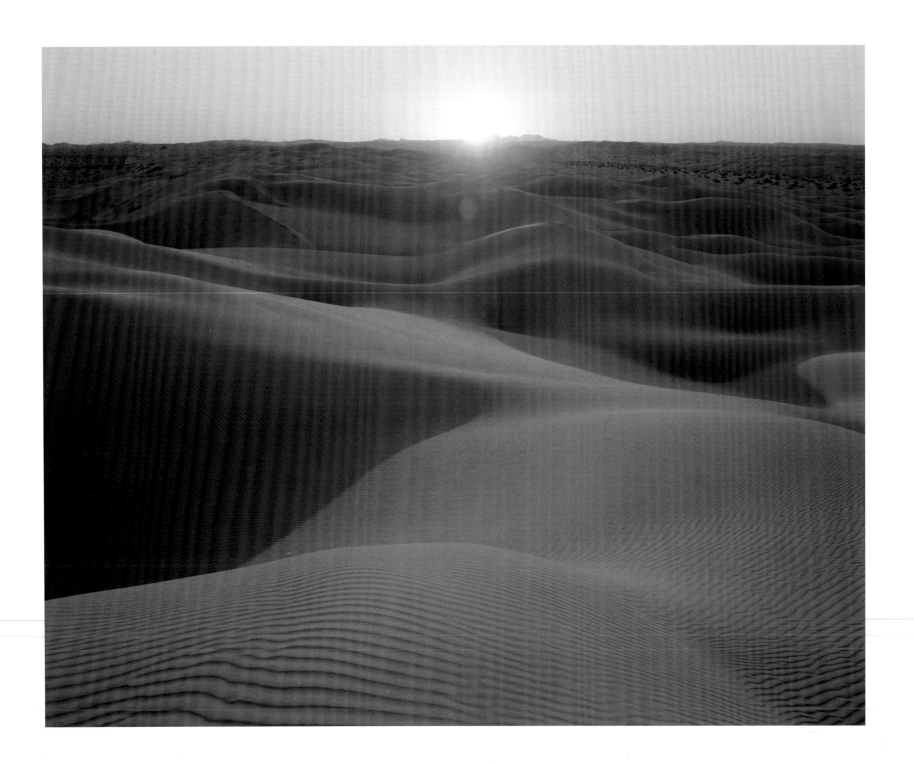

Across the Heart

At the very end of his long effort measured by skyless space and time without depth, the purpose is achieved. Then Sisyphus watches the stone rush down in a few moments toward that lower world whence he will have to push it up again toward the summit One must imagine Sisyphus happy.

ALBERT CAMUS, "THE MYTH OF SISYPHUS"

SHOW A HIKER a map with blank space and some innate impulse roars "go there." A feature, a mood, a line beckons. So with the Gran Desierto. If one outlines the Gran Desierto and then X's its heart, we have a mythical center of power, a heartland, a geographical center, a median of some improbable significance. I had traveled across the heart by a north-south line. I knew it was time to cross east to west. In mountain climbing, as with Ockham's razor, there's a certain elegance to taking the most direct route, however hard it might be. No detours are allowed. It's a straight-line fever. I hadn't heard of this route being done in modern times, and it's unlikely Indians did it for any reason, since it's pointless.

Draw a straight line 105 miles long through hard, crooked country, and try to walk it. You get the idea. This was a route with no easy exits. Snakebite? Fall? Fatigue? Lost? I would be dead before any rescue was launched. And once dispatched, where would they look and how would they find any tracks in the drifting sands? Taking a hiking partner doubles the worry with only a scant improvement of the odds, assuming I could find someone nutty enough to go. Few could. Fewer would. If I didn't make it, there would be no excuses. Failure would mean that I wasn't tough enough, smart enough, fit enough. The fault would be mine alone.

It would not be an easy trip. I counted on finding water in Tinaja Chivos at the twenty-mile mark, but after that it would be a race to cover ground before the food and water ran out. I'd travel light, like much of the world does. Few things. Little food. No camera. When not sleep-

ing, I'd be walking. It would be the no-frills flight, the tramp steamer voyage. Walking the Gran Desierto is like walking a wild, frozen sea, with crests, troughs, and foamy slopes. I did some quick calculations. If the temperature hits 85, I need a gallon a day. If it hits 100, I need two gallons a day. At 8.4 pounds per gallon, that's 16.8 pounds a day. If I can hike at the rate of two miles an hour (optimistic over trailless terrain) and hike fifteen hours a day, it'll take me four days for this trip and I'll need to start with eight gallons, an implausibly heavy sixty-seven pounds of water. If the sun hits 110 degrees, I need even more water—three gallons a day—but can walk fewer miles. It would be suicidal in summer or even late spring. But in late fall or winter, when the midday the temperature stays below 70, I can survive on one-half gallon a day, so going in November was an easy choice.

People want to hear that it was a tough trip, an unbearable misery, a tough-it-out fiasco. Dangerous, arduous, terrifying? Here are my notes from that trip. Come along.

Notes: Dune trip, November 23–29

Saturday, November 23

- Lv. home 6 am: taxi to bus depot; $10.
- Wait 40 min. outside in cold—no such thing as 24-hr bus depot now.
- Lv. Tucson 7:00, $5.95 to Nogales (sounds like a cheap steak); arr. 8:50.
- Wait 2 hours.
- Lv. Nogales 11 am; 500 pesos; arr. Santa Ana 13:05; wait an hr.
- Lv. Santa Ana 14:15; 1150 pesos (three bucks) for the 252 km. to Sonoyta.

- Arr. Caborca 15:32; arr. Sonoyta at 17:40, dusk. Dusty. Bus to Peñasco not leave til 9:30 or 10 P.M. maybe, according to the ticket man. If he's not sure, then it must be a real clunker.
- Hailed taxi; #15, Pedro Caño; arranged ride to Ejido Nayarit for $15, including driving me to Tierra del Sol restaurant for brochetas, the last hearty meal of a self-condemned man.
- Lv. Sonoyta about 18:45; driver had to refuel (not a ruse for advance money—his gauge didn't work); Caño talked of animals, *berrendos* (pronghorn), *borregos cimmarones* (bighorn), *venados* (white-tailed deer), *mulas* (mule deer), *gatos del montaña* (bobcats), and even pumas; claims to have a stuffed bobcat at his home, east of PEMEX station; talked of friends shooting deer; said he'd seen a bobcat near Batamote bridges recently . . . and then as if on cue one crossed the road ahead of us; Caño was a bit surprised not to wheel up to a building with a lantern in the window. Told him I'm visiting friends in area, but that his car wouldn't make it up the road. How to tell a Mexican cabby you're afoot and headed west across open desert to Riito . . . alone? Caño says Peñasco bus leaves at noon and at 9 P.M.; arrives about an hour prior to those times and it will stop for fares alongside the highway.
- At 19:31 I stepped into open air south of Ejido Nayarit and started walking. Took road to Romero Tank, and bedded down at 20:35 on far side of second barren flat. Moon exquisite; heavy dew; smells fragrant and forceful; pack riding fine, maybe 41 pounds; tired from long ride; I've driven my own truck to this spot in less than 3 1/2 hrs, one-fourth of today's time.

Sunday, November 24

- Clouds roll in about 0400.

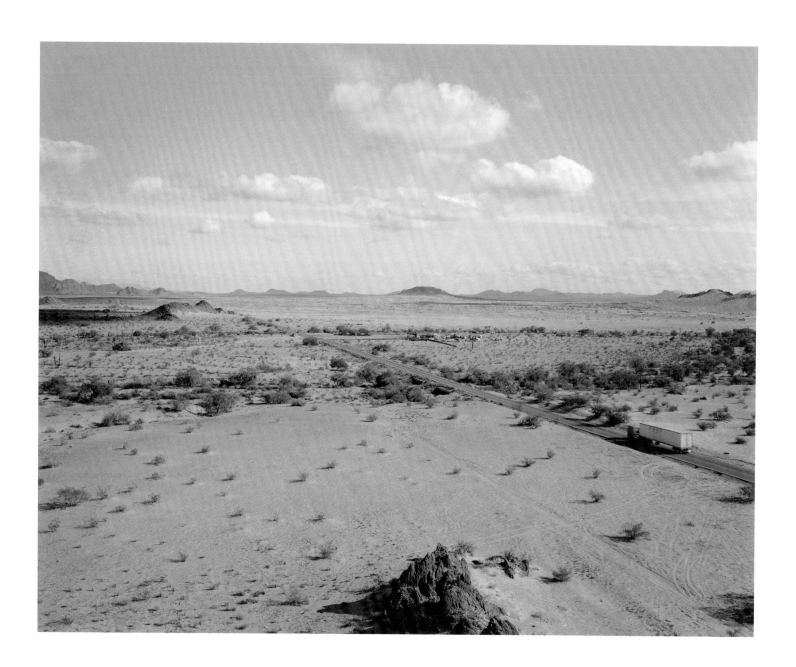

- Temp 58° at 0730 sunrise; and a bedroll of clouds around necks of peaks with summits bareheaded.

- Several hummers buzz camp; wrens musical.

- Scene like looking through green-tinted glasses: green carpet of mosses, green plants, green slopes.

- Passed south of Romero Tank; encountered set of cloven tracks: deer? bighorn sheep?

- Route is 275° magnetic north, direct line, as direct as I can navigate it.

- On route and 340° from Romero Butte's west hump is a temporary waterhole in cut of lava arroyo; estimate 40 gallons.

- Snack at 1050: hot tea, ginger snaps (brought for bus ride, but unopened til now), hunk of salami, half chocolate bar. I think I'm dining at the Ritz. 5 stars.

- A snaky road westward parallels my 275° mn route.

- Didn't check to see if Tinaja Romero was full.

- Found a deep (15'?) plunge pool on arroyo south of route, but empty.

- I bet Julian Hayden mapped it anyway.

- Desert lavender in profuse bloom.

- Almost too warm; 77° at 1102.

- Am shooting route to north of rounded hump on skyline.

- Think it's better to start a trip like this a bit tired, for then am relaxed. Then don't force or press. Better for mind. And for survival. Realize if break leg here will probably die. The irony is that if tensed and worried about that reality, I'll probably trip awkwardly, instead of relax and roll with the fall.

- That's another reason I prefer low-cut tennies, and tie them loosely; there's a lot of play in my suspension.

- Some folks bemoan and fear turning ankles; to my mind, ankles are meant to turn, like swivel feet. Seems to reduce slips, trips, rock-rolls, twists. From my days of tromping in high-bound boots, I remember sore ankles (from being rigid?), tender knees (which tried to turn when the ankles wouldn't), and thought of broken shins. Besides, tennies are more nimble . . . and I need all the nimble I can beg or borrow.

- If anyone asks me, this is a tough, severe, hard, long, dangerous trip—because that's what they want to hear and those are the "given" reasons that they don't try it themselves. The real reasons, as you know, lie far deeper . . . for both of us.

- A cactus wren watched me most of lunch. It sat atop a dead saguaro rib bent double. When the wind blew the rib pulsed up and down and the bird sang. When the wind paused, the bird bobbed up and down like a springboard diver. And sang.

- Still hear the trucks on the highway, but can see progress. The slope is gradual, but definite. Wind 2-5 from SE.

- Main flow from Middle Peak passes east of "My Rounded Butte." Lava flow is only 200-300 yards wide here and easy to cross. Rounded butte is an ash cone? Muddled into covey of three dozen surprised quail. They talked it over for a full 5 minutes, re-posted their guards, and resumed their sashay through the bushes. I had to proceed. Boy, were they miffed.

- Rounded butte is about due south mn of Carnegie Peak. It is, though, not a dome, but is saddled in its n/s axis. Time 1250.

- Tracks of bighorn in interface between Rounded Butte and lava flow.

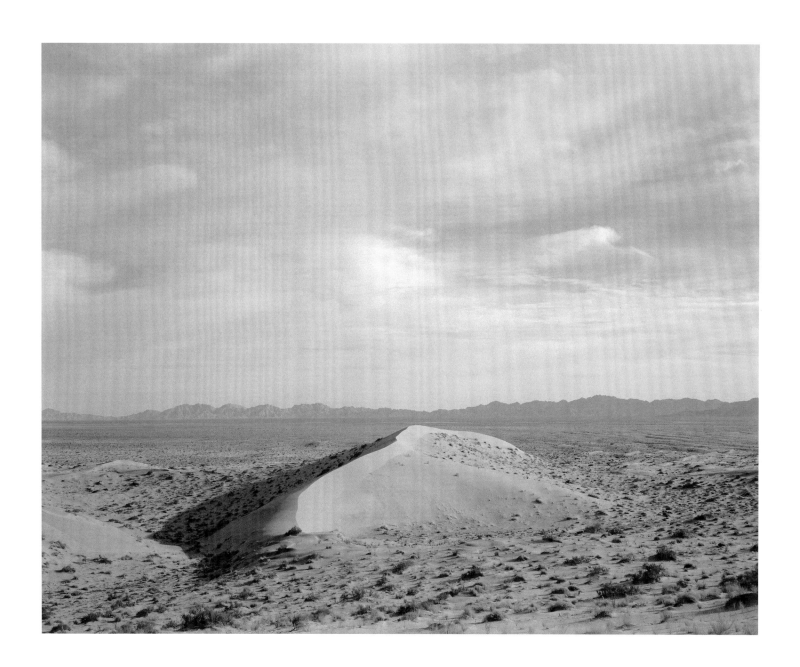

- A ring around the sun. Storm coming.
- Falcon? a fast predatory bird with very bent wings whizzed past.
- A huge, collapsed lava tube at NW corner of Rounded Butte looks akin to main summits themselves.
- Oops, a large flow west of Rounded B., too. Ugh. But not nearly as ferocious as it first appeared.
- 1315 a small rattler. Banded, gray, 9", black tail near button rattles.
- Couldn't identify before it scurried under a rock.
- When there are no trails, everywhere's a trail: says Joe Sam.
- Fragment of Glycymeris shell 1/2 mi west of Rounded.
- Cinder cone: very eroded east wall, west of this second flow. Sheep trails on its flanks, with tracks amidst brittlebushes and sandy cuts. Is 346° mn to Pinacate Peak and about 155° mn to summit of Sierra Blanca.
- 1401: the watershed divide, the trip's crest and literal high point. Now heading down hill, through another flow. An eroded cone poured lava south and westerly.
- 1420 stopped at a sheep niche (like one in Hornaday's book). Sheep scat inside, as well as a foreign Kodak 40 ASA movie film wrapper. Snack.
- Chivos Butte around corner, still out of sight, but can see green of Sunset Camp; Adair Bay sparkling, Picacho Diablo outlined. One layer of clouds below summit and one above it. Expect a change in the weather.
- Has been an unphotogenic day; no regrets about leaving camera at home to save weight.
- Mind wandering: it doesn't matter who's first to the top, as long as we're playing the game, as long as the attainment is in the mind of at least one man for the mind of all men. May as well be in my mind too. Solipsists needn't walk anywhere. What does this blather mean? Must be time for a granola bar.
- Have used 3 quarts water since 1930 yesterday; hope weather cools.
- Can see one of my previous routes following Lumholtz's jaunt several levels downslope to the south.
- 1502: see Chivos Butte, Buried Range, Sierra del Rosario. And spy a good trough through the dunes on this course westward from the Buried Range.
- Halo around sun . . . when it is visible.
- 1528: good cliffs to north; good view of Pinacate Peak, which is for the moment, sun-washed.
- Circled lip of a red cone, breached and eroded to west; sheep beds on north slope.
- At intersection of my course and 25° mn to Pinacate Peak, and 265° mn to Moon Crater, is deep canyon with gouged pools.
- Even Cleopatra probably had a pimple on her butt, so who cares how we look on the trail; the motlier the merrier.
- Moon up about 1630 at 67° mn; will be full the 27th.
- Two big, steep-sided canyons run together here (route and 166° mn to Cerro Prieto and 40° mn to Pinacate Peak). Most impressive. But not too difficult to cross at rim of dry falls.
- Sunset at 1731 on 232° mn.
- Camped at 1820. Great moon. Tired. Know I'm near Tule Tank, but I have water and would like to see it in daylight.

Monday, November 25

- 0100 awakened by hard rain squalls.

- Puddles inside "water safe" bivy bag, so it must be raining even harder than I groggily suspect. Puddles around campsite, too. Measured 1 1/16 inches of rain in GI canteen cup before moved on. Out-smarted myself: used spare clothes for pillow, but they became a sponge.

- 58° at 0730; on move by 0813. In the rain. Can't see top of Chivos Butte for the swirling clouds. Thanks be for polypro jackets. Sleeping bag wet in places. Backpack not as waterproof as advertised.

- Arrived Tule Tank by 0850; hit canyon about 200 yards to south of Tank. Lots of water in lower pools. Recent burro or horse tracks near lower pools.

- Rain and rain. Peak? What peak?

- Clouds to the south, low over the dunes, are tan.

- Filled canteens from puddles (6-8" deep) at Tule campsite. Water ponding everywhere; this is a desert? Didn't attempt slippery rock down to my favorite pool because didn't need to. Took on water to total 8 quarts; had used almost 2 quarts since left taxi: somewhat alarming rate, so will have to ration. Didn't want a bath anyway, though one is being provided gratis.

- A man with a candy bar and a drinking straw could wander anywhere on the mountain today.

- No regrets about leaving camera at home; have seen only two scenes worth shooting; it would be just another thing to get wet. Ever hereafter, I will insert garbage bag inside main pack to give a waterproof liner: this is ridiculous.

- Stopped in wash north of El Falcon butte, stripped off wet cotton T-shirt and slid into polypropylene shirt, a second skin for the rest of the trip.

- Stopped for early lunch. Built a tiny fire.

- Why, you may ask, do I have wet socks hanging out of my coat pockets? A fire going? Why have I re-camped at 1030? Why am I decorating the landscape with colored, moving art?

- I've been wet since 0100. And this backpack is a sponge. Very disappointing, like finding a trusted friend is feckless.

- Lots of desert sunflowers in dunes west from Falcon; made error: put on windpants to protect bare legs, but was colder and wetter with them on and retaining water than without. So took them off and walked bare-legged.

- Pack heavier due to water uptake. Feels a good 4 or 5 pounds heavier, though I may just be that much weaker. Brain is waterlogged.

- Reached Buried Range about 1500. Sand trying to inundate granite ridges.

- Two hawks(?) soaring into the wind and rain, in echelon facing SE; spotted a baby horned toad, immobile, exposed in rain, no sign of life even when picked up; an omen?

- Made decision: no shelter from this mountain westward, looked here for rock niche or tree. Ugh. None.

- Wind accelerating through gaps and canyons. Wind swirl rain behind every rock. No relief. Runoff dredging new runnels, so couldn't 'bury' self in earth's cleavage. Small birds (sparrows?) flit from bush to bush; only obvious mesquite tree was on a slope, and more bush than tree. Wandered around. Mind slow.

- Finally dumped pack below that lone mesquite. Bag wet, pack wet, all wet, but had to dodge wind. Made tea and felt better, but still vulnerable. One thing to fight elements all day and then dry off and block wind. Quite another to face them for night, day, and into night. Moving keeps me warm, but can't move incessantly . . . and body can't rest when shivering.
- Unrelenting squalls pushed by wind to 30 mph.
- So about 1630 buried self in bag and held on. Rainy day: from 0100 until 0800, slackened relax somewhat until 1000, and then steady drizzle and occasional squalls until at least 1900.
- By 1900 winds gust to 45, though moon promises to look in on me. Cleared a few moments, and then it threw more squalls until midnight. Saw Pinacate Peak for first time since Saturday, in moonlight. Clouds lying like shawl around it. Stars.

Tuesday, November 26

- From about 0300 to 0800 fog. Eerie. But good sign that wind will stay down for a while.
- Flocks of birds in bushes. Sparrows yesterday. Hawk heard to north.
- Wonder how they like the rain.
- Thanks to chocolate bars and quick-dry clothes I survived.
- Up at 0800 and cast laundry to sun. Dried one pair sox on chest inside shirt. Left one pair of sox hanging in mesquite bush. That'll befuddle some archaeologist. 62°.
- Have lost half a day, but decide to continue. Is 20 miles to highway and escape, so may as well head on route and not abandon trip.
- 1141: left.

- By 1447 deep into dune trough seen from flank of Pinacate peak—just like I'd hoped. Steep dunes to south, but headed through a pass and into second trough. Longest stretch in heavy dunes was maybe 45 minutes.
- Breeze now from west. Am I in eye of the storm?
- 2 quarts of water gone. OK. 6 remaining.
- 1449: 74°
- Heard 2 trains last night on tracks near Adair Bay. Would have been a sight to see their headlights looming through the fog.
- Fluffy white clouds over peak and over the Cabeza Prieta now; sunny here.
- By 1724: am south of Sierra Viejo range. Strange, almost magical, to see landscape speed past such a slow mover as this human hiker. Flashback of when first came over Pinacate flank and glimpsed Chivos 2 days? 3 days? ago. Losing track of days. Is 224° mn to Picacho Diablo in Baja California.
- 1725: moon up already, though cloaked by clouds at its rise; at 58° mn.
- Sunset at 1734, 234° mn. 68° and all gorgeous!
- Have hit 3 major pockets in the dunes today, so really only about 1 1/2 hours of heavy dune hiking. Rest of time through ephedra bushes and rolling sand, though don't presume that it's level hiking. Nor easy.
- Beginning to realize that rain was a godsend: it firmed the footing.
- Cooled the walker. Blunted the sun.
- Sleeping bag dried somewhat, though large clumps of soggy down in corners. I must have looked like a clothes pole with wet stuff drooping off me.

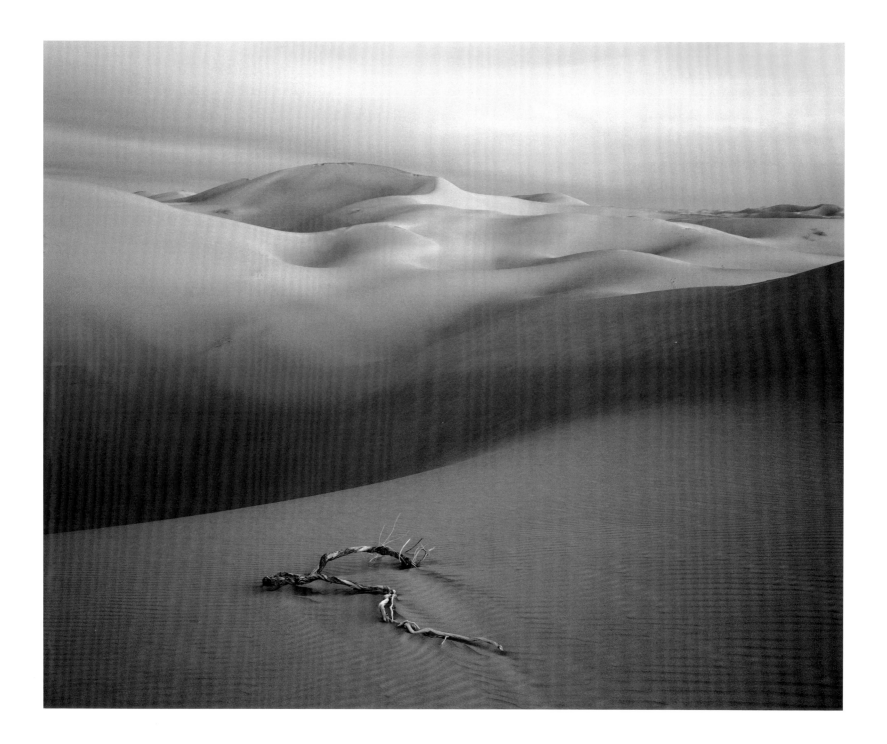

- Heard raven and saw a few eleodes beetles, a few (surprisingly few) red-velvet sand babies, and a sawed-off version of eleodes.
- Great retrospect vistas of Pinacate peak all day long.
- Figure I'm about 1/2 way; now need to trudge, horse to the barn; 349° mn to Cerro Pinto.
- Temp 72° with breeze and lots of clouds on horizon.
- Marched til 1900; hot tea and cold sleeping bag; decided need one good night's sleep; can see a slot in the dunes ahead (estimate at 6 miles away, but maybe is 15 miles off).
- I'm in middle of nowhere south of Sierra Viejo; figure 62 miles to go; will be close on food and especially on water—even after the floodwater bonus.
- Big swale south of Sierra Viejos rimmed on northern side by shifting dunes; then as usual a short stretch of dunes for 15 minutes and back into trough or flat.
- Moon rose well north of Pinacate Peak serenely beautiful.

Wednesday, November 27

- Moved out at 0801, temp 49° and soggy, soggy dew.
- Some wispy clouds and exotic red sunrise. (Let's see: red sky at night, sailor's delight. Red sky at morning, sailors take warning. Is that right? Or is it red sky at night, sailors take fright? Like some impaled snapping turtle that keeps snapping long after it's dead, I think my brain will be long dead but my legs will keep moving. I can become the Lost Dutchman's ghost ship forever wandering the sands.)
- Still trying to dry out sleeping gear. Would be a short task in July.

- Maybe time to buy synthetic-fill sleeping bag.
- If anyone ever did this trip before me, I know what happened to them: they died of boredom. One foot in front of the other. Joints and muscles holding up, though when sleeping I sometimes jerk involuntarily as if still walking.
- Heard two coyotes last night; have heard coyotes every night, usually 3 to 5 A.M. range, and sometimes as late as 8; lots of tracks. Each day see more critter tracks as sand dries out; rain had erased prior tracks. Expected more rodent burrows to show life, but only maybe 1 of 10 tunnels shows signs of freshly cleared damp sand. Maybe fewer animals than one might think. Many burrows caved in, though I can't tell how long ago.
- Does this trip require a brave soul? No, a dull wit.
- 1305: An oil prospect road trending 227° mn. No sign of recent use.
- Looks like one-time use.
- 1321: another trail trending almost on my route at 87° mn, but it disappears in huge dunes.
- Dilemma: walked on the road anyway—so much for principles. Probably could rationalize it as way to not step into innocent rodent's burrow.
- 1413: 76°; some clouds; lunch stop; resting each 1 1/2 hour.
- Still on road. It runs to a slot I've guided on since yesterday. Like to know how they used this road and what procedures they used. A Cat and 6x6 trucks?
- Booms from jets in Goldwater Range; occasional passenger jet high overhead to south. Artistic contrails.

- 1620: road stopped at huge bowl. Could stash a college football stadium in it. An exotic star dune with 4 arms, linking with other star dunes; these are like the ones I hit on prior walk to El Golfo. 300-400 feet from trough to crest. Immense. Like another planet. The movie *Dune* got it wrong and showed sand as blah and lifeless, except for monster worms. Hadn't seen these dunes. Why try to make people fear something as beautiful as sand? Am 347° mn to San Rosario summit.
- Saw 3 jackrabbits today; measured one's stride as five of my baby steps.
- Moments you live for and never forget: these dunes.
- By 1715 out of biggest of dunes. 1752 moon, full tonight, thin clouds; red eastern clouds: red above violet horizon sky over rose (as in rose quartz) dunes. Red to salmon western sky. Subtle changing tints.
- Solitude. Oops, hear a train to southwest.
- 1915-2030: half a dozen huge bowls in immense dunes. Hiking not that hard: contour around slopes, avoiding troughs and uppermost crests.
- Thankfully sand is now solid. If dry and soft, this trip would have been a real struggle.
- Again in giant star dunes 2130. Camped at 2220 when feet revolted.
- Strangest place I've ever been.
- Clammy with fog and dew.

Thursday, November 28

- Thursday (though I must look at watch to know).

- Roll out at 0815. No sun, just a white glow behind the clouds; 62°.
- Hey: Happy Thanksgiving!!!!!!!!!!!!!!!!!!!!!!!!!! Who's today's turkey?
- Still trending down this dune valley with high star dunes on both sides.
- Wearing T-shirt, no jacket; overcast and delightfully cool.
- Clothes getting rancid; ones in pack are even worse, like rags in an old cellar or sweaty gym clothes in a locker.
- Yea! found what must be old head of camote—sandfood—lying strewn on sand, wonderful, almost mythical plant; lots of dumosa, creosote, ephedra, dune buckwheats.
- This is make it or break it day: on last 2 liters of water, and last 2 Hershey's; suspect can go a day without water, but reluctant to experiment.
- 1126: 48° mn to Rosarios; went a whole day without seeing any familiar landmarks, without seeing Rosarios.
- At noon a decision: instead of trending slightly northward of route as forced by a valley (10-15°), I jumped one valley corridor to left (south) to correct course and maybe to get off treadmill. First part succeeded, but second just gave different dune neighbors.
- If bearings are correct, I have 25 miles to go from here. Ugh. But if correct, this is a better valley: it looks open in 3 or 4 miles, with decreasing height of dunes and broadening of valley.
- Rest til 1230: still no sun; 69° . . . a blessing I'm sure. Thought I heard distant heavy machinery; oil well, tractors, pumps? Sound carries.
- Interesting place in life: no options. No escape routes. No recourse. No rescue. No *deus ex machina* possible. Nothing to do but GO!

- Footing progressively easier, but still serpentine.
- Feet ache.
- How much would you have to pay me to get me to do this again???
- Still no sun; ominous clouds to southwest, though some blue patches to north.
- Will be fun to eyeball map when return.
- Many more camote remnants, though I don't know if they linger more than one season.
- 1400: rest, 69° mn to Rosarios; I remember when saw them Sunday from *opposite* direction.
- 1458: sun casts first shadow of the day . . . temporarily.
- By 1510: dunes more like Algodones: rounded and flat-topped, though still some biggies to left.
- 1515: some rounded chert rocks like found west of El Capitán by Lumholtz.
- 1558: could have danced a jig: "regular" desert ahead.
- 1610: hot tea and 2 cookies, 1 candy bar: food going fast. Less than 1 quart water left. Hear occasional notes of civilization to west.
- Only 2 dry socks in the lot. And they don't match.
- 50% cloud cover, and breeze freshening from south.
- Haven't seen a mesquite since the Buried Range, nor paloverde, nor a cactus.
- Ephedras, dumosas, creosotes, desert sunflowers, old friends now.
- 1713: sky reddening; 65° mn to "pink" Rosario summit: lots of camote heads in here.
- Trudged til 2100 when hit a road which trends 230° mn and made decision: want dearly to catch that early bus to town (the I'm-out-of-water-down-on-food-foot-tired blues); if continue straight in to Riito, then may not arrive in time to catch morning bus; however, if slant toward highway, will shorten the route a tad and avoid all the dogs, fields, fences, ditches which introduce one to civilization. So, compromising the pure straight line, I veered left. Crossed four perpendicular grid roads and one main N/S road. A real witch walking through the soft sand, churned by occasional vehicle and more so by cows—cow paths too narrow and hoof craters too short for my feet; actually, worst footing of the entire trip. Soft. Dustlike. A real head-down trudge through here. Out of aspirin, too. Out of Hershey's. Almost out of energy. Feet very sore.

Friday, November 29

- Hit railroad 0059 at km88 +15 paces. Close to El Golfo highway.
- Moonlight subdued because of thin overcast.
- And a wet bag to NOT sleep in.
- Mosquitoes and gnats discovered me when I stopped. So I climbed into moist bivy bag, and hunkered deep down and shivered while listening to the malicious little buzzers. Didn't dare get too comfortable—even if could have—because didn't want to miss bus. Still, grateful: could have been a much rougher trip. But won't repeat it for a few days at least.
- Slept little. More of a bivouac. Muscles twitched all night—and after 15 hours of hiking, why not?—trying to relax and to circulate blood. By 0200 clouds thicken and smudge out all sign of moon. 58° at 0600. Heavy clouds.
- Up at 0600 to sit beside road. Flagged bus. At 0743 no longer afoot. Bus stopped and I got on. No one seemed to question my

how or why or from where. I appreciate their tolerance. I could have been a stranded Martian for all they seemed to care.

- Bus is a retired Superior Coach with 10 rows of seats. Door signs in English.
- 0808 pulled into foggy Riito. Windows fogged up. Visibility maybe 1/2 mile. All side roads muddy messes. Obviously tons of rain here, too. Passengers dressed up for going to school or town or visit; I, dressed down, for the outback.
- 0929, for 300 pesos (you pay as you exit) a stressless trip to San Luis.
- Proud and happy and relieved. I was asked for ID at border. Customs guard said was guarding against an influx of Europeans, but I really think that my hesitation on the tough question—where were you born—and my palsied speech, worried him. Mouth didn't work words well.
- Had candy bar, quart of ice cream, and a Coke from market while waiting for bus to Yuma.
- Lv. 1100, arr. Yuma 1143. Nodded off en route. Legs keep moving.
- Twitching. Very fidgety.
- Small lunch in Yuma. Some folks give me wide berth—a week's beard, a limp and shuffle from battered feet and battered legs, a bag, fishing for money in pocket . . . a few crumpled $1s: all the signs of a wino. Still, waitress at Carl's hamburger shop was her politest. Did get stares when staggered across street. Reminds me of Chuck's comment after one of his recent trips, "When I approached a cop to ask directions and he took his quick-draw stance, I knew I'd been out too long."

- Lv. 1250 for Tucson via Phoenix. Nice traveling dry. Arrive Tucson about 1940.
- Covered about 105 miles straight-line, plus a surcharge of 20 or 25% for the detours.

Lasting Images

- Running water in the Buried Range (Sierra Enterrada). Little waterfalls. Little fingers of sand pushed forward, like mini-avalanches; very artsy. Maybe what it was like 10,000 years ago, though would have seen big trees, not scrubby mesquites.
- The smells at night were extraordinarily intense. If a coyote can smell a hundred-fold better than I can, just imagine its delight. No wonder canines and coatis seem to have their souls in their noses. I think too that one of gardening's prime attractions is its scent, that earthy odor of things alive.
- It was much like a re-run of my favorite movie. Only here, I was the move-ee. A pleasant stroll through the theatre, and not entirely sure how it ends. Still thinking about it.
- The immense bowls in the star dunes. Wish I could describe them. Absolutely awesome, especially being alone and vulnerable.
- Like many hikes, the difficult part is getting to the trailhead and getting from trail's end back home.
- Feel sorry for those too cowed to visit the "wilds." Why is it that half of society seems intent on scaring itself with movies and books? The dark is far too precious to be squandered with fear.
- The out and out pleasure of setting a plan and then doing it; from paper to reality. And the comfort of exercise, of pushing the body beyond old limits. Very relaxing in a perverse sort of masochism.

- Nicknamed this trip "Across the Heart" because it midlines El Gran Desierto from east to west. Did a jaunt several years back which did likewise from north to south, from Mohawk Pass on I-8 to El Golfo, plus salt trips from Ajo to Adair Bay and Moon crater to Adair. Have now hiked an X across Gran Desierto. A long hike is mostly a plod, sometimes interesting, but honest work at day's end. Like reading Goethe's *Faust* or Milton's *Paradise Lost*: I knew I'd been somewhere very special, but unsure I wanted to go again anytime soon.

- Trip of a lifetime. Glad life still has time.

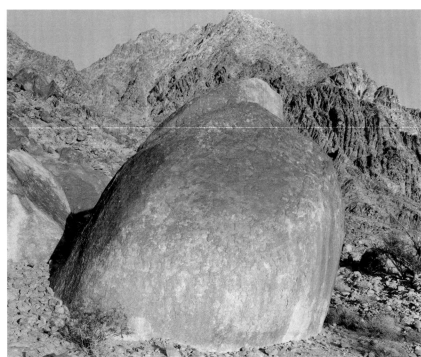

Gear

- Big pack.

- Adidas tennies, running shorts, 2 T-shirts, 4 pair sox, polypropylene long sleeve underwear top. Patagonia jacket, wool balaclava; wind pants; Gore-Tex shell; wool gloves. Wished for wool shirt.

- Maps; compass and flashlight; paper tablet. No camera.

- Emergency kit, small first aid sack, hygiene packet, full bottle of aspirin.

- Hank Roberts pocket stove with one cartridge.

- Food: 2 salamis, 4 boxes (6 each) Hershey's, 4 boxes (x6) granola bars, 1 bag jube-jubes, 1# sugar cubes (soon to be one mess in the rain), about 20 tea bags, 4 cocoa packets, 2 freeze dried dinners (used only one due to limited water).

- Weight: 41 pounds when left home, with 6 quarts water. Leaving Tule Tank, probably 43 or 44 pounds, with 8 quarts (in bottles).

- Will I go again?

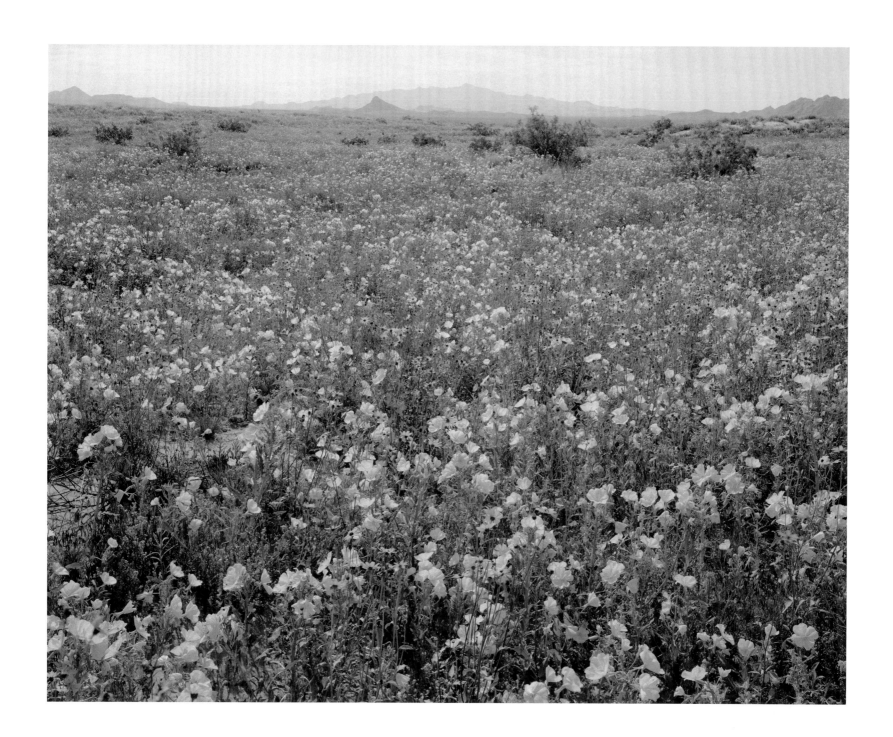

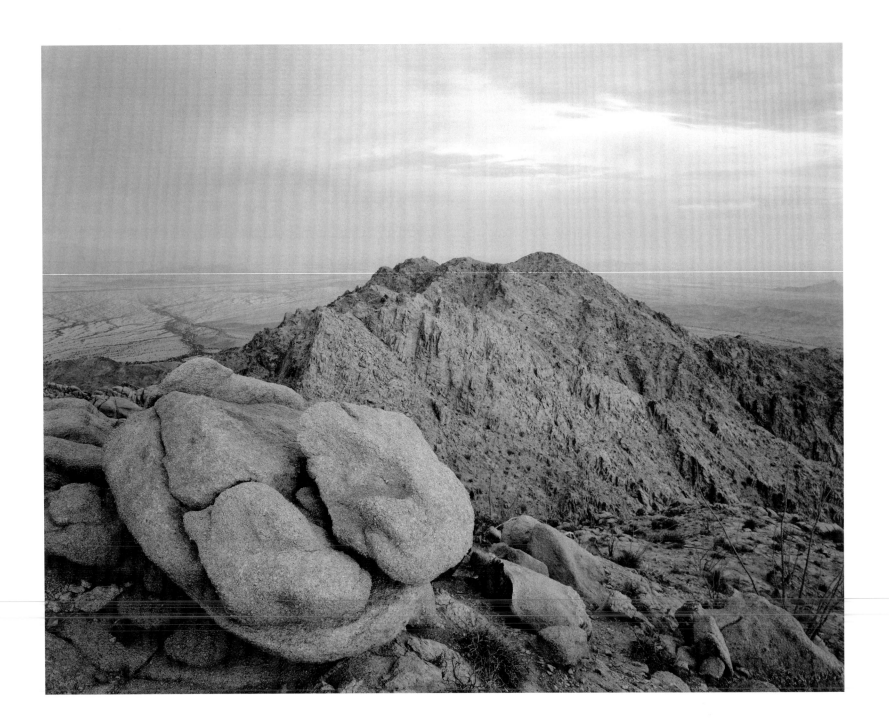

Knowing

WHEN MY FAMILY TRAVELED, we went by car. Before a trip, Dad would go to the corner gas station where we traded and pick up free maps of the states along our route. He marked and folded his road maps ahead of time so he or Mom could look ahead for turns and towns, for landmarks and roadside stops, for multilane routes where we could make time or back roads where we could enjoy the scenery, and maybe even find a cider stand or grassy park with picnic tables. I learned to follow a map and help navigate when one of my parents was napping. The map represented all things possible. If I could connect the dots with lines, we could go there. And, except when we made a mad run to someone's funeral, we had fun when we arrived, wherever it was.

In high school my church group took a hike to Havasupai Canyon, the magnificent blue-water tributary to the Colorado River in the western Grand Canyon. New to hiking, I was a kid with a precipitous learning curve. Our leaders drove at night and we had no map. Someone seemed to know where we were going, but I didn't. I worried what lines we were following.

For the first time, I hoisted a pack on my back. It was a military-surplus wooden backboard to which I had strapped a small canvas bag for under-clothes, socks, and toothbrush. On top I tied my wool army blanket. The lead-

ers gave us each food bags to carry, so I lashed them on, too. The sliced bread I carried became so mangled that we could use it only for dumplings in the stew. Someone should have taken us on a shakedown walk or at least looked at our gear—mine had been borrowed from several neighbors and none of it meshed. Comfortable waist belts, internal frames, and padded shoulder straps were still notions on Dick Kelty's design board.

We parked the cars and stormed over the edge down a steep trail, following switchbacks and walking

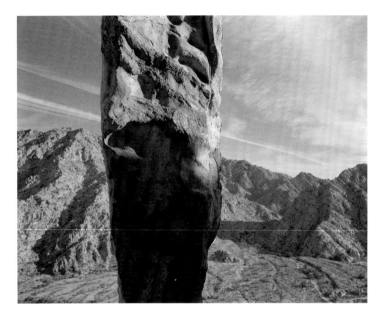

along a sandy wash in the bottom of a gorge. I felt disoriented and had no sense of scale. Back then I could run a mile in less than five minutes, but I had no sense of how fast I could walk or how far. I was a raw recruit at the mercy of our leaders. Somehow I survived. The trip was wonderful and I still have some of those friends. As soon as I got home, I found a map of where we had been and began a lifetime penchant for buying topographic maps and browsing catalogs featuring camping gear.

More trips. More maps. New gear. In a few years I was lucky enough to be wandering the High Sierras of California, the Wind River of Wyoming, the Bob Marshall of Montana, the Fourteeners of Colorado. I couldn't get enough. In the early days, I spent spare change on maps and fishing flies. Friends and I went to the Sierras looking for golden trout and discovered the summit euphoria of Mount Whitney

and the raw beauty of Death Valley. In the Bob Marshall I fished for big cutthroats and lake trout. One summer I fished my way from Big Sandy at the southern end of the Wind Rivers to Green River Lakes at the northern end. And back. Somehow I survived.

Did I ask someone if I was ready for a long solo hike in the desert? I had no one to ask. I had looked at the maps, had driven some of the back roads, most of which were not on maps, knew the major landmarks by sight, and had an idea that I could walk from here to there without crumbling. I had read the basic literature and had "met" with Carl Lumholtz, William Hornaday, Colin Fletcher, Godfrey Sykes, and W. J. McGee on the pages of their words. Going solo is not my first choice, but I'd seldom get out of the house if I waited for a partner or group. And to tell the truth, I'm a little impatient—okay, selfish—about going where I want and lingering when I want. Besides, taking care of myself is a full-time chore.

As much as I loved being in the high school classroom teaching gaggles of up to two hundred energetic students a day, I also enjoyed the counterweight of being alone for days on end. The toughest assignment I ever gave my high school composition students was to spend six hours alone writing their every thought and observation into a diary. The ground rules were simple: no phones, no radios, talk to no one, and pick a safe place, like their own room, a library, or the city zoo.

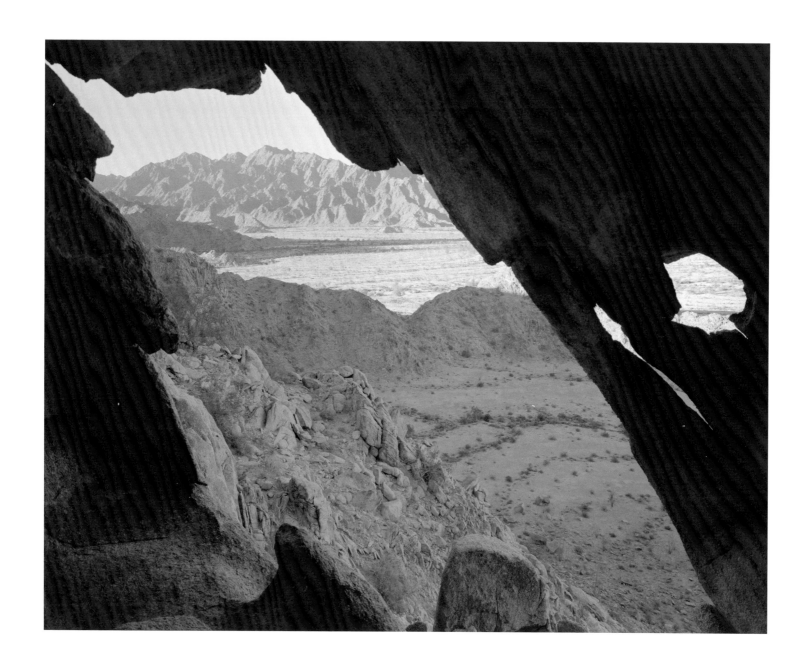

Many were terrified of being alone in their own minds—"What'll I do?!"—but by the end of six hours, most came to realize that their own minds were pretty interesting and safe places to be. I had been there and come back alive and, I thought, a better person. I wish I could have taken each of them, too, across the heart or to gather salt.

Once I went to Sierra del Rosario with a few friends, including a friend's son, who was in my English class and on our school's track and wrestling teams. He was a self-sufficient senior. Following my example and after some discussion, he plotted a walkabout—but neglected to ask for Mom's approval. He shouldered his pack before supper and headed south. Mom soon missed him. I said, "He'll be back for breakfast. He wanted to check out some things south of here." It's a good thing Mom trusted both of us; she was worried but didn't let on. Before lunch the next day he returned, having graduated to a new level of confidence. He had made it to the railroad and back on his own. He carries that confidence today while he searches the remote jungles and mountains of southeast Asia for remains of U.S. servicemen missing in action. When you're ready, you'll know.

Camping comfort is overrated—if I get tired enough, I can sleep in the dirt. Gourmet cookout dinners are too much work—if I want fine food, I'll go to a restaurant that has tablecloths and a chef who won't burn the steak. If I need to be entertained, I'll buy a concert ticket, but I'm perfectly amused watching a lizard chase bugs.

On the first trips I took too much stuff. I had an expedition-sized backpack that I filled with a heavy-weight sleeping bag, camp shoes, a pair of socks for each day on the trail, plenty of food for each meal and spare packages for an emergency, day clothes, night clothes, books, two cameras, and a pile of other useful—but unnecessary—items.

Now I know better. Take water and a few things. In summer, take more water. In winter, take less water and wear warm clothes. Zeno was right: "When we have provided against heat, cold, and thirst, all else is luxury."

When I'm smart, I dress to protect against sun and cold, slip on good walking shoes (running shoes are fine), top off with a hat, and stuff a few gadgets like matches and penknife into my pocket. If I'm going to be away from the car, even for a short walk, I'll carry a light day bag, a cloth to make shade, a compass to find direction, a pocketknife, and a signal mirror. The item we need most in the desert? The name at the top of our list? Water. Water. And more water. If we don't have water in our bag, nothing else matters. After a few hours, we'll kill for water. After a day or two in summer, we'll die for lack of water. The day bag makes life easier; water makes life possible.

And what would happen if we had nothing? This question has crossed my mind and is the subject of countless survival dramas, like the movie *Castaway* (by the *other* Bill Broyles). I figure that if apes can live their entire lives in trees and jungles, I can probably survive a few days in a desert. People have lived in deserts for millennia and done quite well. Some of them have few "things." For a week or two I should be able to be stripped naked and still survive on water and a little food. There's no need to die.

Once I saw a test quizzing what we should take or leave behind. The list was long and the reader had to pick and choose among such things as a winter wool coat, whiskey, electrical extension cord, book, half-full canteen, and other common items. Know what? Every blasted thing on the list could have been used—-in season, it all could have saved one's life. The wool coat? Bedouin wear dark woolen robes to protect themselves from the day's sun and night's chill. And, the coat's

lining could be torn out to make a hat or shirt, keeping the sun at bay. If swallowed, the alcohol in the whiskey would actually dehydrate a person, but it still could be dabbed on the skin to cool off, as well as relieve the usual itches and scrapes. Empty, the bottle could become a canteen to carry water if a seep or pool is found. The book can be used for fire tender or to leave messages or just to calm ourselves. The extension cord can tie a shelter together or make carrying straps. We wouldn't start a trip carrying those things, but if we found them along the way we could make good use of them. Almost anything can prove useful to invent tools and devise shelter, if we're creative enough. We are heirs to a million years of creativity, so we should be able to go from caveman to modern hero within the hour. We already know what fire is and how string works and what spoons and shoes are for: our farthest ancestors didn't.

Stranded? Lost? Down? What we do—or don't do—in the first twenty-four hours likely will determine whether we live or die. Actually, if we lie in the shade and do absolutely nothing, we can probably survive a couple of days. The thrill of pressure? This is it. We can fly apart and die, or take a deep breath and puzzle ourselves to safety. This is a test with no excuses. Pass and we graduate. Fail and we leave tearful survivors looking for our bones and mourning our loss.

We'll likely have a rousing time, but most of our stories will be about what wonders we've seen or how good the breeze felt or the color of the sunset or how much we love our friends and family or how we endlessly whistle dumb tunes—"Theme from the Bridge on the River Kwai" and "When Johnny Comes Marching Home Again" drive me crazy but I can't shake them. Being lost in the desert or on the ocean is a metaphor for being lost deep within the city and trying to connect with people.

The best cure for fear is to worry about our companions or the folks back home, not about ourselves. The real game is not to be better than everyone else, but to become better persons ourselves. My grandmother used to say, "Don't wish for an easy life; work to be a strong person." When the full, innermost stories are revealed, no one has an easy life, and most "failures" I've seen are people who expected an easy one.

The bottom line is this: we can never never never beat Mother Nature. There is no one stronger than the sun. No one is stronger than the ocean. George Mallory, one of the early mountaineers on Everest, wrote, "Have we met with success? That word means nothing here. Have we conquered a foe? Only ourselves."

I had a brief spell when bicycling seemed fun. I even bought a mountain bike and somehow managed to survive a group ride across Arizona from the Grand Canyon to the Mexico border. The bike seemed to offer advantages: speed, ease on the knees, mechanical efficiency, and it could still carry camping gear. I experimented and took a three-day autumn trip on jeep roads to a hidden canyon in the Goldwater Range, and it was okay. The following August I got an urge to ride again, so I took the bike, a little camping gear, and a lot of water, and rode west from Ajo. The first day was slow motion, and the second day even more sluggish. I didn't want to ride farther or to hike away from my camp shade. Lethargy. Occasional dizziness. No appetite. Doubt that I should go farther; doubt that I could make it home. Humbled and disappointed, I pedaled back to town. The sun was telling me "Go home," and I knew enough to listen.

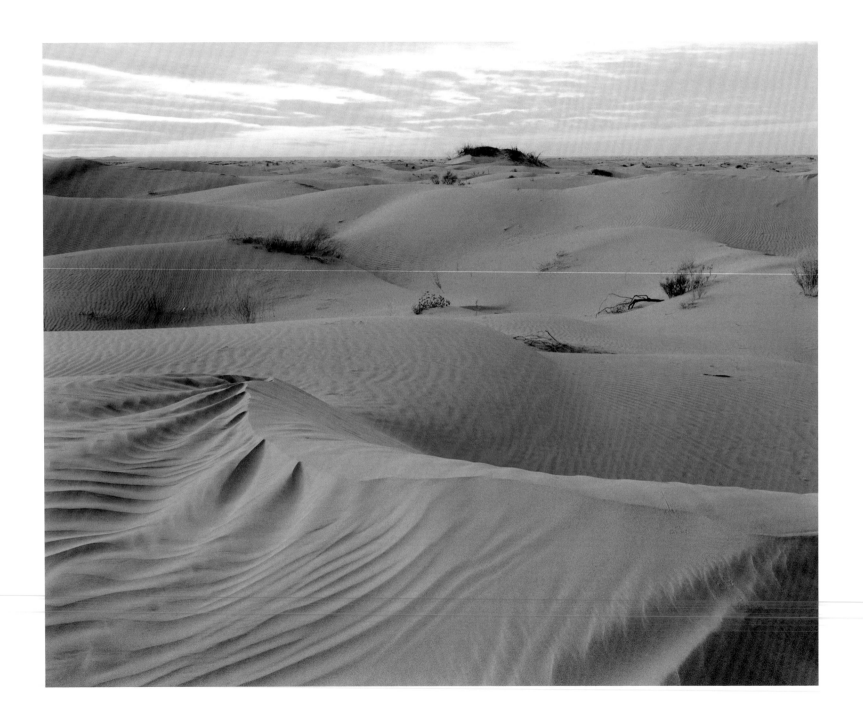

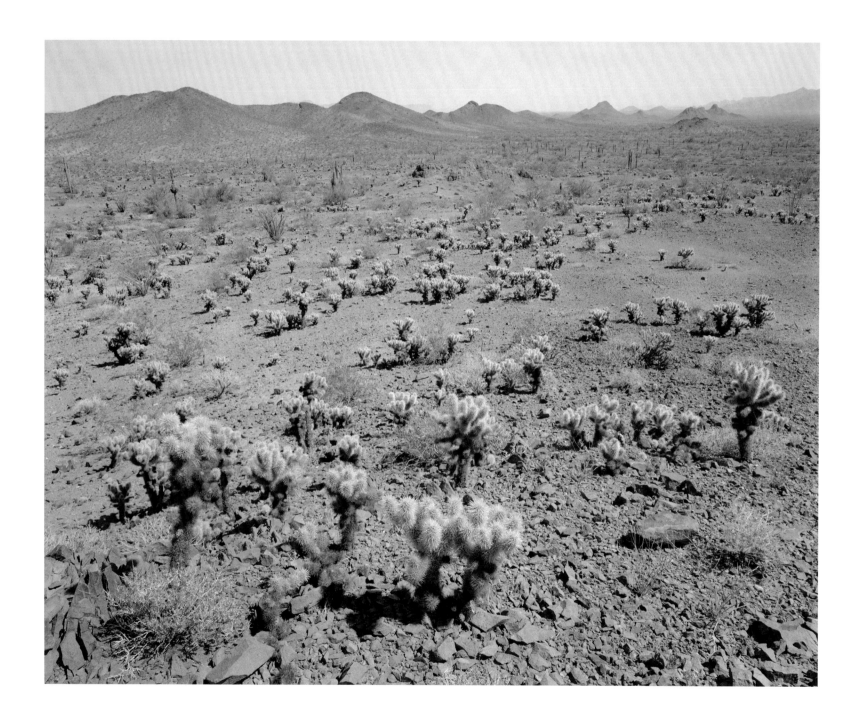

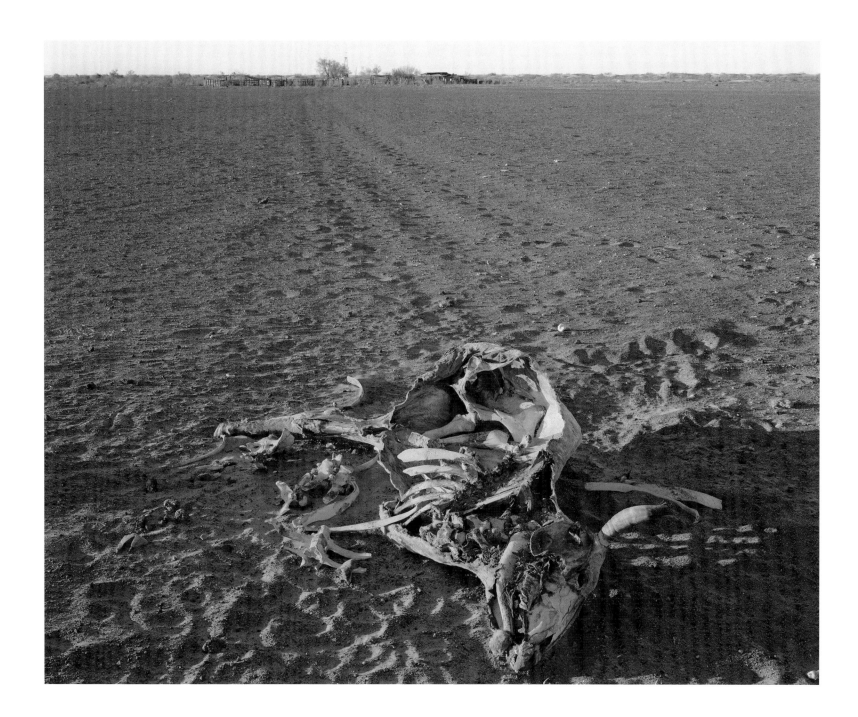

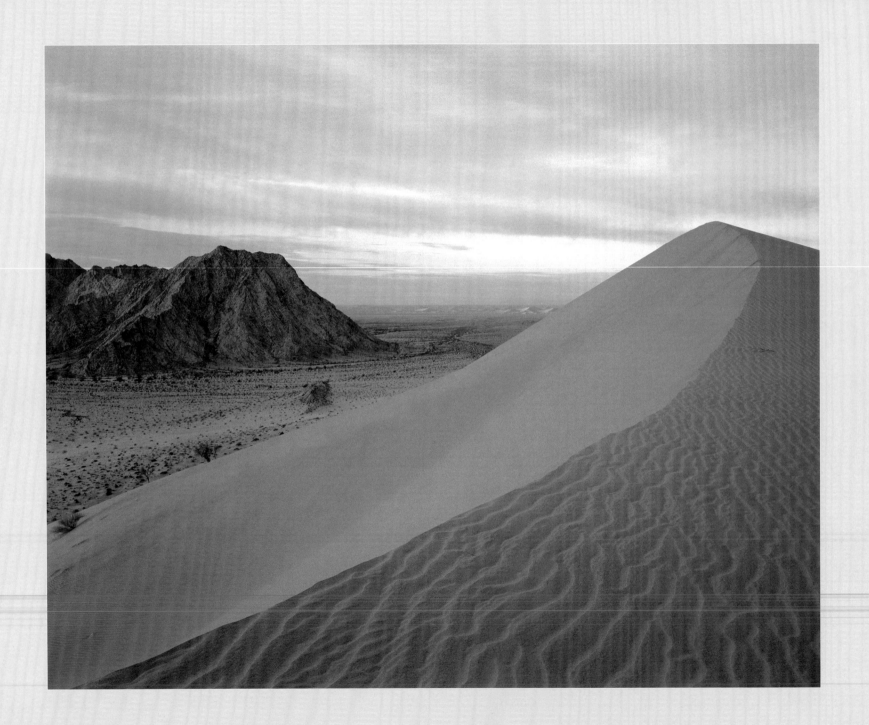

Reasons

LONG DESERT WALKS give a mind plenty of space to think, and although time afoot doesn't guarantee the brilliance or balance of the ideas, it certainly allows them to tumble out in a constant burble of notions, theories, and questions. Why leave a cool home with warm conveniences to wander a wasteland of sand and cactus? Why would anyone go to a place where people die? Where roadside crosses mark fatal head-on crashes? Where thirst shrivels flesh to parchment?

Where can we go that no one dies? Drive across town? Obviously that's dangerous—just listen to the rush-hour traffic reports. Disneyland? No, rides crash and people fall. Home? Both of my parents died peacefully at home in their own beds, and insurance agents rank homes as pretty dangerous places. Hospitals? Many people who go into hospitals never come out alive. Yet we do these things, go these places, and stay alive despite—or because of—the risks.

Like some pilgrim I've gone to the desert trying to find meaning and gone trying to forget some failure. I've gone hoping to discover a new tinaja and gone to enjoy the exhaustion of walking mile after mile. I've gone to be with friends and I've wandered alone for days speaking with no one but birds and ground squirrels. I've gone to find a quiet corner to rest from life's fray for a few moments, like a battered prizefighter repairing to his corner. Life is simpler in the wilds of the Gran Desierto—we can focus and

marvel. I've followed my wanderlust, like the bear over the mountain or the chicken across the road. Long walks and dark nights under the stars remind me that I'm a son of Nature, and even though I reside in a city, I'm subject to Nature's rules and lure. As Byron wrote, "I love not man the less, Nature more."

Adrenaline rushes? Publicity? Loners like me can't afford to walk that edge. We have no backup; there's no partner or film crew to run for help. Caution is law. A rip of adrenaline means that I goofed, made a misstep, was careless and put myself and my trip at risk.

In California's High Sierras, I was coming down off North Palisade Peak, a fourteen thousand-foot summit, and hadn't seen anyone for days. I took a route down a long, steep chute choked with house-sized boulders. As I hopped, stepped, and jumped from boulder to boulder, I could hear and sometimes see a meltwater stream twenty feet below. The holes between the boulders were unlit caves. The rock was dry and I was moving well, in that relaxed zone of efficiency earned by weeks on the trail. It was fun, exhilarating, like a game of hopscotch. I was tempted to test myself, to measure the widest gap I could jump or farthest drop I could make from boulder to boulder. But I didn't. With one slip or misstep I could have disap-

peared into one of those holes, without a trace. No one would ever have found me. Being there was edge enough.

A hiker was having trouble explaining to residents along the Appalachian Trail why he quit his job to walk 2,174 miles. He struggled to talk about the sunrises, the birdsongs, the tranquility, the joy of motion, the thrill of a constantly changing vista. They still didn't understand. Finally he gave up and started using the fib that he had made a high-stake bet with a friend that he could do it. They seemed to accept that.

I wish that instead of writing you a desert book, I could take you there. People don't come to love the desert by rationalizing. They live here for a time and then accept its song or reject its noise. I suspect the logic comes after the emotion, and the rationale comes after the trip, cut to fit the facts of the venture and justify that "it was worth it." Like many things in life, we act first and try to explain later, if ever.

We're back to square one: why go? And once having been there, why do we return? Living is reason enough. I'm not done and neither are you. We have things to do, places to go, people to see. The gates are closing at Disneyland and we have time to catch one last ride.

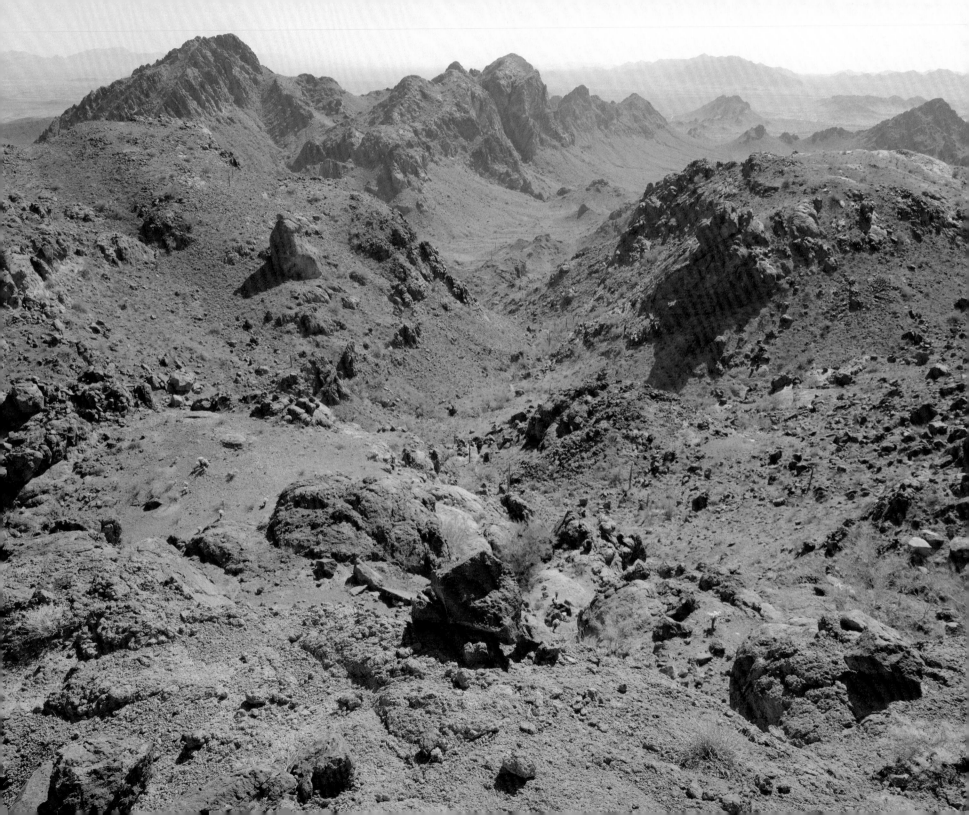

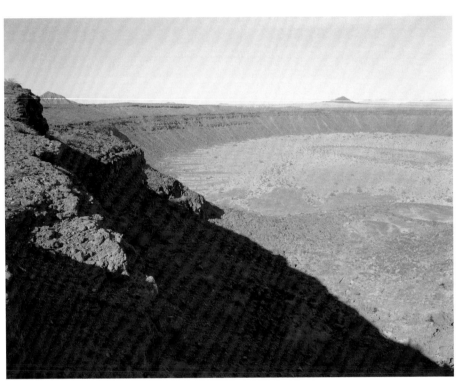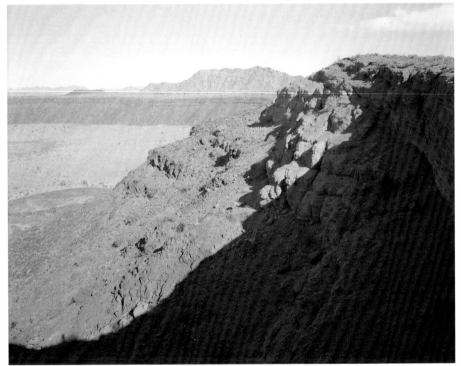

Bowden

If I could only live at the pitch that is near madness

When everything is as it was in my childhood

Violent, vivid, and of infinite possibility

That the sun and moon broke over my head.

<small>RICHARD EBERHART,</small>

<small>"IF I COULD ONLY LIVE AT THE PITCH THAT IS NEAR MADNESS"</small>

"WELL, IF YOU'VE got to eat a toad, don't think about it." Chuck Bowden confronts the green pack leaning against the stack of rocks, grabs a shoulder strap, and swings it onto his back. He grunts against its sixty pounds and wrestles it into place so he can fasten the waist belt. And with a click we're again on the trail in El Gran Desierto. Not many people are attracted to such severe country. Fewer still are willing to venture beyond the sight of their car. And fewer yet will do to hike with. A poor partner is much worse than none at all. A good one is gold.

We're in the fourth day of a three-week ramble through that rude country. It's one rough sucker. The trails today are broken threads of a cloth woven in millennia past by ancient people. Today they are faint and disguised and overgrown. Most folks wouldn't call them trails at all, and even we spend much of our time going cross country. We weave our way as best we can, going with the flow of the land. The walking isn't easy: it's rocky or sandy, it's uphill or down canyon, it's along cinder rubble or across creosote flats undermined by thousands of rodent burrows. Two miles an hour over the day is good pace. And then after a day's gung ho charge we may arrive at a place that looks just like the last.

Trails or no, Bowden loves to tromp around this terra terrible. He is a desert rat. But unlike most of us, reticent and inarticulate, he is able to verbalize what we only feel. He writes what we know but can't express. For many of us the desert is an emotion; for him it is also a thought. "New York City has nothing to tell me I don't already know. You go to Chicago for new ideas. Or to the desert."

It wasn't always so. In college his crowd's idea of a good time was to race and snort through the desert at Rocky Point, Mexico, or the sands near Yuma, Arizona. The desert then was a place to conquer, a place without merit or interest. In and of itself the desert was void and meaningless. He was there to lose himself, to play, to forget life in the rat maze. It was okay to fold, spindle, and mutilate this deserted space. Booze and spinning tires—that's where the action was. But a stint as a researcher for the Arid Lands Department at the University of Arizona was his epiphany. He began to appreciate this land and to know its value. It dawned on him that "If we kill the desert, we may as well kill ourselves."

The desert became his passion. It was a place to release and rejuvenate his voracious energy, a place to study and to know, a place worthy of words. It became a place to find himself. "I'll go sleep a spell on the ground and learn the courage of a spring flower that has waited since the last wet year in 1998. True grit, you know."

While at Arid Lands he researched the problems of water consumption in the Southwest. His report damned the windmill and profligate pumping of groundwater. The department wouldn't print it, so he quit and found a company that would. *Killing of the Hidden Waters* immediately became a classic warning flag. Since then he has taught college history and written a book on Chicago. He worked for IBM in San Jose. He worked three years at the *Tucson Citizen* doing a wide range of features, but he always returned to desert themes. Nowadays he freelances for such magazines as *Harper's, GQ, Arizona Highways,* and *Esquire,* and writes books that no one else can or will. He and photographer Jack Dykinga did a book on the Catalina mountain range north of Tucson called *Frog Mountain Blues* and another called *Sonoran Desert.* Chuck has gone on to write fifteen books. Through it all, he still bills himself as a newsman.

Chuck has an uncommonly strong grip on essences. Though he chides his self-proclaimed mechanical ineptitude, he intuitively and incisively understands how people and situations work. He has the gift of being able to simplify the complex into everyday terms. In Bowden's world a newly appointed administrator becomes "the kid with the sled at the top of the hill"; the land "recoils from machines and the forests are scalped"; and "all editors are assholes," even when his own name is on the editor's door at *City Magazine.*

When he applied for a Guggenheim Fellowship after college, he told the committee he wanted to count cantaloupes. "I had lunch with the jefe who wanted to see just what kind of a nut he was dealing with. I tried to explain to him that the idea wasn't strange at all. The way I explained it, I said 'Look. Imagine the cantaloupe as my great white whale.' And we continued from there to 'I live in the world's greatest economy and I don't understand how it works, how things are produced and shipped and consumed, how people are organized. Maybe if I look at something simple, something isolated like cantaloupes, I could begin to grasp how an economy happens. They're grown in a little desert field, picked by migrants, and then people in New York eat them for breakfast. I want to know how this works.' "

They awarded him the fellowship, but as with any unusual project it was controversial. A recipient in the University of Arizona English Department told him how affronted he was that Chuck had won one, as if cantaloupes immediately cheapened the prize. More recently a physics prof wondered aloud how Chuck could have gotten one when the prof didn't.

Chuck started the project by riding his bicycle from Tucson to Yuma. From there he spent six weeks in Mexico. He wrote a draft—"a three hundred-page hulk" on those experiences. Also, during that year he wrote *Chicago.* Later he trained for the Arizona Challenge bike

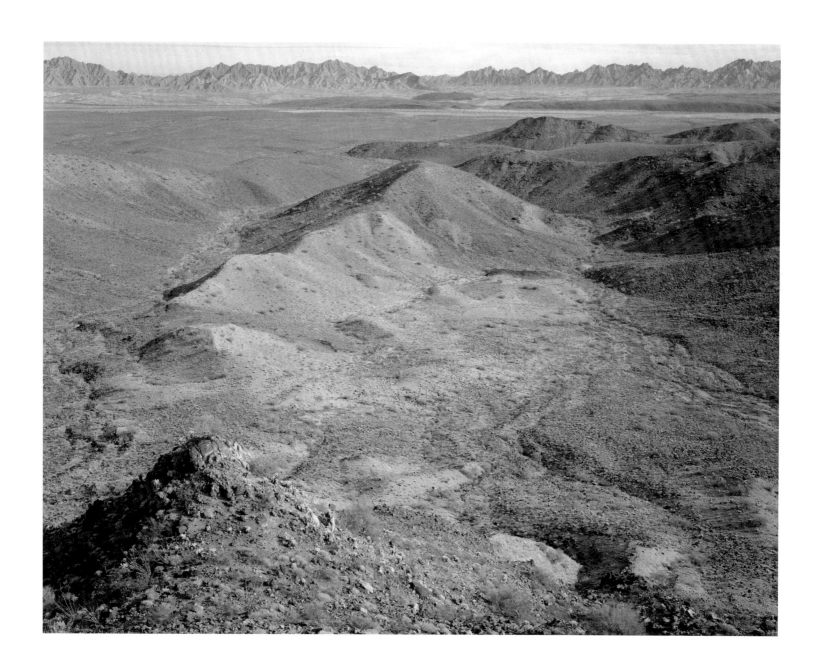

race. It's a 320-mile twenty-four-hour test around the state of Arizona, which includes seventeen thousand feet of hill climbs. He wrote a story for a bicycle magazine on his version of the race. His battle cry was "Bop til you drop!"

We're crossing a lava flow when he drops his hand, motioning me to stop. Then he pulls his binoculars from his heart pocket and focuses on a paloverde tree across the arroyo. "What's that bird?" Neither being able to see it well nor knowing as many birds as he does, I don't venture an answer.

He knows that, but he always asks. "I think its a phainopepla. Yeah, it is. There it goes. Yeah, it flies like a phainopepla. I remember reading a bird-sighting report that a whole wave of indigo buntings was seen moving up the Santa Cruz Valley. What an image! This rising tide of indigo winging northward." He sweeps his hand northward. His own purple jacket hangs from his pack.

We cross the lava flow in the coolness of morning and intersect several arroyos. There the paloverdes are abuzz with bees. Occasional hummingbirds flit to the red-flowered chuparosas. Yellow brittlebush accents the black lava beyond. The sun wears on us as we pick our footing carefully. He reacts to another bird, this one atop a mesquite snag. "Now there's a bird! It's a shrike. See its curved bill and eye stripe? There are three totem birds. The osprey, which is so stately and graceful. The raven, which has a human spirit. And the shrike, which has the body of a robin and the heart of a lion. They drop their prey on cactus spines and barbed wire fences to keep them for another meal. They're afraid of nothing." He beams at sighting a totem.

Yesterday we hiked up Pinacate Peak from base camp. On the return we were greeted by two ravens flying toward us. They croaked their greetings as is their manner. And right then we knew we'd been had. We knew that we'd had visitors in camp. Sure enough, they had plundered our packages of food, and who knows what stories they will tell about finding seeds, raisins, and nuts all in one bag! The gorp was well scattered. We should have known better than to leave food where birds could get to it. Neither of us was mad. Chuck said philosophically, "It's best not to offend ravens. They're such a human bird. Besides, how much can a three-pound bird eat?" The next morning we had barely broken camp when those ravens reappeared on the skyline and made for the remaining gorp.

The teapot quickly boils on the pocket stove and tea is served. It is a nice respite on the march. The caffeine and sugar give a healing shot to the system. Our pummeled feet rebel, so we drop our packs on the shaded sand of a wash and sag to the ground.

"I don't know how you withstand teaching in the public school," he interjects without prompting. "I don't know how to deal with uncurious people. As a student I never enjoyed it. I only had three or four teachers in my life who were worth a tinker's dam. I had one in junior high, one in high school who taught English, and I'd really have to bear down to think of another who not only knew the stuff but could impart it to me. Miss Martin, the one in high school, was the classic spinster who probably went to church three times a day. But she taught honors English and let us read anything—back in the

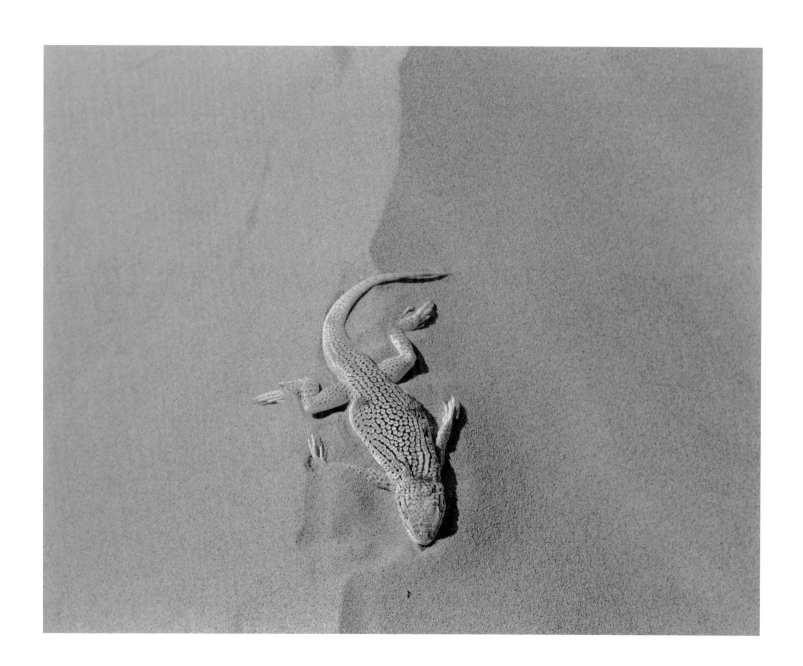

early days that was really remarkable. I learned more in her class by being allowed to be alive than all through the rest of high school."

He fumbles through his pack for another granola bar, rips it open, and continues. "Chemistry bored me. They taught formulas like they were teaching cooking, without any dynamic understanding of the nuclei, without any awe for the whole miracle and its mysteries. I was on the swim team, too. Learned to hate the pool. The monotony of it all, the pressure of it all, took the fun out of swimming itself. To this day I won't flop into a pool for any reason."

He's on a roll now, his subject found and moving. "The reason I got into history—it became my major and I taught it in college in Illinois for a time—is typical of how slippery vocational planning can be. I was trying to get an English class at the University of Arizona, but it was full, so I went down the hall to the next office and signed up for a course on the constitutional history of the United States. I just took it—and loved it. Not exactly that it electrified me. It just was at the right time. As with any good teacher, which the Constitution prof was, it doesn't matter what they're teaching. They're all teaching the same thing: how to think. It always comes out the same whether it's grammar, welding, or physics. That was the toughest course I ever took. The professor would go whole semesters without giving A's. In a class of five hundred there might be only two or three A's. He didn't give a shit. 'Screw your curve.' That was back before the Vietnam War. He was a strange guy. Bitter, lonely, homosexual, strict Roman Catholic, guilt ridden. But a wonderful man. You know how profs punched out the grades on computer cards? He'd write all over the cards, a complete evaluation of each student! Which no one would ever read, naturally. He was for real."

"Yeah, I got an A—earned an A—in that class. But it goes to show what an easy place school is once you're immersed. Or in comparison with a real job. In Mexico at the Cuernavaca Language Institute one summer I was at the head of class and it was like sleepwalking. 'Tough' is when you show up in a strange town knowing no one and have a ten-hour deadline to do interviews, get background, write the story, and file it. Once I drove from Tucson to Ajo and back *twice* in one day. And filed stories both times. After that, anything's easy."

He pokes the tea bag with his spoon. "By graduation, I realized that to teach is to lead out of ignorance. The best at it are charlatans in real life. They perform but don't need to know much. In grad school the teaching game is to know more than your students, but you don't have to teach. By then students teach themselves."

He sips the tea and he smiles that he has wandered into a serious conversation here in the Big Desert. "It's awfully hard not to like life when you're sitting here in a strange canyon in the shade drinking tea." He pulls a book from his pack and proceeds to knock off a few more pages of Frank Norris's *The Octopus* while I stray off to shoot a couple of snapshots. Finally comes a time to resaddle. He quips, "This reminds me a line from a Marine gunnery sergeant at Belleau Wood in WWI just before they amassed an assault from the trenches. He yelled, 'Come on ya sons-a-bitches! Do ya want to live forever?'"

After two more hours of walking, we throw down our packs for a water and sock stop in a flat area bounded by bushes. The conversation starts with, "I never can keep burrobush, saltbush, and bursage straight. To most people they're just weeds, but they and creosote bush are the essence of the desert. When the University of Arizona wanted to plant something monumental for its centennial, they should have planted a creosote, because it'll still be there when we and the U of A are ashes. It'll grow on all our graves. Creosote bush is a plant of two continents with many exotic gene shifts. But no one except Carl Lum-

holtz ever sang its praise. No one ever voted for a Creosote National Park, even though it's probably the most prevalent and important of desert plants. Saguaro and Organ Pipe parks promote trophyism, not overall understanding."

He shakes sand and grit out of one shoe and flops the sock on a limb to dry. "Why don't people hike here more frequently? Nobody's ever told them they could or should. The desert is as empty for them as it sinister. They've been raised with a pine-tree mentality. Have you ever been to Great Basin National Park? It's just as uncrowded as this one is. It doesn't exist.

"Of all the people who have ever loved the Pinacate or the Cabeza, none of them have ever tried to live in it, not McGee, not Ives, not even Tom Childs. They've always lived on the edge and just visited. Actually, it's a model of how people should behave. The whole sad history of the frontier is people loving it to death. But not here. The land refuses." He examines a worrisome stone bruise on one foot and obliquely comments on pain before rolling the socks back on. "I've never run nine miles. It's either eight or all the way to ten. Like in the Grand Canyon. I'm an uphill person. Going downhill you hurt your knees and do nothing for yourself. Uphill you do no damage and you get stronger."

By midafternoon we reach an ancient campsite on the basalt rim above a tinaja. He kicks rocks out of the way and unfolds his foil ground sheet. At the head he stacks rocks so he can make a chair back with his pack. He unrolls his pride-and-joy blue sleeping bag and unfurls his red sleeping pad. With yellow hat, candy-striped shirt, blue shorts, and white shoes he is literally a colorful character. In his own words, "I'm a beacon to every nectar bird in the county." He settles in to read while I prowl for signs of life among the bushes.

While I'm away he finishes *The Octopus* and starts John Reed's Pancho Villa classic *Insurgent Mexico.* "Here I am leading the life of Reilly lying in the desert reading a good book about bad Mexicans. This is better than home! Reed is so admirable. He was there but not central in the story. With his vignettes and details, he was true to his own emotions and yet faithful to the times. He was what a reporter should be."

Bounding back to the morning's conversation, he remarks, "That Constitution class was rough. The prof was strict on writing. He wouldn't let me use passive verbs. He made me pay attention to language. Passive verbs always create languor. The only time to use them is when you want languor. For practice I'd write whole papers without state-of-being verbs.

"My father wrote just in a business sense. He wrote in a very simple style. He hated pretense and loved declarative sentences. He admired 'All Gaul was divided into three parts.' My father hated adjectives. He thought that Hemingway was a macho asshole. He loved Shakespeare. My father thought that Shakespeare was the greatest writer who ever lived. He used to sit me down, take sentences out of Shakespeare, and tell me to try to eliminate a word without changing the intensity of meaning. We couldn't." He smiles at their futility.

"You want writings? Look at Dreiser, London, Edmund Wilson. Don't look at Henry James. His *Golden Bull* is a novel literally about nothing. I once almost flunked out of a class for writing a fifteen-page parody of it. The prof ascribed it to my creative foment and decided to grade my other assignments instead. I don't like what he writes about or how he writes. His are monuments to style without substance."

Chuck marks his place in the book and reaches for a chocolate bar. "When you write, style should just occur. It isn't something you try to create; it's the result of getting rid of things that don't belong. It isn't something that you sit around trying to fabricate. It happens. It's like

finding your own voice. Some don't like my style, like that parody letter to the editor of the paper which attacked my style. I wasn't offended. If she didn't like my voice, she didn't have to listen. In my world rivers really do 'smack on the bank.' Some writers are so conscious of style that whatever they're writing sounds the same. Newspaper people are prime offenders. It all sounds the same, like one note. But it falls apart on something that matters, on something tragic or heroic."

"When I get an idea for a story I try it out on another writer or editor. If they say I'm crazy, then I know I've got something original and worthwhile. Like the wetback hike across the border in June. People told me how stupid I was. They didn't remind me when the awards came rolling in." For pieces on undocumented entrants crossing this desert, Chuck won the Gannett Newspaper syndicate's top award and the Virg Hill Award as Arizona newspaper writer of the year. He gave the plaques to his mother to hang on her wall. I've heard him mildly deprecate himself as a "word viper," a "windjammer," and a "bull slinger." When the newspaper tried to capitalize on his prominence to sell more papers and put his full-page photo on the back of the Sunday funnies, he shrugged and said, "So now I'm a comic character."

"If you're going to be a famous writer," he once admonished, "you've got to be immune to failures." Now he breaks the bar and hands me half. "After the awards I went in for a pay raise. I wanted 500 dollars a week—not 499, not 501. Just plain 500. It was a matter of principle. They didn't want to give it to me and handed me the line 'Well, other people here work hard too.' 'Fine,' I said, 'then call those other hard workers when you need someone to hump across

the state at two A.M. to cover a riot. I certainly want to share the glory with them.' They gave me the raise."

News is in his blood. Even after quitting the paper, it fills his conversation. Evidently few things give the rush of filing an exclusive, incisive story. Few things matter more than writing itself. "I was the only one down there at the paper who just wanted to write. I didn't want to edit or manage—just write. They never understood that and were offended when I passed up their parties and ignored their social network. It was cold around there when I grabbed a couple of awards. The first year I was just a flake, but then I became a threat. I just wanted to write. But most of them went to journalism school like that ensures and legitimizes their every word." He shakes his head.

"Newspapers need a rule that only one of every five on the staff can have studied journalism. Too few of them have any life experience or anything original to say. Most of them just spiffy up what they've been told. Newspapers need to get people who know something, take a week to tell them the mechanics of putting out a paper, and then turn them loose. The bureaucracy is straightforward, but the writing . . . learning to write is a lifetime job. It's really finding one's own voice."

He wads the wrapper and stuffs it into a pack pocket. "And writing, at least for me, takes time. It's a selfish enterprise, at least that's what other people tell me I am." He reclines and reopens the book.

We're tired and foot weary. Carrying big packs over rough ground is, in sum, rewarding—but not all the parts are equally fun. The feet get beat and the hips bruised. A salt-gritted T-shirt rubs the armpits, and filthy socks stain the feet. Resting, sitting down, leaning against the

pack instead of wearing it are rewards. Nobody carries a pack around the block for an afternoon stroll—that would be torture. The pack is a means. And we, the weary, mean to rest. The fable is told of the hard-pressed and hard-working cowboy who regularly bought his boots a size too small. They hurt his feet and his painful limp was obvious. A friend asked him, "Why don't you get some boots that fit?" "Well," he drawled, "most days, takin' them boots off is the only fun I get."

So I guess we're having fun. A slug of water, a munch of candy, a seat on the sand—the mind soon forgets the chafes and strains of hiking. It selects the pleasurable essences. Hiking is a cross between numbness and Nirvana. We have taken our boots off and now dream of more.

We never finish one bout with the trail without planning the next . . . and the next . . . and the Chuck remarks, "There are so many hikes I'd like to take in the historic sense. Wouldn't it be nice to cross the California desert and the Sierras like the forty-niners? It's a route ready-made. Or maybe try the El Camino del Diablo in June to see what it was like for those travelers? I'd like to climb Navajo Mountain in northern Arizona. It's one of the power points, a place with a past. Over by Yuma there's a sacred mountain which was the power point for half a dozen Colorado River tribes, and I want to climb it. At home I have five objects which I don't know why I collected. They are an Indian mano, a rock ball, a stone chopper, each very old and made by people long past, plus a photo of my father as a child in 1904, and my father's .45 pistol. I don't collect things, not even books, which

I simply devour like food. So why do I have these things?" He looks away as if the reddening sky will answer his question.

"This summer I hope to go on a canoe trip to the Sweetgrass Hills by Great Bear Lake in Canada. We'll need beekeepers' suits to keep the mosquitoes off. Should see some grizzlies, too." His smile gleams with anticipation. "The hike that really enchants me is across Arizona. Start in the southeastern corner by Guadalupe Canyon and mosey northward to the Arizona strip and the Virgin River. It would be the Virgin to Virgin hike. I'd swing by San Francisco Peaks and maybe Oraibi before crossing the Grand Canyon. Ten miles a day. Do interviews with the people. See all the life zones."

After a pause, he waves his arm and adds, "I spent my childhood listening to adults explain why they never got to do what they really wanted: the trips they missed, the jobs they never tried. I don't ever want to have to explain."

With the scissors on his Swiss Army knife, he carefully cuts the top of the foil bag that holds a freeze-dried dinner. He pours in the boiling water, stirs, and waits for it to "cook." "When I was a five-year-old kid in Chicago, one of the TV stations had a kid show. It had skits, movies, and stuff. It also had a huge penny bowl where a kid reaches in and gets to keep all the pennies he can handle. I got a chance to be on the show and reach into the bowl." He chuckles at the memory. "I reached in with *both* hands and of course couldn't get either out—but I wouldn't let go either." In the desert twilight his eyes twinkle with impish delight.

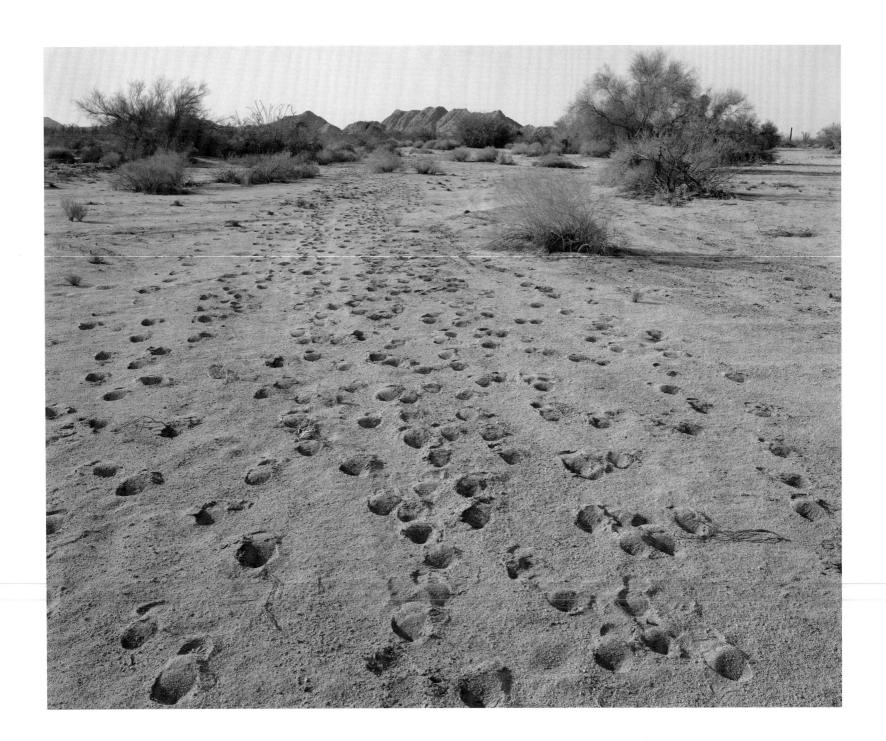

Ground Zero

A couple of gallon plastic jugs sit in a corner of my office, along with a yellow shopping bag stamped in red letters "Casa Wong: Ropa Fina Para Jóvenes y Caballeros. Mexicali." Inside the bag are a pair of cutoff jeans, a blank notebook, and a toothbrush. Years ago I found them in the Pinta Sands, and I keep them as a reminder of the millions of refugees and migrants around the world who leave home with the clothes on their backs and a dream in their hearts.

Some die. Early in the twentieth century Jeff Milton was a border rider for the U.S. Border Patrol and Customs Agency. His job was to intercept smugglers and foreigners trying to enter the United States without proper papers. Accompanied by his dog, riding horse, and pack horse, Jeff rode regular patrols from Sonoyta to Yuma and then back. He tracked sign—footprints, horse tracks, campfires, clothes, and household goods discarded when they became too heavy to carry. He nabbed people—jailed some, buried others, and sent most back across the line.

Foreigners without documents—*los indocumentados*—still try to enter the United States between Sonoyta and Yuma. Still some die in this stretch of ground, suffering hard deaths by thirst. Imagine those who endure the agony but do not find rescue. Imagine others, one by one, two by two, falling into the sands never to rise again, knocked senseless by heat and lying under the partial shade of a creosote

bush, waiting for the angel of mercy or the devil of death. For some, they're the same angel. Once out of water, most die within a day, some within hours. It is quick, but not painless.

The land where I can walk contentedly for weeks and not see another person is also the land where I may stumble across a human skull in a sandy wash, find tatters of clothes hanging from a cactus, or come across a dead man sleeping under a paloverde tree, his radio turned on but batteries drained, his head on his jacket for a pillow, and looking as serene as if taking a siesta in his own village. An agent recounted finding bleached human bones and clothing scattered over a wide area of an arroyo a full day's walk north of El Camino—in the sands, under trees, next to the cliffs, dragged by coyotes and rodents, washed by rains and flashfloods. He and a friend tried to count the number of skulls and femurs, but they lost track at several dozen individuals. They found no identification papers. They didn't call for a coroner. No one could imagine such a place.

⌒

When steelworkers and blacksmiths prepare carbon steel for tempering, they watch its color. The torch is applied or the furnace opened, and raw gray ingots and slabs and flat stock are immolated by fire. When steel glows faintly yellow, it is 420 degrees Fahrenheit and suitable for tempering knives and hammers. At light yellow it has warmed to 440 degrees, material for lathe tools and reamers. The tempering scale rises through browns—axe heads are brown—yellow at 500 degrees, on through purples and into blues, where medium blue denotes 600 degrees, suitable for tempering scrapers. The metal is heated and shaped, then quenched in water.

Bright red—1830 degrees—is the mark of hardening steel, steel that is durable but brittle and ill suited to sharpening. It refuses to hold

an edge and becomes stout but stolid. Beyond that pall more flame is needed, moving from orange-red, orange-white, and into yellow-white. At 2550 degrees the metal reaches white hot, and if we can withstand the glare and heat, we can push the metal to brilliant white until finally, it reaches *blue-white*, 2900 degrees, and melts, intractable and useless.

In the dead of June, high-pressure weather fronts scorch the Southwest like a torch clamped in a vise and held to one spot of metal, unmoved and unquenched. From mid-May to July, when the tempering monsoon rains come, the desert sky feels the torch and turns molten. By night the air is deathly still. Before dawn we sweat and toss on our cots and dread the rising sun. The morning sky glows indigo, and then a thin orange line appears on the horizon. Venus glows above and the sky brightens and pinkens, then yellows. By midmorning the heat fires the heavens, rendering sky pale, finally reaching the blue-white of heat that scalds all color. This is lifeless summer, a time when kangaroo rats huddle belowground and cactus wrens, mouths agape, flit from tree to tree looking for more shade. Lifeless skeletons, once human, are found later, after wind shreds away their clothes and leathered flesh, after their bones whiten, when the whiteness leaps from the pervasive, dulling brownness and skewers our squinting eyes, as if we are seeing a blanched soul arise from the dead.

In the time of the dead I venture into the furnace.

⌒

In the desert sun Carlos and Paco hop down from the bed of a dilapidated Chevy pickup. They reach back for their gear, and the kindly driver gestures toward the arroyo leading northward. They have ridden the rails—an honorable custom in Mexico—to Caborca, Sonora, and then hitchhiked to here, El Sahuaro, a truck stop on arterial Highway 2, which parallels the Arizona border. They come because they have heard

of jobs. In their hometown, Acaponeta, Nayarit, there are no laboring jobs open now, nor have there been for many months. None. An uncle once came to the U. S. of A. to make more money in a day than he could in a week in Mexico. They are coming to find work. Any work.

"It is very hard at home. I work to repay friends who help me, but that isn't a job." At the main PEMEX station in Sonoyta they fill their water jugs, discarded one-gallon plastic milk containers, and pray two will be enough. A dozen tortillas, a pouch of frijoles, and a hunk of goat cheese to fuel the legs. A few jalapeños will temper the hunger. Their mesh shopping bags each hold a razor, toothbrush, spare shirt, notepad, and magazine.

They have heard that at El Sahuaro water is sold to *mojados* ("wets," as even they call themselves, though the legal term is UDA for undocumented alien) for a dollar a gallon. They use a hose behind the building. They hoard their few traveling dollars and bypass the lure of a filling meal and cold soda inside the cafe.

They wave thanks to the driver, hasten purposefully into the wash, and settle into one of the etched trails. They have no map, no compass. Their fate hangs on verbal directions from a driver who has heard about the route but hasn't seen it. "Walk the arroyo through the pass for a few miles to the U.S. Then you'll see a big, wide pass. Through it you'll reach a highway, and beyond it, farms and work."

Loosely, these directions are true. Strictly, the route is fifty-plus miles through uninhabited and waterless desert. Interstate 8 is the first public crossroad. Farms do lie north of it, but jobs are seasonal and frequently already filled; a larger job market, Phoenix, is another ninety miles afoot along the railroad tracks. Hunger and thirst can't wait that long.

The trails merge with a road, and despite the midafternoon heat, they walk briskly another two miles to la linea, the American boundary. Here the border lacks formality or formidability. There is no inspection station. No sign of welcome or rejection. No statue of Miss Liberty. Not even a fence to bar stray cattle. A lone sign forbids vehicles; a faceless, weathered plywood sheet may have warned of a military gunnery range; piled rocks spell out "Mexico" and "USA."

They are now "ee-wees": EWI, entry without inspection. They have no papers to work or travel in the United States and will be returned immediately to Mexico if caught, unless they violate other laws and are sent to jail. Others will leave today from El Sahuaro, La Jolla, Los Vidrios, Sonoyta—names famous among UDAs because they are wide, nameable spots on a thin highway. Some will ride the bus from Yucatán; some hitchhike from Sinaloa with truckers; some hire a professional smuggler, a "coyote" or "pollero," to drive them from southern Mexico and then rendezvous with another coyote once inside the United States. Others simply have a friend drive them over from nearby San Luis. They are the same: they have nothing, and they're willing to work for something, for anything. They are prepared to suffer and endure. They are even prepared to risk death, just to look for work.

They arrive with a few dollars tightly folded and hidden in their shoes or pinned inside their underwear. Some carry small travel or shopping bags; some carry only what their pockets can hold; some carry literally the clothes on their backs, heading into the unknown dressed as you or I might to walk to the mailbox. These are the restless, the brave, the desperate. At home they work for two to four dollars a day—if they can find work. Here they may clear twenty-five to forty dollars a day. For some it is a periodic ritual; for others, a first time. They may stay in the workforce if they get that far—or stay dead in the desert.

Carlos and Paco pause, drink, joke about standing in two countries at once, and walk on. The mountains blunt the falling sun. A few quail stir and a jackrabbit bounds away. Sidewinder tracks engrave both sandy ruts of the road. Carlos and Paco know they must reach

the farms tonight. A delay, an ankle twisted in a rodent burrow, a foot bitten by a rattler, anything, would extend them past their water, lure them into the realm of thirst and jeopardy. Others don't even know that much about the journey ahead. Once in the United States Carlos and Paco look around more frequently; they joke and talk less. This track tees into a wide, sandy road. To cross it they walk backwards and then sit beside a saguaro to plot the skyline. Mountains block the west. Due north rises a mountain castle. Northeasterly, a pass cracks open and reveals a distant rippled range. To the east black and brown mountains remind them of jagged broken glass on a patio wall.

The temperature today, July 3, has reached only 108 degrees, a bit cooler than it might have flared. Still, they each have depleted two of their eight quarts of water. They sight on Big Pass, as both they and the American authorities have come to call it, and head across country directly toward it. The walking is easy, cushiony and pleasant. Cactus are avoidable, even between twilight and moonrise. They walk. For hours they walk, occasionally stumbling as their feet collapse rodent burrows. Once when they crash through an undeniable thicket lining a wash, a viper rattles; they flinch but don't investigate. They are too tired to even increase the pace. Big Pass still seems far; the walk, interminable. When it is reached, they still see no signs of civilization—no lights, no paved roads, no nothing. It is almost midnight; they are tired and sleepy. More importantly, they have finished one jug apiece. Untying the rag handles binding two jugs, they pitch the empties into an ocotillo. They cling to hope, to faith, and guide on the distant nipple of rock.

Yet anxiety is hard to stifle. If civilization is farther than they've come, they'll be thirsty tomorrow. And they'll need to travel in the daylight! Here a man can hide forever in the vastness, but he must travel in the open; and in the summer with one gallon left, he must travel. There is scant margin for safety. Even if they survive the trek,

they still must trust to God. Can they find work close by? At all? Many travel futilely to Phoenix and beyond.

Will they fall prey to an unscrupulous labor contractor who will cheat them, maybe even murder them? This has happened in other areas. Will they live in a field, under a tree, or in a cardboard box? Many do. Perhaps they can find a "wet shack," a rotted remnant of what was substandard migrant-worker housing fifty years ago. Will they be discovered after finding work? One raid at a ranch in this valley netted ninety UDAs. If discovered will they receive their wages? The authorities try to help UDAs recover wages, but when a worker says, "I've worked six days," and, as has happened in other valleys, the employer says, "I never saw him before," the recourse is slow at best. Employers in this remote valley have earned their reputation of "fair pay for fair work," which is one reason workers venture this hot desert. Even so, worry lingers, but their fate is equally unsure back in Mexico.

So they continue, grudgingly, and speak seldom. An occasional oath at the distance. A cheering joke. A slug of water. A few drops of water on a bandanna to dab their salt-rimmed eyes. A comment on a scurrying pocket mouse. By sunrise they are in the rolling sand dunes south of their pass. They have heard a train. And seen car lights on the interstate. They would like to rest their cramping legs and blistered feet. But here no trees shield the rising sun. No water stands to fill their nearly empty *botas*. In the dawn they come across other sets of footprints. They see an occasional discarded jug or shirt or even a shoe. Paco thinks he sees bones bleached beside a creosote bush, but he refuses to look closer, crosses himself, and moves on.

At sunrise the dayshift of the U.S. Border Patrol readies for its job: catching UDAs like Paco and Carlos. At 0600 the agents assemble

in their outpost, a small house converted to offices and a holding cell. Overhead the United States and Border Patrol flags fly twenty-four hours a day. Outside, tired patrol vehicles rest, but don't heal, in a fenced compound. This day four agents will patrol, aided by a spotter plane from Yuma. Their game board comprises thirty-five hundred square miles of flat farmland, rugged ranges, and vacant desert in eastern Yuma County. The few agricultural settlements bear names like Wellton, Tacna, Hyder, Dateland, Horn, Roll.

Dusty roads criss-crossing the area record tire tracks, footprints, snake marks, coyote pugs, and raindrops. These are stories in the dirt. The Border Patrol agents in this sector are trackers. With practiced observation, logic, and tenacity, they read these stories and write the resolutions. If you walk your dog, if you jog, or if you stop to take a picture, the story in the dust will be read within twenty-four hours as surely as if you wrote the details in ink on paper. If you are in the country illegally, they will trail you through creosote flats, over mountain passes, across railroad tracks and canals, into towns and orchards until they catch you or are convinced you've caught a ride out of the area.

Reading a trail for two days and seventy miles is not uncommon, though most hunts cover just a few hours and two or three dozen miles once the track is found. It's like saying that if you walk across an area larger than Rhode Island plus Delaware, one of these agents will know it. And the odds are better than 50 percent he will apprehend you.

Some catches are lucky and easy. While driving along a paved road west of Wellton, agent Glen Payne spots four young men sitting under large cottonwood trees in the yard of a white wooden farmhouse. One passes a jug to another. Glen knows who lives there, and it isn't these guys. He knows the style of their jug. He knows the mode of their clothes. He wheels a quick U-turn, parks fifteen feet from them, and approaches on foot. "Vamanós a México." ("Let's go to Mexico.")

Within a minute they're looking out from the barred truck windows. It's that simple. Aged seventeen to twenty-two, they have ridden the rails from El Paso. They are surprised and discouraged to learn that after three days of grimy railyards and freight cars they're still only forty miles from Mexico. From one jug they drink orange juice squeezed in a grove where they stayed. They wear tennis shoes, slacks, and shirts. One shirt reads, "Go Greyhound." They have no bags. When asked what possessions he has to declare, one pulls a handkerchief, a comb, and an empty nylon wallet from his pockets. One has a wristwatch with a broken band. Another has only lint in his pockets. They will be released at San Luis by sundown and walk back into Mexico.

It's not unheard of for exhausted or discouraged UDAs to turn themselves in to agents for a ride back to Mexico. I can vouch for two who flagged down a patrolman and yelled in English, "Let's go San Luis!"

Other apprehensions involve assiduous detective work. "501 to 504." Joe McCraw calls Dane Bowen on the radio. "The plane has new tracks of six or eight south of Big Pass. Head on down there."

"I've got it." Dane drives quickly, but these are unmaintained four-wheel-drive roads. No need for flashing lights and certainly no place for racers, who might arrive five minutes sooner but more likely would break the vehicle and be no help at all. The road, closely lined by creosote bushes and mesquite trees, is tricky sand rutted with cross washes. The four-wheel-drive vehicle drifts and lurches, but always within Dane's control for the hour-plus drive. Jack McBride in a Jeep is already ahead.

The pilot, Dave Roberson, directs Dane. "By now they must be between that black hill and the wash. Cut that next road east."

Soon Jack spots fresh sign and announces, "Good tracks here. Maybe eight. Were those two walking shoes, three tennies, a 'Nam boot, and a couple of huaraches?"

"Affirmative. Trail 'em. I'll cut ahead." And so the search continues. The pilot checks two roads ahead and sees no sign, so he knows the group must be between there and Jack. Dane can now see the circling plane, which works back toward the Jeep while checking shadows under mesquite trees, sorting out old tracks, and looking for footprints squirting out sideways. Even at fifty feet and fifty miles an hour, Dave can read tracks from the air. He may even land the Piper Super Cub on open spots and track on foot.

The air activity has not gone unnoticed by the walkers. In a wash they sit down under a shading mesquite and have lunch, half hoping the plane won't spot them and half realizing the net has already drawn tight. They could flee. But to where? How far? At what price? On this hot July day it is easier to yield now and maybe try again later.

Bouncing along their trail through the open desert, Jack spots them. He drives up, circles the tree, and stops. He doesn't even need to speak. He counts them and punches the radio, "Eight in custody." They quietly continue lunch while Dave circles overhead.

One asks Jack, "Isn't this a holiday? Your Independence Day?" Jack nods. "Why are you working today?" Jack only smiles. Another bemoans the thirty dollars he might have earned tomorrow. When Jack honestly tells them that there are far safer and easier places to jump the border, several react as if it is a jest, but in fact a number of routes are more advantageous to the alien than this wilting, killing desert. Ironically, the patrol's apprehension rate here is as high as anywhere, helped by the very vastness and terrain on which the migrants falsely rely.

Mostly they sit quietly until Dane arrives. The whole procedure is quiet, low-key, and mutually respectful, sometimes amiable. In a scene

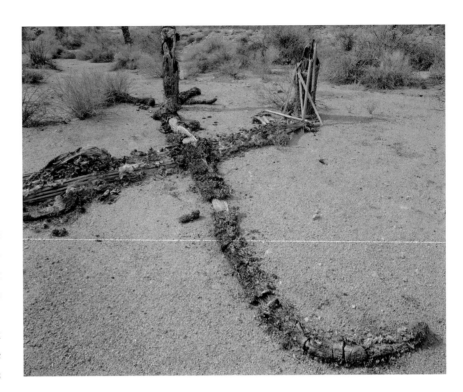

two days earlier, two agents sat in the office processing a pair of aliens. The agents talked and joked in English over the paperwork while the UDAs sat between them. Soon the tired pair asked if they could go into the holding cell and nap. The door was not locked behind them.

The catching and processing of workers (but not smugglers) in this sector is dull and benign for both sides. The sort who cross the fence here respect the patrol for kind and honest treatment—indeed the agents are the only ones who will look for them when they're in trouble. In turn, the agents are sympathetic. Joe has lived in this valley off and on since he was six years old. "I've worked with UDAs on

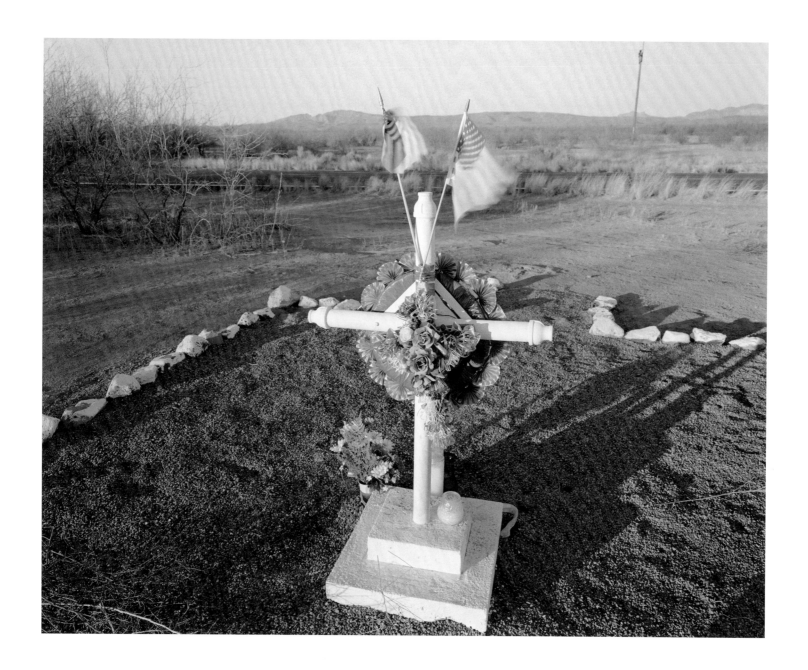

farms. I feel very sorry for them. Walk fifty, sixty, ninety miles just to get a job?" he questions. "In fifteen years of Border Patrol service I've never had to get rough with a UDA. Nor wanted to. I don't abuse or brutalize anybody, and I won't tolerate it and never will from my men. I treat 'em like I'd want to be treated. By twenty-five their life has been rougher than mine if I live to be a hundred."

The eight UDAs are distributed into Jack's Jeep and Dane's Ram Charger. They left El Sahuaro at sunrise and covered about fifteen miles in seven hours. They have ample water remaining and leave their jugs under the tree. Taken to Yuma, then transported to the border at San Luis, they don't even get a free meal. By sundown they'll be back in Mexico. It will have been a hot, discouraging, wasted day. But at least they're alive.

Not everyone who crosses the border survives. From the Search and Rescue Log: "6-25: Unknown subject's body found (partial only). Had been dead several months. Sheriff notified." Water is essential for human life. Not just comfort, but survival. A person requires—not wants, *needs*—two gallons a day in the summer. Three gallons, if the mercury edges 115 degrees. Even those UDAs who escape the desert echo, "We thought it was just a short way to water, and we went dry." Several years back three went to ground after running dry. They used a jar to collect and drink their urine. One was found naked along a back road with his head buried in a badger hole beneath a creosote bush. Initially his rescuers believed he was dead, but with rehydration he recovered. The second was later found dead in the desert. The third died next to I-8. He was discovered four or five weeks later when a motorist fell asleep at the wheel and rolled her car off the road. Traffic officers found his body; at first the hysterical motorist thought she had run over and killed him.

It is not at all uncommon for a UDA to seek the patrol's help for down friends. A June 18 case report reads, "Subject and two compan-

ions ran out of water in the desert approximately ten miles south of Tacna, Arizona. Subject's companions left him and continued north. One of his companions stopped a vehicle on the Interstate east of Tacna and requested they take him to Tacna. Subject notified Border Patrol of his companion in the desert. Agents found sign of other two in desert. Found one [read: rescued] and tracked the other to I-8 where it appeared he obtained a ride."

Rescues give agents their highest satisfaction. International politics, economics, and legalities aside, human lives are still the bottom line. Glen Payne punctuates this when he states, "In rescues we've done some real good."

Joe McCraw confirms, "The thrill is trackin' em up before they die. A rough ol' way to go—run outta water in this desert. We wish they'd try another sector—for their own sakes."

Jack and Dane deliver the UDAs to Yuma and return to Tacna after 4:00 P.M. Literally, they haven't stopped since leaving the office at dawn. No coffee breaks. No lunch stop. Just a candy bar behind the wheel and a few cups of water from the Thermos as they drove. Even then they must finish the paperwork of logging forms and filling the track book, a ledger of all suspicious footprints sighted during the day. Those not apprehended are circled.

Carlos and Paco are not among those caught this round. Hopefully, they are not down. Tonight others will head north. And tomorrow, July 5, Joe McCraw's crew will assemble again at 0600.

⌒

In May of 2001 the game changed. A group of entrants tried to run the gauntlet north from Organ Pipe to the interstate. Pushed by the tightening of the border fence at San Diego, Nogales, and El Paso, they sought a hole in the wire where they thought no one watched. They

numbered twenty-six, mostly farm workers from Veracruz. Fourteen died. *Ya basta.* Enough already. This, coupled with the terrorist attack on New York's twin towers, pushed Border Patrol to move into the neighborhood, and in 2002 they erected an outpost along El Camino del Diablo. This frontier base is named Camp Grip, as in "get a grip."

The area had become a No Man's Land.

At Puerto Blanco, a pass near Dripping Springs, drug smugglers erected a bust of Jesús Malverde, their folk saint of marijuana. Graffiti appears on remote boulders and cliff faces where bored hoodlums hole up by day, awaiting dark. Along with contraband and guns, they carry black spray paint to mask their backpacks, caps, and water jugs for the nighttime journey. Homemade packs tote twenty kilos of marijuana.

Roger DiRosa, manager of the wildlife refuge, knows the ground and left a Pacific island to return to this refuge for a second shift. He came back to save his desert, but he's appalled at what he sees. "There are *so* many people walking north from the border. If Ed Abbey hiked out here today, you'd never find him. His tracks would be lost among the thousands of immigrant footprints."

Vehicles crash the fence or simply cut new gates. Border Patrol calls them drive-throughs. Delta Tangos. In places all six strands of barbed wire have been rolled away and restrung on ranches across Sonora. At one time in 2004, at least one hundred abandoned cars, vans, and pickup trucks littered the desert between Ajo and Yuma. Most of the vehicles had been stolen in Arizona or California explicitly for this trip.

On August 9, 2002, park ranger Kris Eggle was slain in Organ Pipe by a drug cartel hitman who was trying to escape Mexican police. Reportedly, he had murdered four Mexicans the day before. The killer himself died in a hail of bullets from police across the line. Hundreds of shell casings littered the ground after it was over. In another episode

smugglers drove by and fired several rounds at a Border Patrol agent working El Camino; they were apprehended.

Since the mid-1990s the Marine Corps manager of the western Goldwater Range has supervised college students studying flat-tailed horned lizards west of Tinajas Altas. This year he has the students on hold, pending assessment of the risks posed by smugglers and border crossers. Other agencies, including Arizona Game and Fish Department, have put restrictions on researchers and field personnel working near the border. The state's booklet of hunting and fishing regulations warns hunters going south of the interstate: "Homeland security issues along the international border may affect the quality of a person's hunt."

A lifelong hunter and resident of Gila Bend takes the distributor cap off his Jeep so no one will steal the vehicle when he hikes or camps near home, eighty miles from the border. In the spring of 2005, three thirsty UDAs tried to flag him down, but having his wife in the car and unsure of what they really wanted or who else might be in the bushes, he didn't stop. He drove past them one hundred yards and set a water jug on the ground.

The wildlife refuge staff warns visitors that if they leave their car unattended along El Camino, they should be prepared to walk home in case UDAs steal or vandalize it. The staff urges visitors to stash water jugs in the bushes so they'll have water in case the car is gone when they return from a hike.

The Wellton station compiles numbers and graphs charts. We stare at them in disbelief. Apprehensions in 2001: 2,412; in the first eight months of 2005: 6,462. Marijuana seized in 2001: 417 pounds; in the first eight months of 2005: 11,970 pounds. Vehicles seized in the first eight months of 2005: 168. Deaths in 2001: 18; 2002: 3, with 1 a train accident; 2003: 4, with 2 by drowning; 2004: 5, with 4 being old skeletal remains; the first eight months of 2005: 2 related

to heat. Rescues in 2001: 29; 2002: 30; 2003: 51; 2004: 83; and the first eight months of 2005: 120. We struggle to remind ourselves that each datum point represents flesh and blood. Each encounter represents risk for agents, bystanders, victims, and suspects.

Instead of middle-aged *paisanos,* agricultural workers heading to farms along the Gila River where they pick citrus or drive hay balers, today many of the indocumentados are young guys, women with children, entire families moving to the United States. And mixed among the innocents are drug smugglers, slavers, bandits, and criminal flotsam. About 10 to 15 percent of all those apprehended have prior criminal records.

Newspapers run story after story on border problems. On a typical day we may read letters to the editor from those irate about immigration policy, a story about twenty-nine Mexicans and Guatemalans riding in a pickup truck that crashed, and a story reporting that tighter border controls have lead to a worker shortage, causing Oregon strawberries to lay unpicked, rotting in the fields.

Political leaders in both the United States and Mexico talk about solving border problems, but neither country has the willpower or incentive to do much. The stalemated policies can best be described as indecision, ambivalence, and obfuscation. Businesses in the United States rely on the low-paid pool of foreign workers. Those workers mail their money home to Mexico, making them the second or third largest industry in that country with some $15–20 billion in yearly income. Drug smuggling, most of it to the United States, may be Mexico's leading industry, with a gross annual profit of $30 billion as far back as 1993. Without smugglers and indocumentados, Mexico's economy would utterly collapse. In the meantime, people are dying.

At Camp Grip agents don't make policy; they just enforce it as humanely and reasonably as they can. They go to work knowing full well that politicians want them to be successful, but not too successful. The agents do their best to hold the line for a flawed, two-faced policy. Agents put their lives on the line because the aliens do. The aliens accept as gospel that if they can successfully run the twenty- to eighty-mile obstacle course along the border, then they likely can find and keep work in any of ten thousand American cities away from the border. They'll be home free.

I spend four days riding with the Grip agents. By being at Grip they save driving an extra five to six hours a day down from Wellton, hours that they reinvest immediately in patrols. Plus, the camp gives them a genuine presence and they can quickly respond in minutes instead of hours. The strategy seems to be working: far fewer abandoned vehicles dot the landscape, very few crossers get far into the desert, and the intervals between discovering crossers and tracking them down is far shorter. The shifts are twelve to fourteen hours a day for seven straight days, with "days" being noon to midnight and "mids," midnight to noon. Like the crew of Joe McCraw and Glen Payne, it is still a bunch of honest guys staring at dirt and looking for footprints.

I arrive at Wellton late at night and decide not to spend my money for a few hours' sleep in a motel listening to a noisy window air conditioner, so I park south of town off a jeep road that takes you to the Copper Mountains. Past midnight I hear an occasional truck speeding somewhere in the darkness, and I know who they are. At forty-five minutes past midnight one pulls alongside my car, lights on and engine running. The Border Patrolman has his window down and shines a flashlight in my face.

"Hi. What are you doing?"

"Sleeping."

"Okay. Just seeing if you're okay." He didn't drive out here to hear if I was having sweet dreams; he was testing if I were friend or

foe, okay or a smuggler waiting for a load. He drove off, maybe disappointed that I really was okay.

A few hours later at the Wellton station, Steve Johnson, the patrol agent in charge, points to a map where six indocumentados, out of water, died in 2004 south of Paloma Ranch. They had been caught the week before and returned to Mexico with stern warnings about the risks. They didn't listen. Even so, Steve thinks that the station has a good 40 to 70 percent efficiency rate that should improve, especially with Camp Grip in place and other "force multipliers"— ground radar, video cameras, sensors, and night scopes—being deployed and a vehicle barrier being proposed. Of the remaining percentage who evade his net, many will be caught eventually. But Steve was born in Yuma and understands heat, so the specter of rescues keeps him on edge. He is determined that no one die in his sector. A sign on the wall reads "Choose to make a difference."

At the 0630 briefing, Robert McLemore (Mac to fellow agents, Bob to family) takes charge. He runs Camp Grip. He talks about conserving water at the camp, keeping the kitchen clean, and staying safe. He reminds them about radio checks and fuel levels and staying safe. He mentions the phase of the moon and condition of the roads. Stay safe.

Mac reiterates the Grip principles: stop smugglers and crossers at the line; deter or apprehend; rescue when needed. In Mac's words, out here two categories of people try to evade Border Patrol: "Those who have been rescued and those who will need rescuing."

He introduces me to a few of his crew for this week. Jim Fischer, who's assigned to the elite BORSTAR team that specializes in rescues. He carries an M-4 automatic rifle and a first aid kit. Someone quips, "After he kills you, he can put you back together." Jim has a degree in finance but prefers working out of doors. He's worked at Grip since its inception and learned his tracking skills from Glen Payne. Why

BORSTAR and the rescue mission? "I would want someone to do it for me. I'm capable, so I'll do it for them."

Mike Ringler majored in political science and worked in the software industry. On the side, he plays guitar and talks music with Mac. Mike married a bright woman whom he had worked with several years before they even dated. "She's my best friend." He hails from Texas but had never seen anything like this desert. Now he has flown in helicopters and driven Hummers, big Dodges and Fords and Chevys, Jeeps and quads, and is planning to make the patrol his career.

Jeremy Kite tried stints as a termite controller and a nurse, but he thrives outside, so he chose Border Patrol. "It's rewarding work. The aliens are usually glad to see you out here." He's an off-road enthusiast whose idea of fun is going to the dunes at Glamis, so he knows vehicles, is easy on them, and doesn't get stuck. He and his wife have children, and the only time he feels angry is when he finds people bringing children across this desert. "It's heart wrenching. Five-year-olds walking across this desert? You want to yell, 'What are you thinking!'" One set of parents brought their two daughters, one thousand dollars cash, and gold jewelry but had not brought any water or food at all.

Alfredo Delgado formerly worked for the Department of Corrections but had felt like he was in jail himself. Out here he feels free and useful. When off shift he plows into books and is busy devouring classic desert literature. He can hardly put down Hornaday's *Camp-Fires on Desert and Lava* and is looking for a copy of the book on Jeff Milton. He's close to finishing his degree in criminal justice.

Some of the agents—Luis Cotto, Josué Ostos, and others—I see only from a distance. It's a busy station with people coming and going at all hours.

The drive from the station to camp takes two and a half to three hours, more if the road is muddy from rain. It takes the same time

whether driving the road past Tinajas Altas, the one through Christmas Pass, or going clear around through Ajo and Bates Well. The shortest route is 80 miles; the longest, 180 miles; but the arrival time is the same. Prior to the camp, agents had to drive this far just to reach the jobsite.

Border Patrol is the mobile uniformed arm of what's currently called Customs and Border Protection, part of Homeland Security. Camp Grip is a tactical station, which means it is temporary. Though comprising four thousand square feet, it is modular building and can be disassembled and moved. It has a heliport, two generators, full electricity, a 10,000-gallon water tank, landing mat roadways, and fuel tanks with aviation gas and diesel. "It's easier to tell you what we don't have," Mac explains. "The only thing we don't have is a washing machine, because it uses too much water. We have all the other amenities. We have a full kitchen, flush toilets, and Direct TV." They did have a hard time telling the satellite company what the zip code was, which programming menu to provide, and where to send the bill. But it's no resort; with twelve- to fourteen-hour shifts, agents scarcely have time to do more than work, eat, and sleep.

Mac didn't invent Camp Grip, but he has fine tuned it and made it work. For example, the first camp had portable toilets, but in summer the odor and heat were unbearable, and the chemical fluid dried up in a few days. Then they brought in propane toilets (nicknamed "atomic shitters") to incinerate the waste, but one exploded, so they finally got real toilets and showers that work like home.

My first shift I ride with Jim Fischer, call sign Romeo 12 ("R" for rescue). His Hummer H-1 has a Stokes litter and first aid supplies. He wears distinctive tan pants, tan boots, and a red shirt emblazoned with the BORSTAR emblem. We head west and "cut sign"—the ancient art of reading footprints on the ground. Like much of police work, it is methodical, tedious. The sign will tell him their direction, the number in the group, what time they passed here. Sign may reveal whether children are in the group or if someone is already exhausted, shuffling their feet or leaning on a friend. From the signs he reads daily, Jim guesses they catch 60–70 percent of those who cross this vast area. The bigness of the area actually helps agents because agents can clearly see tracks and then have several hours to trail them. From Camp Grip the tracks are fresh, minutes to hours old; from Wellton the tracks are stale, and smugglers get a long head start.

Smugglers want their groups compliant, so they provide verbal instructions but no maps. UDAs may have highway maps to Chicago or Atlanta, but no maps to this desert. The maps wouldn't save them anyway. Distinctive landmarks like Sheep Peak are obvious reference points and are known by nicknames such as La Punta. They refer to Grip as "*el pueblito.*"

It should come as no surprise that smugglers frequently lie to their customers. They tell them "It's only a five-mile walk" or "There's water along the trail." The Vidrios route is fifty to sixty dry miles if they don't get lost or walk in circles. Rescues are tough largely because the victims wander, irrational, lost, not knowing landmarks, and lacking any sense of direction. "When they start to discard their clothing or bags, or drag their feet, we know we really need to hurry," says Fischer, remembering grim scenes etched into his memory. Today the wind is erasing all tracks. Past one hundred yards people blend into the background.

It's not uncommon for smugglers to abandon their group on some pretext. They say they're going back to bring more water for the group, but they never return. Jim scoffs at the thought of some going back to fetch two or three days' water for a group of ten people. It's as

impossible as it is implausible. Or if some are slow, especially women or children, they'll simply leave them behind with no thought of their fate. Only money talks, especially if paid up front. Everything—even life—has a price, especially in tough times. A heroic, compassionate smuggler would merit a movie script.

In some cases, persons turn themselves in at the camp, but the agents wonder if they are just checking how the patrol operates. One guy pushed the button on a rescue beacon but didn't seem thirsty. Agents suspected he was testing response time or was a decoy hoping to divert the agents while a load went around. The following week agents seized a marijuana-laden ATV near the beacon.

Jim and I hike to the top of a ridge where he had previously found a spotter huddled in the summit rocks. With a cloth shade, canned food, water, and a radio, the spotter was comfortably ensconced. Jim caught him, the guide, and eight Chinese nationals anyway. They were smart enough to stay together or they would have become irrevocably lost. I look at the vast landscape below and wonder what it would be like to see this rude wasteland on my first day in America. "This is a very harsh place." Jim sighs. "Things can go bad real fast out here."

The largest group Jim ever collected was fifty-three, by himself, at night. Backup was a few minutes away, so he circled the group with his vehicle and told them that inside his tire track the circle was theirs, and the outside was his.

We rode until past midnight, saw fat jackrabbits, kangaroo rats, sidewinders, and maybe an owl, but no people. That's a good thing. According to Jim, the optimum goal is not to see or catch anyone, but to deter everyone.

Shortly after the camp opened, a pair of ravens adopted it. Nicknamed Bonnie and Clyde, they may have a nest nearby. Though they find no food at the camp, they are daily visitors and seem to enjoy the company. They frequently look at themselves in the mirrors and reflective windshields of the vehicles, and for some reason they delight in tearing the rubber from windshield wipers.

I ride two days with Mac, who pilots a Dodge truck SOR—severe off-road vehicle—with lift kits, armored bottom, and huge tires. But the terrain eats tough trucks for lunch, and realistically, few vehicles last more than thirty thousand miles out here, not even the Hummers. Tires are even shorter lived, with many expiring in fewer than one thousand miles and some lasting only a few days. Grip has lots of spares and an air compressor, but vulnerable sidewalls and the laws of physics doom them all. Contrary to common perception, agents don't like to drive off the roads, for they and their vehicles take a beating and they hate changing tires.

In the early days of Grip, the smugglers were surprised to see anyone in the area. Several times agents faced off against gangs who tried to figure out the new guys. When they did, they hightailed it back across the line. Mac jokes, "They didn't scare me; I'm a married man."

According to Mac, Grip "makes a huge difference." Attempted drive-throughs are down 90 percent, and the other 10 percent are apprehended. "Even if we just drive back and forth, we make a huge difference." The Vidrios smugglers' trail didn't exist five years ago, but it quickly drew so much smuggling traffic that it became a dusty maze of ruts one-quarter mile wide in places. Today the Vidrios is a placid one-lane jeep road. At this pace and with good winter rains, it may disappear altogether.

Pilot Howard Aitken sees the world from above. In a few short years he witnessed the explosion of roads and foot trails. In the Cabeza Prieta alone are over two hundred miles of new roads and thousands

of miles of new walking paths, none of them planned or sanctioned by the Fish and Wildlife Service. Howard echoes that Grip has shut down the Vidrios Road to vehicles and to most people. If Grip continues to work, maybe the wildlife refuge and national monument managers can eventually erase the road scars and piles of trash. Even so, thousands of years from now archaeologists may sift through the discarded bottles and old trails to interpret this phase of history as the biggest mass migration in this desert's history.

Smugglers charge anywhere from eight hundred to fifteen hundred dollars a head, sometimes up front, sometimes cash on delivery paid by friends or relatives. The indocumentados are the ones who aren't making it in their home countries. Rich folks can afford to enter the United States legally or on a visa, and they make their money at home, so they have no incentive to leave.

To keep alert, Mac tunes his satellite radio to a big band channel. At home he plays bass trombone, relaxes with his music, and putters on home projects such as landscaping. He talks about a recently discovered Bach score, even though it has no trombone parts because Bach lived before trombones. Mac admires many musicians, especially trumpeter Arturo Sandoval. In school Mac marched and played tuba, so he goes to football games more for the marching bands than for the game itself. He loves the Star of Indiana, a drum and bugle corps with big band sounds, and he reads Dale Brown (*Flight of the Old Dog*) and Clive Cussler (*Sahara*).

He's been in the patrol nineteen years and has six to go. He and his wife, a Yuma city detective, like to dance, eat at fine restaurants, and catch Vegas shows. "When we dance, I get to lead," and he's succeeded in Border Patrol by enthusiastically tackling any job assigned. Consequently, he earns some plum assignments, such as training immigration officials in Europe (Lithuania, Estonia) and conducting

job interviews in Hawaii. He and his wife went to Dublin last St. Patrick's Day to celebrate and see the big parade.

Mac was born in Texas but didn't learn English until he went to school. His mother still speaks Spanish at home. Some of his friends in Mexico occasionally ask him, "How can you apprehend and deport your own people?" He tells them, "We're not against Mexicans or any other nationality, but to deal with illegal immigration, smuggling, terrorism, and border crime, we've got to control our borders." He reminds them that Mexico regulates its borders too.

We drive past a burnt-out van—a "dead turtle" in the parlance. Smugglers cram as many as twenty people in a van. We drive another hour to the end of the road and see no tracks. Mac keys the microphone and announces, "Vidrios is cut and clean." The radio plays "Straighten Up and Fly Right," then Benny Goodman, Ray Charles, and Frank Sinatra. We cut sign at a slow pace. When we get out to look at prints on the ground, Mac sometimes plucks creosote leaves and crushes them between his fingers to smell. "It's so fresh and clean."

By way of Vidrios Road, it's sixty to seventy miles from the border to I-8. We drive that route across the Goldwater Range, where aliens face all sorts of dangers besides the usual heat, thirst, and fatigue: target practice with live thirty-millimeter bullets, falling bombs, unexploded ordnance, blinding lasers, and occasional small-arms fire. Any of it could ruin your day. It is quite a long trip by car and must seem interminable on foot. Mac points out the landmarks aliens choose and the passes they use.

The guides carry cell phones so they can contact their rides. If apprehended, they throw the phones away to avoid being tapped as a smuggler. We roll past gunnery towers, across vintage runways, and through desert washes burned by range fires, some of the flames ignited by ordnance and some started by aliens themselves. In winter

aliens light fires to warm themselves; in summer they set fires to attract attention when they're lost or out of water. On the gunnery range we pass bullet-riddled convoys and mock villages that are attacked daily by fighter planes.

South of Painted Rocks interstate interchange, Mac slows and eyes a mesquite thicket. Cubbyholes are everywhere and egrets on a hidden pond squawk as we probe the bosque. Trash indicates that aliens have hidden in these trees. He finds a fresh tennie print and follows it to the lay-up spot, a tree with tire tracks to one side. The person has vanished into the American woodwork.

Last week the crew at Grip intercepted only three groups in seven days. That's a good trend. In Mac's words, "Grip gives smugglers something to think about besides where to eat in Phoenix."

～

Across the road from the station stands a cross and piled stones signifying the grave of Pete the Pelican. The unlucky bird was blown off course in a big storm last February and landed near the station. Before a wildlife expert from Ajo could arrive to retrieve the exhausted bird, Pete died.

～

Smugglers have used observation posts in Davidson and Agua Dulce canyons, so Mike takes me to see one. At the border where Agua Dulce trail hits the fence, we see someone run back into Mexico. Mike cuts the sign. Two abandoned jugs of water hadn't yet warmed in the sun. Mike surmises that he's a scout or lookout, but worries that he may be first in a group or a decoy for a group crossing nearby.

Mike calls to see if the helicopter is available and gives our coordinates. We beat the bushes for others but find none. He did find a second set of footprints of someone heavy on his toes: carrying a load of drugs? carrying water? running? On loudspeaker, Mike commands, "Venga aquí. El desierto is muy peligroso," but no one comes and he mutters, "See you tonight."

Mike has committed himself to seeing sign. "Missing a sign would be serious. I'd feel responsible." He was deeply touched by the death of a Pole two hundred yards from I-8. The man had been dead several months. His family photos and money were in his wallet.

At one time about 120 abandoned cars and trucks lay out here, plus dozens of bicycles. Smugglers drive at night, using the moon instead of headlights. It must be a bouncy, tortuous ride over ground they may or may not have scouted ahead of time. Bicyclists usually end up pushing their bikes part of the way and finally find it's easier just to leave the bike and carry the load on their shoulders. Pedaling out here in the thorns and soft sand is futile.

A report crackles over the radio. A Jeep with four indocumentados has been caught near Christmas Pass. Vehicles in the desert usually flee, but once an agent gets on them, they seldom get far. Something invariably happens: a second unit intercepts them, a helicopter dusts them so they can't see where they're going, they get flat tires—sometimes several at once—they wreck, break, run out of gas, and get stuck. "They get stuck and bail out," laments Mac, "but they have no place to go and no plan. They just run, but they don't get far without water and usually come walking back in a few minutes." One fleeing ATV driver was so busy looking at the pursuit vehicle that he ran head-on into the far bank of an arroyo. It's a wonder he wasn't killed. Ironically, smuggler vehicles on the highway usually stop for police, with some dangerous exceptions.

The next morning Luis Cotto, an agent on radio duty, sees movement outside Camp Grip. Three brothers—Victor, Esteban, and

Hugo—are coming to knock on the door after wandering lost and thirsty for the past four days. They had come north from Puebla and found a guide in Mexicali, but he abandoned them the first night out. In Spanish one tells Cotto, "We got tired and went to sleep under a tree. The coyote slept under another tree. When we awoke, he was gone with the water." They don't really know where they've been, but likely they got as far as the Granites, the stark, rocky range where the fourteen died in 2001. On the third day they had to carry Hugo between them. Eventually they backtracked and saw the camp. A single crosser, possibly their guide, is caught by highway patrol on the interstate.

The smugglers had told them that Border Patrol agents would kill them, rob them at least. One said to the others, "They may kill us, but we won't die of thirst," so they resolved to turn themselves in and die if they must. Fortunately, the days have been unseasonably mild (in the 95-degree range). Ten degrees hotter and they probably would have died. One lays his head on the table most of time. Ironically, the most alert brother wore a T-shirt with the logo "Gotcha." Their lips were parched and eyes vacant. They walked stiffly. They are surprised when agents count their money and return all of it to them. They were heading to Washington state, where, a friend told them, they could find lots of landscaping jobs. Three hours after the sun rose, agent Ostos was taking them to Ajo for voluntary return to Mexico. With their lives.

I return home and three days later receive a note from Mac.

Bill,

You missed a hell of a finale. Apprehended a scout south Davidson Canyon on Tuesday. Got his radio and other equipment. Claimed he couldn't get a hold of his partner and decided to abscond back into Mex. His partner was probably the one you guys spooked back the day before.

Had a group of six come in just east of Vidrios and we ended up catching them just north of camp. In the meantime, our flyboys found sign of 2 quads and later located them full of marijane. App'd the 2 drivers also. All this on our very last morning at the camp while waiting for our relief. Phew.

Don't be a stranger
Mac

And as far as he knows, no one got through and no one is down, down under the blue-white sky.

In America's social wars on drugs, crime, poverty, pollution, terrorism, and smuggling, this desert has become my ground zero, a battleground not on distant foreign turf but on my innermost heartland, my sanctuary, my place of places. Never did I imagine that the social ills of our world would collide here; never did I prepare for war here, in this place of few faces. Whether you're reading this in Toledo, Tucson or Timbuktu, Chicago, Caborca, Coventry or Canberra, Boston, Bonn, Bejing or Barstow, this is your ground zero too. No man is an island from hunger or crime. No sacred place on our planet is safe from greed. No isolated place is secure from short-sighted silliness. No wild place is immune to anger or apathy. You should not sleep well. I won't. In my mind the land was the retreat, a final shelter in the last valley below the ultimate summit. It would always be here, a haven untouched by common evils, a haven defended by heat and rock, a haven no one would dare covet. But its very emptiness lures them. For them the land has no value.

We know better.

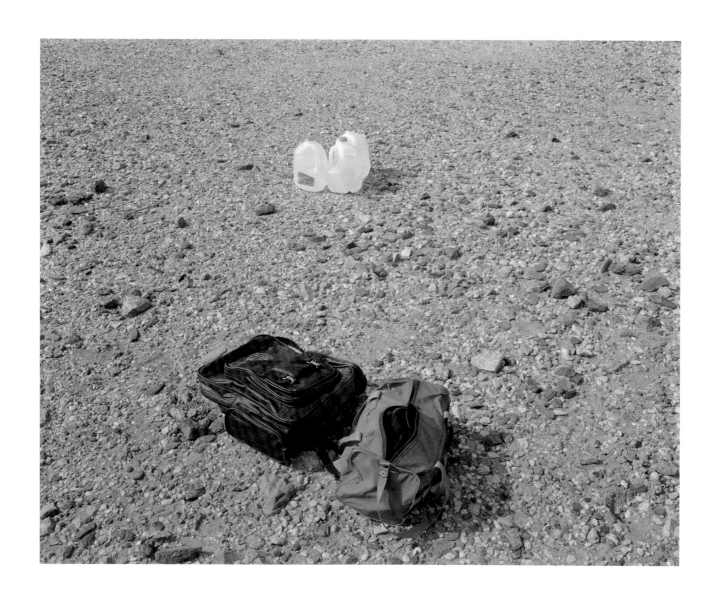

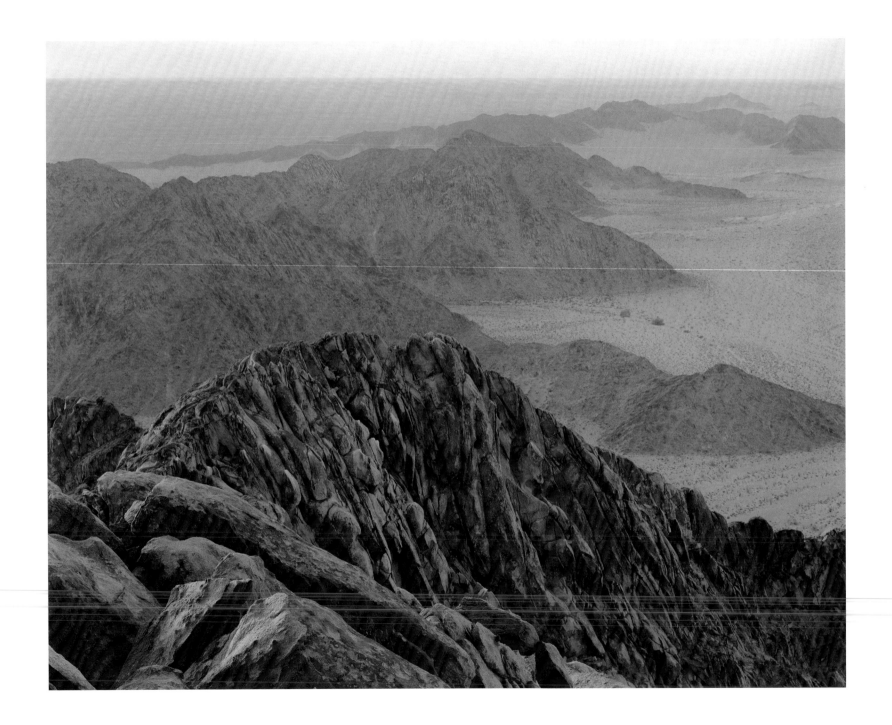

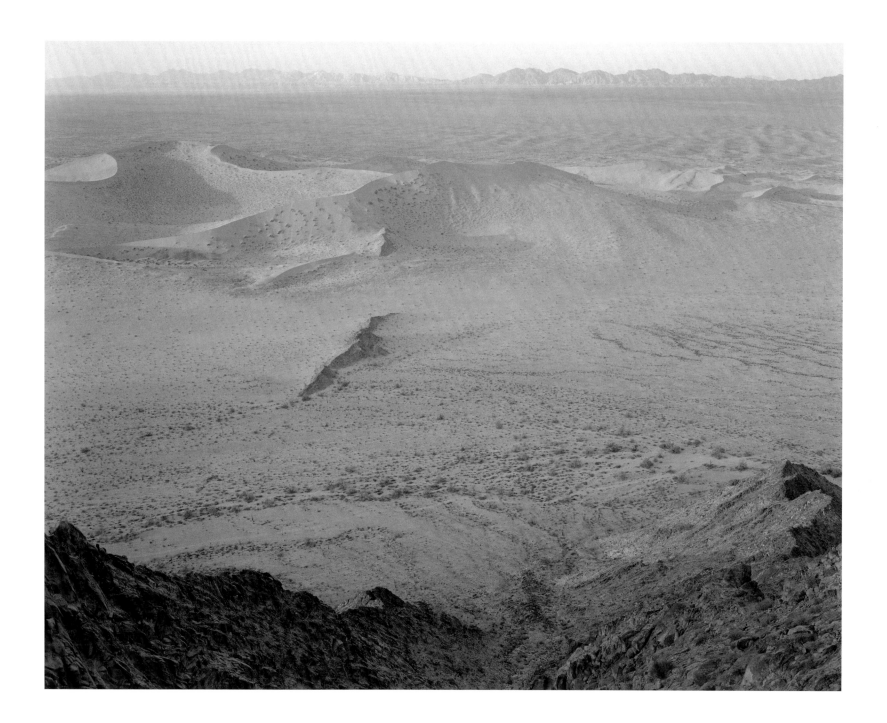

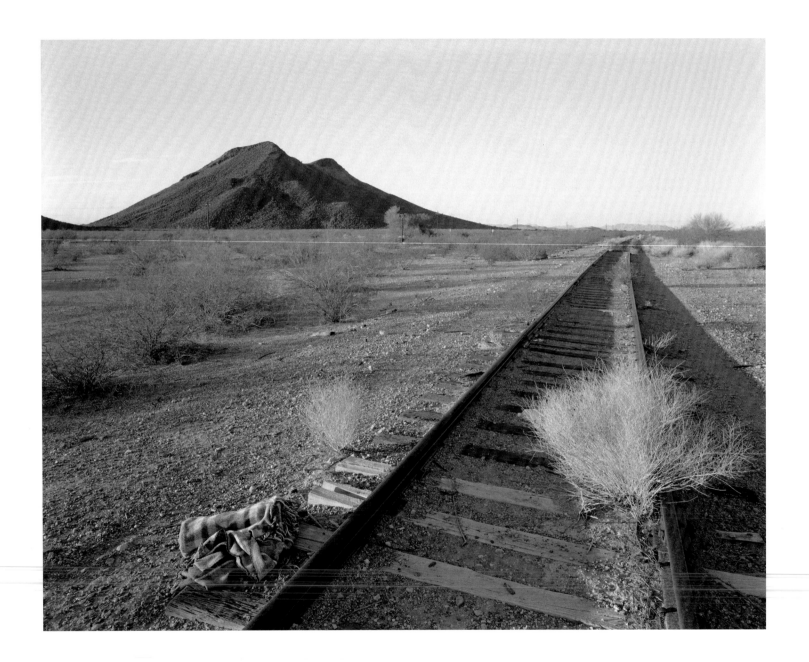

Letting Go

Soon
Soon we shall know
if we have learnt to accept that the stars
do not go out when we die.

ABBA KOVNER, "DETACHED VERSES, 9"

I have flouted the Wild. I have followed its lure,
fearless, familiar, alone . . . ;
Yet the Wild must win, and a day will come
when I shall be overthrown.

ROBERT SERVICE,
"THE HEART OF THE SOURDOUGH"

EVENTUALLY WE ALL LET GO. But we imagine the land remains. Thirty miles east of San Luis, Mexico's Highway 2 ripples through heavy sand. It rises and dips, though seldom curves. It is narrow, crowned asphalt with no shoulder. A bus and a truck collided here, head-on. At least five died. There are five crosses. The memorials for the driver and relief driver of the bus are cut marble worthy of the finest cemetery. The names are chiseled. Badges of brass are inlaid. The stones are old-styled headstones each topped with a cross, and occasionally fresh paper flowers grace them. A smashed windshield and a chrome bumper adorn the bases. Votive candles burn in tribute. Across the road are three wooden crosses. They are nameless and untended. They too display grim wreckage, but they show no signs of devotionals or ceremony. It is a race to see if they will be consumed by the sands before the sun peels them into oblivion.

Elsewhere José, the railroad man at Lopez Collada, seemed surprised that I noticed the white wooden cross along the railbed near Tres Ojitos. He was a veteran of this road. His tired eyes had seen much. He had seen this, too. Slowly he explained to me. "A man fell from a moving train. He fell between the cars." His hands made a tumbling motion. "We found him when we went to repair the rails.

We couldn't help him. We buried him in the sand hills." He motioned toward the dunes. "We later made the cross. It was the least, it was all, we could do for him. We didn't know him."

Even the names of the cuadrillas are monuments to fallen railroaders. Lopez Collada, Gustavo Sotelo, Ysla Sanchez, and José Torres were surveyors laying the route back in 1936. They succumbed that hot July when their truck stuck in the sand. They tried to walk the thirty miles back to camp, but they didn't make it. The search party found them a week later. They are remembered today on maps and station signs.

South of Riito, the highway cuts through stable sand hills. No one should die here. But some have. A cross here is crafted wrought iron. Like most memorias, it is white. A floral wreath hangs from the yardarm. Its paper roses are unfaded. Its paper leaves have yet to wither. Even the cellophane wrapping is intact. A votive burns despite the wind. Fresh tire tracks mark recent visitors. Across the display, red letters read *Nuestro hijo*—"our son." From the dates given on the cross, this son was of driving age. From the tidiness shown, someone will remember long and deeply.

Each of the truck stops along Highway 2 offers a shrine for travelers. Usually St. Christopher or the Virgin preside. West of La Joyita truck stop, which has its own shrine, is a major outpost of succor and devotion. Steps leading up the rock hump are inlaid with colored stones. Candle wax, melted by the fierce sun, puddles in the sumps of the rock. Hundreds of spent candle cups litter the area. Such trail offerings are an old practice, for ancient O'odham placed sprigs of creosote or laid stones atop shrines along their routes. Venturing into the Gran Desierto was not attempted lightly, and some of these shrines contain tons of rocks.

Gristly prospector Dave O'Neill prowled distant hills for the motherlode. Like most of his profession, he traveled alone. O'Neill traded in Ajo for his supplies, using his meager poke to pay for his simplest of needs: flour, sugar, lard, tobacco, matches, cartridges, and a new knife, maybe. He foraged the land for the rest of his food. One afternoon in 1916 his mule wandered back to the mining camp at Papago Well—without him.

A party of friends mounted up and backtracked him along El Camino. They found him, dead, beside a wash and a group of low hills that today bear his name. They dug a shallow grave, laid him to rest, and covered him with stones. A metal cross was set there. Decades later some treasure hunter scattered the rocks and leveled the cross. He of course found nothing of value. Other passersby cursed the grave robber's greed and disrespect, and they replaced the stones as O'Neill's grave is seen today.

But there is more to the story. The two men who first buried O'Neill were friends of his, prospectors by trade, and rugged, practical frontiersmen. They divvied up O'Neill's valuables before covering him with dirt and rocks. A couple weeks later they ran out of tobacco and remembered that they had buried O'Neill's tobacco with him. They returned to the grave and retrieved the tobacco pouch, one reporting that it "chawed just as good as if it had been in my pocket all them two weeks."

It's a stretch of road we'd rather not drive. Gila Bend west to Yuma on Interstate 8 seems dull and long. People who live here along this northern edge of the great desert head to cities in their spare time. They're tired of glare and dust and nothing.

To the south lies a bombing range and a wilderness refuge. It is a land of rattlers, smugglers, and silence punctuated by super-

sonic booms and the roar of warplanes. People die there of thirst. No, it's not a place to go. To the north are Gila River farms. Vast spreads of agribusiness plow and irrigate a reluctant land. The river runs slow and warm, its banks impenetrable thickets of tamarisk. Beyond is more desert. Leave a perfectly good highway for any of that when Sea World and Disneyland beckon? Be sensible. So we speed westward on our way to the beaches and amusements of Southern California.

In days past we left Tucson or Phoenix at night and hit that stretch when the asphalt cooled. Gila Bend was the fan belt capital of the world, and some nights the thermometer clenched three digits as we clung to cold drinks. Canvas water bags helped sputtering radiators. Wet towels hung across open windows as we braved unknown and unseen territory. Nowadays we have cruise control and air-conditioning. And still we speed westward. The stereo fills the car, and tinted windows break the glare. Not one traveler in ten can name a landmark for 116 miles. We don't notice. We don't care. Tourist bureaus don't lavish millions to entice us here.

Tacna has a fine restaurant, but few know about it. Dateland is a friendly spot, but who stops there besides buses and locals? Wellton had a historic hotel where actor Clark Gable stayed while dove hunting, but it is gone. And there are two even lesser known spots along that stretch. They are sadly historic. One bears a white cross with a small commemorative plate. At the other stands a weather-worn wooden cross.

The white cross is hard to see at seventy-five or eighty miles an hour. It's chin high, and its painted steel is starting to show signs of rust. Once plastic flowers wreathed its post. If you look to the south from the interstate about a mile and a half west of Aztec at milepost 71.3, you may glimpse it next to the fence, amid the tumbled weeds. No one stops to read its inscription: "In memory of highway patrolman Louis Cochran who was killed in the performance of his duty, December 23, 1958." He was the first of twenty-seven Arizona Highway Patrol officers to perish in the line of duty. Traffic accidents have proved deadlier than bullets.

The year 1958 seems before history. It was before the interstate. It was before proud Highway 80 became a frontage road. It was before our memory. Those were olden days when one hundred Arizona Highway Patrol officers covered the whole state of Arizona. Officers were stationed one per town and rode alone. They might patrol for days and not see another lawman. Arizona was still the wild West. Those were the days when engines roared, not whined. The V-8 was king of the jungle. Speeders tested these wide open stretches. Patrol cars could run an honest 130 miles per hour, and commonly had to. That was before the patrol became the Department of Public Safety (DPS) in 1969.

Officer Cochran was cruising east on the old highway around 7:00 P.M. when another driver speeding from behind inexplicably smashed into the rear of the patrol car, knocking it sixty feet to the side of the road. Both cars exploded into flames with the impact. A passerby rushed to Cochran's flaming car and saw him slumped over the wheel. The heat drove the Samaritan back while fire incinerated the car. The other driver, from California, also burned to death. His passenger, a woman, lived but suffered serious burns.

Actually, the newspaper says it happened the 21st of December, not the 23rd as the marker reads. Cochran would have celebrated his forty-fifth birthday that Christmas with his wife and two children. He had previously served in the Border Patrol. He was badge number 59.

Officers today recall that the other driver was drunk, but official records are trashed after twenty-five years. The DPS library retains only a few yellowed newspaper clippings. One DPS sergeant recently came across a photo of Cochran in dress uniform and wanted to mail it to Cochran's widow, but he was unable to locate any of the family. He refiled the photo in a black folder.

Another mile and a half to the west stands a wooden cross. Its white paint has flaked badly. Saltbush and an occasional creosote rule the ground. A 1956 California license plate simmers in the sun. The road is straight and wide. A jojoba field struggles between Highway 80 and the interstate. Trains rumble on the rails to the south. The railroad milepost announces 809.

This is the real crash site. No words affirm that. Nothing here declares the who or what. The two small wooden crosses that the patrol would have put here in 1958 to represent two "fatals" have since disappeared. The metal star that once glinted from the crossed arms is gone. It is said that Bud Bell and his wife put up the metal cross and inscription where it could be seen from the interstate. The Bells ran garages, junkyards, and tow trucks at Aztec and Sentinel. They didn't want us to forget. They too are since gone.

Down the road another thirty miles, or twenty-five minutes the way most of us rush to the Golden State, is Tacna. It has a couple of gas stations, a good breakfast cafe, and an authentic Basque restaurant. And just northwest of the overpass you may notice a few planes and a wind sock. That's the airport.

And on down the road two miles, at post 40, you'll pass under a set of overhead power lines. If there were crosses there you'd see two. The plaque might read: "In memory of Border Patrolmen Fritz Karl and John Blue, who died on patrol, October 4, 1973." They had just taken off from the airport and were headed west along the interstate. It was a route they had flown before. It was noon, with the sun over their left wing. Investigators never decided why, but the plane, a Piper Super Cub, hit those 12,500-volt wires. The plane somersaulted backwards onto the median and burst into flames. Both men died instantly. The Tacna Volunteer Fire Department had to call on other units to help douse the fire and clear the wreckage. They were two of six Border Patrolmen to die on duty in southwestern Arizona. One of the others perished in a jeep accident. Two—Les Haynie and my friend David Roberson—died in separate plane crashes. One drowned in the Colorado River after rescuing a UDA from China and while trying to save another.

So we'll slurp on that ice water, punch "max" air, and queue the CD. The present view is wearisome. We'll try not to drowse. We're California dreamin'. The beach or bust! If we could block this stretch of road from mind, we would. As if nothing were here. As if nothing had happened.

I always assumed that the land would far outlast my aging knees. I may be wrong. Today the desert is being pummeled. Smugglers blaze new roads across wilderness that never felt a tire—the wildlife refuge has been slashed by two hundred miles of wildcat roads, and now the pursuers want to build more. Feet pound trails and pioneer new ones, garbage litters the landscape, tires rip the soil, campfires consume entire trees. The military considers some areas so worthless that bombs and bullets are aimed at Mother Earth's heart. Balloons released from festive parties in Los Angeles drift to ground here and snag on the devil's club cholla—if wind patterns ever reverse, I may feel compelled to tie scorpions onto balloons and let them drift to Southern California. That'll

be a party favor not soon forgotten. In spots this wild land resembles a dump. I'm disappointed in my own kind, just as Lumholtz was at one popular campsite where he wrote "after having been accustomed to the absolute cleanliness of nature, the experience of again meeting with pieces of cast-off clothing, rusty tin cans, and other cheerless marks of human occupancy . . . was not a pleasing one."

For ten years I monitored a string of rain gauges and waterholes throughout the Cabeza Prieta and western Goldwater Range. I drove most of the roads and management trails almost monthly, so I got to know every bump and jog. I prided myself on steering in the exact tracks I had made the last visit. There was so little traffic that from one month to the next, I could readily spot where someone had walked across the road, where someone had driven up an arroyo or parked where I never parked, where someone had broken limbs from a tree. Some months no one had driven the route since last I passed through, and following rains the trails were like virgin snow.

Today so many smugglers drive through the refuge that I can't count the fresh ruts through the flats. So many undocumented workers and smugglers walk through the area that I can't count the footprints. Plants are trampled, cactus smashed, bird nests robbed, waterholes drained and fouled, the biological soil crust churned into moon dust. In one brief sweep of the military training range, officers netted 110 bicycles that had been used to haul marijuana from the border to stash houses along the interstate. Armed smugglers have replaced docile farmhands, and now virtually every UDA protects him- or herself with a knife or gun. A park ranger was shot and killed; a reservation tracker was shot and killed. Refuge manager, Roger DiRosa, reports that in 2003 law officers on the refuge caught more than nine thousand undocumented aliens, seized nineteen thousand pounds of illicit drugs,

investigated four deaths, had one gunfight, and recovered five stolen vehicles. At any given time there are about twenty-five abandoned smugglers' vehicles on the refuge; a host of vehicles were seized, and at least 256 vehicles, their smugglers, and their loads escaped. One of the trucks was stolen from a government officer; he parked it in his driveway in Phoenix and the next day police found it crashed in the desert and crammed with two dozen dazed immigrants. In the near future I expect to hear about campers being carjacked, robbed, or murdered. In Roger's words, "This isn't your mother's refuge any more."

It's senseless. The damage to the land, the waste, the loss of human life are preventable. The problems could recede as rapidly as they escalated from about 1995 to 2005, if the U.S. and Mexican governments figure better, saner ways to do business. For now this assault is the biggest threat this landscape has faced in human times. People are dying; a land is dying; a spirit is dying.

My grandparents and parents lived through the Great Depression. Maybe they survived it because they were poor to begin with and knew the value of pennies. They worked hard, saved money, and knew that loans must be repaid, so they paid as they went. Waste is not a virtue, wanton destruction is not a virtue, careless killing is not a virtue. If we don't take care of our bodies, where are we going to live? If we don't take care of our planet, where are we going to live? The land itself doesn't need us—we need it. But we seem to be defaulting on the lands loaned to us.

In the scheme of things, the land will win. With enough time, my own tracks will fade, just as will those of the jeeps and the walkers. But not in my lifetime. Eventually the desert will give way to a new landscape, new species will evolve, life will go on beyond my own days. Eventually the land will erode, the continents move, volcanoes erupt,

and stars flame out. Intellectually I know that, but still I'm angry. I cannot relent. I pray that I'm not the wolf who devours the flaming-haired Deserta. I feel helpless, fearing that I can't save her from the dragons. I must hone my words. We mustn't let go.

For everyone, there must eventually be a last trip, a last look, a final kiss. Charles Sheldon lay in his buffalo robe during a drizzle and wondered, "Will I again know the joys of the upper world and be intoxicated by the panoramas and views?" Olga Wright Smith took one last walk around her camp in the Copper Mountains and wondered if she'd ever be so happy again. Carl Lumholtz, giddy with the beauty of desert springtime, would have gladly picked this place to die. W. J. McGee came here to gather his thoughts as he fought terminal cancer.

Raphael Pumpelly, an ambitious mining engineer and entrepreneur from the East, came to Arizona to develop mines and make big money. Apaches raided the mine where he worked, and some of the workers revolted. He escaped into Mexico to avoid being killed or ransomed. He and a friend ran for California along El Camino del Diablo. At Sonoyta cutthroat bandits dogged their heels, so they fled westward into the night. They nearly died. The tinajas were dry. They ran out of water but were saved by an unseasonal rainstorm. Eventually they evaded the bandits and reached safety.

Pumpelly became rich, did business around the world, and walked with presidents. But in 1915 he returned to the Camino and brought along his family—two daughters, son, and daughter-in-law—so they could enjoy his desert. On this trip, as on his first, difficulty and danger followed. The Model-T Fords repeatedly bogged in the sand, and the expedition, running short of water, finally resorted to laying canvas strips along the road for traction while all passengers pushed. The cars sputtered and broke; one was left behind for repairs. Eventually they

made it from Ajo to Yuma, only to find that worried acquaintances had mounted a search party. Reportedly, two men died in the next group that tried to cross the route by car. Why go to the devil to begin with? After being here once, facing death, desolation, and destruction, why ever come back? Only in death can we let go. Our death? Or the death of the land?

My father sat up in his hospital bed trying to talk. The pillow behind his back gave small comfort, as did the medicines, the bottles and pills and treatments taken together to keep one life going another day. He was exhausted, discouraged, worried for himself and for us. He knew how he felt, and even before a doctor's appraisal, he knew inside that he was dying. He knew but was not resigned. We knew intellectually, for the doctor had prepared us, too, but we had rallied and hoped and encouraged. As do all relatives in such moments, we refused to accept, we denied, we buoyed each other, refused to cry, refused to voice the discouragement that fouled the air. This is what we people do when we love someone, when they love us.

I remember a moment, one morning at the hospital, the blinds open, the sun shining in his room, Dad trying valiantly, asking what we did yesterday, and what the weather might do tomorrow. He slumped his cheek into the pillow and dozed. My hand reached into my pocket for a little notebook, and words began to appear on its pages, almost without my knowing, without my hand, without my will. And I began to write his obituary. From somewhere words appeared, I didn't think about them, I didn't have to. They wrote themselves, dribbling out like acrid urine through a catheter, uncontrolled, into a bottle to later be measured, charted, analyzed, and discarded.

Nothing more could be done at the hospital, so we took him home. Nothing could be done on earth or in heaven. Several weeks

later the inevitable came, and he died at home. How do we sum the man? How do we sum the land?

Graduate of Eastern Illinois University (Charleston, Illinois), where he excelled in track and cross-country, worked part time as an auto mechanic, and graduated with a teaching degree in math and industrial arts. Taught and coached at several mid-Illinois high schools including Gillespie High. Some of his students kept in touch forever.

The doctors are giving us reports on the land. In the name of national security, politicians push law officers to block and chase interlopers regardless of the price to the land. Cut it, trample it, trash it. Never mind. The climate is warming and changing. The desert is heating up, as if to purge itself of an illness. Experts currently predict a three-to-seven degree rise, with changes in rainfall patterns that they cannot foresee. To imagine a desert three to seven notches hotter, we must look at bleak, windswept plains, rockscapes where flowers are seeds shriveling in air too dry to cloud the dead man's mirror. Vibrant land becomes hyperdesert, something foreign beyond what we can see now, hyper as if exposing some medical condition, almost as if the desert fevers, trying to rid herself of the lingering illness of humans, we who do not even have the decency to bathe before taking our hemlock.

Was proud to have served his country in the Army Air Force as an engine mechanic on B-24s and B-17s; later worked as a civilian for the Air Force as a jet engine mechanic and instructor.

The first rule of getting found is to admit being lost. We needn't be orphans. We could do better, could choose, could see ahead. We cannot live without our patient. The here is all there is. Tomorrow is

a coma. Heavenly afterlife is a dream, a wispy dream held by those losing everything. Albert Camus touched the same condition when he wrote, "if there is a sin against life, it consists perhaps not so much in despairing of life as in hoping for another life and in eluding the implacable grandeur of this life." But we party on, avoid the inevitable, refuse to live now, and count on some distant, postponed heaven as a reward for smug, imaginary self-righteousness. The desert won't mourn our passing. Will we find ourselves in time?

A model husband, father, and citizen. Was active in church; member of a pinochle club for nearly 50 years; loved to tinker around the house and to watch birds; believed in Habitat for Humanity. He had many friends and family. If you didn't know him, you missed a good man.

My father died, without pain, though we carry the pain of losing him, as we had lost my mother, precious and full of memories, almost a decade before. She too died at home, cared for by loved ones whom she had cared for.

Profound thanks to his many friends and medical professionals who stood by him through the last decade of multiple ailments. He enjoyed life to the end and was ever optimistic—he had the roof replaced on his house within his last week. He finally just wore out and died peacefully at home in his sleep among family, one day before his 85th birthday.

The land, fevered, lies abed. If land dies, even if we kill it, do we dream that it goes to heaven with us, the land that was our home? The land that *was* heaven? We are all refugees with dry canteens. We wander. The desert winds will cover our bones with sand, then dust. We wonder. Who will light candles for the land, who will shroud the

wind, who will close lifeless eyes? Can we, with our eyes open, let it die? The blood cuff inflates several times an hour and a moving line on the green screen traces vital signs. Again I'm sitting by a window, in a chair next to our wizened parent, staring out, and the saddest of words begin to gurgle like a death rattle. My fingertips probe for pulse in the wrist, thready, weak, rapid, fainter. I write. Eventually we all let go. But now—can it be so?—I feel the desert itself letting go? Writing, scribbling frantically without logic, the words ache, inked in sweat boiled by fever deep within our souls.

"Born. . . . Preceded in death by. . . . Survived by. . . ."

Here lies desert, killed without forethought, by those wet born. Preceded in death by reason. A eulogy will be offered by men leading lives of quiet, confirmed desperation. Here we go round the prickly pear. Rosebud. The dirge plays without music. Nada. Nada! The old desert dreamed of lions. None survived. Forgive us not, for we know what we do. Fire; ice. The horror, the horror. In the ending was the Word, and the word was nothing. In lieu of flowers, we send dust. If you didn't know the desert, you missed a good friend.

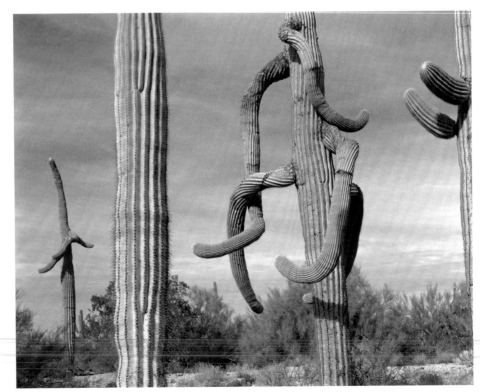

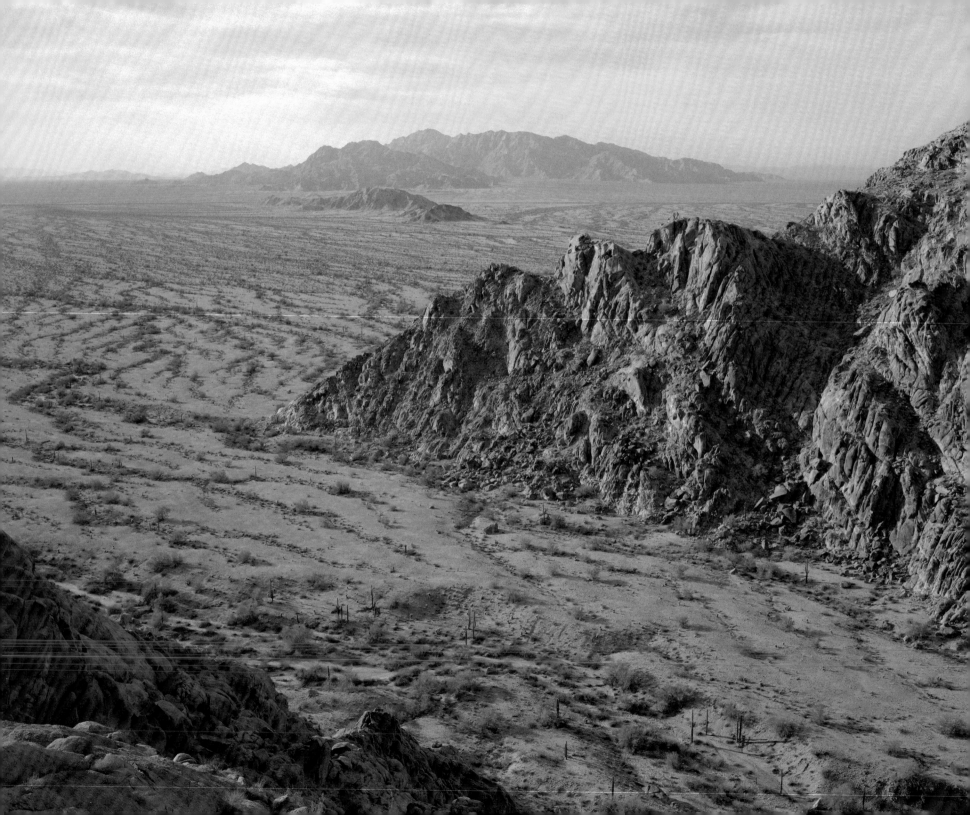

Devil's Oven

The heat was so great that it was just as bad staying where I was, under that flood of blinding light falling from the sky. To stay, or to make a move—it came to much the same.

ALBERT CAMUS, *THE STRANGER*

I WAS TRAILING the ghost of a man I had never met, a modest prospector named Pablo Valencia who had searched for gold in the deep desert in the time of summer, in the time of heat.

I had stumbled upon Pablo in a medical report written in the last century by the frontier scientist who delivered him from death. Pablo's story looked simple enough. He prowled this desert in all seasons and once had found flecks of gold in a lava rock in the seared borderland where southwestern Arizona melts into Mexico. In August 1905 he returned with a partner to mine it. Sixty miles out of Yuma, Arizona Territory, they visited with a scientist camped at the last waterhole, topped their water bags, and headed forty miles deeper into nowhere. Their water ran low, so the partner returned for more while Pablo continued afoot. This far it was just another day of work and travel in the desert. But then the partner couldn't relocate Pablo, and so began an ordeal unique in the annals of survival.

For six and a half days without any water, Pablo fought his way back to that remote waterhole. He walked; he stumbled; he crawled. Dehydration, delirium, and cactus thorns racked his body. He was so far gone that he even endured a near-death experience and saw his soul outside his body urging him to go on. By all odds he should have died within two days. Eight days after leaving the last waterhole, he crawled back, and the scientist who heard Pablo's deathly bellow near the waterhole thought Pablo would surely die. But he didn't, and with broth and watermelon the scientist nursed Pablo back to life.

From the written account I knew Pablo started and finished at the waterhole, but clues only hinted at his route through Hell. Here lay a historic mystery with a blank page. Armchair curiosity roused a challenge, and as I finger traced his possible routes on a map, I touched a deeper need. I already knew the area fairly well, having hiked its trails, flats, and canyons in other seasons and having crossed points of Pablo's route by truck. Yet ultimately I knew that if I ever were to understand Pablo, I'd have to follow on his terms, in August, afoot. But, as Pablo knew and I was to learn, understanding extorts a price.

Encompassing twelve thousand square miles of extremely hot and dry desert, much of it bears the name El Gran Desierto—the Great, Grand Desert. Save for a few pitiful outposts of cowboys, truck stop employees, and squatters, no one dares live within the land of heat. Few travel here in summer, with the exception of reluctant motorists on the one paved highway, which parallels that historic wagon road known as El Camino del Diablo. But Pablo did. He knew, as true desert folk do, that life needn't stop because the season changes. With sufficient water and maybe an afternoon siesta in the shade, people can and do go about their business.

And now, in an infernal August many decades later, I followed Pablo, though you couldn't tell it. I dozed under a mesquite tree, immobilized by thirst. Another pilgrim, W. J. McGee, had passed quite near this very spot a century before and written, "There is a suffering miscalled thirst which sometimes adds to the pangs of hunger in humid lands; there is a thirst of the sea, aggravated by the salt spray on lip and nostril though the pores are bathed in moist air, which is hardly less horrible than hunger; and there is the dryness of the desert, the gradual desiccation of mucus and skin and flesh, which inflicts a torture that hunger only palliates, and this alone is worthy to be called thirst."

The heat and dryness here sucks water at a staggering rate; a pond ten feet deep will evaporate by year's end. My canteen hung from a shading limb, but the water inside had soared to 113 degrees, and the air, two degrees more. I couldn't shake the thermometer down to even measure my own fever. During daylight few animals are out—they bed underground or pant in the skimpy shade. Heat is a storm to be ridden until it ebbs. The sun whips our hide and knocks down those of us silly enough to defy it. Only the turkey vulture, who rides the thermals, ventures out. It isn't unheard of for a jackrabbit and coyote to share shade of the same tree, both bowing to the greater enemy of heat.

I had boarded a steamy bus and stepped off at El Sahuaro, a one-pump truck stop on the two-lane highway through nowhere. Its cafe served warm colas from an ice chest, but the stuffy room drew sweat faster than I could replenish it. My head spun with nausea and I raced outside to throw up. Heat spilled off the asphalt and hot trucks. Some drivers slept in hammocks under trailers; others fanned themselves with cardboard; the lone waiter mopped his beaded brow with a sopping towel: heat favors no one. Already semidehydrated I fled the truck stop and walked five miles to the waterhole where Pablo began. The first steps away from civilization proved sand and rock to be cooler than asphalt. A puff of breeze caught and soothed, allowing sweat to work its magic. Near the waterhole that night I slept soundly.

The first day following Pablo proved uneventful, nothing more than a stroll though a beautiful park of strange desert plants. I laid up during part of the afternoon until the sun faded, and then hiked into the night. Desert nights are serene excursions, at the top of my list. Owls glide past, hoping to snag any rodent I scare from its burrow. Kangaroo rats bounce along their runways. Foxes prance in the shadows. Fanged serpents freeze for passing hikers.

During the night the heat persisted, so I only napped and continued to hike through the morning. By noon I was thirty miles into the walk and reached the first of four caches, which I had left weeks earlier by truck and which I hoped would sustain me for the 120-mile round trip. There I refilled all canteens as well as my belly. Desert trees, also hoarding water, are sparsely limbed with small leaves, so shade is at best a sheer curtain, rather like trying to dodge the sun by hiding under a lamp shade.

And now I lay motionless, conserving energy and sweat, and trying to motivate myself onward. A small voice objected: you've already left a bus and a cafe and a waterhole; why leave this tree? A pair of ravens croaked overhead and stirred me to action. It was too late to philosophize; I had already pulled the ripcord when I left home. Now I was waiting to see if the parachute opened. I crammed things back in my small pack and resumed walking.

In a rock alcove where mountain met flat, I passed a rock cairn and wooden cross, marking the end of some previous but unnamed traveler. At the time I wondered the "who" and "when," but I should have pondered the "why." Onward. The thirst grew. Sure, I had a reader's knowledge of the great desert travelers—Burton, Lawrence, Doughty, Thesiger. On other desert forays I had earned an appreciation of short-term thirst, and at home I had studied desert survival. But that was cerebral and this was different, visceral, a nagging persistence, a rude and uneasy urgency.

Then I realized the significance of last night's lingering heat: it had never dropped below the threshold of sweating, and I'd fought dehydration every hour of the day and night. Because of radiant cooling, desert nights may plummet thirty to forty degrees below the day's high, making the air seem almost cold. Indeed, many of those who perish of exposure out here actually go of hypothermia in the hours before sunrise. But last night the mercury held high like a perpetual fever.

There was nothing to do but continue to the next cache. Jagged granite ridges ripped from the sand flats. Trees were stunted and few, and even the commonest shrubs acted unneighborly and grew far apart. The soil crust wove the sand floor together. Seeds of summer flowers lay underground, awaiting seasonal rains. Later, waves of sand rolled against the ridges. I walked. I marched. I trudged. I tried to whistle, but my lips were parched. I drank often but craved more. I was over the edge but didn't realize it. If you're thirsty, you already have debts to pay and water is the only currency.

Again I hiked through the moon, which set just a few hours before sunup. And again, the night's temperature hovered in the nineties. I made another twenty-five miles but sweated all night. The next day dawned hotter than the last, but about midmorning I reached Pablo's lava and sprawled on the ground near the spot I'd cached my gold—a plastic jug of water. I sighed with relief. Rest. Water at hand. I napped in the thin shade of a paloverde, but even my eyeballs felt hot.

When rested, I'd dig out the cache and resume the hike. From my remaining canteen, I swallowed frequently, but the heat took its toll, and the remainder wouldn't last until sundown, so I decided to open the cache and stock up. In the time since burying my water jug, the wind had obliterated all tracks with sand and had mown the few flower stalks left from spring, so trees and rocks were my only guideposts. No treasure map has ever been more delicately unfolded than the directions to this cache. I reckoned that Pablo had waited nearby in vain for his partner to return with water.

Bracing myself, I lurched out into the sun's full inferno and triangulated my landmarks. I paced the yardage to the X, the spot of salvation, and began to dig, scooping hot sand with bare hands. A few

inches down I felt the jug, but not as deep as I had buried it. In a flurry I brushed sand away, but in horror I found bits of shredded plastic and then bigger slabs, which no longer held water. Through gashes in its top, the jug had filled with sand. A coyote, that inquisitive canine, had done what comes naturally: found something new and sampled it. Wind, that eternal smoother of the land, had covered it again.

Devastated, I crept back under the tree. Breathing accelerated with uncertainty, indecision, fear. Sweat seeped into my eyes. Then I had to smile. Through the throbbing in my head I remembered my reason for being here, Pablo, and I imagined him, here, facing *his* moment of crisis. Undoubtedly he had lain under a tree, maybe this tree, and pondered his predicament: "My partner hasn't come; I'm out of water; what can I do; is this the end?"

I had counted on this water. Without it, my trip died. Without it, I might die. Searching for a man now dead became a race to keep myself alive. Slowly I reviewed the options. When heat sledges the brain, all thought is slow. Simple computations become difficult; the mind drifts uncontrollably from the track, even more difficult than focusing one's eyes burning with sweat. Five miles north, through soft sand, lay the asphalt highway, but I couldn't count on a car or on flagging it down. Six miles eastward, I remembered, was a ranchito with a well; I had driven past it on earlier trips, but I couldn't be certain that someone would be there or that it would have water in this dry season. What are six more miles when sixty lay behind? What are six more if a car is flat out of gas?

Fragments of options and plans swirled though my head. But foremost I knew: if I stayed under this tree, I could count on it being my grave marker within a day. Occasionally I drifted and dozed; I felt myself slipping, slipping toward an eternal slumber. I had to go

somewhere soon, or the coyote that tore into my cache would be sniffing me. I was being repaid for those times as a kid when I used a magnifying glass to focus the sun to cremate hapless ants.

Once I squandered a few drops of water to wet my handkerchief and dab the caked salt from my eyes. The crystals scratched tender skin when rubbed. High above circled a vulture; nothing escapes its view. Once I roused from a doze when I heard it swoosh close overhead and then roost in a snag. When I rolled over it flapped away in disgust.

Heat had sapped nearly all strength and I was very tired. I've read that some thrash against the heat; some strip their clothes and try to bathe in dirt. That urge didn't come to me. I only wanted to sleep. The insidious part? Dying would have been so easy. A powerless, exhausted fading of the mind, much like an accident victim sliding into shock and unconsciousness. But somehow and from somewhere in the same resolve of spirit that had moved Pablo, I stirred. Without even sitting up, I slid the pack from under my head and pulled out everything except two empty canteens. I prayed that I'd need them. I'd also need the sheet I was lying on, maybe for a blanket, maybe for a shroud, but I knew I'd need it. The rest: my money, my camera, my spare clothes I stuffed into a bag and hung it in the tree. They mattered not at all.

The sun pounded relentlessly. Even plants, which thrive on sun power, must have water or die. I was far more fragile than any plant. I knew the direction to the ranch: away from the sun. Top gear began with trudge; it slowed to trudge and rest, rest, trudge and rest. Eventually the best I could muster was a mountaineer's rest step—on perfectly flat ground. One step, pause, breathe twice, then another step. Mirages and dementia turned trees to houses and rocks to cars, each luring me to detour. The first barrel cactus I found died with my

knife, but it tasted like gritty mucilage, left a tight film on my lips, and quenched nothing.

My mind wandered and exaggerated. I feared not finding water at the ranch. Then I feared that the cowboys wouldn't give me any, so I resolved to kill them for it, if need be. When I merged with a cow path, I knew the ranch was near, so I readied my knife. I even rehearsed a speech in Spanish about needing water but wasn't sure my lips and tongue could form the words. Flies probed me, looking for moisture I no longer had. Half a day without water and I was falling over the edge; Pablo's feat loomed even larger.

Six miles. Five hours. The ranch's well tower appeared, then the shack and outbuildings. Two vaqueros stood up under their ramada. They shaded their eyes and looked at the creature walking out of the sun. No speech; no knife; no need. My pathetic looks told them all they needed to know. They slid off my pack and sat me down. One looked sympathetically and asked a few unanswered questions. The other clanged the coffeepot in the cook house. I stared ahead silently. A cup of sweet coffee, then a grape, then the wipe of a wet cloth. I was safe. Their hospitality could have salvaged Pablo himself.

I was now satisfied that I knew his route and knew deeply about him and his struggle. If ever we met, we could speak without words.

It was as if he had shared with me his country, his struggle, and his luck. He had led me to the desert's own heart. This heart is not a place or even a zone. Instead, it is a voluntary contract accepting heat, a *negocio* signed in Life's sweat.

By accepting heat, not denying it, I came to know the desert—and myself—in a new way. A new season opened into a new world. Instead of being locked out of the desert for the summer, I found it even more open, alive, and mysterious than in cooler months. Three things wrong with the desert—June, July, and August—became three things most right. Like one who discovers the beauty of north woods in deep winter, I now had met the dreaded desert enemy and found it was only me. I had been privileged to touch the desert heart—and my own.

Then and only then could I go freely and boldly into the sunshot land of little shade and feel its living pulse. Only then could I clear my city ears and hear ravens. Only then could I touch the land of fiery sunsets, taste evening's breeze, inhale the fragrance of the night's own flower queen, hear the chuff of cactus breathing. Only then could I begin to understand and really love this desert we call home.

Several months after his ordeal, Pablo was back to his old ways, back to his desert, back to life in summer. So am I. So may we.

Epilogue

When you come to a fork in the road, take it.

ATTRIBUTED TO YOGI BERRA

I SPENT THIRTY-ONE YEARS teaching high school students. Occasionally they'd ask me when I had decided to become a teacher. I'd tell them, with a grain of truth, "I haven't yet." I always thought I might do something else. Teaching just happened, starting with a stint substituting in some classes to earn money for graduate school. Then, needing money to live on, I filled in for an English instructor on maternity leave . . . and three decades later I retired with the astounding realization that a teacher is who I had become. It was what I believed in and all I had. It is *who* I am.

So too the desert. I was born in Oregon, and my family and I lived in Florida and Illinois before coming to Arizona when I was seven years old. Desert plants and sky and space were very strange at first, but the climate was mild, the people friendly, and the plants and animals fascinating—giant cactus, gentle sunspiders, soaring hawks, ever-changing mountain vistas, invigorating thunderstorms. In a few years the place grew on us. We stayed, and though we visited relatives and attractions in many other states, we always came home to the desert. Now it's part of who I am. I haven't been able to wrap my mind around the notion of some afterlife heaven, and if hell is hot and dry, I've already been there and enjoyed it immensely. Green pastures and streets of gold? No thanks, give me trackless sand and one hundred days of Sonoran summer. I've been sunstruck, and given a choice, I'll walk the devil's highway.

And now that this book is finished, I'm packing for another desert walk. May your own trips go well. See you around.

209

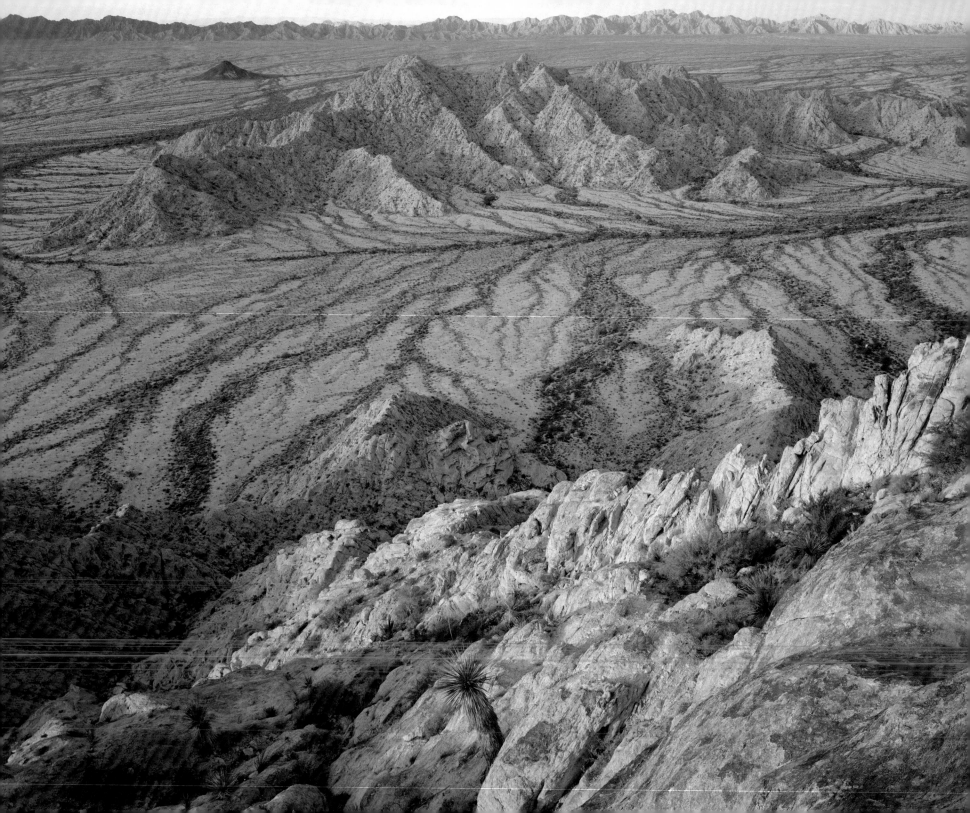

AN EVANESCENT NOTE SCRAPED INTO DEW-DAMPED SAND:

We have been there. The Grand Desert was blooming and it was good. We walked to the range beyond the range beyond the range, and journeyed from the summit down the bajada and across the dunes to the sea. These natural places are necessary counterpoints to mandatory cities, industries, and highways, but the desert deserves better than to be discarded as squandered remnants of our flitting impulses. Great landscapes risk being hit-and-run victims. They are not recyclable, like cans and bottles and shredded paper. True, whole, beautiful desert will exist only if we persist, insist, resist, desist: persist in pushing leaders to enact and enforce regulations to guard and sustain the land, insist on adequate funding for field managers, resist whittling large lands into piles of worthless shavings, and desist from overwhelming the havens and heavens we have set aside on maps. Sist!: stop, take a stand!

Organ Pipe Cactus National Monument, Cabeza Prieta National Wildlife Refuge, Sonoran Desert National Monument, and the Barry M. Goldwater Range in Arizona, and the Reserva de la Biosfera El Pinacate y Gran Desierto de Altar in Sonora and the Reserva de la Biosfera Alto Golfo de California y Delta del Río Colorado in Sonora and Baja California: these are the Grand Desert. Think of them as your newborn children.

Protecting lands already held in trust should be easy. In theory, they are conserved, saved, featured, enshrined, bought and paid for, so that nature can go about its business without much human interference or harm. In reality, they are threatened daily by a litany of petty and felony offences. These sun-rich lands are our patrimony, legacies, treasures for posterity. Besides, they aren't truly ours. If we squeeze the life out of them, all we'll have left is heat. If we let them shatter into shards and fragments, never can all the king's horses nor all the king's men put the Grand Desert together again. Why not formally weld the administrative units together as a great, unified alliance of desert sister reserves or even a borderland peace park, one dedicated to nature, people, and nations? Our resolve must match nature's grandeur, or what's a desert for?

Here is your country. Cherish these natural wonders, cherish the natural resources, cherish the
History and Romance as a sacred heritage, for your children and your children's children.
Do not let selfish men or greedy interests skin your country of its beauty, its riches, or its romance.

TEDDY ROOSEVELT, 1903

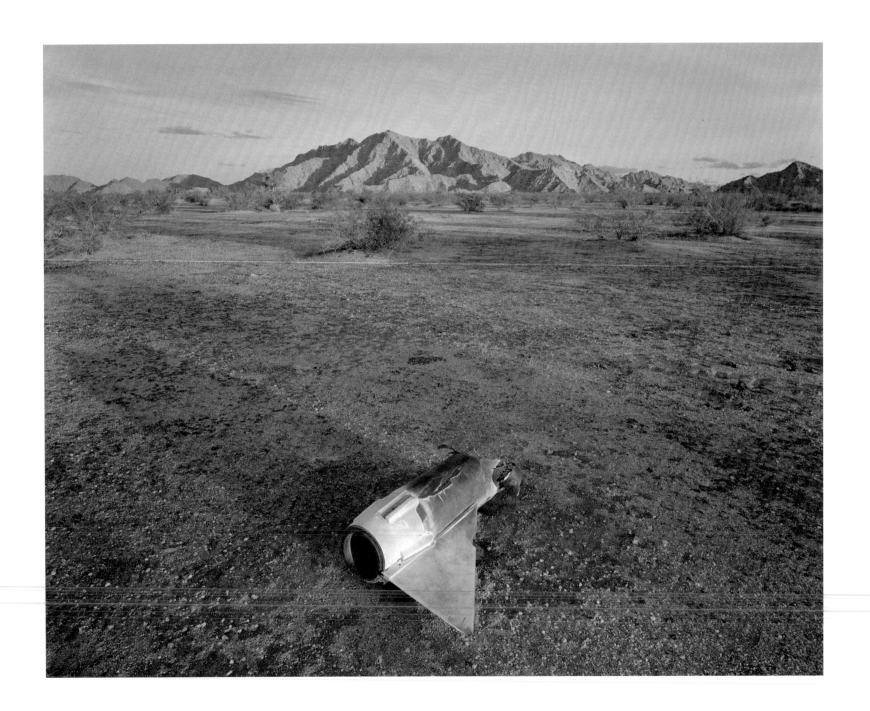

Photographer's Comments

I LIVE IN THE FOOTHILLS of the Black Range along the Mimbres River in Southwest New Mexico. When I drive south of my home, down the valley, I see a river gone dry, and the hills flatten into a sweep of snakeweed, with thin tufts of remnant grasses and mesquite scrub. It is a landscape most people find barren and drive by. I love looking at these places. They are a kind of puzzle. A landscape of the imagination. They have lost their soil. Humans have churned it, stripped it, and let it wash away. What it could be, what it once was, is a beautiful mystery.

Before I leave for the desert my wife, Jennifer, will ask me where I am going, and when I will return. I answer her with, "I think Arizona, but I might cross into Mexico. I'll try and get back in two weeks, but I want to stay for three, and don't call anyone for four"—leaving her understandably uncertain and mildly alarmed about my potential demise, lost and dehydrated, on one of these desert forays. One Christmas, she bought a compass for me as a gift. She never gave it to me. She started thinking of our walks: of how I left the trail, the way I wended from one thing to another, and jabbered about this and that, until an hour or so after dark when we would inevitably walk out, arriving just at the truck. She started worrying that if I spent time looking at the compass instead of looking at the land, I might get lost. She returned the compass to the shop.

I love maps. In the beginning of a walk I take them out and line up the mountains along the horizon. I carefully mark the location of my truck and look for the features I might later recognize. This is a ritual. If I depended on these things I would get lost. By the time I head back to the truck it is usually night. In the

dark the saguaros and big trees disappear, and the distant mountains that looked so prominent have the same scale as the small hills you pass by. I try and put the land together in my mind. The contours of the earth and the map reveal the same underlying logic. They are shaped by water. If you understand how the water flows you can traverse a long distance and still be in the same place. The roads are a counterpoint to the water: they have a human logic that cuts across the land and connects one place to another, and finding the road is the best way to find your truck.

A few years ago I was photographing near my home in the part of New Mexico that sticks out like the heel of a boot along the Mexican border when I ran into an old rancher. He asked me to stop by when I finished. At the end of the day we sat on the porch and talked. I told him where I photographed. I had hiked through some thick oak scrub into a little canyon about three miles behind his house. He told me he never gets back in there. I already knew that. I look for the places that are too rough to get a horse in or a cow out and still have a bit of soil left. I sought out the place for the same reason he avoided it.

I remember another time when a rancher was telling me about how his grandfather had run over 2,000 head of cattle on his allotment and now there was barely grass for 250. When I challenged him and said maybe it just wasn't worth running cows on this land, he looked at me and told me I was just about as stupid as a so and so. Ranchers seldom swear, but he could hardly contain himself. He had me sit down so he could explain how if his family had never run cattle on this land it would not have been worth anything.

Now the formalization of the idea that nature can be worth something independent of human beings, that it has an intrinsic value, is surprisingly recent. Holmes Rolston received the Templeton Prize in 2003, about a million and a half dollars, for coming up with the idea in 1975. How you see the land comes down to what you value. The old ranchers saw grass and they thought it was beautiful because they could use it to raise a family and it tied their community together. I see grass and I think it is beautiful because it underlies an interrelated system of soil and water and microorganisms, of rodents and lizards and insects, of antelope, elk, and deer, of bear and coyotes, rattlesnakes and hawks, and a few top predators—mountain lions or men. I often see a land too dry, too fragile to have ever sustained hard human use for very long. I spend most of my time looking for the pieces that still have some of their native complexity.

Every day I drive along the Mimbres. There are long stretches of big old cottonwood trees and a river that spreads out over the cobble. Without the young trees, cottonwoods, willows, or nogals, it is like a town without children. It is dying. Nowadays the river is cut up by ownership. Along some parts of the river, people put up fences to protect it, and a thicket of young plants grow in a narrow corridor, but it all gets torn up in a heavy rain. A bit more soil and a couple more big trees get washed away every year. When you ask people in the valley about what is wrong with the river, we all just point at the other folks. The river reflects everyone's individual values. It is a symbol. When you look at it you see what you need. You would hardly know the river was part of something bigger. I feel a river is the blood of a watershed. You hurt the watershed and it bleeds hard, and eventually it will dry up and die.

I spend a lot of my time working on enviro projects. I have been to meetings, and more meetings, where everyone in the community sits around a table and tries to hash things out. I hate meetings. I have what I call my bad habit. I go and look at the places people talk

about and I compare it to what they said. And if I can't figure out what they were getting at, I keep going back and looking and asking questions. I always find a disconnect between what is there and how people see it.

Photographers are not much different. Sometimes I think we have a picture in our head, and we just go out and look for it. For a long time my photographs were tied to road trips. I would go off and lay claim to the territory. It didn't matter that I hadn't seen it and didn't know much about it. I was out to discover something and show it to the world. The West had long roads and wide open spaces—who could resist? I was part of a long and venerable western tradition.

In the West photographers use the land as a vehicle to affirm existing ideas they bring with them. In the 1600s the first Spanish settlers came north via Mexico, and in 1862 when Congress passed the Homestead Act, anyone could file for 160 acres of free land. This opened the last floodgates to the Anglo-European settlement, and by the 1890s a couple of million cows and a great drought collapsed the grasslands of Arizona and New Mexico. The land the first photographers found had already changed. They came with the four great surveys sponsored by the U.S. government between 1867 and 1879. The surveys had an agenda—to look for and photograph minerals, settlements, water, roads, and routes for the railroad. The West was to be opened up and its resources made available to the nation.

These images laid the foundation for how we photograph the West. This was especially true of the work of Timothy O'Sullivan. He is often spoken of as a visionary, and his images are now seen as art objects. His genius lay in his ability to claim a personal vision within a practical objective. The way I see it, he was a genius, but his photographs were more about himself and the information the folks back East wanted than about the land. And we are still making the same pictures in the same places for the same reasons.

I used to have an article in my library about the grass at the Trinity site, ground zero for the first atomic bomb. Fifty years later the grass there is in better condition than on the adjacent public lands. One of the little secrets of the American West is that military ranges are in the best ecological condition of our public lands. The reason is simple. The consummate value of our culture is human use. The military has the power to trump all other uses of the land. They have carved out large reserves from the desert, and much of it is for buffers and air-to-air training. In the large buffer zones they keep people out—the land gets left alone.

When you think of pristine landscapes, think bombing ranges. I first went to the Cabeza Prieta, a wildlife refuge in the heart of the Barry M. Goldwater Range, in the early eighties. I would visit for a week or two each year. I rarely made photographs. I found the broad sweeps of land with small mountain ranges in the distance compelling just to look at. I had begun to learn something about the West. Water was a kind of curse we laid on the desert. If you think about it, what makes a desert is the lack of water, and the animals and plants have done just fine for a very long time. It is people that need the water. When the settlers came they asked the federal government for a little help for water projects, and we are still spreading water everywhere. It took me a long time to see what was special about the desert along the border—it was just too damn dry and last in line for water projects, and luckily the military closed off much of it. When someone drives across this desert, a tire track pressed in the earth can remain for ten, a hundred, or even two hundred years. The matrix of soil still exists. This simple thing—intact soil—is the rarest of rare.

There is a complexity here. A completeness of the ecosystem I have found nowhere else.

Six years ago Joe Wilder, the Director of the Southwest Center at the University of Arizona, saw some of my photographs and conceived of a collaboration with Bill Broyles, the naturalist and writer. I was kind of tired and frustrated at the time. I would talk about water and soil and our construct of the western landscape, and everyone—ranchers, environmentalists, artists, curators, art dealers, and even my wife—would look at me like I had slipped a couple gears. Just getting out in the desert as much as I could for a couple years seemed like the right thing to do.

Bill asked me to write something about how I photographed the land for this book, and to say something about cameras and lenses. I was fool enough to do these images with a view camera. One of those old-fashioned cameras that looks like a small accordion and sits on a large tripod. The whole setup weighs about thirty pounds. Any camera can make a good picture. I go to the desert to wander. Photography gives me a reason to go and something to bring back. There is a complexity in these wild places I can never photograph. The very act of selecting one thing at one point in time means you will leave most things out, and the things most likely to get left out are the ones I do not understand. I have tried my best to photograph what is there.

Anyway, my technical advice to photographers is this: the less you bring to the desert, the more water you can carry.

Michael Berman
(March 2005)

Acknowledgments

THE MANY generous, kind, and knowledgeable people of Sonora and Arizona.

Joan E. Scott, my wife.

Dr. Joseph C. Wilder, David Yetman, Lupita Cruz, Adela Hice, and Jeff Banister at the Southwest Center, University of Arizona.

Christine Szuter, Allyson Carter, Anne Keyl, Melanie Mallon, Bill Benoit, and other professionals who cradled this book from concept to your shelf.

Bob Early, Dick Stahl, Becky Mong, Beth Deveney, and the staff of *Arizona Highways.*

Paul Allen and Larry Cheek, *Tucson Citizen.*

Campmates Ed Abbey, John Annerino, Michael Berman, Diane Boyer, Luke Evans, Don Fedock, Richard Felger, Bill and Gayle Hartmann, Julian Hayden, Freeman Hover, Charlie and Marilyn Kline, Al McGinnis, Dana and Betty Smith, Jeanne Williams, and others. Youth leaders Comer Alden and Ed and Tina McRae.

Charles Bowden, Jack Dykinga, Doug Kreutz, and Ed Severson of Team Pollo.

The pilots and agents of the U.S. Border Patrol.

The knowledgeable and helpful staffs at Cabeza Prieta National Wildlife Refuge, Organ Pipe Cactus National Monument, Goldwater Range, Pinacate Biosphere Reserve, and Alto Golfo Biosphere Reserve.

The professionals and volunteers who rescue and treat victims of heat and exposure.

A number of authors and photographers. When first writing for publication, I had visions of cutthroat newspapermen bent on a first-edition scoop, guarding their every source, and backstabbing their colleagues. Not

so. A number of professional and semiprofessional writers and photographers have helped me enormously, offering everything from an encouraging word, to a tip, to opening their own files of hard-earned research, to reading selected pages and offering improvements. They include Edward Abbey, Paul Allen, John Annerino, Diane Boyer, Byrd Baylor, Chuck Bowden, Larry Cheek, Will Clay, Jack Dykinga, Byrd H. Granger, Dorothy Kalil, Doug Kreutz, Patricia Preciado Martin, Doug Peacock, Ed Severson, Leland Sonnichsen, Scott Thybony, Jeanne Williams, Ann Zwinger, and others. They value good writing and did what they could to improve mine.

My grandmother Verna, who recited poems to her grandchildren, including me. She especially loved Robert Service.

And Michael Berman, who sees what I see but cannot capture with mere words.

Bill Broyles

I am grateful to Joseph C. Wilder, the director of the Southwest Center, for the support he has given this project and for the insight he has shown in bringing the words of Bill Broyles and my photographs together. Without his guidance and attention, this book would not have been possible.

I wish to thank my friends Ken Sorensen and Chris Spain for their support of my work, Mike Goss and Rex Johnson for getting me across the border, and William Sutton for long conversations about the land and the West.

It is easy to go off into the desert when there is warmth and love in my home to return to. I wish to thank Jennifer Six, my wife, for her understanding and support of my wandering.

Michael Berman

Chapter Notes

Photographs in this section are by Bill Broyles.

EPIGRAPH

Honoré de Balzac, "A Passion in the Desert," in *La Comédie Humaine,* vol. 20, trans. Katherine Prescott Wormeley, 387–406 (Boston: Little, Brown, and Company, 1896).

DEVIL'S DRIVEWAY

Harry Belafonte, "Talkin' and Signifying." Lyrics by Lee Hayes and Louise Dobbs. *Swing Dat Hammer.* Columbia Records LPM 2194, 1960.

Do not try this at home. Each year thousands of people die of heat stroke in urban settings. Headline heat waves rack places like France, Chicago, and India. The events and situations are simple enough: people—frequently elderly or invalid, sometimes children—live in small rooms; the windows don't open; the air conditioner breaks down; the heat is stifling; there's no breeze to evaporate their sweat, or high humidity interferes with cooling; the person feels exhausted and lies down for a nap, never to rise.

Remember the protagonist in Jack London's story "To Build a Fire"? He struggled against sleep, for he knew that the slope to death is insidiously easy. The body is exhausted, sleepy, and the extreme cold—or heat—quietly pushes the person over the edge. For many, there's no struggle, no ripping off clothes, no panicked terror. Just sleep. Many victims look as if they

had simply lain down after overexerting themselves, which in essence they did. When the body's core temperature rises above 98.6 degrees, it is in fever. At 105–106 degrees, permanent brain damage occurs. At 107 degrees the body goes limp or into convulsions, and death is imminent. Summer temperatures in the desert, as you know, routinely exceed 105 degrees.

One man in Tucson died on a chaise lounge in his backyard beside his swimming pool. He imbibed too much, passed out, and the midday sun literally cooked him. Summer temperatures on bare skin may reach 130 degrees even when the air temperature is only 100 degrees; the ground may sizzle at 180 degrees. One elderly woman in Tucson suffered third-degree burns when she fell on an asphalt parking lot and couldn't get up. The saddest cases of all are infants left locked in cars while a parent dashes to do errands. "I was gone only a few minutes" must be the most haunting words a grieving parent could ever say. Between 1992 and 2002, 570 people died in Arizona due to excessive heat, 55 percent of them elderly, with July being the deadliest month (Ignacio Ibarra, "Heat-linked Deaths on Rise for Elderly," *Arizona Daily Star,* April 26, 2004, B1–2).

Author

I'm reminded of driving to Phoenix one summer afternoon when it was gawd-awful hot. Just south of the Gila River bridge is a small house. A man was sitting under a tamarisk tree. Since I was in my big car and rolling at seventy-five miles an hour with the air conditioner on, I felt sorry for him. Many summers later John Annerino and I made a whirlwind Fourth of July trip and in less than a week visited all the major waterholes in the Pinacate and Cabeza Prieta and some in the Goldwater Range. We had no air conditioner, so we kept the windows

Ejido

rolled down and were comfortable. After sundown one of those days, we drove west along the asphalt interstate from Gila Bend to Mohawk Pass. Even with the windows down, we sweated profusely, and for the only time on the whole trip, we complained about the heat. The heat-island effect of the asphalt nearly overpowered us. I thought about the guy sitting under the tree watching cars zip by on the road to Phoenix and it clicked. While I was feeling sorry for him sitting outside, he could have been feeling just as sorry for me in my closed car on that ribbon of asphalt. You probably have your own stories to tell.

The August hike that motivated my preliminary driveway experiment started as planned. Chuck Bowden and I hiked west along El Camino del Diablo from Sonoyta, hoping to reach Yuma. It rained the first night, and the mugginess and bugs made sleep nearly impossible, and the lack of any breeze was absolutely suffocating. We made forty miles, as far as Los Vidrios, before I surrendered to the heat and humidity. We hitchhiked to San Luis and took a bus home.

This story first appeared in the *Tucson Citizen* magazine, June 22, 1985, 1. Your humbled author still hikes in the desert during summer, but he is much more mindful of his canteens.

Devil's Highway

Edward Abbey, *Desert Solitaire.* (Tucson: University of Arizona Press, 1988) xii; William H. Emory, "Lieutenant Michler's Report," in *Report on the United States and Mexican Boundary Survey,* vol. 1. (Washington, D.C.: Cornelius Wendell, 1859; Repr., Austin: Texas State Historical Association, 1987), 115; Kirk Bryan, *The Papago Country, Arizona: A Geographic, Geologic, and Hydrologic Reconnais-*

sance with a Guide to Desert Watering Places (Washington, D.C.: United States Geological Survey, Water-Supply Paper 499, 1925), 261; Raphael Pumpelly, *My Reminiscences,* vol. 2 (New York: Henry Holt, 1918), 774. This chapter first appeared as "The Devil's Highway" in *Arizona Highways,* February 1993, 4–13.

STRANDED

Dave Roberson

Mike and the Mechanics. "The Living Years." *Favourites: The Very Best Of.* Virgin Records, 1998. Raphael Pumpelly, *My Reminiscences*, 772–73. A photo and an account of the deceased walker I describe in this story is in John Annerino, *High Risk Photography* (Helena, Mont.: American and World Geographic Publishing, 1991), 95. A classic El Camino hike done by David Roberson, Bruce Lohman, and John Annerino is covered in John Annerino, *Dead in Their Tracks: Crossing America's Desert Borderlands* (New York: Four Walls Eight Windows, 1999), 7–28.

One of the first things a kid of my generation learned about driving in Arizona was to make sure he had some basic things before driving beyond the city limits: extra water, a fan belt (and a wrench to change it with), air in the spare, a shovel, a flashlight and matches, a pocketknife, some basic screwdrivers, and a blanket, mat, or towel to make shade or to kneel on when changing a tire. And if we had spare radiator hoses, we felt invincible. Nowadays we blithely charge the batteries in our cell phones and dial the auto club when we get into trouble.

This story first appeared as "Stranded in the Sun-Baked Heart of the Desert . . . and Lucky to Be Living to Tell the Tale," in *Arizona Highways* May 1998, 3.

WAYLAID BY BEAUTY

Edward Abbey. *Desert Solitaire.* (New York: Ballantine Books, 1968) xii.

As I recall, O. D. Luther drove the Greyhound bus that started me on this journey. On several trips I was able to convince bus drivers to let me off at the side of the highway in the middle nowhere. Drivers were like ship captains who set policy and were law and order. One driver was a former deputy sheriff at Bakersfield and carried a blackjack in his hip pocket and maybe a hidden gun. Those were the days when you could sit up front and visit with the driver, sometimes to help keep him awake.

Pete the Pelican

The friend who drove me home was also my mentor in the English Department at Rincon High, Al McGinnis. Think of him as comedian Tim Conway in hiking boots. Al was not a traditional athlete, but he pushed himself to run a private marathon, and later, in the spirit of the British Romantic poets such as Shelley and Byron, he took up long-distance walking, including a perambulation of Lake Tahoe. He and I made a number of enjoyable hikes and trips, including my first trip along El Camino del Diablo. Also on that first trip was Freeman Hover, journalism teacher, newspaperman, one-time resident of Ajo, and Midwestern radio disc jockey, who had interviewed Buddy Holly, Richie Valens, and others in sessions that are now collector's editions.

This story first appeared in *Arizona Highways,* February 1998, 4–9. The editorial staff selected this essay as the magazine's Best Story of the Year for 1998.

Lion in Summer

Harley Shaw. *Soul Among Lions: The Cougar as Peaceful Adversary* (Boulder, Colorado.: Johnson Books, 1989) 137–38. The event in this story occurred at North Pinta Tank in Sierra Pinta. Dennis Segura was the friend at the wildlife refuge. Harley Shaw, an Arizona Game and Fish Department biologist, looked at my photos and pegged the animal as a young tom, probably ranging off the Gila River corridor looking for a mate and territory. Harley's book is one of my favorites. Young toms in southern New Mexico dispersed an average of 104 miles from their mother's home territory (Kenneth Logan and Linda Sweanor, *Desert Puma: Evolutionary Ecology and Conservation of an Enduring Carnivore* [Washington D.C.: Island Press, 2001], 236).

Don McIvor wrote a report on mountain lions in the low desert (*A Critical Review of the Status of the Yuma Mountain Lion* [Logan: Utah Cooperative Fish and Wildlife Research Unit, Utah State University, 1994]), and some mammalogists have argued that there is a subspecies in the lower Colorado River region, calling it the Yuma puma (*Felis concolor browni*). See Aldo Leopold, "Green Lagoons" in

Mac McLemore

A Sand County Almanac (New York: Ballantine Books, 1966), 141–49.

Several people have reported seeing mountain lions near Tinajas Altas, and Bob Henry has a remote-camera photo of one (Richard S. Felger and Bill Broyles, eds., *Dry Borders* [Salt Lake City: University of Utah Press, in press]. A sheep hunter watched one for over an hour near Borrego Tank and resisted shooting it because it was so magnificent. He had seen many bighorns before, but never a lion.

Go Back

Ronald L. Ives, personal communication. Richard F. Burton, 1856. *First Footsteps in East Africa*, vol. 2 (reprinted 1987. New York: Dover Publications, vol. 2, 57–58).

My own modest studies of waterholes includes "Desert Wildlife Water Developments: Questioning Use in the Southwest," *Wildlife*

Ram

Society Bulletin, 23 (1995):663–75 ; "Surface Water Resources for Prehistoric Peoples in Western Papaguería of the North American South-west," *Journal of Arid Environments,* 33 (1996):483–95; "Wildlife Water Developments in Southwestern Arizona," *Journal of the Arizona-Nevada Academy of Science,* 30 (1997):30–42; "Reckoning Real Costs and Secondary Benefits of Artificial Game Waters in Southwestern Arizona," in *Proceedings of a Symposium on Environmental, Economic, and Legal Issues Related to Rangeland Water Developments,* November 13–15, 1997 (Tempe, Ariz.: Center for the Study of Law, Science, and Technology, Arizona State University, 1998), 236–53; with Tricia L. Cutler, "Effect of Surface Water on Desert Bighorn Sheep in the Cabeza Prieta National Wildlife Refuge, Southwestern Arizona," *Wildlife Society Bulletin,* 27 (1999):1082–88; with Andrew C. Comrie, "Variability and Spatial Modeling of Fine-Scale Precipitation Data for the Sonoran Desert of South-west Arizona," *Journal of Arid Environments,* 50 (2001):573–92.

Charles Sheldon shared Tinajas Altas with armed "revolutionists" in 1913. Charles Sheldon. *The Wilderness of the Southwest: Charles Sheldon's Quest for Desert Bighorn Sheep and Adventures with the Havasupai and Seri Indians,* Neil B. Carmony and David E. Brown, eds (Salt Lake City: University of Utah Press, 1993).

An earlier version of this chapter appeared in "The Miracle of Water on the Desert," *Arizona Highways,* April 1991, 18–27.

Spring

Helen Keller, *The Story of My Life.* New York: Doubleday, Page and Company, 1903.

Petey Mesquitey, aka Peter Gierlach, is the sprite of spring. His enthusiastic radio show captures the delights of living in a desert flower world. Some episodes are available on CD: *The Best of Growing Native,* vol. 1 and 2 (Tucson: KXCI Community Radio, 2003).

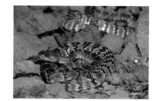
Three blacktails

This chapter first appeared as "The Frenzy Called Spring" in *Arizona Highways,* March 1999, 20–23.

Passing Through

Frances Dorothy Nutt. *Dick Wick Hall: Stories from the Salome Sun by Arizona's Most Famous Humorist.* Flagstaff: Northland Press, 1968, 87; J. Evetts Haley, *Jeff Milton: Good Man with a Gun* (Norman: University of Oklahoma Press, 1948). A posed photo in William T. Hornaday's *Camp-Fires on Desert and Lava* (128a) shows Jeff Milton lying on a blanket looking at a coiled rattlesnake, but the snake had to be warmed up and irritated for the occasion. Milton had found it in a woodpile, and his inclination was to let it be, but the photographer couldn't leave

Don Fedock

well enough alone and insisted on rousing it. On the same trip, Godfrey Sykes walked to the Gulf and bent over to pick up a seashell only to discover that it was a lethargic sidewinder. The snake didn't strike and Sykes left it alone (240). Hornaday, *Camp-Fires on Desert and Lava* (New York: Charles Scribner's Sons, 1908; repr., Tucson: University of Arizona Press, 1983). See also Bill Broyles, *Organ Pipe Cactus National Monument: Where Edges Meet* (Tucson: Southwest Parks and Monuments Association [now Western National Parks Association], 1996).

This chapter first appeared as "Edge of Civilization" in *Arizona Highways,* January 2000, 10–17.

Faces

Rudyard Kipling, "Sussex," in *Bartlett's Familiar Quotations,* 17th ed.

Cerdán

Cerdán: Ejido Aquiles Cerdán was named for a Mexican revolutionary born in 1877 and killed in 1910 by government soldiers in Puebla, Puebla. Also spelled "Serdán."

Charlie Kline, one of my fishing buddies, was the gymnastics coach mentioned in the first story in this chapter. A gentler man I've never met. On another trip, an open-end wrench managed to ram its way into the sidewall of one of our tires on the Sasabe road. If you travel, things happen.

Nopalitos contain vitamin C and can prevent scurvy. See, for example, Ronald Ives, "The Lost Discovery of Corporal Antonio Luis," *Journal of Arizona History,* 12, no. 3 (1970):101–115.

David Roberson flew the candy drop that year. Several years later he died instantly a few miles from here on a clear morning when his Piper Super Cub lost its air column and plunged nose-first into the ground from a height of fifty feet. His wife, Janie, called midmorning and said, "Dave's gone." It was one of the most painful days of my life. Dave helped introduce me to my wife. Other pilots I've flown with or known and greatly respected include Howard Aitken, Colonel Child, Hank Hays, Joe Dunn, Randy Herberholtzer, Jackie Mason, and Harry Aitken. Joe McCraw and Glen Payne were especially good trackers on the ground. I'd trust my life to these guys any day.

Oilman: whatever the PEMEX drillers found was not publicized. See A. B. Guzman, "Petroleum Prospects in Mexico's Altar Desert," *Oil and Gas Journal,* August 24, 1981, 110; J. Dale Nations, Daniel J. Brennan, and Rudy A. Ybarra, "Oil and Gas in Arizona," in J. P. Jenney and S. J. Reynolds, eds., *Geologic Evolution of Arizona* (Tucson: Arizona Geologic Society Digest 17, 1989), 795–815.

The Perez Boys: the Perez's goat cheese was excellent. The natural seeps mentioned in this story were described by Carl Lumholtz in *New Trails in Mexico* (London: T. Fisher Unwin, 1912; Repr., Glorieta, N.Mex.: Rio Grande Press, 1971); and by Exequiel Ezcurra, Richard S. Felger, Ann D. Russell, and Miguel Equihua in "Freshwater Islands in a Desert Sand Sea: The Hydrology, Flora, and Phytogeography of the Gran Desierto Oases of Northwestern Mexico," *Desert Plants,* 9 (1988):35–44, 55–63.

Taxi! and The Bus: in my hometown, taxi and bus service are so sporadic or expensive that I always drive my own car. In Mexico I can reach almost any place by taxi or bus except the backcountry

that lacks paved roads. My few experiences with hitchhiking in Mexico left me shaking my head: a fuel truck driver gave me a ride out of El Sahuaro while he tossed down shots of tequila. Another time a young man and his girlfriend gave me a ride from El Golfo to San Luis. Apparently they had partied all weekend and were drinking their way home. After a few miles and several near accidents, the girlfriend suggested that I drive while they sit in the backseat and drink more brandy.

Charles Bowden

Piñata Man: my friend on this traipse was Chuck Bowden, who wrote a satirical piece on U.S. trade barriers and called it "Don

Camino de Juan

Francisco Must Be Stopped" (*USA Today,* September 12, 1985). I did a photo-essay ("Don Francisco: His Art, His Life, His Memories," *Tucson Citizen* magazine, November 30, 1985, 1–2).

A Man and His Railroad: this first appeared as "Chance Encounter with a Man and His Railroad," *Tucson Citizen,* January 25, 1986.

El Camino de Juan: for a second look at the Hornaday expedition, see Bill Broyles, "Adventure in the Pinacate," *Journal of Arizona History,* 28, no. 2 (1987):155–88.

PERILS

W. H. Auden. "Oh where are you going." *Collected Shorter Poems 1927-1957.* Random House 1964, 191. For one of the best introductions to this region, see David D. Gaillard, "The Perils and Wonders of a True Desert," *Cosmopolitan,* 21 (1896):592–605. Some things haven't changed much.

Nonie McKibbin was the scuba diver. She was a cofounder of the Desert Dolphins scuba club and could fillet a fish faster than anyone I ever met. She authored *Gulf of California Fish Watcher's Guide* (Tucson: Golden Puffer Press, 1976) with Donald A. Thomson, and *The Sea in the Desert* (Tucson: Golden Puffer Press, 1989). She would be proud to know that she helped inspire a new book on the Gulf: Richard C. Brusca, Erin Kinney, and Wendy Moore, *A Seashore Guide to the Northern Gulf of California* (Tucson: Arizona-Sonora Desert Museum, 2004). For many years Nonie was a docent at the museum.

I heard of another snakebite victim from Ed Tuffly, a Border Patrol agent who worked the desert from 1958–1962 and 1967–

Death

1978. "The drags saved many lives. Often aliens in trouble would wait for us on the drags or to save 'Machismo' [they would] stop just after crossing a drag to imitate bad luck rather than surrender. I remember one time some aliens came knocking on my door at 2 a.m. They had left one of their numbers who had been bitten by a rattlesnake on the Hobbs drag. We went down and found him. They had put a tourniquet on his leg but failed to loosen it occasionally to allow some circulation. His leg looked horrible and he was in agony. BP pilot Richard A. Tomlinson landed his Super Cub on the drag, then flew the alien to Yuma. They saved his leg. About two months later we caught him coming out of the desert south of Wellton. I asked him how his leg was and he replied, 'Not so good,' but he had walked from La Joyita to Wellton on it" (Letter to the author April 25, 2005).

See also Bill Broyles, "Dropping in for a Nice Chat with Some of Our Desert Neighbors," *Tucson Citizen* magazine, September 19, 1984, 1–2, and "Driveway Nature Watching Sometimes Discloses Things We'd Rather Not Know," *Arizona Highways,* May 1995, 2. John Annerino, *Desert Survivor: An Adventurer's Guide to Exploring the Great American Desert* (New York: Four Walls Eight Windows Publishers, 2001).

WONDERS

The Wind and the Lion. Written and directed by John Milius. Warner Brothers, 1975. Formerly held by MGM and Turner Entertainment; W. H. Davies, "Leisure," in *Modern Verse,* Anita P. Forbes, ed., 3 (New York: Henry Holt, 1939).

Blister beetles are grouped in several genera, including *Epicauta, Lytta,* and *Tegrodera.* Desert millipedes are likely to be *Orthoporus ornatus,* though there are others. Assassin flies, velvet mites, tarantula wasps, Pinacate beetles, sphinx moths, and even centipedes and scorpions form a fascinating array of watchable insects. See Floyd Werner and Carl Olson, *Insects of the Southwest* (Tucson: Fisher Books, 1994). My favorite among favorites is the tailless whipscorpion, *Paraphrynus* spp. They have implausibly frail-looking, slender legs that may span six inches, and they prey on other insects. They can hide in cracks the thickness of a watchband. Too, they usually move with great deliberation yet can scuttle sideways with amazing quickness. They are nocturnal, and if Darth Vader were a black spider, this is how he'd choose to look.

Perez Brothers

For more about the trip with Ed Severson, see his "Tales of a Desert Rat," *Arizona Daily Star,* August 9, 1992, 2E, 7E.

For more about badgers and coyotes, see Julian Hayden, "Talking with the Beasts," *City Magazine* 2, no. 6 (1987):47–49 and "Talking with the Animals: Pinacate Reminiscences," *Journal of the Southwest,* 29 no. 2 (1987):222–27. See also Peter Gierlach's song "The Badger and the Coyote" on his Petey Mesquitey CD, *Best of Growing Native,* vol. 2, *Out in the Desert Grassland.* There is some evidence that badgers and red-tailed hawks also hunt together. Patrick K. Devers, Kiana Koenen, and Paul R. Krausman, "Interspecific Interactions between Badgers and Red-Tailed Hawks in the Sonoran Desert, Southwestern Arizona," *The Southwest Naturalist,* 49 no. 1 (2004):109–111.

The desert crust goes by various names: biological soil crusts, cryptogamic, cryptobiotic, microphytic, or microbiotic crusts. See Jayne Belnap's "From the Ground Up: Biological Soil Crusts in the Sonoran Desert" in *Dry Borders* (Felger and Broyles, eds.). Belnap writes, "Biological soil crusts are a complex mosaic of living organisms—cyanobacteria (formerly called blue-green algae), green algae, lichens, mosses, liverworts, bacteria, and fungi—that weave throughout the top few millimeters of the soil surface." See also www.soilcrust.org and J. Belnap and O.L. Lange, *Biological Soil Crusts: Structure, Function, and Management* (New York: Springer-Verlag, 2001). The speed with which crusts can begin photosynthesis is also recorded in one of the best desert books of all time: Michael Evenari, Leslie Shanan, and Naphtali Tadmor, *The Negev: The Challenge of a Desert* (Cambridge, Mass.: Harvard University Press, 1982).

HAWK

John Steinbeck. *The Log from the Sea of Cortez* (New York: Viking Press, 1975), 4.

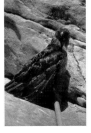
Hawk

See Bryan, *The Papago Country, Arizona.* Bryan noted "the fourth and higher tanks are very inaccessible and are little used except by mountain sheep, many of which fall into the water and drown" (134). His party found two carcasses in the upper tanks. There are nine sets of pools at Tinajas Altas.

See Gayle Harrison Hartmann and Mary Charlotte Thurtle, "The Archaeology of Tinajas Altas, a Desert Waterhole in Southwestern Arizona," *Kiva,* 66 (2001):489–518; Broyles, "Surface Water Resources for Prehistoric Peoples in Western Papaguería."

GLENTON SYKES

Glenton G. Sykes (July 27, 1896, to July 30, 1985). Alfred Lord Tennyson, "Ulysses," in *Century Readings for a Course in English Literature,* J. W. Cunliffe, J. F. Pyre, and Karl Young, eds., 762–63 (New York: The Century Company, 1919); Edna St. Vincent Millay (1892-1950). "First fig," *Collected Poems of Edna St. Vincent Millay* (New York: Harper & Row, circa 1956), page 127.

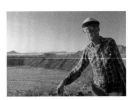
Glenton Sykes

This trip, sponsored by the Tucson Public Library, was led by Kathy Dannreuther and Terry Turner. Glenton's escorts included author Patricia Preciado Martin and her sister Elena Navarrette. Win Bundy, Jane Mallen, Jeanne Turner, Ray Turner, and others were delightful camping companions on this trip. Over the years Glenton's scientific companions included geologists John Anthony, John DuBois, Paul Damon, John Lance, and Wesley Peirce, and astronomer Gene Shoemaker. Julian Hayden and Glenton were friends for over fifty years. See Julian D. Hayden, *The Sierra Pinacate* (Tucson: The Southwest Center and University of Arizona Press, 1998).

Hornaday, who wrote *Camp-Fires on Desert and Lava,* and John M. Phillips previously made a trip to hunt sheep in Canada, recounted in *Camp-Fires in the Canadian Rockies* (New York: Charles Scribner's and Sons, 1906).

Glenton's mother and father were British. His father wrote *A Westerly Trend* (Tucson: Arizona Pioneers Historical Society, 1944) and *The Colorado Delta* (New York: American Geographical Society, 1937; repr., Port Washington, New York: Kennikat Press, 1970), both of which belong on your shelf.

Moon Crater and Hawk Butte were named by Sykes in 1956 (Ronald L. Ives, "The Pinacate Region, Sonora, Mexico," *Occasional Papers of the California Academy of Sciences Number 47,* 1964.) The name "boojum" *(Fouquiera columnaris)* is from Lewis Carroll's poem "The Hunting of the Snark." For more Glenton stories, see his "Life a Mile Down," *Journal of Arizona History,* 17, no. 1 (1976):39–43; "Five Walked Out! The Search for Port Isabel," *Journal of Arizona History,* 17, no. 2 (1976):127–36; "Admiral of the Santa Cruz," *Journal of Arizona History,* 20, no. 4 (1979):387–90; "After Supper," *Journal of Arizona History,* 22, no. 3 (1981):369–74; and "The Naming of the Boojum," *Journal of Arizona History,* 23, no. 4 (1982):351–56.

Diana Boyer

Alice Vail had a middle school named for her in Tucson. It was called a junior high school in its early days. I was a student there during its first two years. We called it Alice Vail Junior Jail, though we loved the place and I still see a number of classmates. We even met Alice Vail herself at the school's dedication in 1956. One of my elementary schools was named for Ygnacio Bonillas, who wrote a sterling report on Pinacate geology. Larry May, who was a high school classmate and track-and-field teammate, did his master's thesis on the Pinacate region ("Resource Reconnaissance of the Gran Desierto Region, Northwestern Sonora, Mexico" [Tucson: University of Arizona, 1973].) As a boy, Larry played at Julian Hayden's house. Need I say more about the strange seeds that fate plants in us long before we ever see the trees of our lives grow full?

A draft of this first appeared in the *Tucson Citizen* magazine December 1, 1984, 1–2. See also Bill Broyles, "Sykes, Scientist and Author, Dead at 89," *Tucson Citizen,* July 31, 1985,1A, 1–2C This article remains the source of some embarrassment to me. In the stress of writing an admired friend's obituary, I emphasized his love of science and his occasional writing but glossed over the central point that Glenton was the City of Tucson's chief civil engineer!

NIGHT

Lumholtz, *New Trails in Mexico, 343.* See also Bill Broyles, "Night Moves," *Backpacker,* July 1986, 67–68.

THE ULTIMATE DUDE RANCH

Dude Ranch

Edward FitzGerald. "The Rubáiyát of Omar Khayyám, 48" in *The Norton Anthology of English Literature*, vol. 2, M. H. Abrams, et al. eds., 1021–32 (New York: W. W. Norton, 1962).

The vaqueros report seeing lightning sometimes when there is no storm. This is confirmed by Ronald L. Ives, who noted, "Quite commonly, at night, weak lights can be seen on high points in this area. These, despite local surmises about the 'bomba atomica,' 'platos volantes,' and 'spirit candles,' are electrical discharges of entirely natural origin, usually named 'St. Elmo's Fire,' and common not only to the Pinacate Region, but also along the sierras of peninsular Baja California." Ives. "The Pinacate Region, Sonora, Mexico," 8.

An earlier version of this essay first appeared in "Savoring the Ultimate Dude Ranch," *Tucson Citizen* magazine, December 29, 1984, 7.

Salt

Song transcribed by Ruth Murray Underhill. *Singing for Power* (New York: Ballantine Books, 1938), 118. You'd probably also like Ofelia Zepeda's *Ocean Power* (Tucson: University of Arizona Press, 1995). See L. R. Bailey, ed., *Survey of a Route on the 32nd Parallel for the Texas Western Railroad, 1854: The A. B. Gray Report and Including the Reminiscences of Peter R. Brady who Accompanied the Expedition* (Los Angeles: Westernlore Press, 1963), and Lumholtz, *New Trails in Mexico.*

Lopez Collada was abandoned by the railroad, resettled as an ejido, and since abandoned once more, except for two persons who live under the immense tamarisk trees by the well.

Francisco, Piñata Man

Betty Smith, who with her husband, Dana, introduced me to snorkeling, also ran a medical lab in Tucson. She and her staff analyzed some samples of the water from four different coastal pozos. Her note accompanying the exam sheets reads, "These are all pathogens, but pozo #3 was the one which grew *large* numbers, >100,000/ml colony count. You must have a healthy gut. *E. coli* is normally found in the lower colon but can cause illness if in large numbers—it's the cause of most *touristas* [diarrhea] as there are many different subspecies of *E. coli*. The *Acinetobactor* and *Aeromones* are pathogenic in the G.I. tract if in large numbers. . . . Pozo #2 (collected July 1981): *Escherichia coli. Pseudomonas* spp, *Acinetobacter calcoaceticus* var *anitratus* >10,000 cc/ml. [colony count per milliliter]. Pozo #2 (collected July 1981): *Acinetobacter calcoaceticus* var *anitratus.* 7,000 cc/ml. Pozo #3 (collected July 1981): *Aeromonas hydrophila* >100,000 cc/ml. Pozo #4 (collected March 1978): Several *Pseudomonas* species. Heavy growth. Lactose neg. org. No *Salmonella* or *Shigella*. CA 2.1

MG/dl, Phos <0.1 MG/dl, NA 77 MEQ/L, K 0.9 MEQ/L." "Water of good quality is expected to give a low [culture] count, less than 100 per milliliter" (Michael J. Pelczar Jr., Roger D. Reid, and E. C. S. Chan, *Microbiology*, 4th ed. [New York: McGraw-Hill, 1977], 787).

Kangaroo rats and pocket mice have acute hearing and can hear foxes walk, snakes crawl, and owls glide. If K-rats had my human visual and auditory acuity, their species would have gone extinct long ago.

Across the Heart

Albert Camus. "The Myth of Sisyphus." *The Myth of Sisyphus and Other Essays.* New York: Vintage Books, 1959, 88–91.

The notes were lightly edited and punctuated for clarity and to amplify abbreviations.

Knowing

Colin Fletcher. *The Man Who Walked Through Time.* New York: Alfred A. Knopf, 1967, 221. From "Lost" by David Wagoner. *Traveling Light.* Champaign: University of Illinois Press, 1999, 10.

David Rankin became a forensic anthropologist and has worked in Southeast Asia recovering remains of missing U.S. servicemen. His will be a book worth reading. I salute his mother, Mary Lou.

Your shelf or bookstore likely has many volumes with reliable information on survival and camping. Two of my favorites are Annerino's *Desert Survivor* and Peggy Larson, *The Deserts of the Southwest: A Sierra Club Naturalist's Guide* (San Francisco: Sierra Club Books, 1977).

REASONS

Henry Aldrich, "Five Reasons for Drinking." *Bartletts's Familiar Quotations,* 17th ed.

The Appalachian Trail story is one I read in a hiking magazine, but John Steinbeck earlier mentioned a similar explanation in *The Log from the Sea of Cortez,* 100–101.

Lord George Byron, *Childe Harold's Pilgrimage,* IV, st. 178.

BOWDEN

Richard Eberhart. "If Only I Could Live at the Pitch That is Near Madness." *Collected Poems, 1930-1986.* (New York: Oxford University Press, 1987).

Charles Bowden, *Killing the Hidden Waters* (Austin: University of Texas Press, 1977; reissued 2004). A thorough list of Bowden's earlier work is offered in *Charles Bowden: A Descriptive Bibliography, 1962-2000,* compiled by W. E. Bartholomew (Tucson: Sylph Publications, 2001).

GROUND ZERO

Life

Much has changed since I witnessed this particular episode in 1984, but much remains the same. Jeff Milton could start work tomorrow, a century after his career began. The Tacna station has been moved to Wellton. Border Patrol has been reorganized under the Department of Homeland Security. Joe and Glen have retired. Dave was killed on duty (Tony Carroll, "Pilot Dies in Crash of Border Plane," *Yuma Daily Sun,* July 14, 1989, 1). See Bill Broyles, "U.S. Border Patrol, Yuma Sector," *Air Beat Magazine,* 8 (1984):16–17. I

Bienvenidos

still miss Dave. His story also appears in Annerino, *High Risk Photography, 92–93.* Howard Aitken is chief pilot at Yuma. His dad, Harry, now retired and living near Tucson, was a pilot in that sector before him.

A photo and essay of Joe McCraw is in Annerino, *High Risk Photography,* 46–47. See also John Annerino, "Heroic Trackers," *Police,* 12, no. 3 (1988):29–33; Jeff Tietz, "Fine Disturbances," *New Yorker,* November 29, 2004, 90–101; Jack Kearney, *Tracking: A Blueprint for Learning How* (El Cajon, Calif.: Pathways Press, 1978); Peter Odens, *The Desert Trackers* (Yuma: Southwest Printers, 1975); Charles Bowden, *Blue Desert* (Tucson: University of Arizona Press, 1986); Bowden, "A Walk Against the Clock," *Tucson Citizen,* July 22, 1983, 1B; Bowden, "The Trek That Can Last an Eternity," *Tucson Citizen,* August 22, 1983, unpaged, four-page pullout section; Annerino, *Dead in Their Tracks;* Ted Conover, *Coyotes* (New York: Vintage Books, 1987); and Luis Urrea, *The Devil's Highway* (New York: Little, Brown, 2004).

Even if we can't locate his footprints, Ed Abbey's spirit remains in the Grand Desert. His fondness and awe can be read in "A Walk in the Desert Hills," "Desert Images," and "The Ancient Dust" (*Beyond the Wall,* New York: Holt, Rinehart, and Winston, 1984).

Newspaper stories for June 18, 2005, included "Pickup Rolls in Avra Valley, 19 People Reported Hurt" (*Arizona Daily Star,* B1) and "Strawberries Rot in Oregon Fields" (*Arizona Daily Star,* A4), as well as the usual reader letters debating immigration and border control.

Wellton station statistics courtesy of Joseph Brigman, U.S. Border Patrol. Refuge road statistics courtesy of Curt McCasland, U.S. Fish and Wildlife Service.

For my stay at Camp Grip, I thank Robert McLemore, Joseph Brigman, Howard Aitken, Ronald Colburn, Luis Cotto, Alfredo Delgado, Jim Fischer, Mike Ringler, Stephen Johnson, Jeremy Kite, and Josué Ostos of the Border Patrol.

An earlier version of this chapter originally appeared as "Patrol vs. Illegals: Friendly Pursuit," *Yuma Daily Sun,* September 9, 1984, 1, 17–18.

LETTING GO

Abba Kovner, from "Detached Verses, 9." Translated from the Hebrew by Eddie Levenston. *Sloan-Kettering Poems* (New York: Schocken Books, 2002), 122. Robert Service, "The Heart of the Sourdough," in *Best Tales of the Yukon* (Philadelphia: Running Press, 2003), 138–39.

Zona despoblada

The story of the railroad surveyors is recounted in Valdemar Barrios-Matrecito, *Por las Rutas del Desierto* (Hermosillo: Gobierno del Estado de Sonora, 1988), and in Guillermo Munro Palacio, "Viento Negro: A Saga of the Sonora-Baja California Railroad," in *Dry Borders*, Richard S. Felger and Bill Broyles, eds.

The Basque Etchea restaurant in Tacna is authentic. Its owner, Fidel Jorajuria, was born in Sumbilla, Spain. His family raised sheep in the Pyrenees before coming to Evanston, Wyoming, in 1947, when Fidel was sixteen. He moved to Arizona, worked in the Bloody Basin area and then Casa Grande before moving his flocks to the alfalfa stubble at Tacna. He dreamed of owning a restaurant and bar, so he designed it in his mind and made the calculations on the back of an envelope. He bought beams in Show Low and notched them with a chainsaw. On the ground in Tacna he scuffed the outline of a 100-by-50-foot floor plan and with the help of his brother and son-in-law built the place in 1978.

O'Neill's story is in A. A. Nichol, "O'Neill's Grave in O'Neill's Pass in the O'Neill Mountains," *Random Papers for Southwestern National Monuments,* July 1939, 65–67.

Lumholtz, *New Trails in Mexico*, 239; Sheldon, *The Wilderness of the Southwest*, 176.

Also of immediate interest: Annerino, *Desert Survivor;* Aron Spilken, *Escape!* (New York: New American Library, 1983); Harold Weight, "Tin Lizzies and Iron Men," *Westways,* November 1968, 32–35; James Riley, *An Authentic Narrative of the Loss of the Brig Commerce, Wrecked on the Western Coast of Africa, in the Month of August, 1815, with An Account of the Sufferings of the Surviving Officers and Crew, Who Were Enslaved by the Wandering Arabs, on the African Desart [sic], or Zaharah [sic], and Observations Historical, Geographical, &c.* (Hartford, Connecticut: Silas Andrus, 1831; repr. as *Sufferings in Africa*, Gordon H. Evans, ed. [New York: Clarkson N. Potter, 1965]).

Cabeza Prieta National Wildlife Refuge manager Roger DiRosa is one of the good guys.

We're reminded of Carl Lumholtz standing amid profuse wild-flowers near Tinajas Altas and reflecting on his life; he wrote, "Could I select the place where I should like best to die, my choice would be one such as this. I hope at least it may not fall my lot to pass away in New York, where I might be embalmed before I was dead and where it costs so much to die that I might not leave enough to defray the expenses of a funeral" (*New Trails in Mexico,* 307).

And we think of Olga Smith, who realized, "It wouldn't be bad to die out here . . . [where] death did not seem the frightening transi-

Roger DiRosa

tion it did in the city. . . . You could simply go to sleep under that ironwood tree over there, and with the shining stillness around you, go on through all eternity feeling the sun and the wind and the warmth of life about you" (*Gold on the Desert* [Albuquerque: University of New Mexico Press, 1956], 247–48).

Albert Camus quotation from "Summer in Algiers," *The Myth of Sisyphus and Other Essays*, 113.

Experts predicting a warmer Sonoran Desert include Jonathan Overpeck, Jeff Price, Gregg Garfin, and Rick Miller (plenary speakers at the 2004 annual Wildlife Society Meeting, Arizona and New Mexico chapters); see also Douglas B. Inkley, Michael G. Anderson, et al., *Global Climate Change and Wildlife in North America* (Bethesda, Md.: The Wildlife Society, 2004). For human damage to the desert, start with Gary Paul Nabhan and Andrew R. Holdsworth, *State of the Desert Biome: Uniqueness, Biodiversity, Threats, and the Adequacy of Protection in the Sonoran Bioregion* (Tucson: The Wildlands Project, 1998). A wider perspective is found in Jared Diamond, *Collapse: How Societies Choose to Fail or Succeed* (New York: Viking, 2005).

Allusions with due respect to Robert Browning, *Andrea del Sarto*, line 97; Joseph Conrad, *Heart of Darkness*; T. S. Eliot, "The Wasteland"; Robert Frost, "Fire and Ice"; Ernest Hemingway, "A Clean, Well Lighted Place" and *The Old Man and the Sea*; The Holy Bible: Genesis, Luke; Edna St. Vincent Millay, "Dirge Without Music"; Plato, *Phaedo*; Henry David Thoreau, *Walden*; Orson Welles, *Citizen Kane*; among others.

DEVIL'S OVEN

Albert Camus. *The Stranger*. New York: Vintage Books, 1954, 72–73.

W. J. McGee quotation from "Thirst in the Desert," *Atlantic Monthly*, April 1898, 483–88. See also McGee's "Desert Thirst as Disease." McGee was the researcher at Tinajas Altas. See his weather notes and his own chronicle of battling cancer: "The Desert Cure," *The Independent*, 59, no. 2964 (1905):609, 670–72 (Reprinted in Emma R. McGee, *Life of WJ McGee* [Farley, Iowa: Privately printed, 1915); "Climatology of Tinajas Altas, Arizona: Preliminary Report," *Science*, 22, no. 593 (1906):721–30; and "Symptomatic Development of Cancer," *Science* 36, no. 924 (1912):348–50.

Hyponatremia is a serious medical condition caused by drinking too much water without also eating food or drinking electrolyte supplements.

I first "met" Pablo Valencia in a book by Alonzo Pond (*The Desert World* [New York: Thomas Nelson & Sons, 1962], 296–313). I was relatively new to desert hiking, but the chapter raised more questions than it answered: where did he walk? Why didn't they rendezvous? How could he survive that long? I tracked down McGee's first published report (*Interstate Medical Journal*) and, after piecing together the ordeal, retraced what I believe was Pablo's route (Bill Broyles, "Desert Thirst: The Ordeal of Pablo Valencia," *Journal of Arizona History*, 23 [1982]:357–80). His struggle and the number of days he spent without water are incredible. It is a really long time. I wanted to know more. I've asked experts and major libraries if they have or know the whereabouts of McGee's 1905 field notebook from Tinajas Altas. No luck yet.

Jim Fischer

A disconcerting passage in another McGee paper makes me yearn to find those notes all the more. In his article titled "The Desert Cure" McGee writes, "On July 20th [1905] I had the exciting experience of rescuing two Mexican prospectors at the point of death from thirst. They had gone out insufficiently supplied with canteens, boastful of their ability to stand heat and thirst. Five days later they straggled back to camp, semi-delirious, neither one able to articulate. They dropped, fifty yards apart, and José attended one, while I looked after the weaker, administering water and a little whiskey, giving also a heart stimulant to the weaker one, to keep the thickened blood moving until the reaction was over. Glimpses of that side of desert life are awful, but happily one can provide against such emergencies" (672).

If this passage is accurate, then we face still more questions: is this passage about Pablo and his partner? If so, why is it so different from the *Interstate Medical Journal* version, where Pablo's ordeal began August 15, not July 20? Was Pablo's ordeal only five days—far more plausible than the stated eight? Is the story changed, and if so, why? If not about Pablo, then it's an amazing coincidence that McGee similarly rescued two sets of prospectors a month apart. And why doesn't McGee mention the first episode alongside other harrowing cases of thirst in his fuller account of Pablo Valencia? "The Desert Cure" appeared in print only a month after he left Tinajas Altas, and the longer paper was published a year later. Perhaps McGee penned the first, shorter account hastily and offhandedly, but why would he confuse three key details: the date, both prospectors going instead of just one, and the episode's duration. The field book might settle details of Pablo's ordeal.

To further confound the matter, David Gaillard, who toured the area in 1895–96, nine years before McGee's encounter, wrote, "The desert still claims its victims, and not a month passes but that some inexperienced prospector yields up his life in search for the fabled mines of the desert—sirens which have lured scores to their deaths" ("The Perils and Wonders of a True Desert," 604). He then recounts a story of his party finding and rescuing two prospectors who had run out of water, and several elements of the story parallel McGee's tale. Maybe many prospectors did founder or maybe Gaillard's account added a seed to McGee's fertile harvest of stories that he had already gathered. I can't yet say.

Saved

I can neither challenge nor corroborate McGee on his Pablo report without more evidence. Having walked the ground and felt the sun, eight days out—six and a half without water—stretches my imagination. It is an anomalous datum point, an outlier off the chart. McGee's field book would confirm or debunk this persistent desert myth, one that we'd like to believe but one that should be corrected if untrue. I nearly died following McGee's account of Pablo Valencia, and I've trusted McGee enough to tout it as a real-life adventure. If McGee exaggerated the time span, I owe people an apology for perpetuating a myth and need to correct the record. I'll continue looking for the field notes or other evidence. Please call if you locate them.

The original report about Pablo is reprinted in W. J. McGee, "Desert Thirst as Disease," *Journal of the Southwest*, 30, no. 2 (1988): 228–53. This chapter was originally published as "The Blistering Desert" in *Arizona Highways*, July 1999, 4–13. The *Arizona Highways* editorial staff selected this essay as the magazine's Best Story of the Year for 1999.

Library

If I were starting a basic library on this region, I'd start with these books. Most are available new, in paperback, or as reasonably priced used editions. I never tire of rereading these books and refer to them frequently for information and inspiration.

Edward Abbey. *Cactus Country.* New York: Time-Life Books, 1973.

John Annerino. *Dead in Their Tracks: Crossing America's Desert Borderlands.* New York: Four Walls Eight Windows, 1999.

Charles Bowden. *Blue Desert.* Tucson: University of Arizona Press, 1986.

William K Hartmann. *Desert Heart.* Tucson: Fisher Books, 1989.

Julian D. Hayden. *The Sierra Pinacate.* Tucson: The Southwest Center and University of Arizona Press, 1998.

William T. Hornaday. *Camp-Fires on Desert and Lava.* New York: Charles Scribner's Sons, 1908. Reprinted, Tucson: University of Arizona Press, 1983.

Ronald L. Ives. *Land of Lava, Ash, and Sand.* James W. Byrkit and Karen J. Dahood, editors. Tucson: Arizona Historical Society, 1989.

Carl Lumholtz. *New Trails in Mexico.* London: T. Fisher Unwin, 1912. Reprinted, Glorieta, N.Mex.: Rio Grande Press, 1971; Tucson: University of Arizona Press, 1990.

Olga Wright Smith. *Gold on the Desert*. Albuquerque: University of New Mexico Press, 1956.

You also will want Richard S. Felger and Bill Broyles, editors, *Dry Borders* (Salt Lake City: University of Utah Press). It's scheduled for publication in winter 2005. If I do say so myself, it is an enjoyable and valuable reference with a superb cast of authors.

When You Go

Most visitors to the Gran Desierto prefer traveling between October and May. Supplies and accommodations can be found in Ajo-Why, Gila Bend, Puerto Peñasco, San Luis, Sonoyta-Lukeville, Tacna, Wellton, and Yuma. There are few facilities along the highways, and once you leave the paved roadways, travel in this region is a self-contained venture with no reliable water. Gasoline, water, and supplies must be carried. High-clearance, four-wheel-drive vehicles are strongly recommended. At times roads are impassable for reasons ranging from deep dust to mud bogs to fallen saguaros to law enforcement or military operations. Driving off the road is illegal, with good reasons. And whatever you do out there, don't you dare die on us.

List of Photographs

Page ii. The fate of mountains. Sierra Enterrada (Buried Range), El Pinacate Biosphere Reserve.

Page vi. Cinder cone halved by ocotillo. El Pinacate lava flow.

Page viii. Shadow across the cactus forest. Cabeza Prieta National Wildlife Refuge.

Page 2. Grave along El Camino del Diablo. Nameer, 1871.

Page 5. Duel. Long-leaved joint-fir holding its own against drifting sand.

Page 6. Saguaro sentinel at Black Gap. Goldwater Range.

Page 7. A-1 Basin. Cabeza Prieta Mountains.

Page 8. Feel the fire. Crater, El Pinacate lava field.

Page 13. Miles to go. Cabeza Prieta Mountains and Sierra Tuseral.

Page 14. Mound. Aguila Mountains.

Page 15. Granite islands in a dry sea. Isla Pinta, Sierra Pinta.

Page 16. At the edge of the Earth. Aguila Mountains.

Page 18. Abandoned car. Route 2, Sonora.

Page 19. Glory comes to small hill. Gila Mountains.

Page 21. Ridgeline sunset. Mohawk Mountains.

Page 22. Heartrock. Cabeza Prieta Mountains.

Page 24. Desert agave. Gila Mountains.

Page 25. Hideout. Sierra Pinta.

Page 27. Burning bush. Ironwood tree swept by wind.

Page 28. Nolina on granite wall. Bigelow bear grass, Tinajas Altas
Mountains.

Page 31. Shelter in the heights.

Page 32. Waterlines. Tinaja, Sierra Pinacate.

Page 35. Dancing ocotillos.

Page 38. Cinder slopes of Pinacate Peak.

Page 41. Defiant organ pipe.

Page 43. Waiting for rain. Ironwood trees, living and dead, along
dry channel.

Page 44. When dreams go bust. Angel Monreal's ranch, Cabeza
Prieta National Wildlife Refuge.

Page 47. Senita cactus. Sierra Pinacate.

Page 49. Ironwood trees in nameless canyon.

Page 50. Granite waves. Cabeza Prieta Mountains.

Page 51. Sphinx. El Pinacate Biosphere Reserve.

Page 52. Barrel cactus. Sand Tank Mountains.

Page 56. Fork.

Page 59. Ghosts. Abandoned Ejido Cerdán along Route 2, Sonora.

Page 61. Coyote Howls Campground. Why, Arizona.

Page 69. Stone rich. Sentinel Lava Plain.

Page 71. Power. Sonoran Desert National Monument.

Page 72. Snake.

Page 74. Mother wood and saguaro.

Page 75. Twin spaces, shadow and stone. Butler Mountains.

Page 77. Eye arch. El Pinacate lava field.

Page 81. Mismatch, tire treads and creosote bushes.

Page 82. Organ pipe cactus salutes Kino Peak.

Page 85. View north from Table Top. Sonoran Desert National
Monument.

Page 87. Zigzag backbone. Vopoki Ridge. Gila Mountains.

Page 88. No easy way. Granite Mountains.

Page 91. Bush by moon.

Page 92. Cloud and ravens. Goldwater Range.

Page 95. Sierra Arida.

Page 96. MacDougal Crater. El Pinacate Biosphere Reserve.

Page 98. Blue paloverde tree. Davis Plain.

Page 99. Ripples on stone water. From the Cabeza Prieta
Mountains south.

Page 103. Gargoyles. El Pinacate Biosphere Reserve.

Page 104. Dreamland. Cabeza Prieta Peak.

Page 106. Aerie. Buck Peak.

Page 107. Arch Canyon. Organ Pipe Cactus National Monument.

Page 110. Among peers. Tinajas Altas Mountains.

Page 111. Hungry granite. Copper Mountains.

Page 112. Well pump and tools. Rancho Victoria.

Page 115. Lava chaos. Sierra Blanca.

Pages 116–117. Rancho Victoria.

Page 118. Salt flat. Salina Grande.

Page 120. Digging for water. Coastal salt flat.

Page 121. Waiting for the tide. Fishing boats. El Golfo
de Santa Clara.

Page 122. Steel rails through shifting dunes.

Page 127. Walking dunes.

Page 131. Rivers of lava. El Pinacate Biosphere Reserve.

Page 132. Sand sunset.

Page 135. Thin line highway. Route 2, Sonora.

Page 137. Lone dune. Sierra del Rosario.

Page 141. Stem anchored to sand sea.

Page 146. Child of the mountain. Sierra del Rosario.

Page 147. As far as the eye can see. El Gran Desierto.

Page 148. Cornerstone seer. Copper Mountains.

Page 150. Pillar. Gila Mountains.

Page 151. Owl cave. Gila Mountains.

Page 154. Sculpted sand.

Page 155. Sal si puedes—escape if you can. Teddybear cholla and saguaros, Goldwater Range.

Page 156. Anthill in a flat. Goldwater Range.

Page 157. Bone dry. Rancho Pozo Nuevo.

Page 158. Face to face, rock and dune. Sierra del Rosario.

Page 160. Ant trilogy.

Page 161. Naked rock clothed in sun. Aguila Mountains.

Page 162. MacDougal Crater diptych. El Pinacate Biosphere Reserve.

Page 165. Relief. Lechuguilla Desert.

Page 166. Branch on desert pavement. Sand Tank Mountains.

Page 167. Desert iguana with talon punctures.

Page 172. Crossing.

Page 178. Crossed saguaros.

Page 179. Two flags. Roadside memorial.

Page 189. Last stop. Travel bags and water jugs.

Page 190. From the ridge, 1. Sierra del Rosario.

Page 191. From the ridge, 2. Sierra del Rosario.

Page 192. Letting go. Blanket and tracks, Black Gap, Goldwater Range.

Page 200. Four saguaros.

Page 201. When rock flowed. Pahoehoe lava, El Pinacate Biosphere Reserve.

Page 202. Big Pass, between Buck Mountains and Copper Mountains.

Page 208. Shadow moon.

Page 210. Beyond beyond. West from Cabeza Prieta Mountains.

Page 212. Spent missile. Goldwater Range.

About the Author

BILL BROYLES devoted thirty-one years to teaching English and physical education to high school students and is now a research associate with the University of Arizona's Southwest Center. He earned a B.A. in English and philosophy from the University of Arizona and an M.A. in philosophy from Claremont Graduate School. He spends his free time writing, hiking, and learning about deserts. His written work has appeared on such pages as *Arizona Highways, Journal of the Southwest, Journal of Arizona History, Journal of Arid Environments, Wildlife Society Bulletin,* and three books, *Organ Pipe Cactus National Monument: Where Edges Meet* (1996), *Our Sonoran Desert* (2003), and *Desert Babies A-Z* (2005). With Richard S. Felger he is coeditor of *Dry Borders: Great Natural Reserves of the Sonoran Desert* (in press). He prefers long solo hikes across the valleys, dunes, and mountains, but he also loves sitting under an ironwood tree to read a book or watch desert bighorns.

About the Photographer

MICHAEL BERMAN was born in New York City in 1956 but came west to Colorado College, where he studied biology. He received an MFA in photography from Arizona State University. Fifteen years ago he settled in southwestern New Mexico, where he now lives in the Mimbres Valley near San Lorenzo. He wanders the border wildlands of the United States and Mexico and works on local issues—mining, grazing, wilderness, timber, water, growth, and the border—that affect the land. To his art, Berman brings an awareness of the complexity of the biological world; to the political and social dialogue of the West, he brings his art as a catalyst to renew our perception of the land. His photographs are included in the collections of the Metropolitan Museum of Art, the Cleveland Museum of Art, the Amon Carter Museum, and the Museum of New Mexico. He has received Painting Fellowships from the Arizona Commission on the Arts and the Wurlitzer Foundation; his installations and paintings have been reviewed in *Art in America* and exhibited throughout the country.

The Southwest Center Series

Ignaz Pfefferkorn, *Sonora: A Description of the Province*

Carl Lumholtz, *New Trails in Mexico*

Buford Pickens, *The Missions of Northern Sonora: A 1935 Field Documentation*

Gary Paul Nabhan, editor, *Counting Sheep: Twenty Ways of Seeing Desert Bighorn*

Eileen Oktavec, *Answered Prayers: Miracles and Milagros along the Border*

Curtis M. Hinsley and David R. Wilcox, editors, *Frank Hamilton Cushing and the Hemenway Southwestern Archaeological Expedition, 1886–1889,* volume 1: *The Southwest in the American Imagination: The Writings of Sylvester Baxter, 1881–1899*

Lawrence J. Taylor and Maeve Hickey, *The Road to Mexico*

Donna J. Guy and Thomas E. Sheridan, editors, *Contested Ground: Comparative Frontiers on the Northern and Southern Edges of the Spanish Empire*

Julian D. Hayden, *The Sierra Pinacate*

Paul S. Martin, David Yetman, Mark Fishbein, Phil Jenkins, Thomas R. Van Devender, and Rebecca K. Wilson, editors, *Gentry's Rio Mayo Plants: The Tropical Deciduous Forest and Environs of Northwest Mexico*

W. J. McGee, *Trails to Tiburón: The 1894 and 1895 Field Diaries of W J McGee,* transcribed by Hazel McFeely Fontana, annotated and with an introduction by Bernard L. Fontana

Richard Stephen Felger, *Flora of the Gran Desierto and Río Colorado of Northwestern Mexico*

Donald Bahr, editor, *O'odham Creation and Related Events: As Told to Ruth Benedict in 1927 in Prose, Oratory, and Song by the Pimas William Blackwater, Thomas Vanyiko, Clara Ahiel, William Stevens, Oliver Wellington, and Kisto*

Dan L. Fischer, *Early Southwest Ornithologists, 1528–1900*

Thomas Bowen, editor, *Backcountry Pilot: Flying Adventures with Ike Russell*

Federico José María Ronstadt, *Borderman: Memoirs of Federico José María Ronstadt,* edited by Edward F. Ronstadt

Curtis M. Hinsley and David R. Wilcox, editors, *Frank Hamilton Cushing and the Hemenway Southwestern Archaeological Expedition, 1886–1889,* volume 2: *The Lost Itinerary of Frank Hamilton Cushing*

Neil Goodwin, *Like a Brother: Grenville Goodwin's Apache Years, 1928–1939*

Katherine G. Morrissey and Kirsten Jensen, editors, *Picturing Arizona: The Photographic Record of the 1930s*

David W. Lazaroff, Philip C. Rosen, and Charles H. Lowe Jr., *Amphibians, Reptiles, and Their Habitats at Sabino Canyon*

Bill Broyles and Michael Berman, *Sunshot: Peril and Wonder in the Gran Desierto*

Library of Congress Cataloging in Publication Data

Broyles, Bill.

 Sunshot : peril and wonder in the Gran Desierto / text by Bill Broyles ; photographs by Michael P. Berman.

 p. cm. — (The Southwest Center series)

 Includes bibliographical references (p.).

 ISBN-13: 978-0-8165-2524-9 (pbk. : alk. paper)

 ISBN-10: 0-8165-2524-2 (pbk. : alk. paper)

 1. Southwest, New—Description and travel. 2. Deserts—Southwest, New. 3. Sonoran Desert–Description and travel. 4. Pinacate Mountain Region (Mexico)—Description and travel. 5. Yuma Region (Ariz.)—Description and travel. 6. Southwest, New—Pictorial works. 7. Deserts—Southwest, New—Pictorial works. 8. Sonoran Desert—Pictorial works. 9. Pinacate Mountain Region (Mexico)—Pictorial works. 10. Yuma Region (Ariz.)—Pictorial works. I. Title. II. Series.

F787.B765 2006

917.9—dc22

 2005024486